Design for Motion

Combining art and design principles with creative storytelling and professional savvy, this book covers everything a serious motion designer needs to make their artistic visions a reality and confidently produce compositions for clients.

In this updated second edition of *Design for Motion*, author Austin Shaw explores the principles of motion design, teaching readers how to creatively harness the essential techniques of this diverse and innovative medium to create compelling style frames, design boards, and motion design products. Lessons are augmented by illustrious full-color imagery and practical exercises, allowing you to put the techniques covered into immediate practical context. Industry leaders, pioneers, and rising stars contribute their professional perspectives, share personal stories, and provide visual examples of their work.

This second edition also includes updates on the following:

- Illustration techniques
- Typography
- Compositing
- Visual storytelling
- Incorporating 3D elements
- Social/mobile-first design
- Portfolio and concept development
- How to develop a distinct personal design style, and much more

Plumb the depths of core motion design fundamentals and harness the essential techniques of this diverse and innovative medium. An accompanying Companion Website (www.routledge.com/cw/shaw) features video tutorials, a student showcase, and more.

Austin Shaw is a full-time Professor of Motion Media Design at the Savannah College of Art and Design. He has also taught at the School of Visual Arts in New York City. For over 15 years, Austin has worked as a motion designer for clients including Target, Ferrari, Fedex, McGraw Hill, Ralph Lauren, and VH1 and as a Creative Director, Designer, and Animator for companies such as Brand New School, Curious Pictures, Digital Kitchen, Perception, Sarofsky, and Superfad.

Design for Motion

Fundamentals and Techniques of Motion Design

Second Edition

Written by Austin Shaw
Edited by Danielle Shaw

Focal Press
Taylor & Francis Group

NEW YORK AND LONDON

Second edition published 2020
by Routledge
52 Vanderbilt Avenue, New York, NY 10017

and by Routledge
2 Park Square, Milton Park, Abingdon, Oxon, OX14 4RN

Routledge is an imprint of the Taylor & Francis Group, an informa business

Library of Congress Cataloging-in-Publication Data
Names: Shaw, Austin, author.
Title: Design for motion : fundamentals and techniques of motion design / written by Austin Shaw edited by Danielle Shaw.
Description: Second edition. | New York, NY : Routledge, Taylor & Francis Group, 2020. | Includes index.
Identifiers: LCCN 2019019234| ISBN 9781138318649 (hbk) | ISBN 9781138318656 (pbk) | ISBN 9780429452949 (ebk)
Subjects: LCSH: Computer animation—Study and teaching (Higher) | Computer graphics—Study and teaching (Higher) | Animation (Cinematography)—Study and teaching (Higher) | Television graphics—Study and teaching (Higher)
Classification: LCC TR897.7 .S3885 2020 | DDC 777/.7076—dc23
LC record available at https://lccn.loc.gov/2019019234

First edition published by Focal Press 2016

ISBN: 978-1-138-31864-9 (hbk)
ISBN: 978-1-138-31865-6 (pbk)
ISBN: 978-0-429-45294-9 (ebk)

Typeset in 11/15pt DIN Regular by
Servis Filmsetting Ltd, Stockport, Cheshire

Visit the companion website: www.routledge.com/cw/shaw

Dedication

This book is dedicated to my daughters Athena Blue and Chloe Shaw, who remind me to be curious. And to my father Larry Shaw, who always believed in my words.

Table of Contents

Acknowledgements

I would like to thank the many generations of my Design for Motion students! You are a continuous source of inspiration. You challenge me to be a better teacher. Thank you for contributing your talent and hard work to many of the visual examples presented in this book.

Thank you to my wife Danielle Shaw for editing this book. I could not have written this book without you.

Thank you to Erin Sarofsky for writing the foreword to the 2nd edition, and for many years of friendship. Also, thank you for being a champion of women in our industry.

A special thanks to my colleague John Colette for believing in the *Design for Motion* course and for your contributions and persistent support throughout the writing of both editions of this book. To my fellow Motion Media Design faculty at the Savannah College of Art and Design—Michael Betancourt, Kelly Carlton, Dominique Elliot, James Gladman, Karla Johnson, Min Ho Shin, and Duff Yong. Thank you for your support and for creating a wonderful community for teaching and learning.

I want to thank all of the industry contributors for sharing your time, insights, and examples of your work and process. Thank you Melanie Abramov, William Arnold, Ed Barrett, Beat Baudenbacher, William Campbell, Patrick Clair, Peter Clark, Lindsay Daniels, Karin Fong, Brian Michael Gossett, Chace Hartman, Lauren Hartstone, Joshua Harvey, Lilit Hayrapetyan, Greg Herman, Will Johnson, Tom Judd, Stephen Kelleher, Robert Lester, Kylie Matulick, Sarah Beth Morgan, Bradley G. Munkowitz (GMUNK), Daniel Oeffinger, Pablo Rochat, Erin Sarofsky, Matt Smithson, Sekani Solomon, Carlo Vega, Alan Williams, Mike Winkelmann (Beeple), Audrey Yeo, Danny Yount, and Lucas Zanotto.

Thank you to Sofie Lee for designing the hero artwork for the cover of this edition. Thank you to Chace Hartman, Sekani Solomon, and Peter Clark for humoring all of my various requests for supplemental imagery. Thank you to Islay Joy Petrie, Madison Kelly, and Michelle Parry for educating me about the wonders of social media. Again, with this 2nd edition of the *Design for Motion* textbook, I want to give a very special thank you to Geraint Owen for making this book possible.

Thank you to my copy editor, Yvette Chin for being incredibly thorough and efficient. I would also like to thank my publishing team at Focal Press/Routledge for your patience and support. Thank you to the interior design team for creating a beautiful book.

Foreword to the 2nd Edition

Erin Sarofsky

In *Back to the Future Part II*, when Marty McFly gets out of his DeLorean in 2015, he stands, aghast at how advertising moves around him. He spins around to take it all in. Everything is in motion, layers and layers of media assaulting him.

We have arrived at a time when motion design is more than animating on type over live-action imagery. It's literally everywhere and in everything we see. Now we are all Marty McFly being barraged by content that is trying to grab our attention with flashy animation.

Like Marty, we're not sitting in front of a TV. We are all out in the world. So, content has to be delivered to us; on our mobile device, in our chosen social media platform, at the venue where we're hanging out, in the elevator on the way to our job, or in the game we're playing. Information moves faster than ever, and we are consuming it as fast as it appears. The happy upside of this phenomenon is this: Opportunities for motion designers are at an all-time high.

Now, most designers have to be more than one-frame thinkers. The art we mastered many years ago in print design has to be reimagined and extrapolated into a narrative. That means designers now have to ask themselves, "What is the story and how does it unfold? How do we capture the attention of a viewer and

take them on a journey?" These questions are just as important for a 6-second Instagram animation or a 60-second main title sequence. This process, exploring design in a narrative, is also what separates amazing motion designers from the pack. How can you not only create a look and a proficient animation, but also take the viewer on a journey of discovery, keeping them engaged and wanting to know more?

* * *

When I started out in this business, motion design had pretty specific uses. In commercials, we animated logos and supers with the offers of the day. Occasionally we would have product demos to "plus up" with bits of motion design to call attention to things. Sometimes, though rarely, we'd get to do completely animated commercials. I'm not talking about traditional cel animation, which could actually be quite sophisticated. I mean traditional motion design, which was anything but.

In entertainment, most VFX were all in-camera or shot as plates for compositing. Even displays and monitors had set designers building practical objects. It was unthinkable to purposefully lean on CG and motion design to sell anything convincingly.

Right as I entered the field, tools started emerging that allowed designers to be able to dig deeper into motion design work and not only produce it more efficiently, but also inspire and influence its development. Designers like me were being tasked with inventing new design-driven looks and narratives for products. To do that, it also meant we had to develop new processes, new ways to present and produce work throughout the production pipeline. This work created demand for better, faster, and more intuitive software and hardware to help designers keep up.

This was a beautiful and treacherous time in motion design. We created imaginative stills and storyboards (works of art in their own right) that we sold to big agencies and clients with promises of bringing them to life (as if we really knew how). The truth is, most of the time, we didn't. We just started making things. Through tireless days, finding work-around after work-around, we made things that were even better than we imagined they could be.

Now, as with all early forms of communication and craft, when you look back at that work, it's a bit primitive. But that's when the industry was invented; so many of those amazing pieces created back then inspired the whole motion design field. This field—once a few people at a few studios—is now a vast industry with artists and animators working across all markets in every aspect of the marketing and development pipeline. That evolution occurred in less than 20 years.

* * *

I met Austin Shaw when the motion graphics industry was in its heyday. There were still very focused studios creating this work. The demand for artists was insatiable. Media was leaning into new looks we were developing because they were so fresh and "unlike anything seen before."

Because the field was still so new, and we were creating innovative work, pushing the boundaries of the software and trying to manage client expectations along the way, Austin and I were among many ambitious artists and producers who were developing a new process. Following this process helped to guide both the selling and production of great work.

As the field has grown to accommodate new techniques, mediums, platforms and technologies, that process has become even more important ... because it creates a paradigm for success amongst ourselves and our clients.

Having been both on the professional and the academic sides of this emerging industry from its infancy, Austin has rare insight. He has been able to distill the processes we have created and to serve them up in a way that students of motion design can easily absorb. He's also constructed it to work in layers, offering pieces of knowledge that are like tools in a toolbox. Each tool makes you a stronger artist, communicator, and animator.

The depth of information covered in this book is important because motion design encompasses a range of mediums and a variety of skill-sets. Back in the day, learning one motion tool like After Effects meant you were easily in the game; that's not the case anymore. In addition to that tool, there are both compositing and 3D tools. There are also a variety of techniques like cel animation, motion graphics animation, footage manipulation, photo-real comping, and many others that should be understood, if not mastered.

This diverse base knowledge is so important because motion designers are needed now in many different capacities:

- Commercials still need animated logos and offers.
- Products are now fully CG, flying around and forming in ways that defy gravity and logic.
- Liquid can magically fly into frame and form objects that would be impossible to achieve practically.
- Motion can be captured and applied to CG objects.
- Interactive video installations.

products into present and future, while also inspiring new ways of telling stories.

* * *

Notwithstanding reality, what Justin Cone touched on in the original forward for this book remains spot on: Learning and discovery always meet with the reality of your situation. Sometimes you are short of time, sometimes short of money, sometimes your team is missing a key person, sometimes your software or hardware lets you down, sometimes clients get in the way, and sometimes the assets provided aren't up to snuff.

This book will help you problem-solve through all those situations. Through its illumination, you will fully grasp the process that has been created to allow you to work through every sort of challenge you will face.

What Austin does extremely well in this book is to teach that process and use it to guide you through both the projects you are working on and your career as a whole. It will also help you avoid falling deep into one specific trend. Those of us in the trenches of this industry know that once something is hot, it will fall out of favor very soon. If you use this book as a base, and hone in and lean on strong design skills, production skills, and conceptual thinking, you will have the opportunity to make successful work, no matter what medium you are working in or where your work ultimately appears.

- Where video archives of deceased performers have been projected at concerts, there are now holograms of the artists.
- AR and VR have become a new reality for motion designers as companies are embracing those technologies in their marketing campaigns.
- Gaming is also evolving to be more design centric, with some games being created entirely by designers and illustrators.
- Web design, social media and all platforms you explore feature motion design elements throughout (just clicking *like*, prompts a lovely heart animation).
- Facebook makes photo albums for you.
- Billboards aren't print; they're LED video panels.
- Even mall and airport kiosks animate and respond.
- And the list goes on. …

In movies and entertainment across the board, entire sequences are created in CG. More and more motion design elements are integrated into scenes because it elevates the production design and character development. Where would Iron Man be without his famous heads-up display (HUD)?

Motion artists are needed not only to create these things, but also to make pre-visualizations of them so they can be coded and developed for all the various platforms. Pre-visualizations are needed to develop what's next. They are needed to sell ideas. They are needed to inspire people into thinking beyond the platform, to help bring

Preface

When I began my career in the field of motion design in the early 2000s, the people who were designers of motion came from a variety of creative backgrounds. Many were like me, having trained as fine artists, illustrators, or graphic designers. Some were film majors in school, while some had studied animation. Still others had no formal training, but they were quick to learn software and had innate artistic ability. During this time, it was common for designers to be hired as freelance talent by production companies and animation studios. These companies had staffs of animators, compositors, and directors. Then a shift occurred where a number of small design studios opened. The designers were the core staff of the companies, and the animators and compositors were the freelancers.

Today, you can find all kinds of opportunities to work full-time or as a freelancer in the field of motion design. Although it is still defining itself as a discipline, the need for motion designers is growing. As digital media generalists, creative problem-solvers, and visual storytellers, we are employed across a wide range of creative industries. Motion designers work at design boutiques, advertising agencies, media networks, tech companies, and major corporations. In the academic world, motion design is becoming a recognized major and course of study. The principles and exercises detailed in this book are designed to teach you how to come up with ideas and create design for motion.

Design for Motion originated as a class that I created at the Savannah College of Art and Design. As a Professor of Motion Media Design, I wanted to teach a course that focused primarily on the design side of motion design. I reflected on my years spent as a designer in the industry. My goal was to create a curriculum that emulated real world studio demands and standards. After a period of trial and error, through early iterations of the course, a syllabus emerged. This textbook reflects the syllabus and can be adapted for usage by educators.

Many of the visual examples presented in this text were created in my Design for Motion course. The students range from undergraduate to graduate. Their creative work serves to demonstrate the validity of the principles, theories, techniques, and exercises outlined in this book. Additionally, I have reached out to a number of industry leaders to share their personal perspectives and experiences as designers for motion.

Contributors

Professional Perspectives—Industry Contributors

Melanie Abramov
William Arnold
Ed Barrett
Beat Baudenbacher
William Campbell
Patrick Clair
Peter Clark
Lindsay Daniels
Karin Fong
Brian Michael Gossett
Chace Hartman
Lauren Hartstone
Joshua Harvey
Lilit Hayrapetyan
Greg Herman
Will Johnson
Tom Judd
Stephen Kelleher
Robert Lester
Kylie Matulick
Sarah Beth Morgan
Bradley G. Munkowitz (GMUNK)
Daniel Oeffinger
Pablo Rochat
Erin Sarofsky
Matt Smithson
Sekani Solomon
Carlo Vega
Alan Williams
Mike Winkelmann (Beeple)
Audrey Yeo
Danny Yount
Lucas Zanotto

Additional Professional Contributors

Jason M. Diaz
Evan Goodell
James Gladman
Andrew Herzog
Sofie Lee
Nath Milburn
Graham Reid
Robert Rugan
Paige Striebig
Michelle Wong

Student Contributors

Eleena Bakrie
Joe Ball
Fransisco Betancourt
Vanessa Brown
Daniel Chang
CJ Cook
David Conklin
Casey Crisenbury
Gretel Cummings
Eric Dies
Jackie Khanh Doan
Gautam Dutta
Chrissy Eckman
Wendy Eduarte
Taylor English
Kalin Fields
Chris Finn
Ben Gabelman
Preston Gibson
Camila Gomez
Vero Gomez
Eli Guillou
Bobby Hanley
Chase Hochstatter
John Hughes
Rainy Fu
Trish Janovic
Dominica Jane Jordan
Roy Kang
Madison Kelly
Kenny Kerut
Rick Kuan
Hyemin Hailey Lee
Stasia Luo
Nick Lyons
Marcelo Meneses
Madeline Miller

Alonna Morrison
Robert Morrison Jr.
Eddy Nieto
Lauren Peterson

Patrick Pohl
Lexie Redd
Ryan Brady Rish
Aishwarya Sadasivan

Keliang Shan
Yeojin Shin
Stephanie Stromenger

Jordan Taylor
Taylor Thorne

Introduction: Motion Design

Building on Traditions

Although motion design is a relatively young discipline, it builds upon the foundations of many other creative fields. As a commercial practice, motion design continues the tradition of the *atelier*, or classical workshop. The modern roots of motion design can be traced back to artists like Saul Bass, who translated his poster designs into film title sequences beginning in the 1950s. Other artists like Pablo Ferro and Maurice Binder also laid the foundation with similar work in title sequences. Experimental filmmakers like Oskar Fischinger, Len Lye, and Norman McLaren pushed the boundaries for what motion design would become.

For decades, the commercial practice of motion design was bound to the world of post-production. During the late 1980s and into the 1990s, creative industries experienced a digital desktop revolution that allowed motion design to detach from the pipeline of post-production companies and begin a sojourn towards a multiplicity of creative practices. Kyle Cooper, working under the banner of RGA reinvigorated the art of title design with his work on the film *Se7en* in 1995, inspiring a new generation of motion designers.

As we entered the 2000s the price of hardware, including computers, cameras, and storage devices, decreased while the processing power and capabilities of these machines increased. A new breed of boutique-style motion design studios began to emerge in a few major cities around the

world. This technological revolution made the field of motion design accessible to a wide range of creative types from graphic designers, filmmakers, animators, and visual effects artists, as well as self-taught motion designers. Television titles experienced their own revolution with work like *Six Feet Under*, created by Danny Yount, et al., at Digital Kitchen in 2001. Throughout this decade studios rose, fell, and adapted into hybrid models of design-driven production companies. *Motionographer* was born from Justin Cone's *Tween* and became one of the primary online communities for aspiring motion designers and seasoned veterans of the post-production houses alike.

In the last decade, motion design has expanded beyond television and film screens as the dominant platforms for usage. With screens seeming to never be further than our pockets, motion designers have a crucial place in the *mobile-first* revolution. Social media platforms need a wide variety of motion design projects, from animated GIFs to feed-friendly mobile content. Although the traditional "motion graphic broadcast show package" still exists, moving forward it is difficult to see widespread application beyond specific programming, such as sports, news, and documentary-style content. However, motion design packages for social and streaming networks have arisen and afford a myriad of opportunities for motion designers. Advertising agencies and social first marketing boutiques are utilizing data-driven analytics

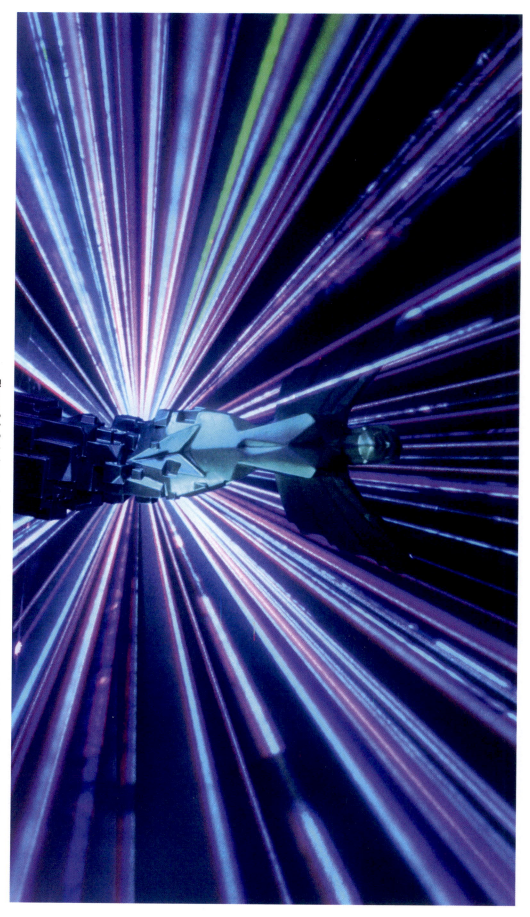

Figure 0.1: Style frame for *The Game Awards 2017* title sequence. Created by Peter Clark for The Game Awards.

Figure 0.2: *Good Luck America*: graphics for Snapchat show. Created by Graham Reid, Motion Designer at Snapchat. These frames showcase motion design for vertical platforms.

to create a new level of specificity for motion design at a very granular level.

Platforms that fall under the description of "emerging tech" such as VR (virtual reality) and AR (augmented reality) continue to increase the utilization of motion design. In addition to crafting immersive virtual environments for VR or assets that add to our existing world for AR, designers need to consider user experience and agency. Furthermore, the accessibility of high-quality projectors has advanced the art of projection mapping, providing opportunities for motion designers to work across a range of public spaces, including visuals for live music, theatre, retail, and artistic installations.

Although most professional motion design jobs are concentrated in the major cities of the world, opportunities continue to spread to more local venues. As motion design

becomes a more standard need for creative industries and platforms, this trend will continue to grow. The radically enhanced capacity for transferring large amounts of data via the internet has allowed motion designers to work from nearly anywhere. Already it seems, a legion of remote freelancers can be found supplementing the in-house workforces of boutiques and corporations alike. At the same time, corporations are expanding their internal creative teams to meet many of their own creative needs and motion designers play a role here as well.

In the realm of academia, motion design is studied as a major at a number of universities worldwide. Where motion design is not yet offered as a dedicated course of study, elective course options of motion design classes have become standard for many design programs. Outside of traditional brick and mortar institutions, a host of online schools have emerged to offer

remote learning opportunities. In the early 2000s, Chris and Trish Meyer's book *Creating Motion Graphics with After Effects* was the primary source to learn software. Today, video tutorials on nearly any motion design software can be found online. In addition, an abundance of inspirational work awaits anyone who is interested in learning about motion design.

Motion & Graphic

Motion design is a field that combines both motion and graphic media. Motion media includes disciplines such as animation, film, and sound. The defining quality of motion media is change that happens over time—thus we can consider motion design to be a *time-based media*. Graphic media includes disciplines such as graphic design, illustration, photography, and painting. Graphic forms of media do not change over time. They appear static through a defined viewport. Change can happen over the course of a few frames, seconds, minutes, hours, or even days. Interactive motion, installation art, and new media art

may not even have a fixed duration or may possess shifting timelines. Motion offers the opportunity to play with qualities of rhythm and tension. Regardless of a project's duration, an understanding of how to create interesting contrasts through the framework of a timeline is essential for strong motion design.

Art & Design

There are two different extremes of motion design: motion that is more like fine art and motion that is more like design or commercial art. Motion in the realm of fine art evokes qualities of mystery or ambiguity. Motion in the realm of commercial art aims at communicating certainty. Of course, there is motion design that has aspects of both fine and commercial art. For instance, a commercial may start with art and mystery, but finish with design and certainty. The first 25 seconds of a 30-second commercial takes the viewer on a journey that inspires emotions and ideas. The final 5 seconds invariably ends with a logo animation that

Figure 0.3: *Floating Shapes:* VR animation created by Carlo Vega for Microsoft. "Working closely with the Microsoft creatives and engineers, we adapted one of my animated video art pieces into an augmented reality animation to be exclusively experienced with Microsoft's Hololens. The 1-minute animation feels and moves like a virtual sculpture."[1] —Carlo Vega. Creative Directors, Alanna Macgowan and Stephen Bader.

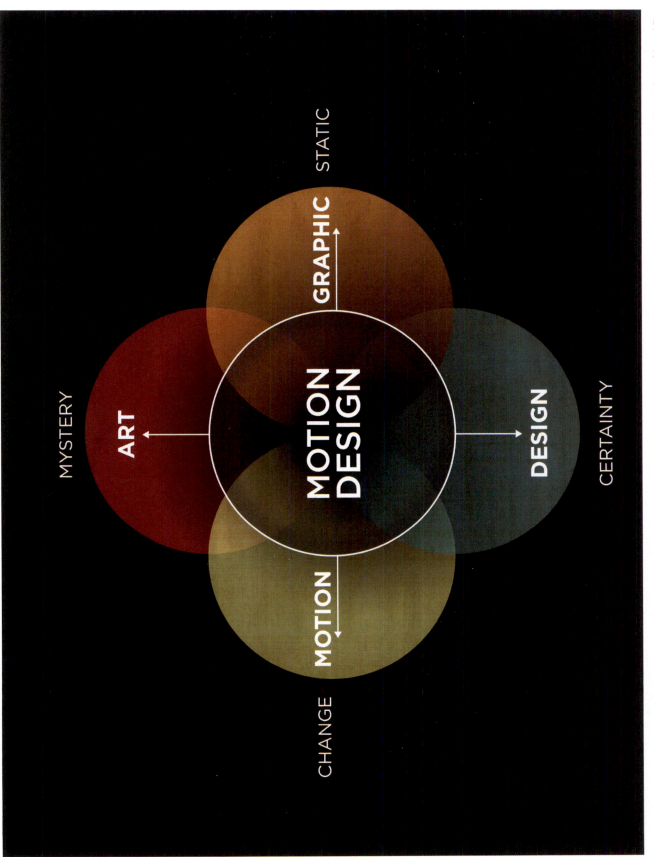

Figure 0.4: This information graphic represents two essential spectrums that compose motion design. The horizontal axis depicts the continuum between motion and graphic, while the vertical axis depicts the continuum between art and design.

leaves the viewer with no uncertainty about who has delivered the message. This combination of art and design is one aspect of what makes motion design appealing for both creators of the media and the audience.

Planning Motion

A still image depicts space, depth, and a focal point. A single frame can represent a moment in time for a motion design project. It also illustrates the visual style. By starting with a single frame, a designer can imagine and plan for animation. Effective compositions are more easily created in graphic form, which can then be translated into motion. Regardless of the style of a graphic image, a strong composition is required to generate interest in a viewer.

Contrast Creates Tension

An overarching theme of this book is the use of contrast to create tension. Tension draws a viewer into a piece. Contrast can be expressed through concept, story, and image composition.

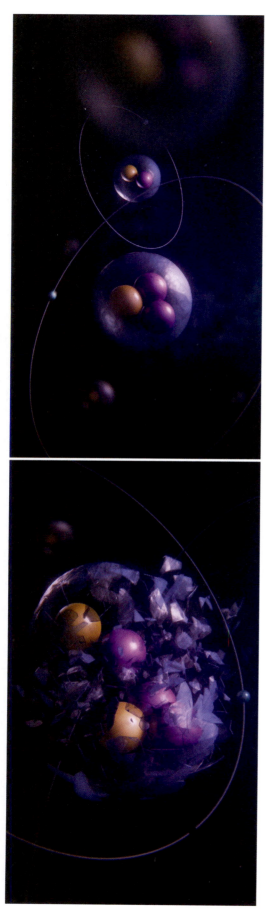

Figure 0.5: Style frames by Sekani Solomon, Freelance Designer. Style frames created at SCAD, Design for Motion class.

Typically, when we go to the movies, watch a show, listen to music, or read a novel, we hope to be told a story that grips us in some way. We want to be transported and moved emotionally and intellectually. As designers of motion, we need to create tension to produce this experience. Contrast is the key to delivering tension in a piece. Successful design requires variation in composition between positive and negative space, dark and light values, large and small scale, etc. because these qualities help to create visual interest.

Varying Compositions

Effective motion design requires strong compositions that vary across timelines. These changing compositions allow for rising and falling tension, unexpected surprises, and impactful communication. In order to be effective with motion, one must first be effective with composition. This precept is one of the primary principles that links motion and graphics. In addition, a motion designer must learn how to change composition with intention. Compositions can transform with subtle grace or

Figure 0.6: Style frames by Preston Gibson, Art Director at 90 Degrees West. Style frames created at SCAD, Design for Motion class. This sequence of style frames represents the principle of varying compositions. They illustrate how a motion design piece will change over time.

with shocking abruptness. These types of decisions are at the essence of how motion designers effect a viewer's experience of a piece.

Design-Driven Production

Design-driven production is a term used to describe a business model that has arisen from motion design. Design-driven production is a hybrid of traditional film production companies and design firms. Some also include qualities of traditional advertising agencies. The entire range of preproduction, production, and post-production can be found in design-driven studios.

Some of the creative roles in design-driven production are designers, animators, editors, art directors, writers, creative directors, and live-action directors. On the production side, there are talent coordinators, producers, and executive producers. There may also be sales representatives, recruiters, or other types of production roles, like production assistants or runners. The combination of creative and production roles at a company or studio comprises a *production team*. Although this text focuses primarily on the design side of motion, anyone working in design-driven production can benefit by learning more about the design process.

Types of Projects

Design-driven production companies service a range of creative industries such as advertising, entertainment, film, digital, and social. Traditional types of motion design projects for advertising include commercials, network branding, show packages, TV promos, news graphics, and sports graphics. Advertising, packaging, and content for entertainment includes film titles, TV titles, event titles, film graphics, and video game cinematics. Motion design projects are also utilized in digital signage, web banners, user experience design, and apps. Further interactive projects that use motion design include AR and VR. With social media, an entirely new avenue for motion design has arisen. Advertisements for social-friendly feeds across multiple platforms has created tremendous opportunity for motion designers. Indeed, social media has become one of the primary industries that employ motion designers. Motion design projects of a less commercial nature include music videos, short films, visual essays, and fine art installations.

What Is Design for Motion?

Design for motion is the combination of image-making and storytelling. It encompasses the initial creative stages of a motion

design project or production. Before we begin to create motion, whether in camera or through animation, a certain amount of planning is helpful. A project needs a strong concept, a visual style, a story or narrative, and specifications for output and delivery.

We begin this process by developing concepts through a variety of techniques that include research, writing, and drawing. As a concept emerges, we create a distinctive look and feel, or style. After we define this visual style, we give our narrative sequence its shape. We depict every scene and key shot in a motion design project, prior to animation, so that both the visual style and the story are easily understood. As a project moves from design into motion, the creative goals and boundaries are clearly mapped out for the production team. This process produces the primary *outcomes*, or *deliverables*, of design for motion. An outcome, or deliverable, is a finished product that is either given to a professor in an academic setting, or delivered to a client in a professional setting.

The Purpose of This Book

The purpose of this book is to teach you about these outcomes and how to make them. They are called *style frames* and *design boards*. Style frames exemplify the image-making aspects of design for motion by conveying the mood or feeling of a piece, whereas design boards represent storytelling by demonstrating a sequence of events in chronological order. Another design for motion deliverable is the "container" that holds style frames and design boards for presentations. In an academic setting, this document is referred to as a *process book*. In a professional or commercial setting, this document is referred to as a *design deck* or *pitch book*. Process books and design decks are delivered to a professor or client. These "books" contain the finished outcomes of a design for motion project, as well as various degrees of process work that helped in developing the concept.

Style frames, design boards, process books, and design decks embody the principle of *pre-visualization*, which is the plan for a project's visual style and narrative prior to production. The need to arrive at a defined style prior to motion is very important, as motion design can be very tedious and labor intensive. Commercial productions are particularly sensitive to having a defined visual style that a client agrees to before creating motion. For more artistic productions, it is still a great benefit to flesh out the visual style in the graphic stages of a project.

Other Disciplines

This book is for students and aspiring professionals who want to work in design-driven production. Motion design offers tremendous opportunities to those interested in creative careers. Until the early 2000s, screens to display motion design primarily consisted of SD (Standard Definition) televisions, movie theater screens, and computer monitors. Then HD (High Definition) resolution became prevalent, and motion designers could create content for SD and HD aspect ratios.

Apple's introduction of the iPhone in 2007 and the iPad in 2010 started a whole new revolution for screen content. Since then, other companies have created variations of smart phones and tablet devices. All of these screens need beautifully designed motion. Original motion content is being created solely for digital platforms and regularly delivered in multiple formats such as horizontal, vertical, and square. Additionally, the modern incarnation of *projection mapping*—the projection of digital images onto a real, 3D surface—is expanding our definition of screens by transforming environments and architecture into displays for motion design. As technology makes screens more adaptable, we can expect to use them in more areas of our lives.

Motion design needs strong designers to concept ideas, create unique visual styles, and tell interesting stories. Above all else, motion design needs people who understand how to

effectively communicate. Students or professionals working in Animation, Graphic Design, Visual Effects, Illustration, Advertising, User Experience Design, Film, Editing, Sequential Art, Photography, and Creative Writing can find professional opportunities in motion design.

Animation

Motion design is a form of animation. However, traditional animation tends to focus on character development and literary narrative. Motion design focuses on art direction and uses a wide range of design assets. Also, traditional animation is typically long format, whereas motion design is relatively short. Despite these differences, animators and motion designers work side-by-side in many design-driven production studios. Animators who want to work in a fast-paced environment, and on a variety of projects, do very well in motion design.

Graphic Design

Graphic designers are trained to create effective visual layouts, work with typography, and communicate messages clearly. These are skills that also apply to motion design. I encourage my students to refine their skills with typography, as motion design often requires precise and elegant usage of type. Graphic designers who are interested in making their work move, can translate their skills directly into motion.

Visual Effects

Like animation, visual effects has similarities to motion design. Many of the same tools and principles are applied to both disciplines. The key differences exist in how they fit in the production workflow. Visual effects artists bring an incredible attention to detail and mastery of technical skills. In the film industry, they tend to work on specific shots for a project over a long period of time. Motion designers tend to work on a lot of projects, and in many different capacities. They may concept and design for one project, then work as an animator or compositor on another. Like animators, visual effects artists and motion designers often work side-by-side in design-driven production studios. Visual effects artists are very valuable in motion design because of their highly specialized skill sets.

Illustration

Illustrators do very well in motion design. They are trained to create strong compositions across a range of visual aesthetics. They are the quintessential image-makers of the creative world. Illustrators who learn the language of design for motion, or how to think sequentially, can play a very creative role in design-driven productions.

Advertising

The advertising industry is one of the primary employers of design-driven production studios. Advertisers work directly with clients to formulate strategies and big picture ideas for marketing campaigns. Advertising uses motion design for everything from prototyping to executing commercial projects. Design for motion and advertising are similar as they both serve the purpose of giving form to creative ideas. An advertising student or professional who wishes to become more hands-on can utilize design for motion in design-driven productions.

User Experience Design

Students and professionals of interactive design and user experience can also utilize motion design. Both disciplines rely on the principle of change. In motion design, change is something witnessed by the viewer. With interactive and user experience design, change is something that is initiated by the user. Although

there are different considerations in terms of passive and active change, motion design can be used to enhance the experience of interactivity.

Film

Directing and cinematography are also essential to motion design. Although motion designers may rarely direct live talent, they are always directing the movement and expression of visual elements. Some motion designers are quite comfortable directing live-action, and they can move fluidly between live talent and digital media. Cinematographers paint with light and record beautiful compositions through the lens of a camera. These skills translate directly into motion design because an understanding of light and dark help a designer to direct the focal point of a scene. Design for motion draws heavily from the art and language of cinematic storytelling.[2] Students and professionals of film find motion design to be an accessible and alternative approach to filmmaking.

Editing

Strong film editing skills are essential to motion design. A project must be arranged in a manner that takes the viewer on a journey. Editors understand the rhythm of storytelling and how to create dramatic tension through a viewport. All motion designers can benefit from education and training in editing. Some editors add motion design to their arsenal of skills to be more versatile and valuable in the workforce.

Sequential Art

As creators of comic books, graphic novels, and hand-drawn storyboards, sequential artists already think about images changing over time. They understand storytelling and cinematic changes that make a visual narrative interesting. These skills are essential to design for motion and can be

combined with digital illustration to create style frames and design boards.

Photography

Image-making is rooted in frame composition. Photographers are trained to see and capture strong compositions through the lens of a camera. They understand how to frame a scene through a viewport. They also have a strong foundation in lighting and value, which is essential for any kind of image-making. Compositing live-action or photography with design elements is a common aesthetic direction for many motion design projects. Photographers who are interested in exploring motion will find many opportunities to work with their images.

Creative Writing

Writing is an extremely important part of motion design. Conceptual development and narrative development rely on writing to record ideas. As a time-based media, motion design tells a narrative or story. This process requires the ability to write a script or treatment. For communication purposes, it is essential that a designer is able to write descriptions about his or her work. Many design-driven studios employ writers to help brainstorm projects, prepare presentations, and develop scripts for larger productions.

How to Use This Book

Chapter 1 introduces and defines the primary outcomes of *Design for Motion*—style frames and design boards. They are the building blocks of design-driven storytelling. Style frames give form to a concept, and design boards envision how a story unfolds. This chapter describes the anatomy of both style frames and design boards as well as their practical application in commercial and artistic productions.

Chapter 2 focuses on the creative production process, presenting broad-stroke ideas about how to effectively navigate

a project from "Kick-off to Delivery," or beginning to end. Strategies for working with creative briefs, project scope, and creative constraints are covered. Additionally, this chapter provides suggestions for when to exercise your imagination versus practicing creative discipline.

Chapter 3 explores a variety of concept development techniques including creative writing, drawing, and searching for inspiration. These exercises help to generate ideas quickly and keep the creative process fresh, fun, and exciting. Creative problem-solving is a vital skill for designers. As technology and platforms of media distribution evolve, the ability to come up with solutions to creative problems is fundamental for professional sustainability.

Chapter 4 looks at both image-making and storytelling. Classic visual principles such as composition, color, value, and contrast are discussed as related to motion design. Narrative tools such as cinematic vocabulary, thumbnail sketches, and hand-drawn storyboards are also introduced.

Chapter 5 examines tools, technology, and techniques. In addition to asset creation, compositing and 3D software for design are covered in depth. Compositing is a skill that allows designers to confidently create a range of visual styles. Competence in 3D software is rapidly becoming a fundamental skill in the designer's toolkit.

Chapter 6 explores "Social/Mobile-First" thinking for motion design projects. The commercial industry has radically transformed to meet the needs of creating content across multiple platforms. This chapter introduces key terms, concepts, and best practices for creating motion design on digital platforms.

Chapter 7 focuses on presentations and pitches. Documenting and professionally showing your work are vital for both students and professionals alike. This chapter covers best practices for creating process books and design decks.

Chapters 8–15 introduce a number of creative briefs across a range of aesthetics for portfolio development. These exercises can be utilized to practice creating style frames, design boards, and process books. Every chapter features interviews with industry professionals sharing their unique perspectives and personal insights.

Notes

1 Vega, Carlo. "Copy for Book." Message to the author. September 30, 2018. E-mail.
2 Van Sijll, Jennifer. *Cinematic Storytelling: The 100 Most Powerful Film Conventions Every Filmmaker Must Know*. Studio City, CA: Michael Wiese Productions, 2005.

Figure 1.1: Design board by Yeojin Shin, Designer at Buck. Board created at SCAD. Design for Motion class.

Chapter 1:
Design for Motion

Beautiful Motion Begins with Beautiful Design

Motion design is the art of composing change over time. However, before we begin to make things move, it helps to have a plan. We have a much better chance of creating beautiful motion when we begin with beautiful design. A strong visual composition captures a viewer's attention, tells them where to look, communicates ideas and feelings, and often provides a jumping-off point into a narrative. A motion design piece without a strong design plan will have elegant movements at best but will more than likely fail to connect with a viewer.

Figure 1.1 is an excellent example of design for motion. Every frame feels like it belongs in the overall piece because of a unified visual aesthetic. Color palette, contrast in dark and light values, contrast in positive and negative space, and illustrative line qualities all define the constraints of this unique design style. The piece also tells a story and communicates ideas. Cinematic considerations are represented by changes in camera distance. Transitions are clearly designed as well, serving to demonstrate how the visual story moves from scene to scene. Additionally, the concept of memory is explored through various images that inspire a viewer to feel a dramatic range of emotions. Each individual frame is called a *style frame*.

"It's like the relationship between a songwriter and a singer. Someone who writes a song is creating the

structure of the music, but then a singer takes that and brings it to life in real time—they can't fully exist without each other. Similarly, to be a designer of motion is like being a music composer writing down notation, but the ultimate form of your work is the performance of that music—for us, that performance is the animation."[1] — **Stephen Kelleher,** *Designer*

Style Frames

Style frames are the visual representation of what a motion piece will look like prior to animation. A style frame is a single frame or image that depicts the look and feel of a motion design project. Style frames are one of the primary outcomes of design for motion. From a business perspective, they help to win pitches for commercial projects. One image can be the difference between a studio or designer winning a project or losing to the competition. Because style frames help to win jobs, the designers who create them play an extremely important role in design-driven productions.

Ideally, a style frame is both beautiful and functional. Style frames present the ideas, emotions, and narratives associated with a concept. Although style frames are singular moments of a motion piece, each frame can propel a story forward. It may take a lot of practice to consistently make strong style frames, but if you enjoy image-making and storytelling, embrace the process of

Figure 1.2: Style frame by Peter Clark, Freelance Designer/Director. Style frame created at SCAD, Design for Motion class.

Figure 1.3: Style frame by Chris Finn, Art Director at Gentleman Scholar. Frame created at SCAD, Design for Motion class.

iteration. Grit, determination, and making a lot of style frames will make you a better designer.

Look & Feel

The purpose of a style frame is to establish a unique look and feel that visually holds a motion design project together. Stylistic choices include which method or medium to use, such as 2D, 3D, illustration, collage, etc. Inexperienced motion designers will often rush through this phase of a project or skip it altogether. It is easy to tell when a motion designer has not spent time on style frames. Concepts are not fleshed out, compositions are uninteresting, stories are flat, and transitions are not considered. Conversely, when motion designers invest time and effort into

Figure 1.4: Style frames by Rick Kuan, Freelance Designer. Frames created at SCAD, Design for Motion class. These style frames show a defined and consistent visual pattern through the use of texture, contrast between dark and light values, a limited color palette, variations in opacity, and the treatment of positive and negative space.

style frames, the odds of creating beautiful motion design are greatly increased.

"On a personal level, style frames are about completion of an idea and a concept for yourself. On a professional level, style frames are important because they set the stage for everything. They inspire and inform your team, they give your client confidence in you and your ability to execute. Ultimately, they are your target. They are like a map to a hidden treasure—you can't find the treasure without drawing your map first."[2] —Joshua Harvey, *Designer/ Director*

Stylistic Guides

Aside from their financial importance, style frames help to direct a production team's efforts. They serve as visual guides by establishing the creative boundaries of a project. Style frames provide clear specifications about the use of visual elements

such as color, typography, texture, camera placement, etc. They are especially important when working with large teams of animators, compositors, and 3D artists where everyone needs to be working towards the same visual goal. For large-scale productions, ideally there will be a style frame for every scene or setup within the project to maintain overall cohesion. For smaller productions, or even solo projects, style frames are just as important because taking the time to define a visual aesthetic before going into motion will help create a much stronger project.

Concept Is King

Style frames should be visually striking, but, more importantly, they should express a concept. Even if a style is beautiful, a weak idea will be eye-candy at best. This kind of design falls into the category of *form over function*—an error that occurs when a designer focuses only on making something look great. The design may be flashy, but it lacks an impactful message

Figure 1.5: Style frames by David Conklin, Motion Graphics Designer at Rockstar Games. Frames created at SCAD, Design for Motion class. These style frames demonstrate a compelling concept coupled with a distinct illustrative style. The illustrations suggest interesting ideas and narratives that are open to interpretation. The contrast and limited color palette form a particularly striking and memorable vision.

or purpose. However, a beautiful design coupled with a strong concept is powerful. As Frank Lloyd Wright said, "Form and function should be one, joined in a spiritual union."[3]

Design like a Champ

If you are interested in being a designer for motion, then you will need to build a portfolio of your best work. Design as if you have an infinite budget at your disposal and a roster of insanely talented production artists who will bring your vision to life through motion. In other words, do not dumb-down your style frames or limit your design to *what you think you can animate by yourself.* You can always reduce or modify the scope of your project once you begin to make things move. Chances are your

motion will turn out better than you thought, especially if you begin with strong design.

In design-driven productions, it is common for large teams to work together to create a motion design project. In addition to designers, a creative team can include animators, compositors, 3D artists, live-action directors, cinematographers, editors, and producers. It is not realistic to expect a single person to create the same caliber of motion as a full production team. However, you can always *design* like a champ.

Enjoy the Process

Motion design is a serious business that requires a professional attitude, especially in the realm of commercial art where

Figure 1.6: Style frame by Jackie Khanh Doan, Designer at We Are Royale. Style frame created at SCAD, Design for Motion class. This style frame is an example of an aesthetic direction that is very intricate. It combines many layered organic elements and expressive facial features. In production, it would be very time-consuming or technically challenging. However, with a team of experienced animators and compositors, it has the potential to be an interesting motion design piece.

design-driven production is fueled by financial budgets, teams of creative artists, and producers. However, this professionalism does not mean that we cannot enjoy the process. We should always do our best and strive for the strongest outcomes, but we will probably create better work if we are having fun. Additionally, we should not sacrifice our wellbeing to achieve our creative goals. Learning how to pace yourself while retaining the joy of being creative are essential for a sustainable practice.

Author's Reflection

I have always felt excited about the freedom, exploration, and discovery of making art. There is a magical sense of adventure in the ability to open doors into worlds of the imagination. Often from very young ages, motion designers have expressed our creative interests through drawing and painting. Those of us who have entered creative professions have managed to preserve and develop our curiosity about art and design.

It is important to remember that style frames are fun to make. Often, they are the most open and creative part of a project. Style frames offer the designer opportunities to be creative and expressive. Once a project moves into production, the amount of freedom and flexibility decreases more and more as it moves toward completion. Style frames afford an opportunity to dream big and push the boundaries of your creativity.

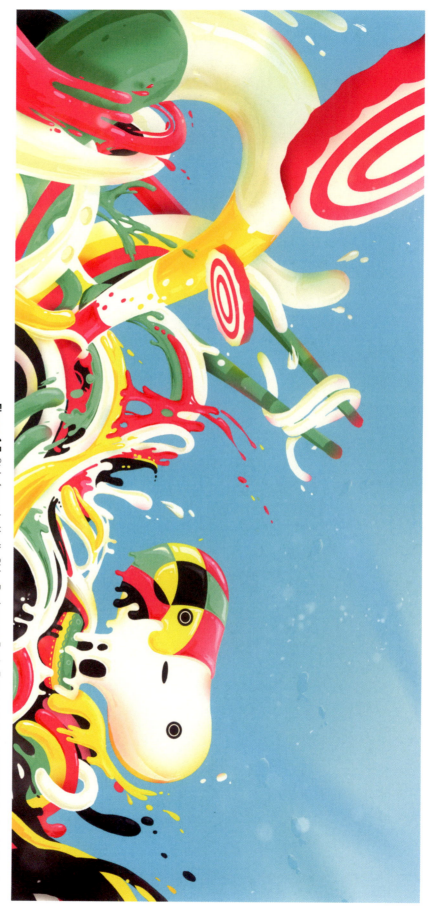

Figure 1.7: Style frame by Yeojin Shin. Designer at Buck. Frame created at SCAD. Design for Motion class.

Professional Perspectives
Joshua Harvey

Joshua Harvey is a Los Angeles-based freelance Creative Director with a background in Design and Animation. His career started in 2005 after studying at the School of Visual Arts and then being offered a position at Psyop's NY studio. Since then he has been a part of projects and campaigns for clients large and small, in roles that run the gamut of production.

As Creative Director at Buck's LA office, he co-led, designed, and animated on projects that garnered several awards. To name a few: the prestigious Clio, Gold at the London International Awards, ADC Designism, and the ADC Gold and Silver Cubes as well as Finalist at the Cannes Lions Festival. He was honored in 2013 with a Young Guns Top 30 under 30 Award at their 11th annual awards show.[4]

What is your art and design background?

I was fortunate to have a father who kind of had his ambitions taken away from him. So, once he saw I was interested in being creative, he basically knocked down all of the obstacles for me and gave me a clear path when I was young. That definitely plays a lot into my character now, the fact that I was encouraged to go after a career that I was passionate about. He got me into an art class with an illustrator who used to do illustrations for the National Wildlife Foundation and NASA. This guy happened to live in my hometown in the middle of nowhere in Indiana. I didn't really understand a lot of what I was being taught, it was very

technical. But I think, later on as the years went by, a lot of those things sunk in and permeated into my process. I had a really good art teacher in high school as well, who pushed me to think more conceptually about what the art is really saying. I went to the School of Visual Arts because I was really interested in doing computer animation.

How have you refined your design aesthetic?

I went to Psyop in New York, so right off the bat I was working with people at the top of their game. The people I was working with went to schools that focused on design, so I was more or less an executor of someone else's ideas. I was doing technical direction, a lot of rigging, coding tools, and fixing problems in the pipeline. There is a lot of creative problem-solving in that, but ultimately, I was being driven by an idea that someone else had. It's not necessarily that I wanted to be in control, but I didn't feel like it was what I wanted to do. I wanted to be an artist.

I realized it had been a long time since I had drawn on paper or created images for myself. So, I bought sketchbooks again and started drawing as much as I could, trying to develop my skills. A job came up for Guinness, and because I had expressed that I wanted to get into the creative side of things, I was asked to do some style frames. We ended up winning the job. It was a really great experience because I actually sat down and made digital paintings, and I was excited about doing it. They came out really

well, and I was surprised that I was able to accomplish things on that level. That project changed my whole perspective and so I started to focus on design.

I started freelancing after the Guinness job. I continued to do my own creative work so I could convince studios to hire me to do that kind of work. I didn't have too much to show, but I put a lot of the drawings I had been doing in my sketchbook on my website. I also had cool technical work from being at Psyop. It was a good way to get into it because I could go to other studios and help them out technically and also get creative participation in the projects,

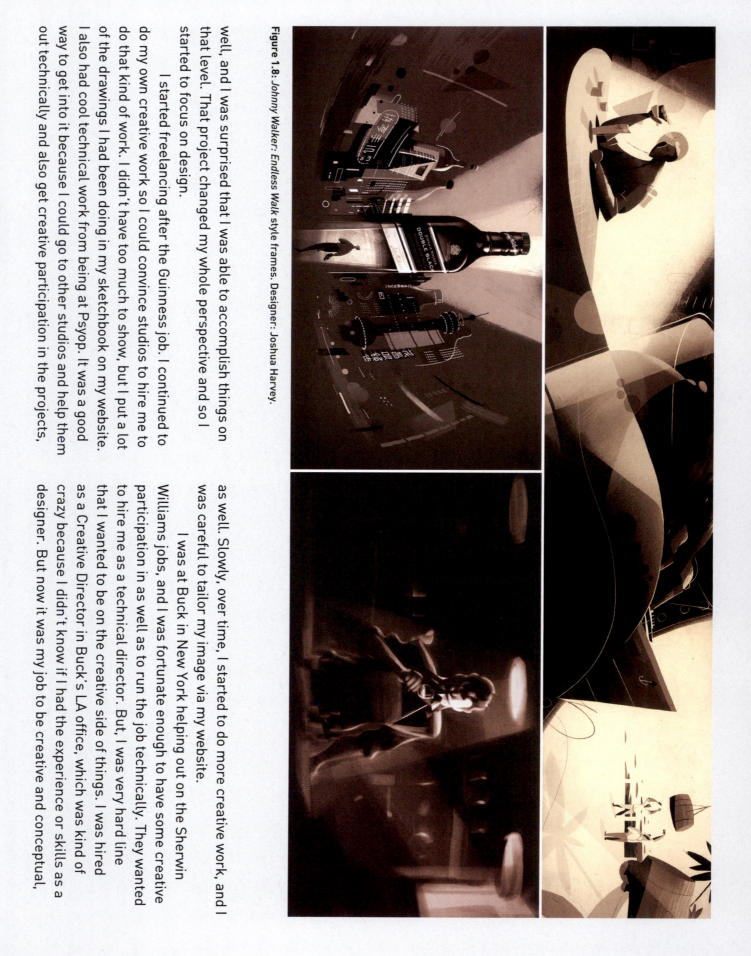

Figure 1.8: *Johnny Walker: Endless Walk style frames. Designer: Joshua Harvey.*

as well. Slowly, over time, I started to do more creative work, and I was careful to tailor my image via my website.

I was at Buck in New York helping out on the Sherwin Williams jobs, and I was fortunate enough to have some creative participation in as well as to run the job technically. They wanted to hire me as a technical director. But, I was very hard line that I wanted to be on the creative side of things. I was hired as a Creative Director in Buck's LA office, which was kind of crazy because I didn't know if I had the experience or skills as a designer. But now it was my job to be creative and conceptual,

Figure 1.9: *Guinness: Alive Inside* commercial. Created by Psyop and Nathan Love. Designer/Director: Joshua Harvey.

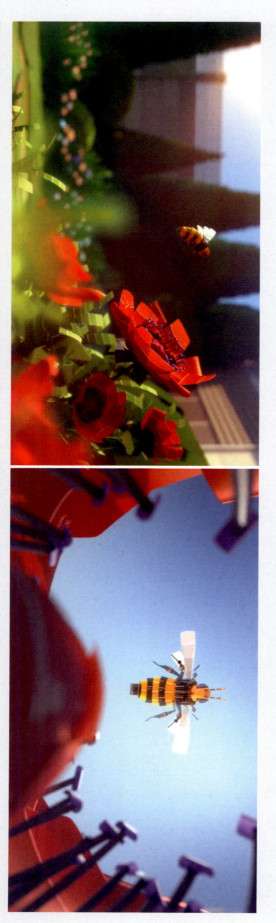

Figure 1.10: *Sherwin Williams: Bees commercial. Created by Buck. Designer/Art Director: Joshua Harvey. Creative Director: Orion Tait.*

and I could task and direct the technical stuff. At this point, I was 100% focused on developing my creative side. I was doing style frames and boards every day and thinking about story and concept. It was a steep climb. I was around incredible talents there and that taught me a lot. When you are doing design and creative in an environment where you're turning projects around in weeks or months, it's all about banding together and everyone throwing their ideas in and filtering out the best ones, guiding that process.

How have you developed such a wide range of both technical and aesthetic skills?

It was really just chasing my interests. If I find something interesting, I am going to do it. At one point, I was really into technical proficiency with these tools. Then, I started thinking conceptually and aesthetically: "how can I change this stuff and experiment with it?" Design is an idea that things are built out of systems. There is a hierarchy for how things are put together.

There is a set of rules that creates something, and images are no different. Whether you choose to put an outline on something, or no outline? How do you fill things in? Does the fill stay inside the line really cleanly, or does it break out? Is it rough? I create a process, or find a process every time I try to make something. It's a lot of experimenting. It's a lot of failure and frustration. But in the end, I know how to make something. Here is the idea we are trying to get. What process will make that idea? My process starts at that point, which allows me to go in different directions.

Do you have a favorite project?

Good Books is definitely one of my favorites. This project was about doing something big and cool to put on Buck's website and get more interesting work. But it also served the creatives involved because it was about making art. We started coming up with ideas, and we knew it needed to be wild because Hunter Thompson's whole nature was like "fuck the rules." I did some initial design that I kind of hated. So, I reverted back to digital painting and

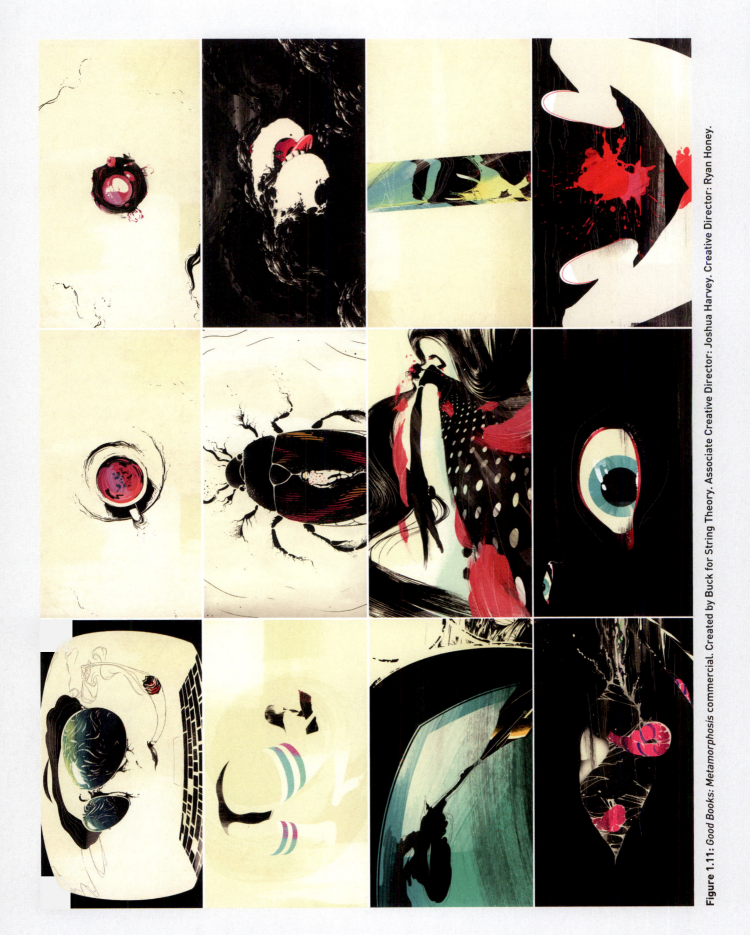

Figure 1.11: *Good Books: Metamorphosis* commercial. Created by Buck for String Theory. Associate Creative Director: Joshua Harvey. Creative Director: Joshua Harvey. Creative Director: Ryan Honey.

coming up with a feeling or a mood. Joe Mullen came up with a graphic look, and we threw our styles together, and that's how we got the visual aesthetic.

There is a lot of distortion of form and making shapes from negative space. Joe helped tighten it up into a more graphic style, and I would bring it back into more of a painterly aesthetic. From a creative standpoint, that is where the visual design came from. Once we had one style frame that we thought was really working, that excited us about the language we were dealing in. That initial style frame breaks open everything.

Do you have any suggestions for young designers?
Experiment as much as possible, all good things are found in the process. If you are repeating the same thing over and over again, eventually you are going to get bored. Get comfortable with failure. Fail as much as you can, so you can get comfortable with the process of throwing ideas out there, even if they don't work. The first part of your process should be a bunch of failures that inform what you are actually going to do. Then, you start the process of creating something. If the first thing you grab is the same thread you grabbed last time, your work is not going to evolve. At some point, you have to introduce new ideas. Accept that as part of your process.[5]

A Moment in Time

Style frames showcase a moment of time within a scene or project. Ideally, a style frame should feel like a still pulled from a finished motion design piece. This degree of refinement is needed to help sell a concept and keep the production team on task. Style frames are also the starting point of a narrative and, in practical terms, the bridge to *design boards*—a sequence of individual style frames laid out in a linear fashion. Design boards utilize the "language of cinematic storytelling" to pre-visualize an entire motion design piece prior to production.

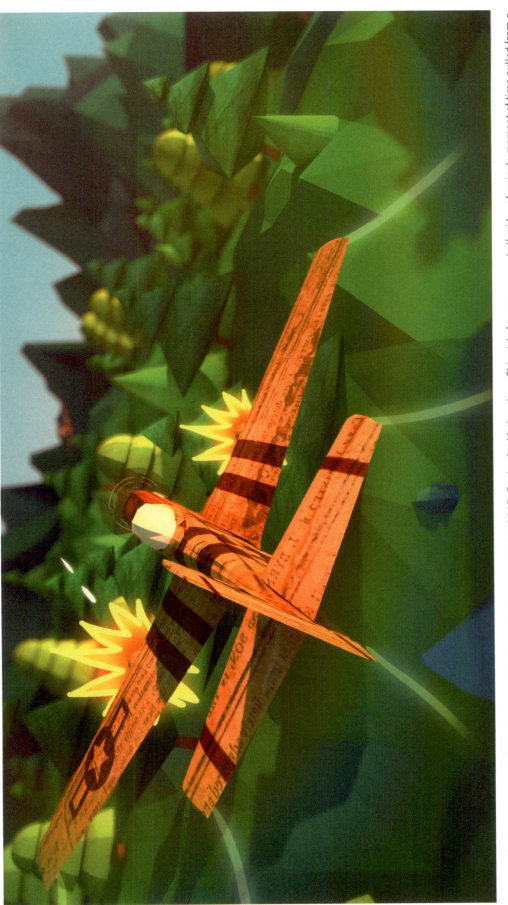

Figure 1.12: Style frame by Keliang Shan, Freelance Designer. Frame created at SCAD, Design for Motion class. This style frame represents the idea of a single moment of time pulled from a motion design piece. Visual elements such as composition, depth, camera angle, and texture create a window into this representational world.

Design Boards

"Design boards are among the first steps in the motion design process and what I have spent most of my career creating. When I design a board, I'm doing more than designing frames—I'm figuring out the best way to tell a story or communicate an idea. I am visualizing the spot and using the boards and a written treatment as a tool to share and sell my idea. Essentially, the boards visually articulate the concept and story so that the client, animation team, and creative director are on the same page before beginning the production process. Each frame in a design board needs to represent a moment in time in the piece, but together the frames need to tell a story. To me, it's important that the story is grounded in a smart concept because that is what will ground the work and make it memorable."[6] —Lindsay Daniels, *Designer/ Director*

What Is a Design Board?

A *design board* is a series of style frames that tell the visual story of a project. The term "design board" is derived from storyboarding—a practice that originated in film productions as a way to plan the action of characters, events, and camera direction. Like hand-drawn storyboards, design boards depict key scenes in a project as well as transitions. The difference between a design board and a hand-drawn storyboard is the level of art direction. *Each frame in a design board is a fully realized style frame.* In addition to clearly illustrating the cinematic intentions and narrative, a design board firmly establishes a visual aesthetic. They are an effective way to plan and present the concept, story, and style of a motion design project.

Unified Visual Aesthetic

One of the first questions asked during a class critique of design boards is, "Does every frame feel like it belongs in the board?" The same visual pattern that unifies the look and feel of a style frame needs to translate across an entire design board—conceptually, visually, and sequentially—in order to create a cohesive project. This pattern requires design consistency in areas such as color, texture, typography, and cinematic qualities. A style frame that does not adhere to the defined visual pattern in a design board will feel out of place. This inconsistency disrupts a viewer's connection to the piece and fails to communicate.

"Motion design is all about focus and flow. So much of our work, and the development of our work, is based around design boards. When you are working with clients, they are going to pour over those boards and pick them apart. It's part of the process. Ultimately, you want to engage an audience and draw people in. When people look at a moving image, they don't see the whole thing. They don't see the whole frame. They are always looking at something within that. If you can chart where your audience's eye is moving through your images, where they are going to leave one image and pick up with another image, and really make the journey interesting and engaging, and understand the pace and rhythm, then you will be able to do a piece of work that really engages people." —Patrick Clair, *Designer/Director*

Visual Storytelling

Design boards are a visual and narrative representation of a concept. Ideally, motion designers should be familiar with the

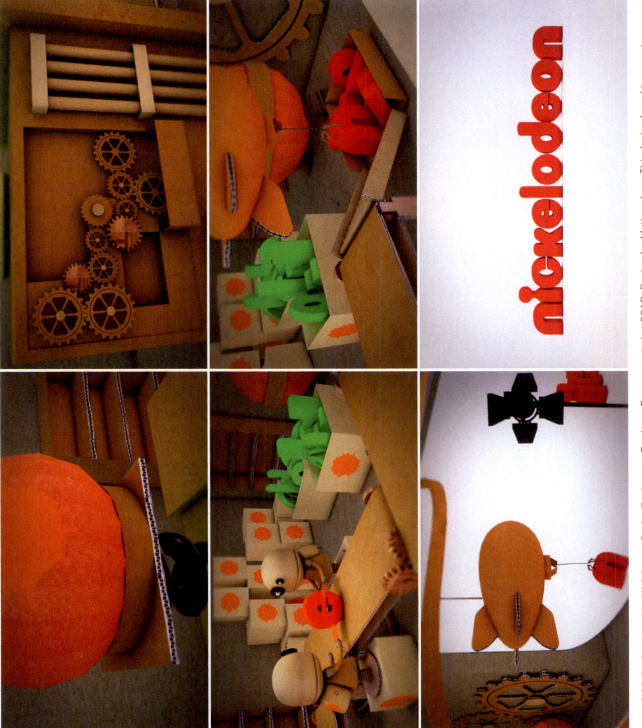

Figure 1.13: Design board by Nick Lyons, Senior Designer at Territory. Frame created at SCAD, Design for Motion class. This design board is a great example of clearly illustrating a visual style, the cinematic positions and movements of a camera, and the narrative plan from the beginning until the end of the piece.

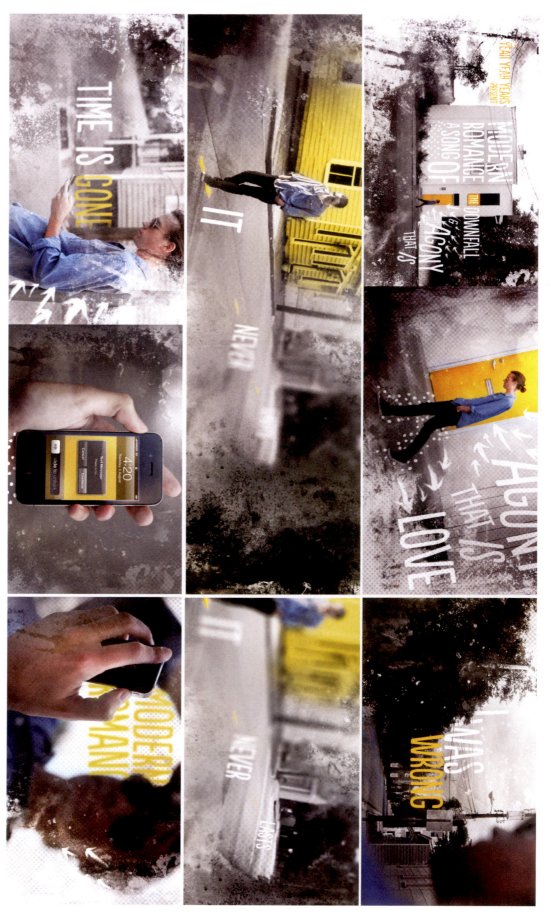

Figure 1.14: Design board by Joe Ball, Associate Creative Director at Manvsmachine. Board created at SCAD, Design for Motion class.

traditional narrative structure of introduction, rising tension, climax, falling tension, and resolution—or, in simplest terms, the beginning, middle, and end. Although narratives can play out in infinite variations, the two most common types are *linear* and *non-linear*. Linear narratives follow a clear progression from the beginning until the end. Non-linear narratives unfold non-chronologically or in an abstract manner. In addition to understanding the structure of narratives, motion designers need to be able to tell a story by crafting visually compelling boards.

Variety of Shots

Utilizing a variety of shot sizes and angles in a design board creates a sense of movement. Showing changes in camera distances and angles takes the viewer on a journey through the board. The cinematic flow of how style frames are arranged crafts the rhythm and the arc of a piece.

Establishing shots are typically the first frames in a design board. These shots are key to orienting the viewer in time and space. They introduce locations, characters, and the representational world of the motion design project. Establishing shots can also be used to define new scenes.

Figure 1.15: Establishing shot style frame by Eric Dies and Kalin Fields. Frame created at SCAD, Design for Motion class.

Hero frames are style frames that portray important moments in a motion piece. They require strong compositions and clear focal points. Hero frames indicate where the viewer should be looking and what the viewer needs to process. In order to achieve this engagement, a hero frame needs to establish a sense of presence.[8] A designer of motion uses visual principles such as contrast, value, color, negative space, depth, and texture to effectively control the viewer's eye.

Between hero frames, we find *transitions*. Transitions illustrate seamless changes of visual elements or scenes. Transitions can be executed in any number of ways, from simple camera movements or adjustments of visual properties to

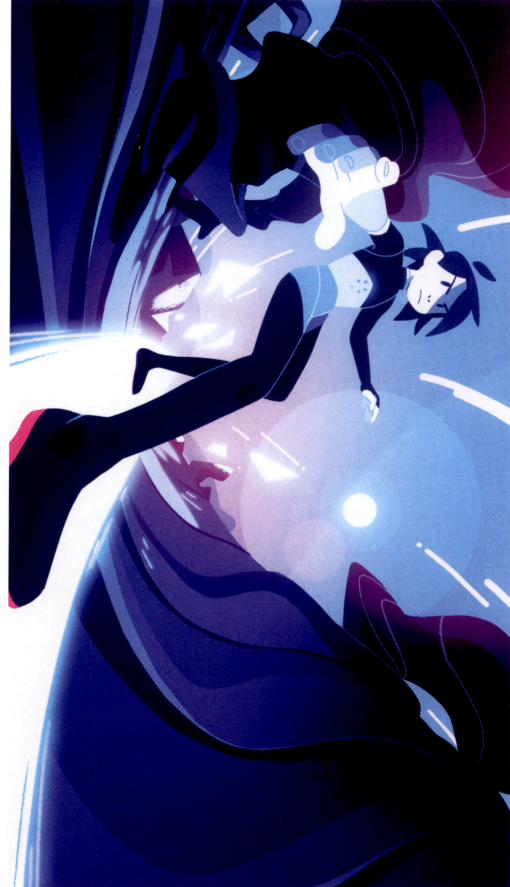

Figure 1.16: Hero style frame by Stephanie Stromenger, Freelance Designer. Frame created at SCAD, Design for Motion class.

beautiful lighting, moving in the right way. The simplest things done well can be much more powerful than some kind of super complicated morph."[9]

The Shape of Stories

When we go to the movies, see a play, watch an episode of a show, or read a novel, we are seeking a dramatic experience. *Drama* is the art of representing extreme changes to entertain and to instruct.[10] A story without change is flat. In motion design, we are creating stories and narratives on a smaller scale than movies or novels. However, our stories still need to be able to create stories that engage viewers with dramatic change, contrast, and tension. When creating a design board, it is important to be clear about the overall shape of the story you are telling.

American author Kurt Vonnegut introduced an idea called "The Simple Shape of Stories" (see Figure 1.19).[11] His theory illustrates how classical tales have recognizable patterns. Vonnegut identified a number of simple shapes that repeat over and over again in storytelling. Joseph Campbell explored similar ideas with his books *The Hero with a Thousand Faces*[12] and *The Power of Myth*.[13] Campbell identified archetypal stories that occur repeatedly in different cultures around the world and at different points in history. Christopher Vogler translated Joseph Campbell's ideas into a text for writers called *The Writer's Journey*.[14] This text outlines the essential patterns that repeat in heroic stories and has served as a template for many Hollywood films. These authors have identified contrast and tension as the primary ingredients of dramatic storytelling.

To illustrate this idea, I will often show my students the graph editor in After Effects because it is an information graphic of how velocity changes between keyframes (see Figure 1.20). In the graph editor, velocity that does not change over time appears as a straight line, which is relatively static and boring.

frame-by-frame liquid motion or complex CG. Whatever the form, ideally, transitions should be aesthetically pleasing in addition to serving the concept and story. If a transition can produce a pleasant surprise in the viewer, it has effectively done its job.

In Figures 1.17 and 1.18, we see transitions for *The Night Manager* title sequence. This motion design project showcases excellent examples of transitions. Dramatic changes in relatively short amounts of time create compelling moments that engage the viewer. These transformations are elegantly crafted and express the underlying ideas and themes of the show they are introducing. Here is a description of the conceptual thinking and technical approach, by director Patrick Clair.

"I watched the show and I loved it and started talking to the producers and the director. They were talking with how the show dealt with the commercialization of war and weaponry. Back when I was doing documentary pieces, they were most often concerned with the fascinating bleeding edge of new technology driving warfare or being harnessed by warfare on one side and the ethical complexities that emerge when war and technology and killing is merged with business, and economics, and international relations. So, I had all this thinking in my head about that. But the actual idea was really simple. Let's take luxury stuff and turn it into weaponry, and back again. That tickled my brain and I love fitting things together. How can the plume of a missile launch match the shape of a martini glass? What does a tea set look like if it is laid out in the form of a Gatling Gun? My favorite shot in that piece is a cluster of diamond earrings break, and as they fall, they become cluster bombs. You look at it, and it feels like the images are fused together in an impossible to understand way. It's just a cross-dissolve. But it's a cross dissolve done with the intent of really

Figure 1.17: *The Night Manager* title sequence. Created by Elastic for BBC and AMC. Director: Patrick Clair.

Figure 1.18: *The Night Manager* title sequence. Created by Elastic for BBC and AMC. Director: Patrick Clair.

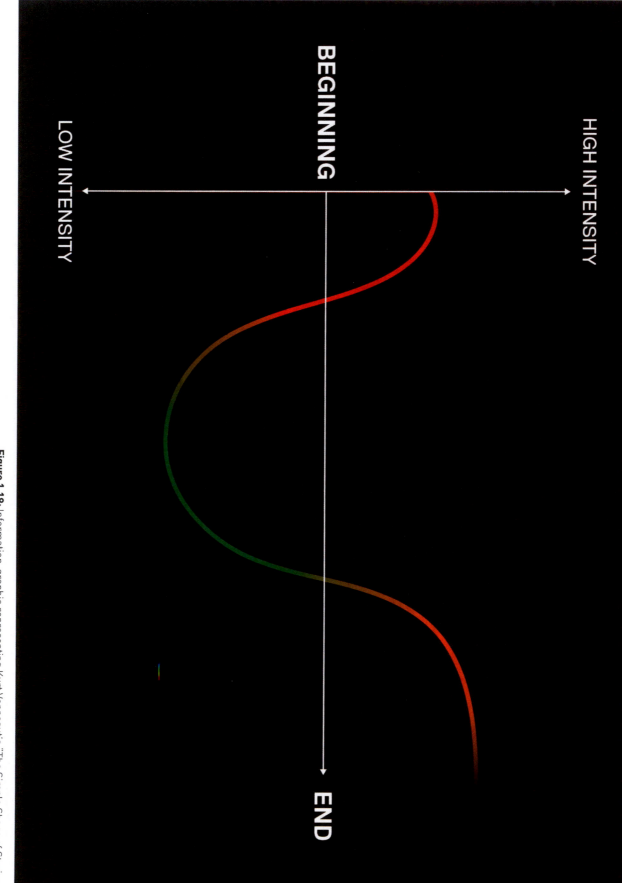

Figure 1.19: Information-graphic representing Kurt Vonnegut's "The Simple Shape of Stories."

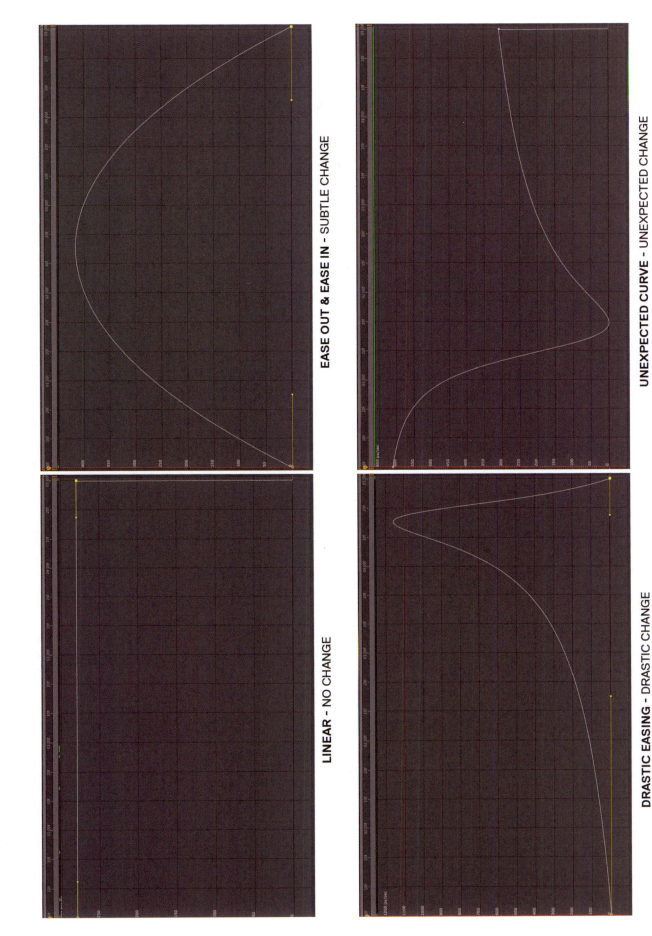

EASE OUT & EASE IN - SUBTLE CHANGE

LINEAR - NO CHANGE

UNEXPECTED CURVE - UNEXPECTED CHANGE

DRASTIC EASING - DRASTIC CHANGE

Figure 1.20: Screen captures of After Effects graph editor.

Author's Reflection

The layout of a design board is just as important as the composition of a single style frame. The arrangement of style frames reveals how the story unfolds. I often advise my students to think about their design boards as a journey from one beautiful composition to another.

Students often ask how many style frames are needed in a design board. There is no set number. You need enough frames to clearly communicate the concept and narrative. However, you do not want so many frames that it either confuses the viewer or overly constricts your production. Leave some room for growth, to think about their design boards as a journey from one change, or simply for the viewer's imagination to fill in what happens between frames.

The more dramatic the shape of the graph editor curve, the more dynamic the motion. The graph editor in After Effects and Kurt Vonnegut's "The Simple Shape of Stories" idea can be helpful tools for planning the shape of your design board's narrative.

Design Boards in Production

Like style frames, a vital function of design boards is to plan and guide productions. Design boards establish the parameters for the visual style and narrative of a motion design project. For a studio, the design board keeps all members of the creative team on the same page. There are a lot of moving parts in every production, and ideally, they all need to move in a unified manner. Throughout a design-driven production, all members of the team can refer back to the design board for clarity and consistency.

With competitive pitches, clients *award* projects based on the strength of a concept and its visual presentation. When a client awards a project, they are buying that style and story. Design boards are like a promise, or a visual contract, that a studio or designer makes with a client. There is an expectation that the final outcome of a motion design piece will look like the style frames and design boards that the client approved.

Design boards are like insurance policies for an artist or a studio. Because design-driven productions can be very time-consuming and costly, it is vital that the client signs off on the design aesthetic prior to animation production. The last thing an artist or studio wants to do is to spend weeks building assets, compositing elements, and creating motion only to be told by a client that they want a different design style. If the client is willing to pay for these changes and push the deadline for delivery of the project, that can be negotiated. However, even under the best circumstances for the artist or studio, it is challenging to switch aesthetics halfway through a project. Design boards offer the opportunity to be sure that the client and studio are in agreement regarding the visual look and feel of the project before production gets under way. *Be very cautious of starting a commercial production before a client signs off on the visual style.*

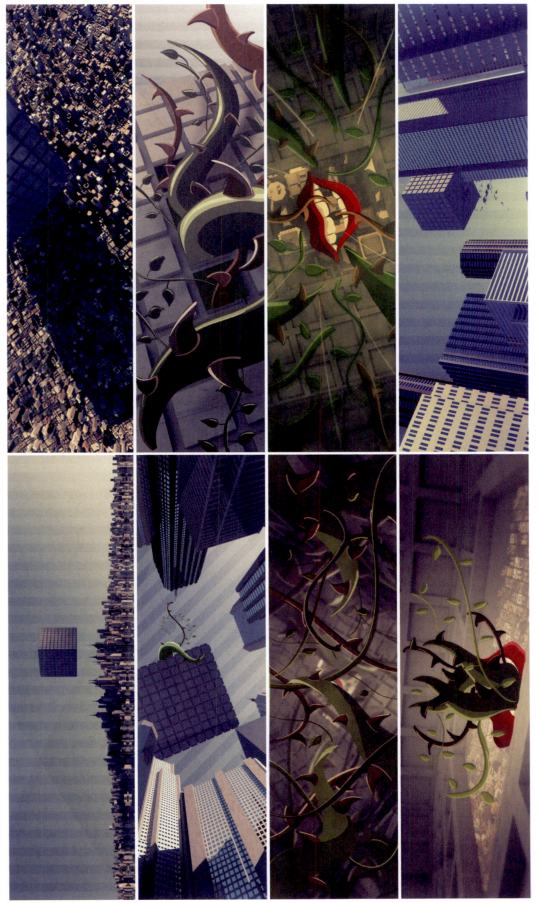

Figure 1.21: Design board by David Conklin, Motion Graphics Designer at Rockstar Games. Board created at SCAD. Design for Motion class. The variety of camera angles and distances in this design board creates a sense of change and movement throughout the story. The contrast between organized city structures and more organic illustrations produces both visual and conceptual tension.

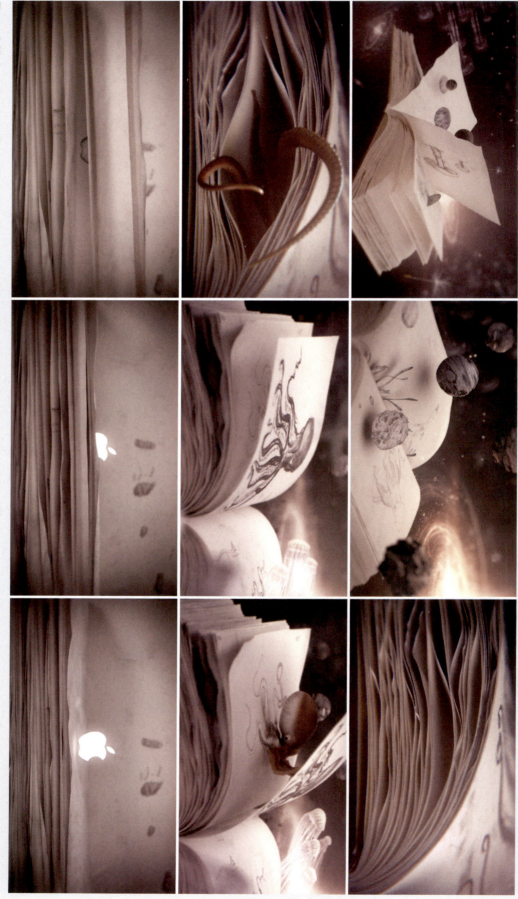

Figure 1.22: *Imac Pro: Artist Films.* Created by Sarofsky for Apple. Director: Erin Sarofsky.

Professional Perspectives:
Erin Sarofsky

Erin Sarofsky is a multi-talented artist and designer who runs her own studio, Sarofsky, located in Chicago. Erin leads a design-driven production company that produces original content for entertainment, broadcast, branding, and advertising. Her work has been featured in industry publications including *Shoot, Stash, Boards Magazine, Motionographer, Forget the Film; Watch the Titles, Art of the Titles,* and *PromaxBDA*. Her work has received multiple nominations for prestigious awards such as the Type Directors Club, the SXSW Film Design Awards, and a Primetime Emmy nomination.[15]

An Interview with Erin Sarofsky
What drew you towards motion design?

I like the linear nature of motion design. It's as close to storytelling as you can get when it comes to design. I also like that people can't touch it, can't do anything to it. They just watch it. I enjoy doing work that you get a captive audience for, like film titles. I think it's really important that your work really satisfies what you want to do in the world.

What do you like most about motion design?

I personally love coming up with concepts and the early phases of execution, when we translate that concept into motion. After that, I like seeing what the animators and other artists bring to it. It's always rewarding to see where a job starts, then watch how

it evolves. If you're a strong creative director, you can lead the process in a way so that comments are addressed and the work gets elevated.

I also love what we do because it is a pretty quick process. We are rarely on a job for more than a few months. ... And then, it's on to something new.

How do you come up with ideas?

I do a lot of writing. I mind map in a journal to see where thoughts lead to other thoughts. It always starts with words on paper. I also create style frames that are completely disposable. A lot of people treat style frames like they are precious commodities, but for me, I can create a full design board and then decide not to show it. It can be something that I spent a lot of time on, but it doesn't matter if it is not working. I put everything down and start over. Once you have done hundreds of design boards and won maybe 10% of those pitches, you begin to realize how disposable it all is.

Where do you find inspiration and reference?

I pull more towards history, architecture, and photography. I do believe everything is derivative. There is nothing you can say that is completely unique or original now, especially in the days of Pinterest. We have accessibility to everything, immediately, on your phone, in your hand, any second. So now, it is about how appropriate the reference is for what you are doing and how you

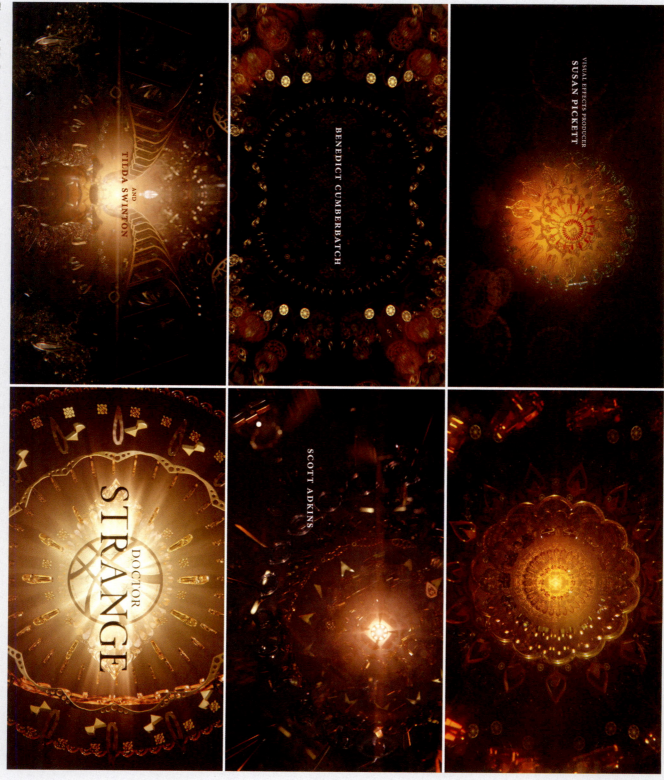

Figure 1.23: *Doctor Strange* title sequence. Created by Sarofsky for Marvel. Director: Erin Sarofsky.

evolve it to become own-able, even in this land of everything being unoriginal.

Do you have any specific methods or tools?

I approach every job very differently. Sometimes, I want to get out the crayons and paper; sometimes, I might want to do some ink; sometimes, I will scan it; sometimes, I just want to look for the right images and treat them. Every job is its own thing. I am most happy when what I am doing is most appropriate for the project at hand.

Because of my photography background, a lot of my early work had a filmic look. Even my graphic design and typography looked like it was photographed. I used vignettes and color grading and made images feel like there was a natural light source. It was very subtle and simple stuff, but it helped me stand apart.

Do you have any suggestions for young designers?

To do great work, it is not about getting the big paycheck right away. It's about putting yourself in a place where you are going to grow, learn, and absorb. After you spend a few years there, then you can go chase the paycheck. But, to start on a career that is really going to be fulfilling, you need to find the right studio for you and somehow get your foot in the door. That's going to mean a little bit of sacrifice at first, but in the long run, it will get you where you need to be.

How do you see the role of designers in design-driven productions?

The role of a designer has to be present throughout everything we do. Front end with concept development and design boards, and back end with production and delivery. I can always tell when a designer has had a hand in a piece, and when one has not.

I think there are two different kinds of designers. You need to have someone with the eye, but also someone who is realistic. There is the optimistic designer, who is always pushing to make the design a little bit stronger. Then there also has to be a realistic designer, who knows how far you can push a client. Artists who create design boards tend to be more optimistic, where designers in production need to be more realistic about what is going to work. It's the balance of those that get the work done that is beautiful, on time, and on budget.

Do you have suggestions about building a successful company?

In general, when speaking with students, there is a naivety to it all. Students have no idea what it takes to get access to the work we do. For me, it took the process of making hundreds and hundreds of design boards and producing who knows how many spots just to build a career and a name for myself. Then, once your career is going, you meet like-minded people along the way. ... People that complement each other. Those people slowly became my team. Now, that team is this company, and as we grow, we are mindful of keeping that team growing in the right direction.

Success for me isn't only defined by the bottom line (though that is a big part of it). It's also about creating work my team and clients can be proud of, growing fulfilling careers, and making sure our company culture is happy and upbeat.

Do you have any design heroes or mentors?

When I was younger, I was impressed by designers like David Carson. I think this speaks to the exact point in time I was in college and the kinds of books that were coming out. But now, I really look to the oldies; people like Saul Bass, who had a look and a way about their work that is a little more timeless. So, my inspirations have definitely changed over time.

What is your favorite project that you have produced?

The film titles for *Captain America*. I think it is very special visually because of the restraints and the color palette. There is thoughtful consideration to every single aspect of it.[16]

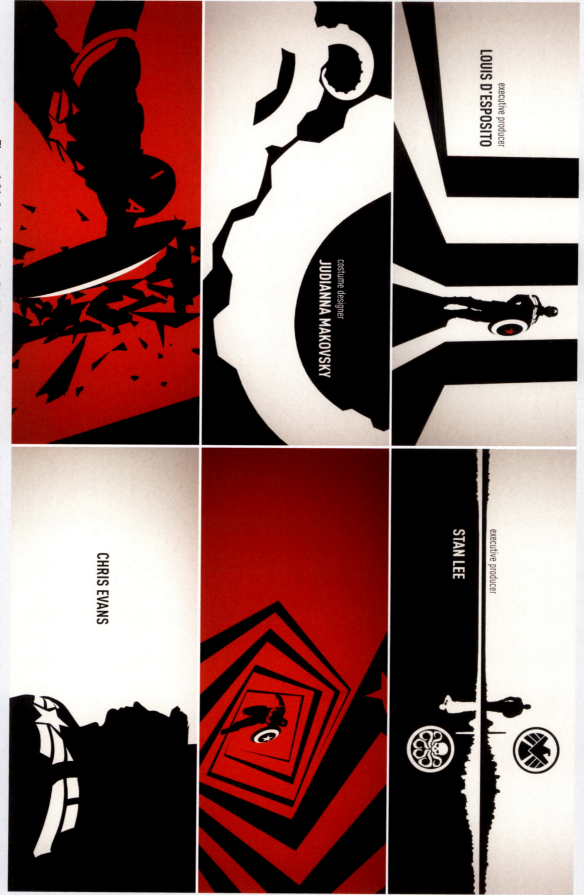

Figure 1.24: *Captain America: The Winter Soldier* main on end title sequence. Created by Sarofsky for Marvel. Main Title Director/Lead Designer: Erin Sarofsky.

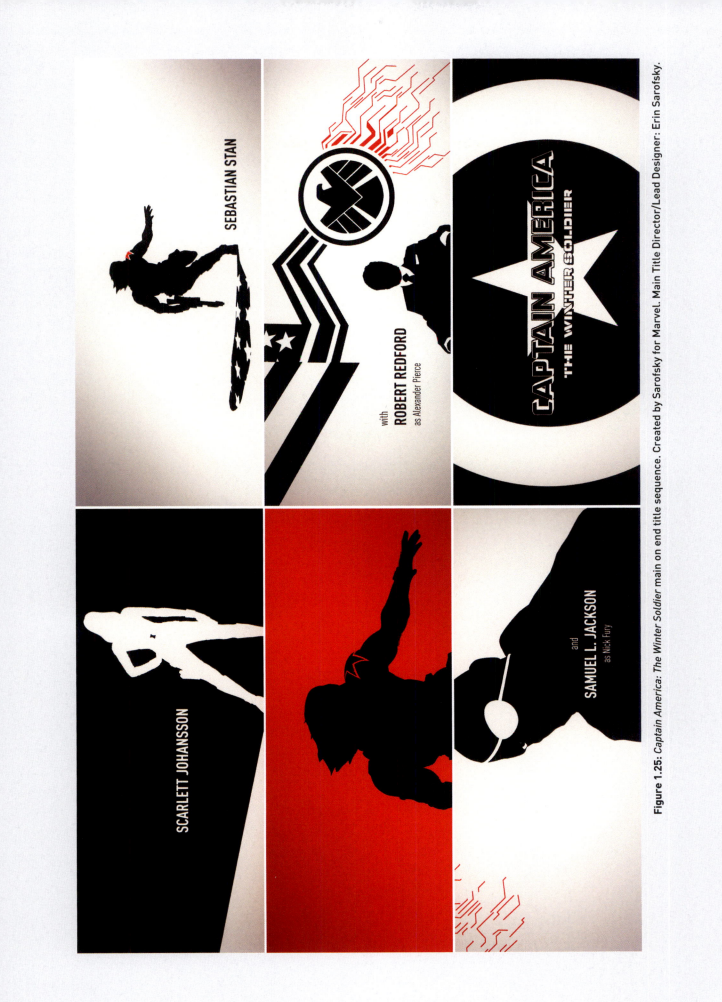

Figure 1.25: *Captain America: The Winter Soldier* main on end title sequence. Created by Sarofsky for Marvel. Main Title Director/Lead Designer: Erin Sarofsky.

Notes

1 Kelleher, Stephen, telephone interview with author, July 27, 2018.

2 Harvey, Joshua, telephone interview with author, June 23, 2018.

3 "Frank Lloyd Wright." Brainy Quotes. https://www.brainyquote.com/quotes/frank_lloyd_wright_127722.

4 "Who?" Joshua Harvey. Accessed July 15, 2018. www.joshuaharvey.com/who/.

5 Harvey, Joshua, telephone interview with author, June 23, 2018.

6 Daniels, Lindsay, telephone interview with author, June 3, 2014.

7 Clair, Patrick, telephone interview with author, August 13, 2014.

8 Clair, Patrick, telephone interview with author, September 8, 2018.

9 Clair, Patrick, telephone interview with author, July 9, 2018.

10 Jacobus, Lee A. Bedford Introduction to Drama, 4th Edition, and Bedford Guide to Research, 3rd Edition. (n.p.): Bedford/St. Martin's, 2002.

11 Vonnegut, Kurt. "Kurt Vonnegut Diagrams the Shape of All Stories in a Master's Thesis Rejected by U. Chicago." Open Culture. February 18, 2014. www.openculture.com/2014/02/kurt-vonnegut-masters-thesis-rejected-by-u-chicago.html.

12 Campbell, Joseph. The Hero with a Thousand Faces, 3rd ed. San Francisco, CA: New World Library, 2008.

13 Campbell, Joseph. The Power of Myth. New York: Anchor Books 1991.

14 Vogler, Christopher. The Writer's Journey: Mythic Structure for Writers, 3rd ed. Studio City, CA: Michael Wiese Productions, 2007.

15 "About." Sarofsky.com. August 25, 2014. http://sarofsky.com/company/.

16 Sarofsky, Erin, telephone interview with author, April 28, 2014.

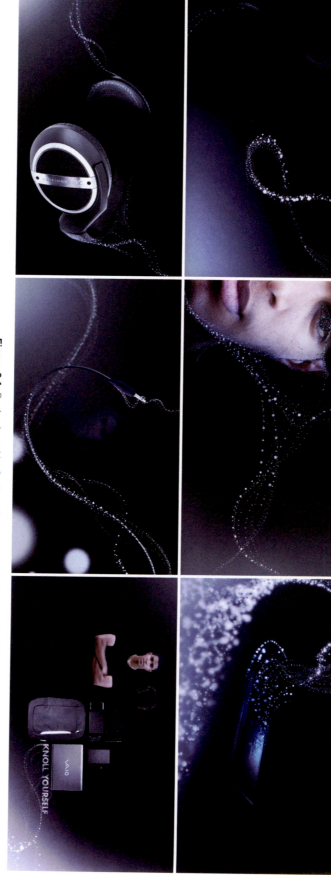

Figure 2.1: Design board by Graham Reid, Designer at Snapchat. Board created at SCAD, Design for Motion class.

Chapter 2:
Kick-off to Delivery

"The presumption ... is that since one works to assignment, the work is not for oneself. My view is that *all* the work I've done is for myself, and it also involves accommodating either a personality (the client) or problem that has to be solved. Such is the nature of the design profession" —Milton Glaser[1]

Creative Briefs

In order to become an effective problem-solver in motion design, one must learn how to work with *creative briefs*. A creative brief is a document that summarizes a creative problem, as well as outlining the overall *scope* and *deliverables* of a project. Scope can be understood as what a project is trying to accomplish. A deliverable is the final product or outcome. Often, a brief begins with a client, who then employs agencies, studios, or individual artists to help achieve their goals. When a problem is clearly understood, a creative team or designer can begin to work towards providing an effective solution. Therefore, it is integral to be able to interpret creative briefs. Learn to listen, ask questions, and set aside your ego. Though it may sound simple, it sometimes takes a while for designers to hone these skills.

"I had to learn how to read client briefs and to talk to clients. Making sure we were on the same page, showing them references, hearing them out. You have to have conversations about a project if you are going to solve their problem in a creative way. You have to collaborate if you want the client to be happy in the end. It is a partnership, and it is teamwork. I am helping them accomplish something they want to do."[2] —Carlo Vega, *Designer/Director*

How can we expect to solve a client's creative problems if we cannot hear their concerns? Active listening affords opportunities to clearly understand what is being asked, discern what is most important, and help arrive at an appropriate answer. Sometimes, a client may not know exactly what they want—they just have an idea, a message, or a product to sell. In these instances, it helps to ask your client questions like, "Who are you trying to reach? What are you trying to say? Is there anything we should avoid?" On the other hand, even when a client has a pretty good idea of what they want, a designer can suggest innovative approaches to the direction of a project. Ultimately, this process is a collaboration between a client and a creative problem-solver. Through analysis of a creative brief and discussions with a client, the needs and constraints of a project become clear.

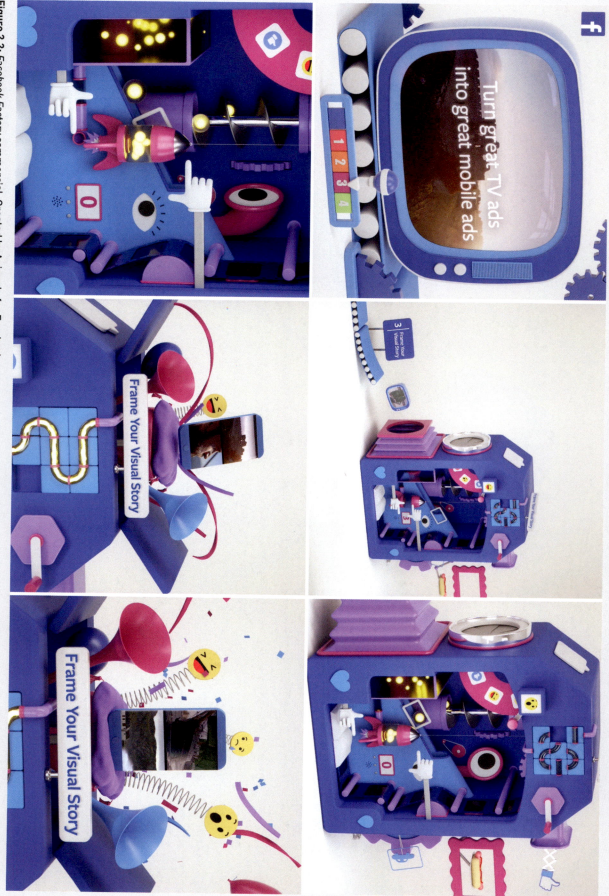

Figure 2.2: *Facebook Factory commercial. Created by Animade for Facebook.*

Professional Perspectives
Animade

An Interview with Animade
What is your art and design background?

Ed Barrett—Creative Director

I went to art college in the UK, and I had my mind set on doing animation. It was something I really enjoyed watching and experimenting with at school. I was pretty keen for that to be a career path for myself. I went to a very animation-focused University, the Surrey Institute of Art and Design (now known as the University for the Creative Arts). It wasn't necessarily design focused at this stage; it was more about the fundamentals of animation. We were kind of left to find our own way in terms of design. I knew what I was doing in terms of movement, but I wasn't that familiar with the design world. My tutors recognized that and recommended that I do a master's degree to fill the gaps in that knowledge—to have a bit more time to experiment in that space. So I applied to Royal College of Art and went there right after my bachelor's. What was really great about the RCA was that we had some prolific tutors, who weren't just animation focused; there was cross-course pollination. I was able to learn a fair degree of stuff there, and that really helped me into the industry. I was animating first and designing and illustrating second.

Tom Judd—Creative Director

I was kind of the opposite to Ed. In school, we had some very traditional teachers that taught us expressionist painting. I did

lots of drawing, lots of painting, and color work. The foundation was great, but I had a very blinkered view of what was out there in terms of design, illustration, animation, and the whole commercial industry. I went into an illustration course that had an animation pathway and really enjoyed it. My tutor pushed me to apply for the Royal College of Art. I found myself in a 2-year master's studying animation—the year below Ed, coming from a very different angle where my animation knowledge was very limited. I had been through an illustration degree. I think that is when we got together and started working through the early days of Animade. It was a nice relationship and meeting of the minds. I was blown away by all of the traditional animation knowledge that Ed had. That forged what would be the Animade style.

Ed Barrett

We kind of arrived at two sides of a different coin, with two different strengths. The two of us fit quite well together in terms of design and animation directors. Our strengths and weakness complement the other.

Tom Judd

As we have grown as a studio, we look to our creative team to have a similar mixture of animation prowess plus this design and illustration specialty. That has really helped to carry on and broaden the studio's style, values, and palette into different areas

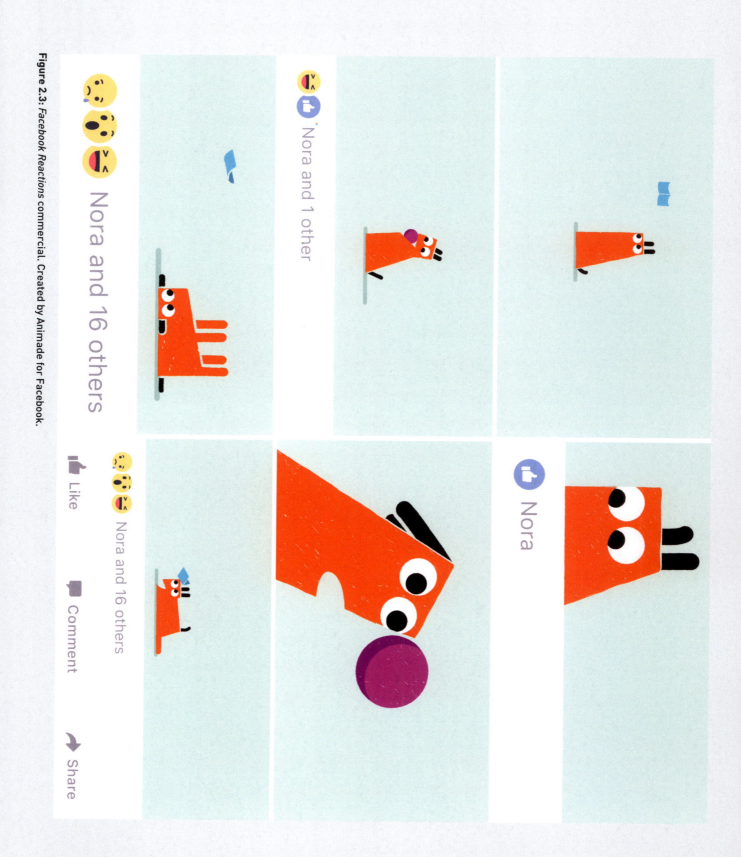

Figure 2.3: *Facebook Reactions commercial.* Created by Animade for Facebook.

like 3D and hand-drawn, in addition to 2D. It's been a really nice organic growth of our style and design theory.

How do you approach design and character development?

The interesting thing about our studio and our mantra of incorporating character into a lot of our work doesn't necessarily mean we always want to design characters. It's more from a motion side, where we inject character into whatever we do. Even if it's a text-heavy kinetic type of project, we are still looking at our background as animators in terms of character animation to elevate the level of our motion piece. Understanding what we need to do to make something not only look good, but move well. It's a hugely competitive area right now, so we have to look at what we do well as our unique selling point. Motion and character first and then applying that knowledge to our design work.

When we were kicking off as a studio, most of the projects we were getting were explainers and digital pieces, around the time when YouTube and Vimeo were becoming content portals for businesses to use animation and film as a medium. There was a boom in the requests for videos. Historically all the companies around us in the industry were set up to make TV spots essentially. We came in picking up projects where we wanted to deliver the fidelity of movement and richness of character, the emotive strength of the craft, but do it on a shoestring budget. That is where this whole idea of finding design styles that were simplified and stripped back really helped us to find a business model that worked. It was a fun and exciting way to refine our design, but also to make it feasible.

You can achieve something that feels engaging with a simple shape. The Facebook *Reactions* project was one of the most characterful pieces we've done yet it was essentially a dog in the form of an orange rectangle with eyes and a tail. It's awesome to have those challenges, and we love those projects where it's super stripped back. You are not hiding behind layers and layers of artwork. We found a way of working where we could achieve pretty high standard of work within tight constraints.

With *Tend*, we had a similar situation where we wanted to achieve a very rich, engaging world but we didn't want to stray into a realm that was foreign to Animade's style. It's surprising how much you can strip away and how much the mind fills the gap. You can actually have a less formed illustration and when you put in that level of characterful motion, it can fill the gaps for your brain.

How do you approach concept development in relation to a creative brief?

Design and concept development is so interesting in this industry because you are trying to answer a client's brief with a number of different variables to play with. It is our job to tweak and refine those variables to find the perfect answer. It is a balancing act where you have a happy client, a nice piece of work, within budget, and within time. We aim to optimize and shape a project around those restrictions and develop problem-solving tactics to create the best outcome possible.

We really enjoy building up concepts and stripping them back to the clearest message. It's one of those factors that comes into narrative storytelling as well as shorter social pieces. Much in the same way as an illustration needs to sell everything through a concept, quite a lot of our work goes down that same route. Think of a really strong concept, make sure it's totally clear, and really nice results come through that pipeline.

In the early days, we wanted to do what we wanted to do. We were sure it would be fine if we ignored a part of the brief to shoe-horn in a style we wanted to do or had a neat idea we thought would look good on our show reel. We realized really quickly that, by not answering their brief, you start losing pitches.

Now whether it's for a pitch or to kick-off a project, we look at the brief given to us and make sure we rearticulate that very same ideology into our work. We implemented a page in our

creative deck called "Understanding Your Brief"—it's not only to show the client that we understand what they are talking about, but to also drum it into our own brains. No matter how good an idea is, if it doesn't answer the question or meet the client's needs, they are not going to be happy with your pitch.

The problem is that the creative process is like a pathway. That path can meander, and you can end up somewhere different to where you expected. The trick is to go back to that original brief, look at what you have, compare it to what they want, and make sure that idea is still in there.

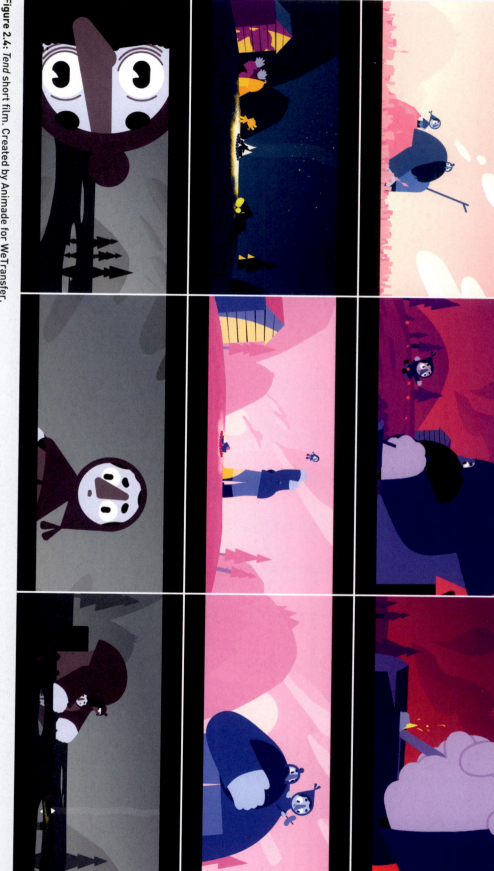

Figure 2.4: *Tend short film. Created by Animade for WeTransfer.*

What are your thoughts on social/mobile first as related to motion design?

The great thing about working on a short is that it allows you to focus a lot of attention on a small amount of time. You can achieve higher production values than if you were making something longer. Restrictions can be really enjoyable, and you can end up with a really great piece of work.

It is so different from that very classical mindset of storytelling. People are now viewing their content on a phone screen. When we started off, we were making long-form content for 16:9 viewing. Now the commercial work we are doing is social first—small screen size, limited or no sound. It's a totally different field.

Work now needs to be for everything—16:9 for TV; square for social media; portrait for phones, Instagram Stories, and Instagram Video. We are now thinking about how to change our workflows to cover all bases and look good across all platforms. We need to produce huge amounts of deliverables with the expectations of the high-fidelity of a TV spot. It comes back to having the ability to design in a clever way to answer the client's brief.

If you are scanning through a feed, you need to be able to see it, engage with it, and watch it for that few seconds before panning on rather than just gliding straight past it. That is probably the most important thing—to make sure it grabs your attention really quickly. Our attention spans are getting shorter and shorter. So, this is what you need to consider when creating for social media.

What about designing for vertical aspect ratios?

Designing from 16:9 to square is kind of acceptable, but portrait really needs to be its own format. [Our project for] Puma was really lovely because we knew it was going to be for Instagram Stories only. Portrait is quite a nice aspect ratio—it is a nightmare

to add it into a show reel though! Reformatting is something we now have to consider when working on multi-platform campaigns. For example, it takes additional time to format a campaign for both Instagram and Twitter, and we will often have to articulate these limitations to our clients to prepare them for additional costs!

How important is drawing to your process?

As painful as it can be, iteration is really good. Finding clients that you can share rough sketches with is such a benefit to the creative process. Very quick sketches can show charm, humor, and what it can become. It's a great way to explore the conceptual side without getting too heavily pushed down a design direction.

Drawing allows a certain freedom. Even if you know it's going to end up being a vector piece or whatever, when you draw you are going to bring something to your work that you potentially wouldn't if you'd gone straight into Illustrator or After Effects. We encourage people to draw first—sketch really quickly. When a new project comes in, the lead creative can usually be found at the front of the office with a sketchbook drawing rather than working out technical details on a computer.

What do you enjoy most about motion design?

Everything we do is bespoke to each client. The fact is that every time a client gets in touch, we are thinking about a new angle, a new design, a new narrative; it can go anywhere. It is a new challenge each time. It's really exhilarating, and that is the beauty of the industry. We get motivated by restrictions and problems, and we love solving those problems through design.

"It's the whole idea of constraints—understanding what the problems are and looking to solve them through design. You look to the problem to shape the outcome."[3] —Tom Judd, *Designer/Director, Animade*

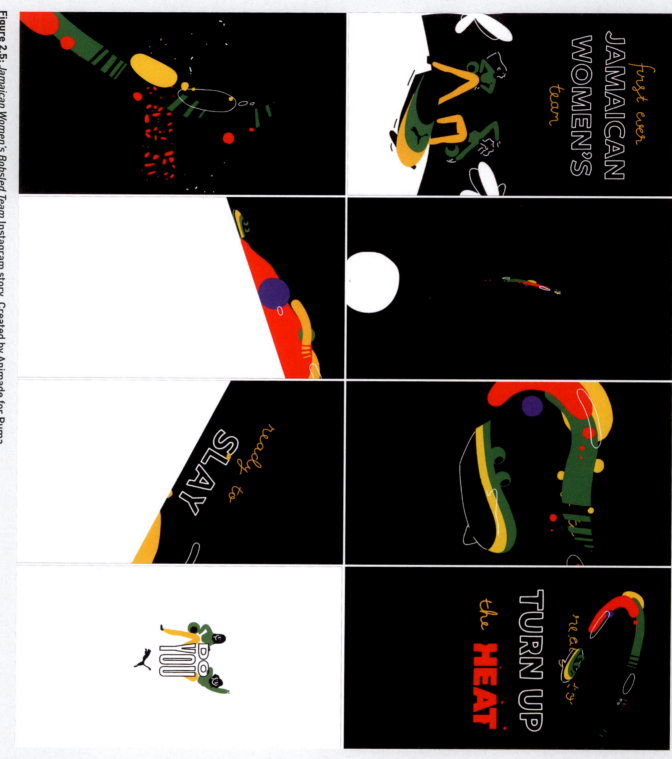

Figure 2.5: *Jamaican Women's Bobsled Team Instagram story.* Created by Animade for Puma.

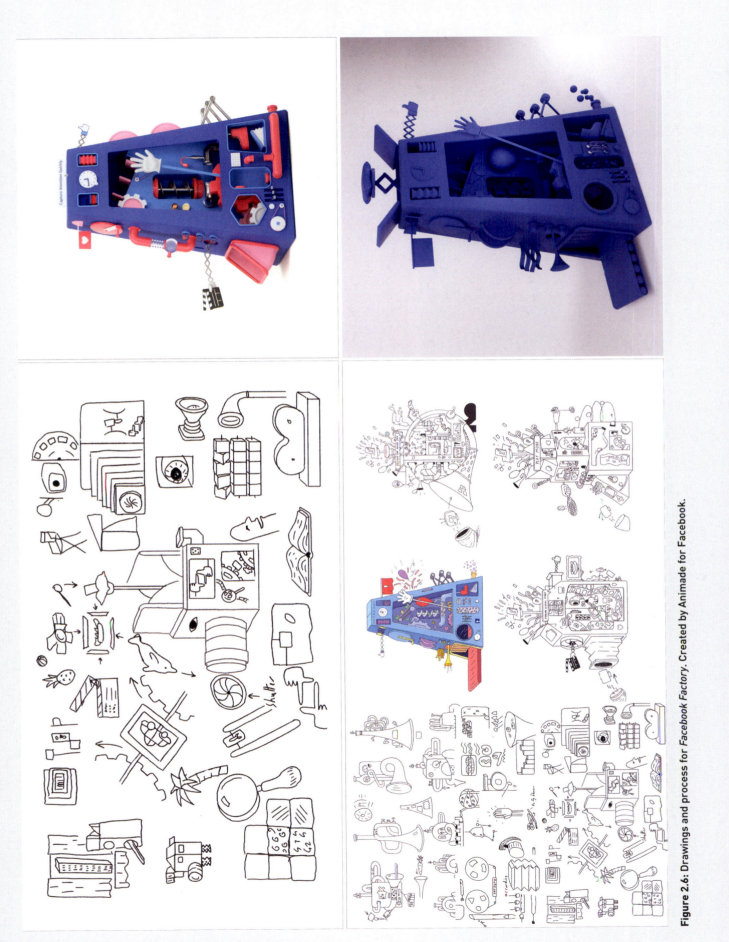

Figure 2.6: Drawings and process for *Facebook Factory*. Created by Animade for Facebook.

The Needs of a Project

Creative briefs contain a variety of needs including emotional, intellectual, and narrative attributes that a project is aiming to embody or to communicate.

Emotional

Knowing the *mood* or *tone* that a creative brief seeks to produce in an audience helps to shape the direction of your concept. Are there pivotal sensibilities or emotions a client wants to express? Should the viewer to feel happy, sad, hopeful, excited, or serene?

In Figure 2.7, we see frames from the *Westworld* season 2 title sequence, directed by Patrick Clair. These images portray the classical motif of mother and child. This theme is universal to human experience and can evoke powerful feelings of love and vulnerability. However, juxtaposed within the context of artificial intelligence and 3D printing, these images convey additional feelings of threat, fear, and uncertainty. Artistic rendering and aesthetic choices such as high-contrast lighting in the tradition of *Caravaggio* serve to enhance these emotions in the viewer.

Figure 2.7: *Westworld: Season 2 title sequence. Created for HBO by Elastic. Director: Patrick Clair.*

> "I would say where I am definitely really obsessed with is working with powerful symbols. If you disrupt that or mess with it, or combine it with something else can serve up very complicated feelings." [4] —Patrick Clair, *Designer/Director, Antibody*

Intellectual

Creative briefs also have intellectual needs, which relate to ideas and messaging. What should the viewer think after seeing the project? What is the project seeking to communicate? Is there a *call-to-action*, where the viewer is prompted to do something, or a deeper meaning to convey? Should the piece be reflective, irreverent, political, or comedic?

Figure 2.8 shows a series of political banners by designer Stephen Kelleher. These banners speak directly to the tensions within the American political system and break-down of civil discourse. These ideas are expressed through the use of modern design aesthetics such as reduced shapes, iconography, clear typography, and bold colors. Additionally, contemporary methods

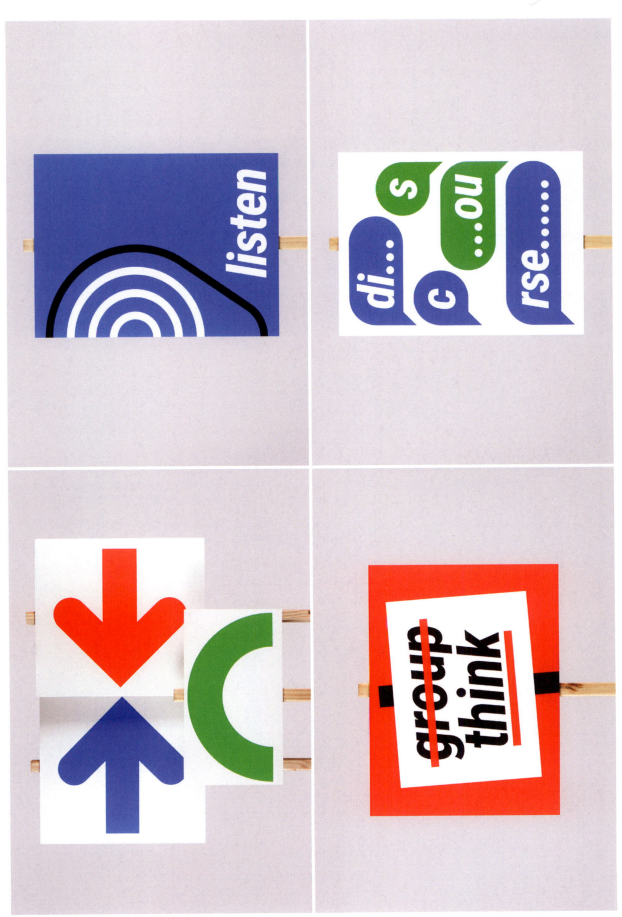

Figure 2.8: *It Takes Two* series of protest banners. Created by Stephen Kelleher.

of technological communication, such as texting, are paired with the traditional and tactile form of the hand-held protest sign.

"This series of protest banners are inviting a conversation; asking us to talk more, shout less and with political violence on the rise, calling for rational debate and discourse when it seems like we need it the most."[5]
—Stephen Kelleher, Designer

Figure 2.9 showcases examples of Everydays art projects created by the designer Beeple. These images illustrate ideas and themes of dystopian futures. In some, we see the technology giants of today continue to evolve towards popular memes of singularity and domination. In others, we see these titans of the digital age relegated to the dustbins of history. In all of these examples, thought-provoking ideas are explored through compelling design.

"There are pictures imagining what Facebook and Google will be in the future with more advanced robotics. In the past, I did some imagining these cargo container structures of what Facebook, Google, and Apple might turn into if they fizzle out."[6] —Beeple (Mike Winkelmann), Designer

Storytelling/Narrative

Motion design is a form of visual storytelling, and thus, it has needs related to narrative. A brief may include a script that outlines the sequence of events, which in turn may require the development of a storyboard. A creative brief should provide both clarity and structure about the theme of a project's narrative. Is the story about transformation, discovery, tragedy, or friendship?

Figure 2.10 shows the title sequence for the TV program *Shameless*. In addition to setting the tone of the show, the title sequence introduces the viewer to what types of stories one can

expect. The sequence itself shows a story of drama, dysfunction, and comedy through the lens of voyeuristic observation of the cast. The sequence places the viewer into one of the most private areas of a home—the bathroom. These narrative choices, expressed through camera position, camera distance, and the direction of talent, instantly creates a level of uncomfortable intimacy. In other words, we are taken on a journey that is indeed "shameless."

The Constraints of a Project

Platform

It is vital to know what *platform* your project is destined for, so you can design within the appropriate constraints. Traditionally, design for motion was primarily for film and television. Now, there is a tremendous need for motion design on mobile and social media platforms. Additionally, designers of motion create projects for emerging technology such as projection mapping, AR (augmented reality), VR (virtual reality), live visuals, and all manners of digital signage. The technical specifications for these various platforms can be radically different.

Size/Aspect Ratio

In addition to horizontal aspect ratios traditionally used for television and film, motion design for mobile and social platforms is regularly created in both *vertical* and *square* sizes. Furthermore, motion design is created for app-based emojis, AR filters, animated stickers, and feed-based motion overlays that have a range of aspect ratios and sizes. Events and digital signage offer opportunities to create motion design at uniquely custom sizes through advances in screen technology and screen array capabilities as seen in Figure 2.11.

A creative brief may require you to deliver for a variety of sizes such as 16:9 (horizontal), 1:1 (square), and 9:16 (vertical/portrait). Reformatting a design direction for all of these sizes

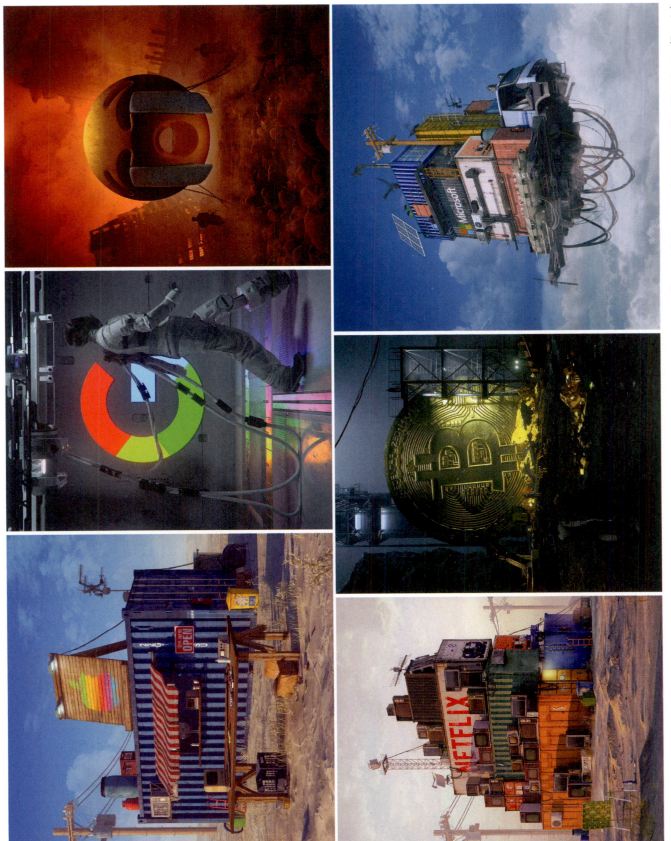

Figure 2.9: Everydays. Created by Mike Winkelmann (Beeple).

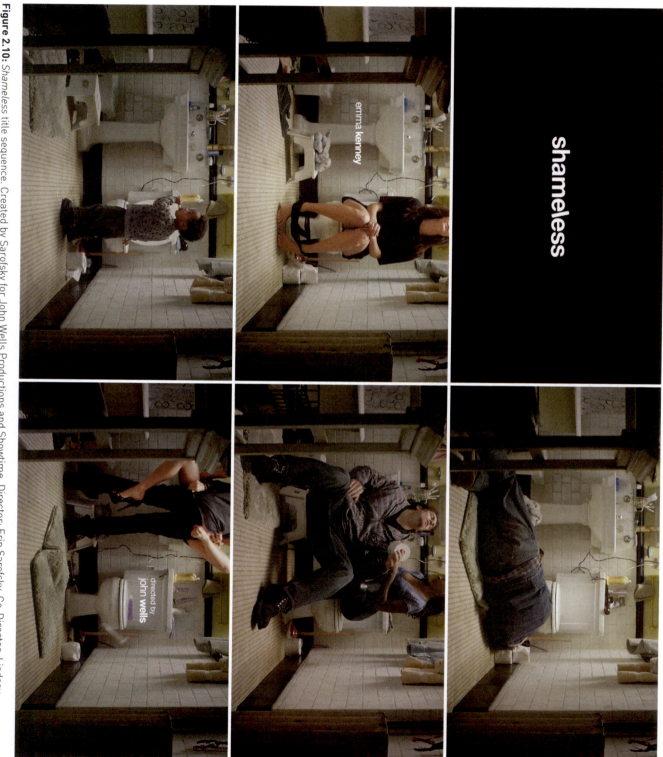

Figure 2.10: Shameless title sequence. Created by Sarofsky for John Wells Productions and Showtime. Director: Erin Sarofsky. Co-Director: Lindsay Daniels.

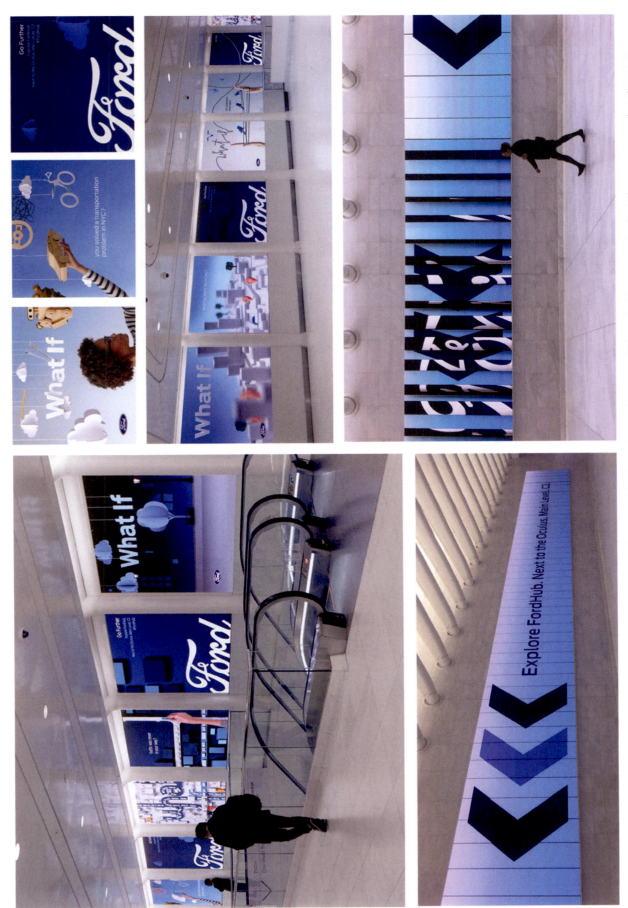

Figure 2.11: *Ford @ The Oculus.* Created by Sibling Rivalry for Ford. Creative Director and Designer: Lauren Hartstone. This project is an example of multi-screen arrays that showcase branded content for 19 LED displays at the New Westfield Mall in downtown NYC.

presents challenges in terms of effective visual compositions and production time. It is vital for a creative team and client to understand the technical specifications required for every project.

Creative Director Chace Hartman of Gentleman Scholar designed an effective information graphic to help visualize the variety of sizes across multiple platforms.

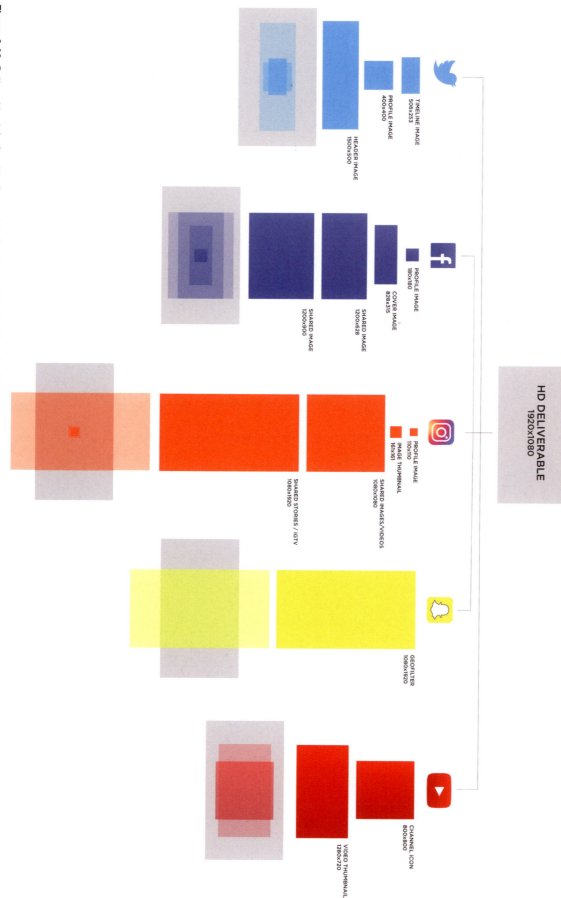

Figure 2.12: *Deliverables Info-Graphic.* Created by Gentleman Scholar. Creative Director and Designer: Chace Hartman.

Deliverables

When there are multiple elements or versions being delivered for a project, a creative brief typically includes a *deliverables list*. A deliverables list specifies the complete range of assets to be created for a client by a studio or designer. This list reflects pre-determined marketing goals a client has for placing creative material in various advertising spaces including broadcast, digital, social media, and print.

Duration

Duration is the length of time for which a motion design project plays, like a 30-second commercial or a 5-second logo animation. Depending on the platform, duration and storytelling constraints may vary drastically. With more traditional motion design platforms, you have the luxury of allowing the story to unfold. However, with short-form mobile content, you only have a few moments to capture attention and deliver key information. Also, the duration of a project directly effects the amount of work required to achieve a desired look and feel, which in turn effects the costs of production.

Budget

Budget is perhaps one of the most pivotal constraints for any commercial project. In addition to the ability to concept and design for motion, one must be able to produce a visual style that is reflective of the project's scope and budget. For financial success and professional sustainability, designers must be able to appropriately match their creative solutions to a project's financial constraints. Producers typically work with creative leads to plan creative direction around costs.

Schedule

Of course, deadlines are fundamental constraints that need to be considered when working with a client project. The overall schedule will determine the amount of time that can be allotted to concept and design development in addition to production. It takes experience to properly gauge how much time is needed to execute a given design direction. All of these variables factor into the overall scope of a project. A creative brief provides a framework for the entire project, from concept development through design, production, and delivery.

Ultimately, a creative brief is the starting point, or impetus, to begin the creative problem-solving process. Briefs help designers stay focused on solving creative problems and maintain the creative boundaries of a project. Remember, if a client's needs or constraints are not clear, it will be difficult to come up with a solution to their problem.

Kick-off to Delivery

The term *kick-off* refers to the start of a project, whereas the term *delivery* indicates the end. These terms are used regularly across creative industries. It is daunting to be presented with a brief that asks you to come up with a creative solution that includes an innovative concept, a compelling visual style, and a dynamic plan for motion. Sitting with uncertainty of any kind can be challenging, and every project kick-off presents varying degrees of ambiguity. If you add deadlines, pitches, payments, and client approvals, you may even feel like you want to rush towards a solution as fast as possible. The stress to arrive at the "right" answer can result in ineffective outcomes for the client and burn-out for the designer. So, how can we effectively traverse the process between kick-off and delivery?

The *Kick-off to Delivery* information graphic (see Figure 2.13) is funnel-shaped—widest at the top and narrowing to a point at the bottom. This shape represents the idea that with creative problem-solving, it is helpful to begin broad, then gradually refine towards a specific outcome. In other words, do as much research, ideation, sketching, and creative brainstorming as

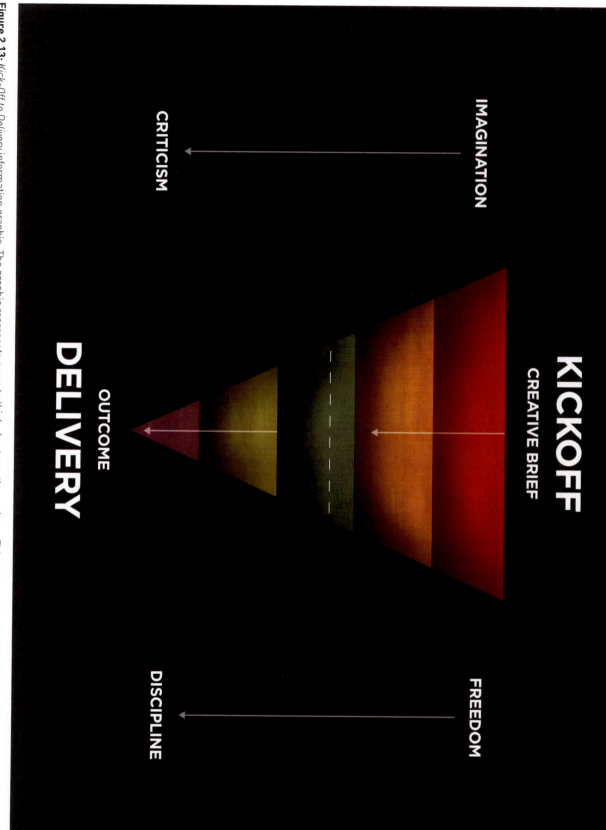

Figure 2.13: *Kick-Off to Delivery* information graphic. The graphic represents a way to think about creative projects. This approach to creativity builds on the tradition of Alfred North Whitehead, an English mathematician and philosopher who contributed to the field of education and philosophy in the early 20th century. Whitehead is associated with the school of philosophy known as *Process Philosophy*, which emphasizes change and development over static being.[7] Included in this graphic are two continuums quoted from Alfred North Whitehead, "Imagination to Criticism" and "Freedom to Discipline."[8]

Author's Reflection

My experiences as a commercial artist and as a professor have taught me about the importance of concept development. I spent many years working as a freelance designer for motion design boutiques in New York City. It is an extremely fast-paced and high-pressured place. The field of commercial art is also fiercely competitive. I have had success as a designer, winning pitches and leading high-profile projects. However, it was not until I had taught full-time for a few years that I realized how limited my approach to concept development had been.

I was hyper-focused on the outcome of projects. From the moment that I received a creative brief, I was determined to arrive at the solution as quickly as possible. Of course, the outcome is extremely important. Projects are awarded based on strong concepts and strong design. Ultimately, productions exist to deliver finished outcomes. But my approach was completely centered upon outcomes. I felt a lot of pressure to find the *right* idea, the *right* style, and the *right* story. I based how I felt about myself as a designer on winning or losing a pitch. Winning a pitch meant I was awesome, and losing a pitch meant I was a failure. Needless to say, it was often stressful and left me feeling burnt out.

Returning to the academic world allowed me to reflect upon my experiences in the industry in relation to my goals as an educator. I realized that my hyper-focus on outcomes was not ideal for creating the best designs or enjoying the process of creating motion design. Through working with my students, I discovered new ways to approach the design process. During one class in particular, a student asked me how to come up with ideas for projects. As a discussion ensued, I began to sketch out an information graphic that looked like a triangle. The wider side of the triangle portrayed the beginning stages of a project, where there are many possibilities of what the concept can be.

The narrow side of the triangle represented finished outcomes, a concept that had definitely become something. This discussion led me to begin really exploring my own personal process of coming up with ideas and creating motion design.

I found that I had a lot of resistance internally toward going slow and not committing to initial ideas. It was really difficult to sit with a creative brief without rushing towards the outcome. I realized that an immediate answer to a creative question skips all the possible stages of growth and expansion. However, I still found it challenging to sit with the uncertainty of a creative brief. Upon exploring this experience, I recalled my early education. Years and years of sitting in classrooms, being pressured to come up with an answer as soon as a teacher asked a question. I sat through countless tests with time limits that required a certain amount of "right" answers to pass. Of course, I was generally rewarded in some way when I got an answer correct. Sometimes it was a good grade, other times it was praise. The point is that our culture encourages answering questions quickly and correctly. Making mistakes or simply not knowing an answer is not exactly encouraged.

After these reflections, it dawned on me that my creative approach had been to answer a creative brief as quickly as possible by coming up with an idea, plunging right into the design phase of a project, and hoping that the client liked it. My process had been a straight line from the beginning of a project all the way until the end. I decided to practice dedicating a period of time to exploration, at the start of a project, no matter how short of a deadline. I began to give myself more breathing room and discovered that I was coming up with better solutions as well as enjoying the process more. Through workshopping these ideas in the classroom, I developed an information graphic to help my students approach creative problem-solving.

possible while you improve an idea and design direction through iteration. Although this idea may seem self-evident, I have seen both students and professionals struggle with this process. In most instances, the greatest challenge creative problem-solvers face is their own *inner critic*.

Inner Critic

The inner critic is the voice inside your head that makes judgments and seeks perfection. For most of us, editing ourselves and carefully choosing our words is a regular part of our lives. Indeed, the inner critic serves very useful and necessary functions. However, in the realm of creativity, an overly active inner critic can stifle ideas and kill the joy of the process. Too much doubt, worry, or criticism will make anyone self-conscious, and the creative mind even more so. During the early stages of concept development, try to allow your inner critic to take a break. Freedom and imagination are the qualities we want to nurture during the kick-off of a creative project.

Clients come to designers to help them solve creative problems. In general, it is understood that there is a gestation period between the beginning of a creative brief and the presentation of a concept. Clients do not kick-off a project with a creative artist and then immediately say, "Okay, so what is your answer?" They want the best possible solution to their creative needs. Clients expect designers to engage in concept development and brainstorming.

Imagination & Freedom

At the start of a project, there are many possibilities about what it can become. What will the design style look like? What

will the client think? These questions are important, but try not to rush towards the answers. Allow a creative brief to metaphorically digest before diving into the design process. A designer of motion spends a lot of time creating images. It will be a more rewarding experience if the images we create are inspired by powerful concepts. It is okay to make mistakes, especially in the early stages of a project. Take chances, dream big, and fail hard. Your project has the potential to become anything at this stage. Generating a number of options through ideation at the onset is a way to kick-start your process. Above all, stay curious and have fun. A mind driven by a need to explore will make discoveries. In other words, embrace playing in your creative sandbox.

Criticism & Discipline

As we move towards the conclusion of a project, we want to employ our inner critics. We need to examine our work with an eye towards perfection and detail. Double-check everything from a creative standpoint and fix anything that is out of place. The end result of a project should communicate certainty or resolution. Ambiguity is not helpful at this time. In terms of the *Kick-off to Delivery* information graphic, we are at the very end of the process where our solutions are clear, defined, and effective. Being aware of the relationship between the start and end of a project can help you manage your time and energy. In other words, lean into freedom, imagination, and exploration at the beginning of a project. Exercise discipline and criticism as you approach delivery. If you know where you are in the process, you can effectively chart your course and manage your time.

Professional Perspectives
Lindsay Daniels

Lindsay Daniels is an Emmy award-winning designer, storyteller, and live-action director.

Her diverse experience on the branding, agency, and motion design sides of the creative industry enable her to deliver smart, relevant solutions for the current evolving landscape.

She served as creative at Digital Kitchen where she designed the main title to *Dexter*, *Path to 9/11*, and several commercial campaigns. At Publicis, she was a creative director for T-Mobile and Chevrolet accounts, leading both brands through multiple print, broadcast, and digital campaigns. She is currently a live-action director and designer that works with major corporations, television networks, and production companies to define, design, and direct content for broadcast and digital platforms. Her work has been recognized by organizations such as Communication Arts Design Annual, The National Addy's, The Art Director's Club, and The Academy of Television Arts and Sciences.[9]

What is your art and design background?

I started my design education at the University of Washington. Through high school, I never really took art classes. When I got to college, I started taking art classes and really enjoyed it. I took a graphic design class, and my mind was blown. I would spend hours working on the computers at the library completely immersed in my projects. I transferred to the California College of the Arts. I honed-in on the ability to think conceptually, understand myself as a designer, and learn my skill and craft. I had seen the opening titles to *Six Feet Under*, and was like, "That is what I want to do." It was a defining moment. I also found a lot of inspiration in Kyle Cooper's work.

CCA was a more traditional design school so I was the only person in my entire class who did a thesis with motion design. I had been dealing with an eye problem and did a film reflecting how I was seeing the world. I had surgery, and something went wrong causing me to have double vision for 4 months. So, I made a film about it. I was able to drive all this frustration into this film. I diligently focused on how to tell a story, how to tell a story visually and emotionally. It was the only motion piece in my portfolio. But, it armed me with a strong enough piece to walk into Digital Kitchen and get hired as a junior designer. That's how I started my career.

How do you approach concept and storytelling?

I attribute so much of my storytelling and concept skills to my education. I had professors who really pushed concept. We learned all the important tools you need to know to design something, but most importantly, we learned to think like designers. Your final product had to be great, but the concept was pushed more.

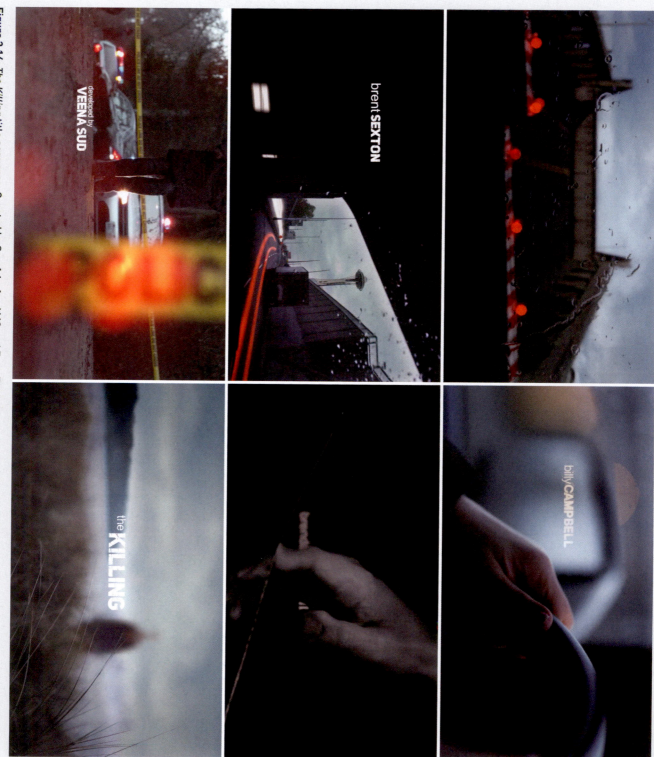

Figure 2.14: *The Killing* title sequence. Created by Sarofsky for AMC and Fuse Entertainment. Lead Designer/Co-Director: Lindsay Daniels. Director: Erin Sarofsky.

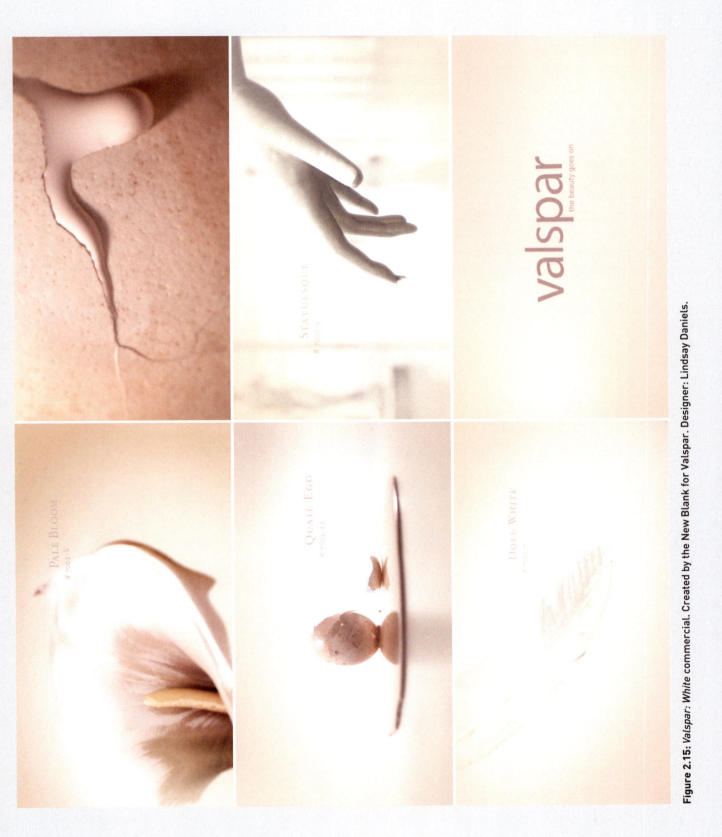

Figure 2.15: *Valspar: White* commercial. Created by the New Blank for Valspar. Designer: Lindsay Daniels.

What is the role of a designer in a design-driven production?

Designers are tasked with solving problems, forming ideas, and developing stories. In motion, the designer has to consider and inform what the audience sees, hears, feels, and understands. That complexity is what makes it interesting to me.

Designing boards and coming up with ideas has given me the skill set to work on different levels in the creative industry. After working at Digital Kitchen, I took a job at Publicis, an advertising agency. I had been working with brands to come up with concepts and art direction for commercials, so I was always close to the big idea and the brand. Instead of pitching ideas to an agency, I started pitching directly to the heads of marketing at corporations. I like helping them figure out what story they should tell with motion and then help them by designing creative solutions.

How would you describe the relationship between motion design and branding?

Motion designers are starting to have more influence on brands because companies are using more motion to tell their stories. Great motion design is not just reserved for brands who can afford a 30-second broadcast spot; it's an accessible and relevant medium to everyone. There are simply a lot more opportunities to connect your audience with your brand.

The digital world is constantly changing and growing. I think that evolution will continue to influence how motion design is utilized and consumed, which will affect how we approach assignments. It is interesting to see how motion is fitting into the process of digital and branding agencies. It's not about designing a piece that begins and ends. It's about an entire ecosystem that embraces a story and leaves the audience feeling something.

How do you approach image-making?

Part of creating design boards is making sure things look the way you envision. Sometimes that can be really difficult because what you want is very specific. There are so many layers that need to work together to articulate your story and concept. The trick is finding or making the right image that captures the tone of your idea.

There are so many different approaches to a creative brief. You need to whittle it down and get to the end point where the client feels confident that it is right. The way you can get to that point is by showing them different solutions. Starting wide in the beginning is really important.

Do you have suggestions for young designers?

When I was graduating from college, I was offered a job at a branding firm. I was also offered a position at Digital Kitchen. The branding firm was offering a lot more money. I was talking with one of my mentors, and he said, "For your first job, don't take a position just for money. Your first job can really influence your career path." I am really thankful I listened to that. I would urge designers to make sure that, whatever you're getting into, you really want to do it. Have patience, learn your industry, and learn your craft. Build a strong foundation. Learn from people around you. When you are involved in a team, all the knowledge that is there is really valuable.

Do you have a favorite project?

Being a part of the opening titles for "Dexter" was a huge opportunity and a wild ride. As a designer, to have something you thought of and designed come to life and resonate with so many people is really special. Every motion designer should have the experience of doing something really hands on, where the process unfolds in front of you. [10]

Figure 2.16: *Dexter* main title. Created by Digital Kitchen for Showtime. Creative Director: Eric Anderson. Designer: Lindsay Daniels.

Notes

1 Glaser, Milton. *Drawing Is Thinking*. New York: Overlook Duckworth, 2008.
2 Vega, Carlo, telephone interview with author, May 12, 2014.
3 Judd, Tom, telephone interview with author, July 6, 2018.
4 Clair, Patrick, telephone interview with author, July 9, 2018.
5 "It Takes Two." Stephen Kelleher. Accessed June 16, 2019. https://
 stephenkelleher.com/It-Takes-Two.
6 Winkelmann, Mike, telephone interview with author, June 16, 2018.
7 Internet Encyclopedia of Philosophy. Accessed February 5, 2019, https://www.
 iep.utm.edu/processpl/.
8 Whitehead, Alfred North. The Function of Reason. Princeton, NJ: Princeton
 University Press, 1929.
9 "About." Lindsaydaniels.com. August 25, 2014, www.lindsaydaniels.com/
 about/.
10 Daniels, Lindsay, telephone interview with author, June 3, 2014.

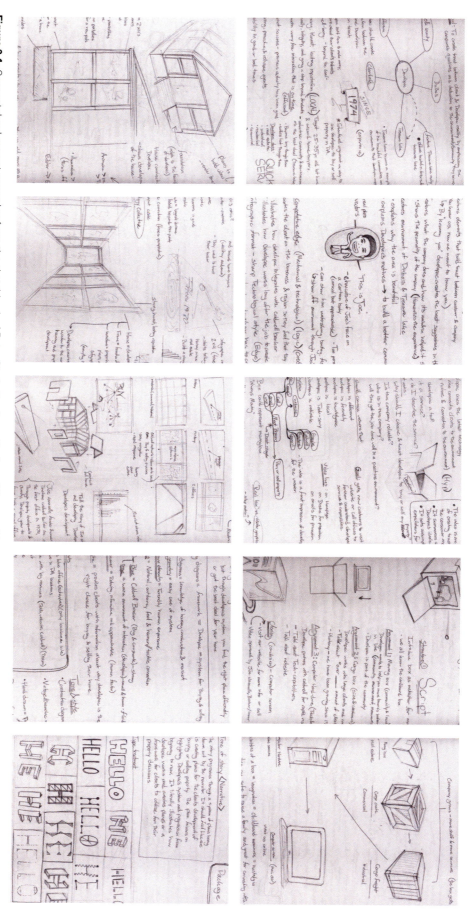

Figure 3.1: Concept development examples from the sketchbook of Peter Clark, Freelance Designer/Director. Sketches created at SCAD, Design for Motion class.

Chapter 3:
Concept Development

Good Ideas Are Hard Work

An idea rarely emerges fully fleshed out. Concepts begin with an initial spark but, ultimately, need space to grow. It can be easy to grab hold of the first thought that comes to mind and start to design. However, we may end up spinning our wheels if we go in a direction that does not meet the needs of the client or creative brief. The style may look beautiful but lack a powerful concept or story if not given breathing room to evolve.

"When I first started out, I would just jump right into design. I would try to design my way out of a problem, and sometimes that works. But, more often than not, you end up at a dead end. It definitely helps to know what the concept is first and design from there."[1] —Lauren Hartstone, *Designer/Director*

Concept development is the process of coming up with ideas or solutions to creative problems. There are countless theories, methods, and books about how to ideate. However, there is no single *right way* to problem-solve. Although creative problem-solving is a personal endeavor, this text offers general suggestions and approaches to coming up with ideas. With

practice, our ability to quickly create style frames will increase dramatically. Rather than rushing straight into design, it is suggested to dedicate time to research, writing, and sketching during the early stages of a project.

This section introduces a variety of concept development techniques. These exercises generally follow the initial kick-off of a project. Therefore, emphasis should be placed on exploration and iteration, rather than finding the "perfect" solution. Try and embrace the ambiguity and mystery of this phase of a project. Sometimes it is difficult to sit with uncertainty, especially if there are external pressures, such as deadlines and competitive pitches. Our internal pressure can be just as bad, particularly if we are perfectionists and place high expectations on ourselves. The techniques discussed are designed to help explore possibilities and make unforeseen associations. Ultimately, we are searching for ideas that resonate with the creative brief. These methods are but a few examples of concept development exercises that have long traditions and have been employed across a variety of creative disciplines.

Writing for Concept Development

"Writing is such an important part of the design process. Half of defining it—and selling it—is how you write it. If you are conjuring up a particular idea, you're probably not going to find exact visual references that exist already. Like a screenwriter, you might have to use words to make the scene come alive. So, you have to be able to have somebody imagine what you are going to make, and buy off on it. It is such an integral part of the design process to be able to articulate what it will be verbally as well as visually."[2] —Karin Fong, Designer/Director

Designers create beautiful images, but sometimes that is not enough to sell a concept. The ability to write descriptively and express yourself with words is an important skill that will make you more versatile and valuable. Writing benefits concept development in a number of ways. As soon as a designer is presented with a creative problem or question, they can begin an inner dialogue by writing down their ideas. As a tool for ideation, writing is extremely accessible and low-cost in terms of resources. However, many students and professionals alike struggle to write. Often, designers avoid writing because they do not think they are very good at it. However, you do not need to be a novelist to add descriptive writing to your creative toolkit. All that is required is a willingness to write your thoughts down. Do not let self-consciousness about your writing keep you from trying. Like other creative skills, practice is the key to improvement.

Free Writing

Free writing is an unedited continuous stream of thoughts written down on paper or typed on a computer. Julia Cameron popularized this technique with an exercise called "morning pages" in her book The Artist's Way.[3] Free writing can help as an initial step of concept development after receiving a creative brief. The purpose of this exercise is to bypass your inner critic and tap into unexpected ideas, thoughts, or connections. Free writing builds on the tradition of surrealist games, which sought to unlock the unconscious contents of the mind. In the spirit of games, it is important to approach this exercise with an attitude of play. Free writing allows us to get our first thoughts down on paper and dig deeper towards solutions that may be less obvious.

Surrealist Manifesto

"Psychic automatism in its pure state, by which one proposes to express—verbally, by means of the written word, or in any other manner—the actual functioning of thought. Dictated by the thought, in the absence of any control exercised by reason, exempt from any aesthetic or moral concern."[4] —Andre Breton

How to Free Write

There is no wrong way to free write. However, there are a few suggestions that can help to create a framework for this process. Most importantly, try not to judge what comes into your mind during a free write. Just write down your thoughts without editing yourself. Do not worry about spelling, grammar, or punctuation. A free write does not have to make sense. It can be sloppy, messy, or unrefined. The goal is to let your thoughts and words flow.

At first, it may be difficult to let go of your inner critic. We spend much of our daily lives carefully choosing our words. Of course, there are times when your internal editor is very useful. However, a free write is not one of those times. Rather, writing in this manner offers an opportunity to detach from your inner critic.

The more you can allow yourself to be unrestrained during a free write, the more you will benefit from this exercise. Moments of insight may arise and these are the kinds of discoveries we seek. When ideas, emotions, or images surface during a free write, see where they take you. Try not to be discouraged if you need to write a lot of nonsense before you discover more interesting ideas. Above all, *do not pressure yourself with expectations during this exercise.*

You can choose to write for a set amount of time, or to write a specific number of pages. It is advised that once you begin a free write, do not stop writing until the exercise is over. If you choose to free write for 10 minutes, do not stop writing for the entire 10 minutes. Even if nothing of substance comes to your mind, just keep writing. Some people prefer to free write in their sketchbooks or on paper. They enjoy the tactile experience of writing by hand and feel like they can express themselves most naturally in that form. Others are more comfortable free writing on a computer by typing at a keyboard. I have had students who do a variation of free writing by talking into a recorder non-stop for a set amount of time. Again, there is no wrong way to free write. Experiment with different forms of this technique to find what works best for you.

Free writing requires you to be courageous. It is not always easy to sit with your thoughts, especially if you are feeling stressed or uninspired. However, free writing can help you clear away mental clutter that blocks the path of creativity. Be open to what comes during a free write as your ideas may develop into amazing concepts.

Sharing Is Optional

Because free writing can be raw and unedited, do not feel compelled to share your free writes. It would be counter-productive to feel self-conscious during a free write and potentially difficult to turn-off your inner critic if you think your

← Free WriteNG → Calm, tranquil. Clear

• Serenity: 고요함. 아늑. 평화로움. 정감. 고요함 (평화로움·기쁨)
 (애뜻함·정감) 진정. 정취.

• Time : 10:40 AM - 10:50 AM (10mins)

• Early in the morning, there is one bird singing alone. Songs are clear + beautiful. No one on the street. Weather inspiring. Enjoy its life with peace. Spring is coming. Trees are shaking by deep window, now windy little bit. Sun is coming out from the further mountain. Sunshine comes on the street + a bird sight. Bird being enjoying the sunshine. Flying Bird to Sunshine. Disappear in to the Sunshine from the mountain. Colors + Tones are warm + bright. → Some parts are cold not cold as Winter. Serenity include cold tones on one sight. Peace into World. Making people warm hearted + not lonely. No clouds in the sky. Moving slow + clear + serenity Sound become a background. Hugging other people, and love others. Forest, there is only one animals. Noone

Figure 3.2: Free writing example from the sketchbook of Hyemin Hailey Lee, Motion Designer at *Huge*. Free write created at SCAD Design for Motion class.

writing will be reviewed. By keeping your free writing private, you can explore your thoughts, ideas, and feelings with less restraint.

Word Lists

Words are powerful. We use them to express ourselves and to communicate with others. We also use words as symbols for meaning as we interpret and make sense of the world and our experiences. In this way, words are like the seeds of ideas. They can grow into concepts that seem to have a life of their own. Each keyword has the potential to create a new branch of thought and meaning. But first, we must search for words that resonate with the creative problem we are trying to solve. Then, we can organize them into lists that clearly and efficiently communicate our intentions.

A *word list* is another tool for concept development. Like free writing, a word list utilizes language and semiotics to inspire creative ideas. Word lists contain *keywords*—words that are most relevant to your concept. Keywords can open metaphorical doors to imagination. They conjure images, ideas, emotions, and stories. Like signposts, they can direct and guide your ideation. Putting keywords into lists can help to structure your thought process. For a word list, seek words that are most potent in relation to a creative brief.

How to Make a Word List

Word lists can be written on paper or typed on a computer. Some people like to write them in really organized columns, while others are more chaotic with their lists. However, the form of the word list is less important than taking time to reflect on keywords that can influence the direction of a concept. In the early stages of creative problem-solving, a word list can help define creative boundaries for a project. Ask yourself if your keywords resonate with your concept? Do they create vivid images in your mind? Are they alive with depth and meaning? If so, they may be worth keeping. Ideally,

your keywords will also have personal meaning to you. If you are going to invest time and energy into a project, adding personal passion to your creativity will only make it stronger.

Creative Juxtapositions

Any number of creative juxtapositions can be utilized with word lists. Try pairing nouns, verbs, and adjectives to visualize your ideas. You can also create conceptual tension through contrast by listing the opposite meanings of your keywords. This opposition is extremely important as concepts are made stronger when dualities of meaning are explored. Even if both sides of a keyword are not presented in a project, the research and awareness of opposites can help you to develop a better concept. As you build tension through contrast, potential themes can emerge from your keywords.

Figure 3.3: Word lists from the sketchbooks of CJ Cook (Designer/Director/Director at Meister) and Peter Clark (Freelance Designer/Director). Word lists created at SCAD, Design for Motion class.

Mind Maps

A *mind map* is an information-graphic that represents your thoughts and ideas. When created after a word list, a mind map provides an opportunity to create associations between your keywords. Although it is not required to make a word list prior to a mind map, there are benefits to working in this sequence. A word list takes you through a process of reflection and discernment to find keywords that resonate with your concept. Mind maps organize keywords into more complex thought structures or idea families.

We all have a mental "screen" or "viewport" within our minds. As we explore ideas for our concepts, our minds conjure thoughts, feelings, images, and stories. Mind maps help us visualize unseen mental landscapes. Once our keywords and ideas are given form on paper or on a screen, they become easier to work with. The goal is to visualize emotional, intellectual, narrative, and aesthetic associations with a mind map.

Figure 3.4: Word list from a process book by Peter Clark, Freelance Designer/Director. Word list created at SCAD, Design for Motion class.

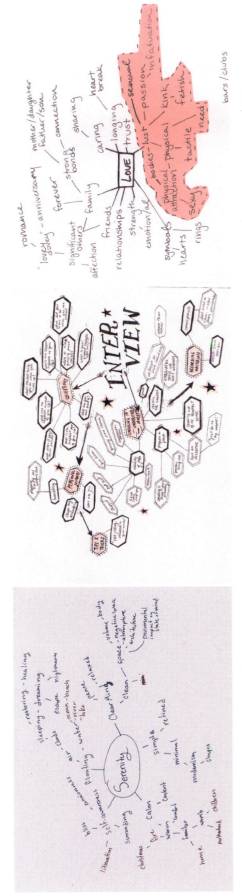

Figure 3.5: Mind maps from process books by Taylor English (Motion Designer at Fox Sports), Sara Beth Morgan (Freelance Designer/Art Director), and Lauren Peterson (Motion Designer at Viceland). Mind maps created at SCAD, Design for Motion class.

How to Make a Mind Map

There are many ways to make a mind map. Some people prefer to make them by hand, on paper, or in a sketchbook. Others make them digitally using design software or apps that specifically create mind maps. A mind map needs a focal point, a center from which your keywords and thought structures can orbit. A simple mind map can contain a main keyword written in the center of a page, with lines branching out and connecting to other words. The starting point of a mind map is very important. Not only does it kick-off the creative organization of ideas, but it also serves as an anchor, or center point of certainty, that you can return to. You may find yourself branching out to very unexpected territories,

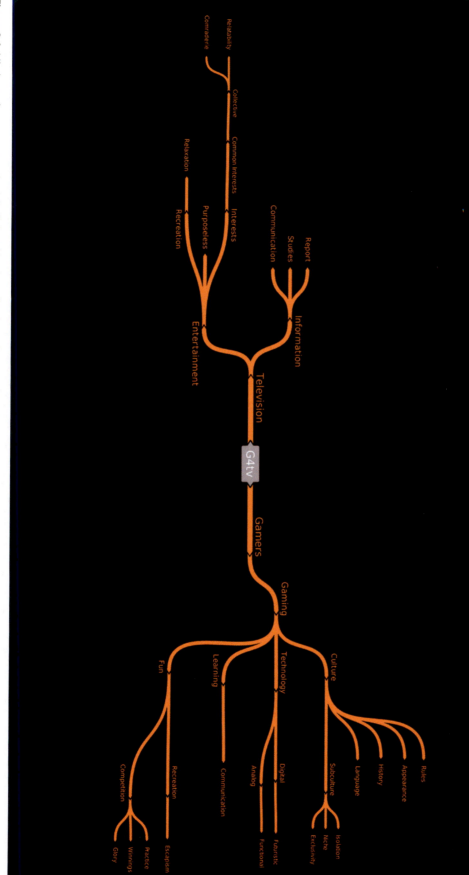

Figure 3.6: Mind map from a process book by Robert Morrison, Freelance Designer/Developer. Mind map created at SCAD, Design for Motion class.

which is great. However, if you stray too far or lose your way, the center point can bring you back to focus. A mind map helps you bring your internal world of ideas into an external form.

Making Connections

Connecting ideas and discovering new directions are the goals of a mind map. This kind of infographic can help you to see the relationships between your thoughts in a clear and efficient manner. You can wire your thought structures together and allow stories and connections to begin to unfold. It is not a static chart but, rather, a living map that offers opportunities to develop and expand your concepts.

Using Contrast & Tension

Just as contrast can be used to refine and strengthen the meaning of a keyword, it can also be used to highlight the important differences contained in a mind map. By mapping out opposing thought structures, you can visualize the full spectrum of meanings. Adding contrast and tension can help begin the crafting of a narrative. Strong narrative needs conflict, and a mind map offers the opportunity to visualize dynamic contrast.

Dos & Don'ts List

After a project kick-off, there are many possibilities about what it can become. Identifying the constraints around a brief is essential to effectively solve a creative problem. As we progress through developing a concept, we may need to further establish constraints for ourselves. A *Dos & Don't's list* is a collection of word lists that clarifies your intentions for a project. On the Dos side, you list desired outcomes. On the Don'ts side, you list qualities that you want to avoid. It is a simple exercise that roughs out a tangible plan for your project. Although a Dos & Don'ts list contains clear borders and boundaries for a project, the structure needs to be loose enough to evolve. As your concept develops, your list may change and grow.

A Dos & Don'ts lists reduces and amplifies a project through specific choices.[5] The guidelines that emerge define what you want your audience to think, feel, and experience. You can clearly communicate your goals for the mood and messaging of a project. A Dos & Don'ts list can inform your stylistic direction with choices about color palette, style, fonts, and materials. For narrative development, your list contains decisions about what kind of story you want to tell. You can refer back to your list as

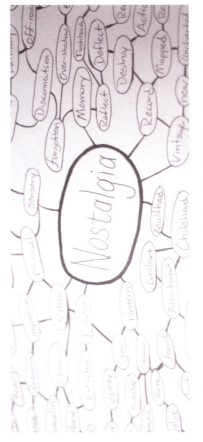

Figure 3.7: Mind map from a process book by Peter Clark, Freelance Designer/Director. Mind map created at SCAD, Design for Motion class.

DO
- Rely on optics and real footage rather than digital methods
- Create something seemingly disjointed
- Leave people somewhat confused at the end of viewing the project
- Rely on heaving finishing and color grading
- Make this an editing piece
- Allow people to help you
- Using different techniques

DO NOT
- Use 3D unless you can make it look photorealistic and be comped perfectly into a scene
- Go MTV on this shit
- Forget you may not be able to do this kind of stuff for a while

Figure 3.8: Dos & don'ts list from a process book by Joe Ball, Associate Creative Director at Manvsmachine. Dos & don'ts list created at SCAD, Design for Motion class.

you continue to develop your design direction or if you feel you are straying too far from your original intention.

Written Descriptions

Written descriptions summarize and convey the story and vision of a concept through words. In the world of commercial motion design, selling concepts is part of staying in business. Written descriptions are a significant aspect of communicating your solution to a creative brief. In some instances, an idea may be too big to illustrate solely with style frames and a design board. A written description can help craft a well-rounded presentation by filling-in any vital information that is left out of a design board.

> "If you can write down your idea in a paragraph, and it makes sense, I think that is a great foundation for what you are going to do visually. It helps you distill an idea into something simple enough to execute. I encourage designers to do that because it helps get to the core of an idea."[6] —Beat Baudenbacher, *Designer/Director*

A written description can also communicate the narrative shape of a motion design project. Because storytelling is a fundamental aspect of motion design, motion designers need to be comfortable creating narratives. Approaches to narrative can be formal or informal, typed out in script-writing software, or written on index cards. The point is to dedicate enough time to develop an interesting story. A well-crafted narrative will add depth and meaning to your project. Digital software affords the ability to easily rearrange, save, and iterate. Concepts and stories evolve through the process of editing and revisions.

Scripts

Written descriptions offer broad stroke summaries for narratives and concepts. However, some projects require a more detailed approach. Scripts contain a refined plan for the action of a motion design piece. They organize the exact sequence of events as well as coordinating specific points in time. Scripts also help to develop a *shot list* that can be used to schedule a production. Shot lists organize all the various shots that need to be captured in a live-action production or created in post-production. Scripts can also contain dialogue and voice-over, as well as direction for camera movement. A designer or animator can use a script to plan the syncing of visuals with audio. Scripts help to keep all the members of a design-driven production on task and "on the same page."

Brainstorming

The production side of design-driven production implies collaboration. In commercial projects, finding effective and appropriate solutions to creative briefs often needs to happen rather quickly. Working with others through brainstorming sessions can help to efficiently produce ideas. Additionally, bouncing ideas off of your creative team or peers can inspire concepts you may have never come up with by yourself. Effective brainstorming requires active listening, a willingness to present your ideas, and, most importantly, respect for your fellow designers.

Professional Perspectives
Karin Fong

Karin Fong is an Emmy Award-winning director and designer working at the intersection of film, television, and graphic design. A founding member of Imaginary Forces, she is known for designing iconic title sequences. Her projects include the opening credits for the TV series *Boardwalk Empire*, *South Park*, *Black Sails*, and *Counterpart*, as well as numerous feature films. She has directed commercials for major brands, including Target, Lexus, Sony PlayStation, and Herman Miller. From cinematics for Sony's God of War video game series to large-scale video installations in Times Square, Karin's projects showcase her inventive mix of design and filmmaking expertise. Her work has been shown at the Cooper-Hewitt National Design Museum, the Wexner Center, and the Walker Art Center as well as in many publications, including *Fast Company* magazine, which named her one of The 100 Most Creative People in Business. Karin has lectured around the world and has taught at Yale, RISD, Art Center, and CalArts. In 2018, she was awarded the AIGA Medal in recognition for exceptional achievement in design.[7]

An Interview with Karin Fong
What is your art and design background?

I was always the kind of kid who could draw in school. When I was in elementary school, I imagined I'd grow up to make children's books or greeting cards. I'd always find a way to do art. For instance, in high school, instead of writing a paper for my history class, I did a stop motion animation film with cut paper. I wanted to make things that would be seen and experienced by people, whether they were posters around campus or my own little books. Because I also liked writing, I chose a college that had a very strong English department, as well as an art school. I knew that writing was a big part of what I wanted to do. I ended up going to Yale and majoring in art, with a concentration in graphic design. I fell in love with graphic design because of the way it combines text and image. There's a real opportunity for narrative and storytelling.

Ever since I was a child, I was very influenced by *Sesame Street* and *Electric Company*. They showed that you could have any visual style. Nothing was off limits: puppets, live-action, animation, cel animation, claymation—it was all fair game. Consequently, the animated alphabet book I made for my senior project combined my love of children's books, animation, sound, scanned drawings, and collage. It landed me a job after graduation as an animator for *Where in the World Is Carmen Sandiego?* [TV show] and more importantly, with Kyle Cooper, who was then the creative director at R/GA Los Angeles. Imaginary Forces was founded from that studio in 1996, and since then, I've not only worked out of our original studio but spent 8 years in our NY one, before returning to Los Angeles in 2015.

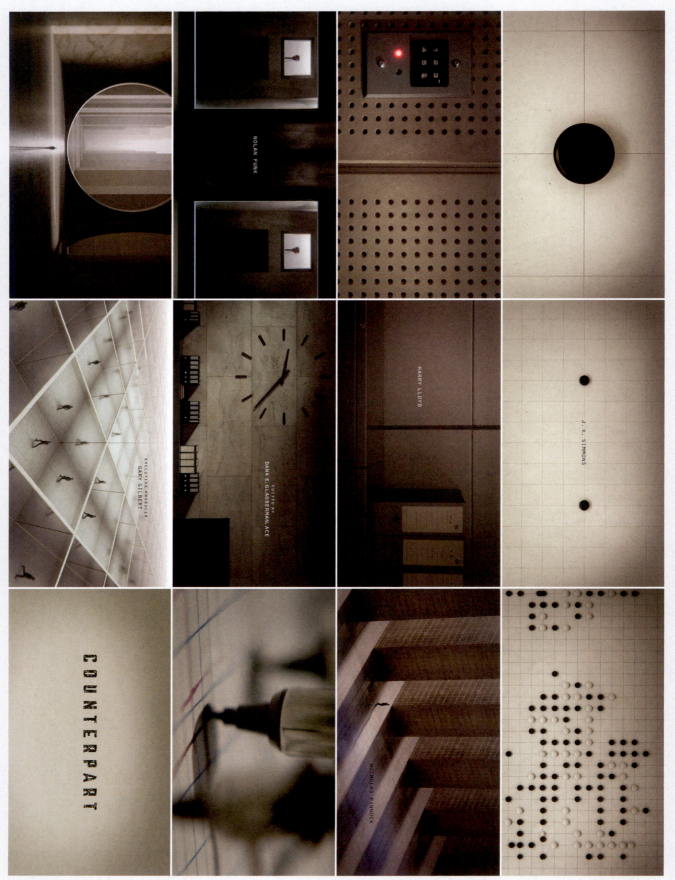

Figure 3.9: *Counterpart* main title. Title sequence for a spy/espionage show that deals with parallel worlds. Created by Imaginary Forces for STARZ. Director: Karin Fong.

How do you approach concept development?

I love the opportunity with any new project to dive into the content, in terms of research. I want to listen to the music of the time, see what the clothes of the time looked like, read the real-life stories behind the characters, read what the history and politics of the time were, what people were thinking about. To me, a really good design solution captures the unique qualities of the material, so it is always helpful to be as informed as possible about the subject matter.

I like boiling ideas down to a metaphor, to take the essence of an idea and turn it into a symbol. Something memorable, a little "aha" moment is something that inspires me. You want to make something memorable for a viewer, take two things that maybe you didn't know would go together, and make something new with it—a surprise. I love a lot of the techniques we have in this medium. Something that can go from 2D to 3D, or a simple turn of phrase can change the whole meaning. Simple transitions can be really powerful.

Where do you find inspiration?

A lot of the time it's travel, and getting away from the computer screen. Taking a swim or going for a walk. I love looking at art books, galleries, and talking with collaborators. I always try to keep working on several things at a time, because the idea for one project will come inevitably while I am working on a different project.

Do you have suggestions for young designers?

The work you do early on often leads to the work you do later. So you want your work to reflect what you are interested in. Your work should reflect who you are. It's not helpful to get hired to do work that you don't enjoy. Think about the parts of the job you like to do. Make sure your reel reflects that. You should only put on the pieces that you're proud of and that represent

you. We want to know that you know what your best work is, that you know how to edit, and that you know your strengths. If your reel or portfolio is all over the map, we don't know if the best pieces exist because you had a good teacher or a great art director for that one time. We want to feel confident that you are consistent.

Do you have suggestions for building a successful company?

Always work with people who are better than you. Work with people you admire and hire people you think are better than you. One of the greatest working joys is when you have a project and someone on your team adds something to the idea, and you know that if you were working by yourself, that wouldn't have happened.

How can designers become content creators?

As designers, we have all these different formats for content creation available to us. It's all an extension of filmmaking. Now, people often get their information and consume entertainment in little nuggets. Short-form content—things that are a couple minutes or even just a few seconds long are becoming more and more popular. This content is easily shared and can become viral. Plugging into little moments really speaks directly to what we do as designers. More and more people and organizations need their stories told in concise, memorable ways. Social media has increased the distribution of video and in ways that merge live action, type, and animation—which makes it a great playground for designers to create content.

The idea that a designer functions as a director is really powerful. We can have a point of view, and we have the tools to make it compelling. The more you begin to think of yourself in that way, the more you can take part in communicating a vision. Design is so powerful because you can get an emotional response. When you hit it right, it can really open people's minds.[8]

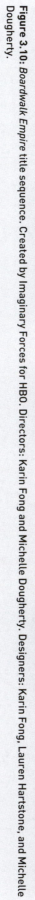

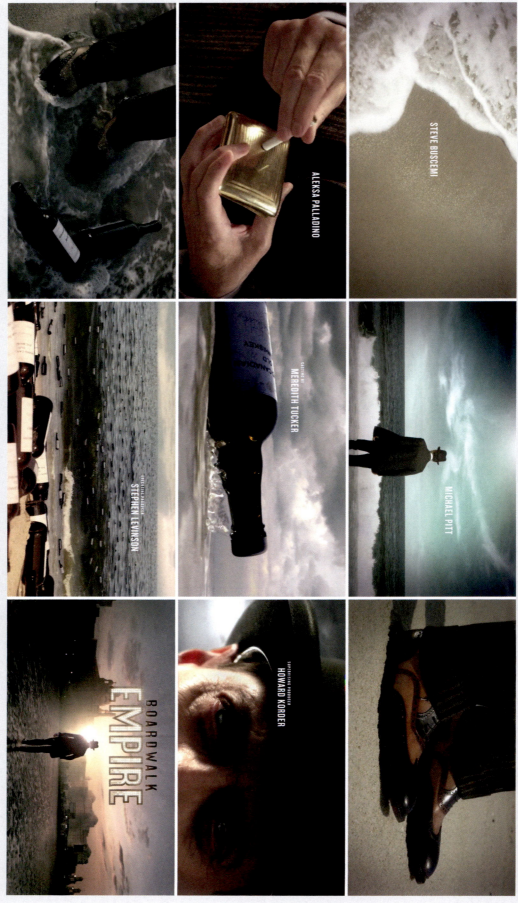

Figure 3.10: *Boardwalk Empire* title sequence. Created by Imaginary Forces for HBO. Directors: Karin Fong and Michelle Dougherty. Designers: Karin Fong, Lauren Hartstone, and Michelle Dougherty.

Figure 3.11: *God of War: From Ashes* commercial. Created by Imaginary Forces for SCEA. Director: Karin Fong.

Figure 3.12: *A Monster Calls*. An opening title sequence that sets the tone for J.A. Bayona's film by illustrating a journey into adulthood through the lens of a boy's imagination. Created by Imaginary Forces for Apaches Entertainment. Directors: Karin Fong, and Grant Lau.

Drawing for Concept Development

Drawing is fundamental to giving vision to our ideas. In relation to concept development, drawing allows exploration through mark-making, rather than words. For many designers, drawing and illustration are often the creative entry point into the discipline of motion design. Many have been drawing regularly from a very young age. However, if drawing is not part of your background, you can still utilize this creative tool. As Milton Glaser states in his book *Drawing Is Thinking,* "you need to have enough skill to be able to express your idea. How much skill that is varies, depending on the context."[9]

Mark-Making Tools

Artists have been using tools to make marks for thousands of years. Early cave paintings were created with brushes made from plant and animal materials. Today, we have a myriad of tools at our disposal to make marks in our sketchbooks. Pencils, pens, charcoal, markers, brush pens, crayons, and paintbrushes are a few of the most common mark-making tools. Use the tools you are most comfortable with, but be sure to have a pen or pencil within reach of your sketchbook so you can record any ideas that may come to mind.

An important idea to remember is that most of the tools we use on the computer are digital translations of analog practices. The *scissor,* the *brush,* and the *ruler* are but a few of the tools that are directly digitized versions of actual tools. Creative software allows us to utilize these digital means in a rapidly efficient manner. However, we should not set aside analog tools. Often, analog methods contain a personal and unique quality that is very difficult to produce digitally. Additionally, working on paper can feel less intimidating than starting on a screen. Ideation in a sketchbook may feel less risky and thus allow greater freedom for exploration in the beginning stages of a project. The art of combining analog and digital offers an opportunity to harness the creative potential and power of both mediums. Experiment with how far you can mix analog and digital methods.

Sketchbooks

Sketchbooks are a vital tool for designers. They come in many different sizes, from pocket-size sketchbooks that are very portable, to large-format sketchbooks that take up half your desk. Artists and designers have been using sketchbooks for ages. You can record what you see in your daily life, develop concepts, and work on images. Sketchbooks are excellent for taking notes, roughing out drawings, and exploring potential ideas. Writing down or sketching your ideas and inspirations are like planting seeds in a garden. Over time, they may develop into something beautiful. However, if you do not record your ideas, they will fade away. Traditionally, sketchbooks are analog. With the introduction of tablets, digital sketchbooks are emerging. Use the medium with which you are most comfortable. However, an analog sketchbook can be used virtually anywhere and facilitates a tactile experience of creativity.

"Very quick sketches can show charm, humor, and what a project can become. Exploring that conceptual side, without getting too heavily pushed down a design direction—the freedom of drawing, even if you know it's going to end up being a vector piece or whatever. If you draw it, you are going to bring something to your work that you potentially wouldn't if you'd gone straight into Illustrator or After Effects. We encourage people to draw first—sketch really quickly. When we get a project in, whoever the lead creative is, we see them at the front of the office with a sketchbook just drawing away after the kick-off. They are not going on the computer trying to work out all the technical side of things. It's such a good way to bring all of yourself to a project."[10] —Ed Barrett, *Designer/Director, Animade*

Thumbnail Sketches

There is a tendency among inexperienced designers to immediately start making assets or creating a polished image. No matter how well these elements may look, without a strong composition, the overall image will suffer. Composition is the arrangement of visual elements in a scene or viewport. It is the master plan of a scene or image. A poorly executed composition will not connect with the viewer and will thus fail to communicate the intended message. Thumbnail sketches are very helpful to explore composition, prior to investing a lot of time and energy refining an image.

A thumbnail sketch is a drawing that roughs out the composition of an image very quickly. Thumbnail refers to the size, meaning that these are typically small drawings. Additionally,

thumbnail also implies the idea that these drawings are low-risk in terms of the investment of time and effort. Thumbnail sketches are preliminary ideas of what an image can become. At this stage, the composition can be anything. You can draw in a sketchbook, on index cards, or in a computer application.

Thumbnail sketches explore the essential qualities of an image in a fast and loose manner. They are like gesture drawings, defining the underlying essence of the composition. Details are not that important in a thumbnail sketch. Rather, the core elements, such as positive and negative space, light and dark values, and spatial planes, can be worked out in thumbnails. Like blueprints, thumbnail sketches provide the structure for a future image. Once you arrive at a solid composition, you will have laid the foundation for creating an effective style frame.

Figure 3.13: Sketches courtesy of Yeojin Shin, Designer at Buck.

Figure 3.14: Example of thumbnail sketches from a process book by Hyemin Hailey Lee, Motion Designer at Huge. Thumbnails created at SCAD, Design for Motion class.

Approach & Practice

In your sketchbook, tablet, or on a computer, create a frame that is approximately the aspect ratio or dimension of the image you plan to create. Begin by blocking out the positive and negative space. Work quickly and with freedom. Try not to worry about the outcome. Rather, have fun searching for an interesting visual flow. Determine if you are creating a more design-centered, symmetrical composition, or a more art-centered, asymmetrical composition. Define a focal point, or where you want the viewer's eye to focus. If you want depth in your composition, establish foreground, middle ground, and background planes. Decide on a light source and direction in the scene and block out the range of values.

Try making a series of thumbnails for a single composition. This practice will allow you to explore a variety of visual arrangements in a short amount of time and also serves as a reminder that thumbnail sketches are disposable. Do not be too precious with them. They are sketches and intended to be unrefined. You may need to make a dozen thumbnails before you arrive at a strong composition. Of course, remember to have fun! All parts of the process should be enjoyed, and thumbnail sketches are no exception.

Thumbnails for Style Frames

You can be more efficient with your time by working on thumbnail sketches prior to making style frames. Thumbnail sketches can help to establish the compositions of your hero frames. These

frames are the moments in a motion design piece that help to define the visual style and the narrative. Once you are satisfied with a thumbnail sketch, use it as a reference for making your style frame. You could also place it in a digital workspace to use as a template for your design.

Thumbnail sketches can also block out transition frames in a design board. Again, with thumbnail sketches, you can quickly try out different options until you are happy with how a transition is working. What distinguishes a thumbnail sketch from a style frame is the level of polish. Both types of frames establish the composition and the camera angle of an image. However, only a style frame takes a composition to a fully realized look and feel.

Drawing for Creativity

The transition from creative student to creative professional can be difficult—especially if an artist or designer is attempting to derive "pure" creative fulfillment from every commercial project. The reality of client revisions, unexpected changes to project scope, and the sometimes banal nature of advertising can grind at

Figure 3.15: Example of thumbnail sketch and completed style frame from a process book by Daniel Chang, Freelance Designer. Thumbnail sketch and style frame created at SCAD, Design for Motion class.

the creative spirit. For long-term professional sustainability, it is extremely important to maintain a personal creative practice. For commercial artists, it is vital to dedicate time and space to make things just for yourself. Exercising personal expression without the need for client approval or polished outcomes can help replenish your creativity. Drawing is an excellent way to preserve your creative joy as well as refine your aesthetic skills.

"For me, drawing is an outlet. Commercial work is not the same. When I came to the realization that every commercial job was not necessarily going to be a creative outlet for me, it was a relief of sorts. I needed to balance the work I was doing for clients with personal projects in order to fulfill my need to be creative. I was so much happier after that. The drawing and personal stuff is a huge outlet, and it's great when it can cross over. However, whatever I am experimenting with in my drawings will probably find its way into an animation for a client."[11] —Matt Smithson, *Designer/Director*

Figure 3.16: Drawings and mixed media by Matt Smithson.

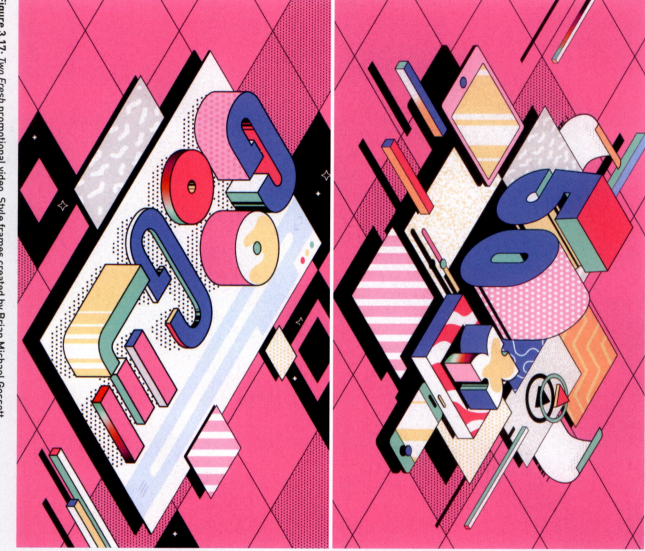

Figure 3.17: *Two Fresh* promotional video. Style frames created by Brian Michael Gossett.

Professional Perspectives
Brian Michael Gossett

An Interview with Brian Michael Gossett

Brian has been fortunate enough to have worked on a wide swath of projects with some of the best of the best in the advertising industry over the past 10 plus years, both large and small in scope. In 2007, Brian was honored to be on the Motionographer "Cream of the Crop" list; in 2008, he was awarded an ADC Young Gun as one of the top 50 artists under the age of 30. Brian was a main event speaker for AIGA with a talk entitled "The Evolution of a Creative and His Hairline" as well as exhibiting in the A+D Museum in Los Angeles for the "Come In: A Spatial Intervention" show in 2010.

Brian approaches every brief with an open mind and imagination while hoping to bring humor, charm, wit, and his own unique style and voice to a project. When he's not chin deep in solving client problems, he's usually talking to other artists for his popular podcast *Motion Sickness* or cracking dad jokes for his two biggest fans, his children River, Sage, and Birdie.[12]

What is your art and design background?

I have always drawn. It was a thing I did to escape from a very young age. I had a really good childhood, but when it came to wanting to zone out—I had two things, baseball and drawing. I drew all the time, and I was known as the guy in our group who drew. I would draw caricatures of all my friends. When

we used to wrap our textbooks in that brown craft paper, all my friends wanted me to draw stuff on their textbooks. That was my first job as an illustrator! I just kept drawing and drawing and excelled in school, got a lot of great feedback from teachers. I was in the first honors art class at my high school and got to do a lot of figure drawing, learned how to use oil paints and acrylics, and I got to learn a lot of cool tangible studio art.

That launched me into college at the University of Houston, in Texas. I was doing a lot of life drawing and color theory classes. A friend of mine suggested graphic design because I could combine all my talents. I could draw, take photos, and work with typography. I took the introduction class and fell in love with graphic design immediately. Eventually, I got lured into motion graphics because it's just so sexy. When you see things and it's not just one static image, it's all moving—that's exciting! On the first day of Motion Graphics class, the professor showed a bunch of stuff and then showed the *Se7en* titles. She said Kyle Cooper was probably the most respected motion designer, and instantly he became my hero. Before that, David Carson was my guy—probably everybody's guy at that time. Their style was of the time; everyone was kind of fucking up type. It was a very experimental time for graphic design, which was great.

Figure 3.18: *Green Peace.* Style frames created by Brian Gossett.

How did you transition from student to professional?

It was 2000 when I graduated in Houston, which didn't have the most exciting or thriving graphic design community at that time. Desktop publishing and desktop animation was just getting going, so there wasn't a ton of opportunity locally. I eventually got a job at one of the cool graphic design shops called Metal, and I got a taste of what it was like to be a professional. My first motion design job was at a studio called Exopolis, in LA. I got the opportunity to interview, so I put this big book together—spiral bounded, printed on really nice inkjet paper, and made this leave-behind book. I

had a website, but I wanted to show more than what was on the site, to show there was a lot more work I could do like drawings and illustrations. The interview went really well. It seemed like everyone was really nice. They called me later that day and asked when I could start. I was like, "Oh my god, I got the job!" They were a hot little shop for a minute and a lot of great people have come from there—Brien Holman and Jay Whitmore from We Are Royale are alumni. I also met GMUNK, when he was freelancing there. I was at Exopolis from 2004–2006.

It was an exciting time for the industry; Motion Graphics had hit its stride with studios like Logan, Brand New School, Motion Theory, and Psyop. There was really no industry rag [magazine] so to speak. There was no press, studio's had websites, and you went there to see cool work. And then Justin Cone came along and made Tween, sporadically sharing stuff he thought was cool, which turned into Motionographer. Around 2007, I went freelance and permalanced for a while at Logan as an art director. I consider that like my grad school, because they threw me into the fire. I worked long hours, learned what a 3D pipeline was, and soaked it all up. After freelancing for a few years, I took another staff directing and art directing gig at the Mill+ in NYC for two and a half years where I got to work with some of the best people before moving back to Austin, Texas, to work freelance again.

Have you primarily worked as a designer for motion, or do you animate as well?

At one point, I could animate some basic things. But I always pushed myself to be on the design side because I like developing the art direction behind a project. I would rather have someone who is way better at animating do it, than me. Somebody wise named GMUNK told me to specialize. He said, "You're really good at design, so just do that." I took that advice to heart. I decided to focus on design and started off more as a generalist. I did a lot of different things and could take on a lot of different kinds of projects. I did a lot of photo-comp stuff and made stuff look super-cool and CG and did the whole shallow depth of field over UI thing.

How have you refined your design aesthetic?

I did this project for Motion Theory where they wanted me to lead this tiny 2D animation job. I fell back in love with that kind of work, and it was a turning point for me. I was like, this is the kind of work I want to do. And it wasn't in vogue at the time, back in 2009, 2D character and 2D animation was not the hot stuff. It was kind of an uphill battle, but I really enjoyed it. I created a style; I had my first portfolio where I wasn't a generalist.

When I first started getting into figuring out this style, I was really looking a lot at mid-century designers and illustrators. That was my pool of influence, rather than looking at what was currently cutting edge. Eventually, that actually became the hip trend. A year or two later, everyone started to do it. That was probably the only point I was ahead of my time. I wasn't trying to be, I just really liked the style. One of my first influences in graphic design was this designer named Reid Miles, who was the art director of Blue Note records in the 1950s, 1960s, and 1970s. He was one of the pioneers of type and image working together. Guys like Herb Lubalin, Milton Glaser, Saul Bass, and Paul Rand are up on my pantheon of great designers too. So, I started bringing that taste into my motion design.

For years and years, I always harped on trying to build your own library of assets. I would get messy at home creating marks and brush strokes and stuff. I would turn those into Photoshop brushes and pass those around. They didn't hold a candle to Kyle Webster. We all are spoiled now with *Kyle's Brushes*. But at the time, that is what I did, whatever I could find. I was very resourceful. I would find textures and create brushes out of them to paint with. Always pulling image references. If I needed to draw a horse, I would pull 12 different images of a horse at different angles. I was trained by life drawing and drawing from models.

Figure 3.19: *Century Link.* Style frames created by Brian Gossett.

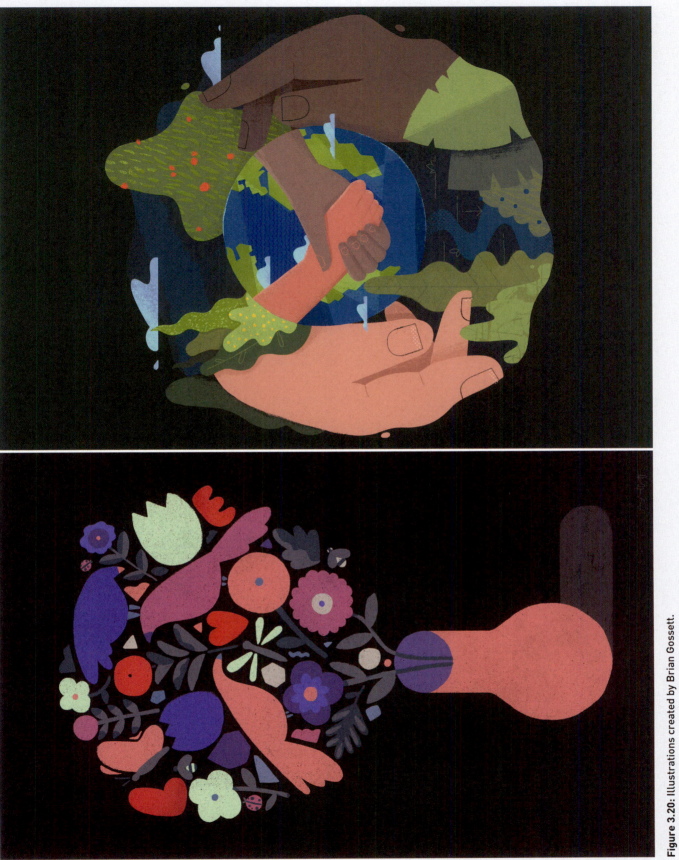

Figure 3.20: Illustrations created by Brian Gossett.

But if you are in a studio, you can't be like "can we get a horse, so I can draw it"? You have to be resourceful, get your proportions down, then break those rules. Growing up, I would always try to draw based on reality. Then at a certain point in college when I got really into abstraction. That was another turning point for me—no longer trying to make things look real, but now abstracting. Reducing how much information you need to give in an image, and that was always exciting for me.

Do you have suggestions for young designers?
I don't think there is any set path or magic formula to becoming successful. I think it involves a lot of hard work, a lot of ambition,

and a lot of raw talent. I look at the internet, and I am floored by how many talented people are out there. So, I think a little bit of luck comes in too. You can't really build a business model out of luck. But, you have to want it. You have to be flexible, know when things are trending and which way to steer your career. Sometimes you steer away from where everyone is going. I have done that stylistically, where I was kind of zigging when everyone else was zagging. I think you need to do what you love. If you are working on a project and you find yourself saying, "this is exactly what I want to do," make a point of doing that! Show the best of what you like to do. Find something you're really good at and target that thing, be the best at it

Mood Boards

"A lot of times we take for granted that when we are inspired by something, that it will stay in a part of our minds that we can always go back to. Take things that inspire you seriously. When something moves you, screen-grab it, write about it. Build collections of inspiration. Being able to quickly write down ideas is so important. Otherwise you won't remember it, even when you think you will."[13] —Alan Williams, *Designer/Director*

What Are Mood Boards?

Mood boards inspire and inform concepts. They contain images that influence the visual aesthetic and art direction of a project. Additionally, they can inspire narratives, emotions, and ideas. Creating them is a process of gathering and organizing images into combinations that create a specific mood or feeling.

Mood boards are used across a wide range of creative disciplines. From a creative perspective, using mood boards eliminates the need to "reinvent the wheel" every time you sit down to create a design style. Rather, finding and grouping images that resonate with your concept can help you kick-start the design phase of a project. As the concept of a project solidifies, you need to define what it will look like. Mood boards help to establish the visual style and feel of a project. We can find inspiration by tapping into the collective stream of creativity and gathering images that harmonize with our concepts.

Although mood boards are very useful, it is vital for a designer to maintain a personal vision for a concept. Designers are a part of a visual tradition that spans back to the beginning of image-making. You can honor the creative efforts and contributions of others by building on the traditions of what they have created. Remember, though, there is a difference between paying homage and stealing. Ask yourself, "Am I adding to what was done before, as well as expressing my personal vision? Or, am I copying the creative work of another?" Do not rip-off other artists and designers by directly imitating their styles.

Efficiency

Design-driven production is fast-paced and demanding. In the world of commercial art, speed is valuable. Mood boards help designers arrive at creative solutions quickly and efficiently. Designers are often expected to rapidly develop concepts and design creative solutions. You may be asked to produce a design presentation in as little as a day. Mood boards can help you arrive at your design goals in an efficient time frame. By finding images that resonate with your concept and allowing them to inspire aesthetic choices, such as color, material, and typography, you will give yourself a running start as you jump into the design phase.

How to Make a Mood Board

A simple way to begin is to search for visuals that inspire you. When looking at images, seek to be moved in some way by the images you choose. Select the ones that make you think or feel. If an image makes you say "wow" to yourself, then it is a good find. While gathering images and making a mood board, try not to be overly concerned with how your project is going to turn out. The project still has the potential to be anything. Do not let your inner critic drive your search for inspiration. Looking for images and making a mood board should be fun. If you are not enjoying yourself or feeling inspired, then you are probably too worried about the project's outcome.

We are lucky to have so many inspirational resources available to us. There are numerous websites and media platforms that showcase interesting visual work. Stunning visual work can easily be saved into collections or delivered to your feed each day. In addition to digital inspiration, consider starting a collection of

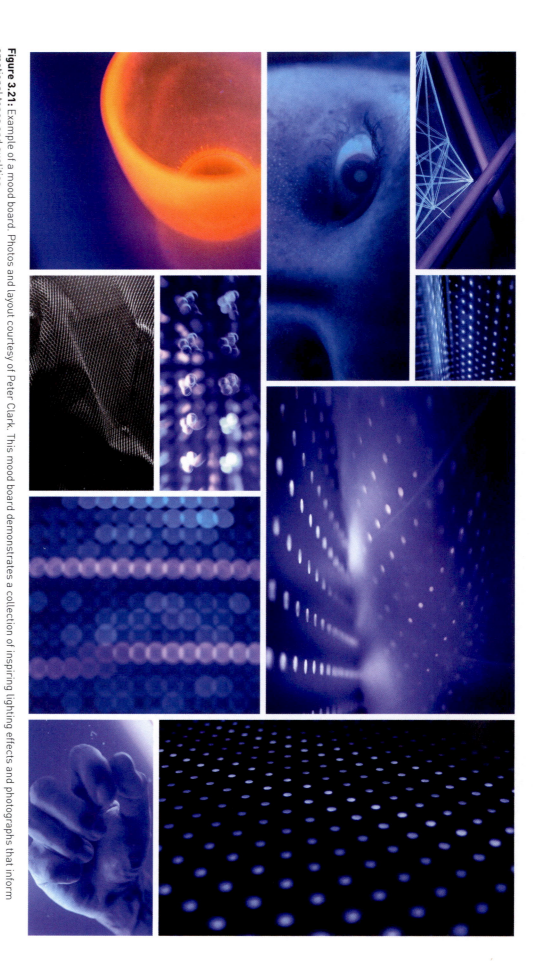

art and design books. Make regular use of a library if you can, and keep your eyes open. The world is filled with beautiful images.

As you find images that move you and resonate with your concept, save them. Once you have gathered what you need, curate your inspiration. Select images that relate to your concept and inform the direction of your visual aesthetic. It can be helpful to

group images in categories based on similar visual qualities like color, style, or material. For example, you can have a page of your mood board filled solely with typographic reference. Or, you can arrange your images in juxtaposition to create visual and narrative tension.

Figure 3.21: Example of a mood board. Photos and layout courtesy of Peter Clark. This mood board demonstrates a collection of inspiring lighting effects and photographs that inform emotional tones and qualities.

Figure 3.22: Example of a mood board. Photos and layout courtesy of Peter Clark. This mood board is a collection of inspirational textures, landscapes, and typography that inform a Western and weathered sensibility.

Before desktop publishing and the digital revolution, mood boards were made by hand. Art directors and designers would tear images from magazines or books to gather source for their mood boards. Although the tactility of physical mood boards can be very intimate and personal, it can be very time consuming to make them by hand. Today, we are fortunate to have efficient digital tools and software at our disposal to create mood boards.

Software like Adobe Photoshop and Adobe InDesign are great for digital image handling and layout. The idea is to place images in such a way that you can see them easily. These layouts can be very structured like a grid of images or more random with pictures overlapping like a collage. The choice is yours, as long as the layout makes sense to you and works for presentation purposes.

Author's Reflection

I did my first internship with the creative team at RCA Records in New York City in 2001. I was in Graduate School at Pratt Institute and excited to get my feet wet in the world of commercial art. One day, my art director asked me to help her gather some visual inspiration. She gave me creative direction about an album cover she was working on and wanted me to go down to the New York Public Library to search through the magazines and books. My task was to make color copies of anything I thought was inspiring in relation to the concept. I was given a $20 bill to cover the costs of making color copies.

I took the elevator from the 32nd floor down to Times Square below, then walked across town to the library to begin my search. After digging through magazines and books, I brought a stack over to the counter to make color copies. I gave them to an attendant who operated the color copier, and I paid for the copies. I walked back to RCA Records, took the elevator back up to the 32nd floor and delivered my 10 color copies of visual inspiration. Each color copy cost $2, and the entire expedition took a few hours.

I tell this story to my students to illustrate how far we have come since the early 2000s. The internet has completely revolutionized our ability to create mood boards. What took a few hours for me to gather a minimal amount of visual inspiration can now be accomplished in minutes. There are multitudes of design blogs dedicated to organizing and displaying visual inspiration. Some blogs have keyword associations, so a selected image will generate additional images based on tag descriptions.

Other sites exist solely for the purpose of creating and containing mood boards.

It has never been easier to be inspired by external sources and gather images to create mood boards. One of my favorite phone apps is designed to search for inspiration and gather images. If I have a few minutes waiting for a doctor's appointment, or just killing time, I will often do a search for visual inspiration. Additionally, access to digital cameras allows us to capture inspiration constantly. Most designers carry a decent digital camera within their pockets as a built-in feature of their phones. We have the ability to collect and record visually interesting pictures within seconds at our fingertips.

Of course, the flip side of this accessibility is the danger of oversaturation. A designer needs to be able to discern between images that are beautifully timeless and images that are part of a trend. Trends rise and fall as popular culture changes. Designers should also be wary of losing their individual voice and aesthetic by relying on stylistic fads as their only source of inspiration. This concern is why it is important to maintain a healthy balance between your inner and outer eye when looking for visual reference and developing concepts. Be sure the images you are choosing for your mood boards align with the concept you are developing. Do not let a cool or pretty style become the driving force of your concept. Rather, beautiful design styles should support and enhance smart, effective, and meaningful concepts.

Professional Perspectives
Alan Williams

Alan Williams lived most of his childhood in a treehouse in the hills of North Carolina. He is confident that this, along with his lifelong interaction with pop-up books, camcorders, and sketchpads, has led to an obsession with the imaginative. While pursuing his Bachelor's in English, he began delving into the fantastical world of Computer Arts, which led to him to earning an MFA in Motion Media Design at the Savannah College of Art and Design. Alan Williams designs and art directs for Imaginary Forces, NYC and is eagerly searching for better ways to build you a story.[14]

An Interview with Alan Williams

What is your art and design background?

From my earliest memories, I loved the idea of telling stories and being able to move a person. In my undergraduate studies, I majored in English and Philosophy. That evolved into wanting to be a visual storyteller. I went to grad school at the Savannah College of Art and Design. I had never taken an art or design class. I felt like I was drowning day one. I was placed in the middle of students whose undergrad was in Design or came from a Fine Art background. It was a bit overwhelming at first. But, it made all the difference in the world by sticking it out. The faculty and my classmates were supportive and encouraging. I found the most talented people in the room and watched them and learned from them.

Have your undergraduate studies in English and Philosophy influenced you as a designer?

English and Philosophy are equally as important to me in the work I do today as techniques, designs, and concepts. Clients come to us with a problem. They don't know how to communicate to the viewer. Understanding the way people respond to certain things, the structure of a good story, the idea of conflict and resolution, and surprise—all of these things were rooted in me. Anyone who has taken the time to read the masters of Literature, to have a pool of reference of all these amazing literary greats, and to understand what drove their writing, and what inspired them, you can pull from those references and find beautiful ways to retell stories.

How do you approach concept development?

My ideas do not come from nothing. They are always coming from a past experience, reference, an author, or an artist. I make a really strong effort to observe everything around me. People-gazing in the city, at coffee shops, and riding on the subway often leads me to inspiration. Taking the time to step away from the computer screen. I take breaks and walk around and observe. That is where the majority of my ideas come from.

Where else do you find inspiration?

I am a huge fan of Pinterest. For me, it is an online smart hard drive. It makes my procrastination smart. I develop well-organized

Figure 3.23: *Anne with an "E"* main title. Created by Imaginary Forces for CBC/Netflix. Creative Director: Alan Williams.

Figure 3.24: *South Park* intro. Created by Imaginary Forces for South Park/Central Productions. Art Director: Alan Williams.

Figure 3.25: *Vinyl* main title. Created by Imaginary Forces for HBO. Creative Directors: Alan Williams and Michelle Dougherty.

folders. As I explore the web, I come across images that belong in those folders. You can begin to collect and create themes and systems that you can go back to. I approach the internet in a determined way to observe and collect.

Why are you drawn towards storytelling?

I love being able to evoke a response in a person. When I was a kid, my grandmother would take me walking through acres of mountain landscapes in North Carolina. She had a story for everything. It was like *Aesop's Fables*. Her stories made everything come alive. I learned from a young age that was how I could best communicate with people, through storytelling. The calling of a storyteller is to look at something that is so moving and repackage it, so the rest of the world can be moved in the same way.

Do you have suggestions for young designers?

Don't give up. When I first started at SCAD, I felt like everyone around me was a thousand times more talented than I was. I notice a lot of students who fall down, or fail, and they just stop. You can't stop. You got to just keep going. Think about what you

want to do in a way that is not restricted by your current skill-set. Be optimistic about the potential of what you can do.

Notes

1 Hartstone, Lauren, telephone interview with author, May 10, 2014.
2 Fong, Karin, telephone interview with author, August 5, 2014.
3 Cameron, Julia. *The Artists Way*. USA: Penguin Group, 1992.
4 "MoMA Learning." MoMA. Accessed June 16, 2019. https://www.moma.org/learn/moma_learning/themes/surrealism/.
5 Gladman, James, personal interview with author, July 14, 2014.
6 Baudenbacher, Beat, telephone interview with author, August 12, 2014.
7 Fong, Karin. "Copy for Book." Message to the author. September 16, 2014. E-mail.
8 Fong, Karin, telephone interview with author, August 5, 2014.
9 Glaser, Milton. *Drawing Is Thinking*. New York: Overlook Duckworth, 2008.
10 Barrett, Ed, telephone interview with author, July 6, 2018.
11 Smithson, Matt, telephone interview with author, August 7, 2014.
12 "About." Brian Michael Gossett. Accessed February 5, 2019. www.brianmichaelgossett.com/about-2/.
13 Williams, Alan, telephone interview with author, July 22, 2014.
14 "Alan Williams." Behance.com. September 20, 2014. https://www.behance.net/alanwilliams/.

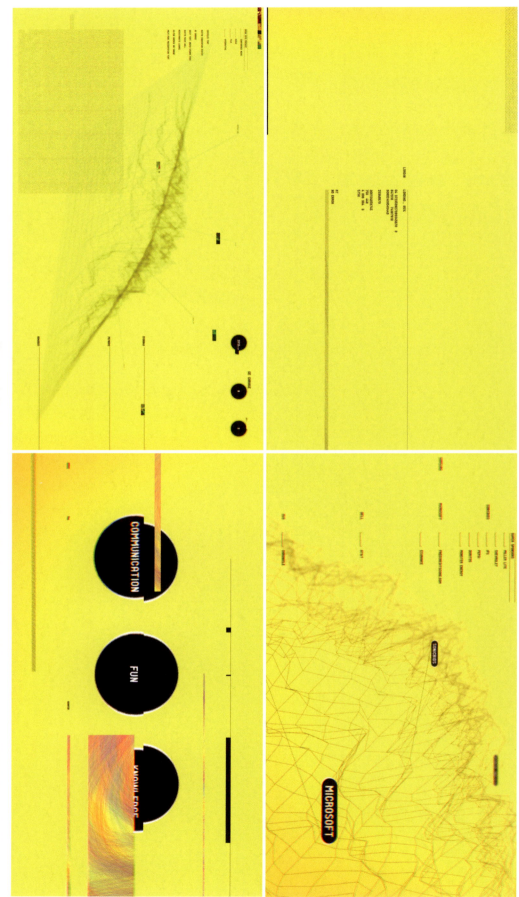

Figure 4.1: Style frames by Daniel Chang, Freelance Designer. Style frames created at SCAD, Design for Motion class.

Chapter 4: Image-Making & Visual Storytelling

Composition

When we make a style frame, our goal is to effectively depict an idea or concept. In order to achieve this goal, a style frame needs a strong *composition*. Composition is the arrangement of visual elements in a space. A strong composition will attract the eye of the viewer and help to communicate a style frame's intended message. A designer of motion needs to refine their ability to consistently create strong style frames. In order to do that, we must first develop our sense of what makes an image compelling.

Hierarchy of Visual Importance

Within each style frame, a designer establishes a *hierarchy of visual importance*. Effective control of visual focal points is accomplished by the intentional arrangement of elements in a composition. Space, color, value, scale, depth, shape, line, and texture all contribute to image composition. How these visual elements are composed affects how they relate to each other. The designer is responsible for directing the eye of the viewer. If you change a single element in a frame, all of the elements change by varying degrees. The more dramatic the change, the more the composition as a whole is affected.

Positive Space & Negative Space

The relationship between *positive space* and *negative space* is at the essence of composition. When an image contains too many elements, it can feel busy and appear to flatten out. When all of the visual elements in a frame are shouting for attention, the viewer will not know where to look. Negative space gives the eye room to breathe. Therefore, negative space plays as large of a role as positive space. In other words, what you leave out of an image may be just as important as what you put in. The viewer's eye needs negative space in order to be purposefully directed towards the focal point of an image.

Symmetry & Asymmetry

Symmetry is an arrangement of positive and negative space in such a way as to create maximum balance and certainty. Design-oriented compositions are often symmetrical, making them easy to read with little doubt about the intended message. Think about advertisements such as posters, print ads, and end tags for commercials. In general, logos and title treatments are centered in the composition, allowing plenty of breathing room in the form of negative space. Symmetrical compositions are effective at capturing attention quickly and delivering maximum clarity.

"I use a few simple tricks. Put something symmetrical in the middle of the frame. Add more negative space than usual. Approach laying out frames in the most pretentious graphic design centric way that you can and get something that has a sense of presence to it. I love doing that and I am surprised people don't do it more often. You get a lot of stuff in the world that is kind of midsize and not very interesting or off-center. Rule of 3rds framing works in a dialogue scene, but you don't do that in a title sequence. In a title sequence, you can be far more graphic design driven, and just putting stuff in the center of frame and giving it space to breathe is the easy way to do it."[1] —Patrick Clair, Designer/Director

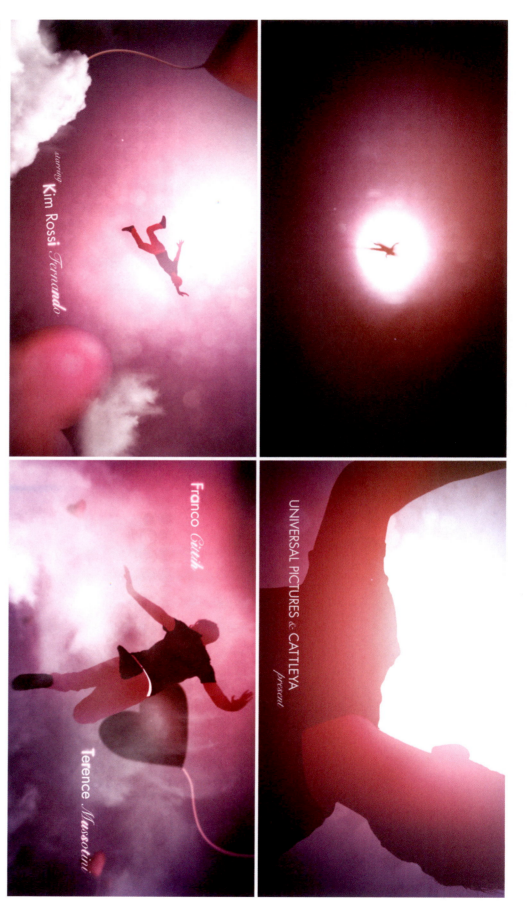

Figure 4.2: Style frames by Jordan Taylor, Freelance Designer. Style frames created at SCAD, Design for Motion class.

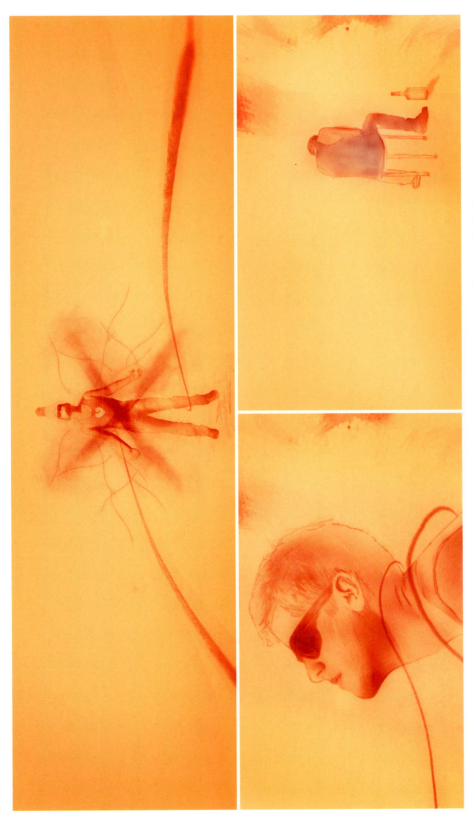

Figure 4.3: Style frames by Joe Ball, Associate Creative Director at Manvsmachine. Style frames created at SCAD, Design for Motion class.

Asymmetrical compositions are considered to be more in the tradition of fine art, where the arrangement of visual elements is off-centered or unexpected. Contrary to symmetry and certainty, an asymmetrical composition is most effective to create a sense of mystery in an image. Mystery creates openness to interpretation. Knowing when to employ a symmetrical or asymmetrical composition is key for a motion designer. Of course, with a time-based media like motion design, we can have both types of compositions in a single piece.

Methods & Formulas

When building a composition, there is a struggle between the understanding of visual principles and artistic intuition. Methods such as the *golden section* and the *rule of thirds* can be helpful. These tools use classical proportioning systems to construct visual relationships based on geometry.[2] These mathematical ratios also occur in nature.

Figure 4.4: Examples of proportioning systems. The left image represents the golden section. The image on the right represents the rule of thirds.

The golden section is a proportion (as one involving a line divided into two segments or the length and width of a rectangle and their sum) in which the ratio of the whole to the larger part is the same as the ratio of the larger part to the smaller.[3]

The *rule of thirds* is a simple method that helps create aesthetically pleasing compositions. It "aims to position the composition's main areas of interest along lines that separate the image into three equal rows and columns—most preferably at or near the intersection of the lines."[4]

Although these are powerful tools, be careful not to be too reliant on any formula for image-making. An image can fall into the trap of becoming contrived or even static when overly balanced. Rather than using such tools to construct compositions, try using them more as guides. The struggle required to make beautiful compositions is a vital part of the process. The effort of arranging and rearranging visual elements, until they look and feel right, adds dynamic tension to a composition.

Sea Glass

Strive to build beautiful compositions and persevere through failed attempts. There is a journey in the process of creating an image. Facing obstacles and challenges are a part of that journey. The turmoil of building a space, moving elements, undoing, and starting over will make you a better designer.

Sea glass is a great metaphor for art and design. It begins as rough, jagged, and broken glass that is discarded into the ocean. The glass is tumbled and scraped against the bottom of the shoreline by the ocean waves. The sharp edges of the glass are repeatedly battered against the rocks and sand. This process happens over and over again. Gradually, the glass begins to smooth. The hard rocks and gritty sand of the ocean floor polish the glass as it is regularly dragged across them. Over time, the rough and jagged sea glass becomes something quite beautiful.

Becoming an artist or designer is a lot like sea glass. You need to be engaged in the process and willing to endure the pain of being metaphorically tumbled against rocks and dragged through the sand. Grit and dedication are required to embrace this process and will reward you with the ability to make beautiful images.

Professional Perspectives
Kylie Matulick

Kylie Matulick is a creative director and co-founder of Psyop. In addition to designing and directing award winning projects, in 2007, she was nominated in *Creativity* magazine as being in the top 50 creative people in the USA. Psyop helps brands and agencies connect with consumers and solve business and marketing problems by telling compelling stories and building engaging worlds, using whatever techniques and media are appropriate. Skilled in animation, design, illustration, 3D, 2D, and live-action production—and seamlessly combining some or all of these—Psyop takes a unique, tailored approach to each and every project.[5]

An Interview with Kylie Matulick
What is your art and design background?

I studied graphic design in Australia. It was a very traditional and highly regarded design school. At that time, there were no motion design programs. Even computers were barely being used. We were doing a lot of stuff by hand, typography by hand. It was all about composition, cutting and pasting, a lot of craftsmanship. It definitely helped create a great foundation for thinking, concepting, using my hands, being really sensitive to color and composition, playing around with different mediums, experimenting. Sometimes you need to step away from the computer and get your hands dirty. I find that process helps me think more expansively about an idea. I got into packaging design.

I love the smaller details. Packaging design was interesting because it is something you interact with physically. It needs to communicate, but it also needs to set people up for an experience.

I moved to the US and stumbled into an opportunity where I was designing for motion. I had a design folio with no motion examples in it, but it showed a strong aesthetic and a clear opinion. So I really learned on the job. The process of storytelling was so intriguing. Combining my visual sensibility with a layer of story and narrative was a creative mind opener. I also started at a very interesting time where people were just beginning to use technology in creative ways. Having a design background helped me to think in motion more expansively. I wouldn't describe myself as a highly technical person, but that is where collaboration became very important. I started working with teams of people whose technical prowess blew my mind. It became an invigorating collaboration between my design/storytelling sensibility and others technical artistry which yielded great results.

We started Psyop in 2000, and luckily there was a real appreciation for it. We were pushing the design, creative, and conceptual elements through our technical team and had a lot of fun experimenting. We pushed the technology in ways that hadn't been pushed before. We were more interested in thinking for the problem and not locking into a particular style. We tried to approach each project uniquely. That is the basis of our work at Psyop. We don't have a house style. There may be some areas

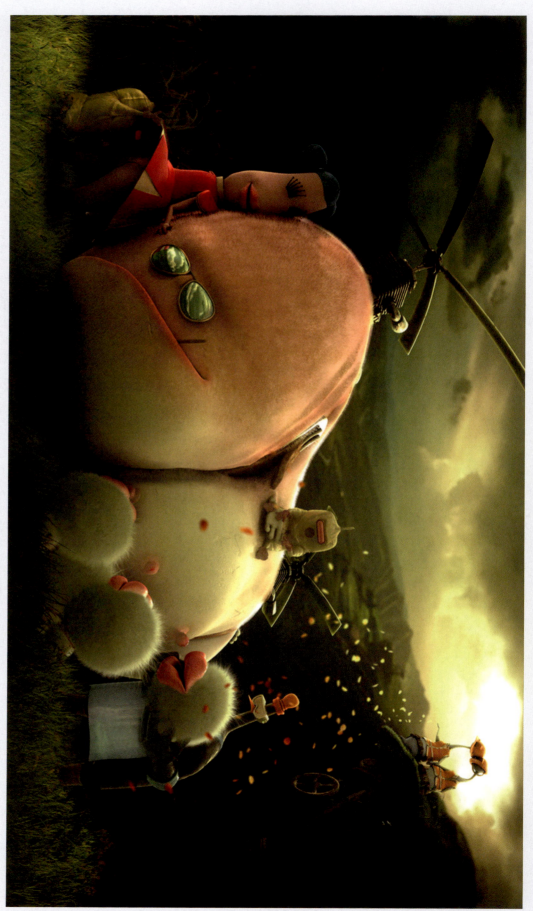

Figure 4.5: *Coke "Happiness Factory" commercial. Created by Psyop for The Coca Cola Company. Directors: Kylie Matulick and Todd Mueller.*

we explore more deeply, but we always try to push ourselves into uncomfortable territory. As a designer, you need to do that. Every problem has a different solution so you almost have to start fresh every time. You start with a fresh perspective and think forward.

How do you approach design?

An important aspect to getting a good end result is making sure you're representing your vision clearly. We have always created very elaborate style frames—whether we pitch on a job, or take on a project—that clearly represent what we are looking to

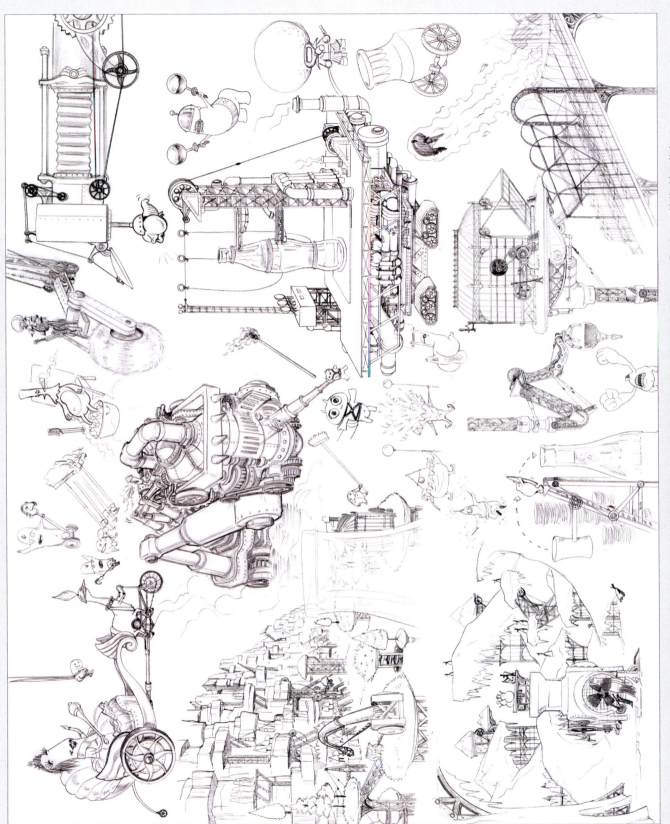

Figure 4.6: Process drawings for *Coke "Happiness Factory"* commercial. Created by Psyop for The Coca Cola Company. Designer: Kylie Matulick.

produce. The 3D artists know what the goal is and they try to solve for that. We like to explore different mediums like charcoal, oil paint, vector graphics, paper cut, hyper-real photography, and our technical team can then take those frames and figure out how to best capture that look.

It is an important skill to be able to visualize what is in your head. It is a time when you can experiment. You're not locked into anything. You're not hindered by any technical obstacles. You put it on a page, and it can be anything you want it to be. Once you've gone through your creative process, you may need to make some adjustments. Your idea might not be possible to produce in the time you have, or it's not going to be possible for the money, or it might be technically difficult to achieve. It's a reductive process, but the initial creative step is to get your vision out there and represent your ideas as accurately as possible.

How do you approach concept development?

Sometimes, we will sit down and brainstorm. We work a lot in teams. That brain trust is really good, to be able to bounce ideas off of someone. There is a constant dialogue, which is generally healthy and exciting. Sometimes it is a really quiet meditation. Sometimes it is quite yet and you need to get a feel for it. You go into a state of flow, where you are listening to your instincts. You don't see anything specifically, but you start to lock into something that feels right. A combination of colors, or a palette of textures, or a sense of motion, or the kind of story you want to tell, or a moment in a story that feels impactful. You build around that. It's always different, the place from where your inspiration comes. Everyone is inspired by something different. My process is quite emotional; I am always trying to find the special ingredient that will draw people in, that will move people, and make them think or laugh. It could draw them in because the scene is visually arresting or make them cry because the story resonates emotionally. That's what this is about—engaging

people. Making them feel something, or think differently, or lighten someone's day for a moment. The idea needs to come from that place. I think it's harder to start with "I've got this really cool visual" and then inject it with some emotional meaning after the fact.

Where do you find inspiration?

I find challenge inspiring. Solving the problem, winning the job, producing something spectacular and unexpected, jumping in the deep end outside your comfort zone. Sometimes, I like to find inspiration in the smaller moments. Hanging out with the kids, looking for four-leaf clovers, drinking a morning coffee. All of these moments might take you to a special place. You want to stay open. It's not always easy. I think it's also important to have a creative expression outside of work.

Do you have suggestions for young designers?

This is a very competitive marketplace. There are lots of designers and lots of people who have a vision. As a junior designer, you will be working under a creative director, or you will be guided at some point by a peer or by a mentor, or you will collaborate with someone. But, you always have to be able to hear your own voice and trust it. That way you will be able to infuse other people's ideas clearly with yours. It won't get too muddied. You will know when you are right and when you are wrong, because sometimes you are wrong. You need to be flexible enough to adjust your vision so the idea is communicating. If you are not communicating what you need to communicate, then you have failed. Sometimes you just need to stand firm and find convincing ways to sell your approach because you believe it's the right path. These are things you get a feel for with experience.

Secondly, if you want to succeed in whichever field you choose, you have to work your ass off. Natural talent can only take

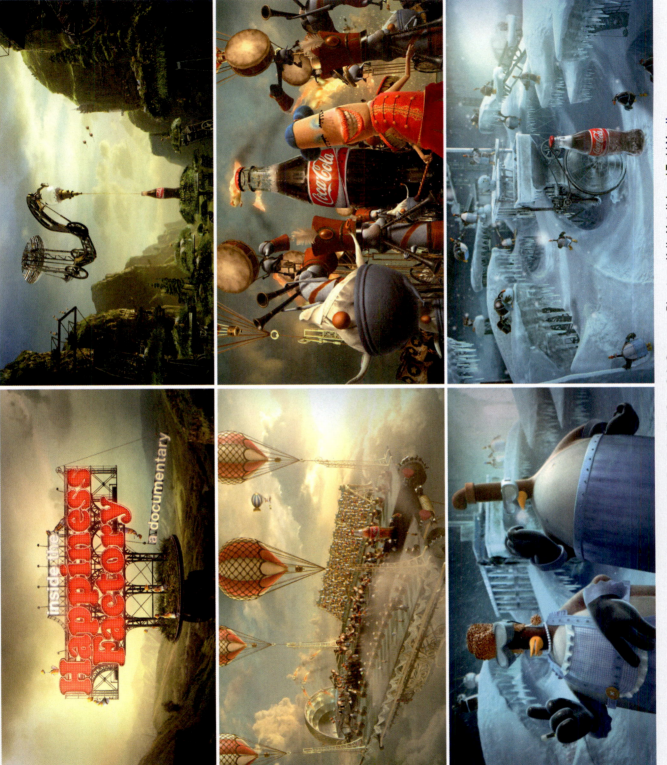

Figure 4.7: *Coke "Happiness Factory"* commercial. Created by Psyop for The Coca Cola Company. Directors: Kylie Matulick and Todd Mueller.

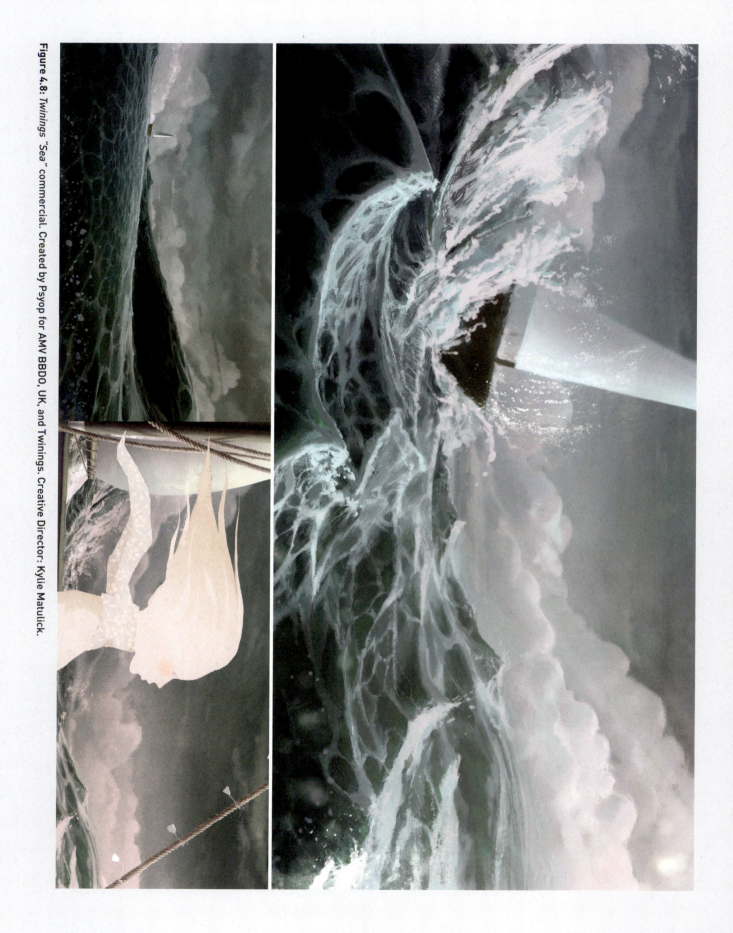

Figure 4.8: *Twinings "Sea" commercial.* Created by Psyop for AMV BBDO, UK, and Twinings. Creative Director: Kylie Matulick.

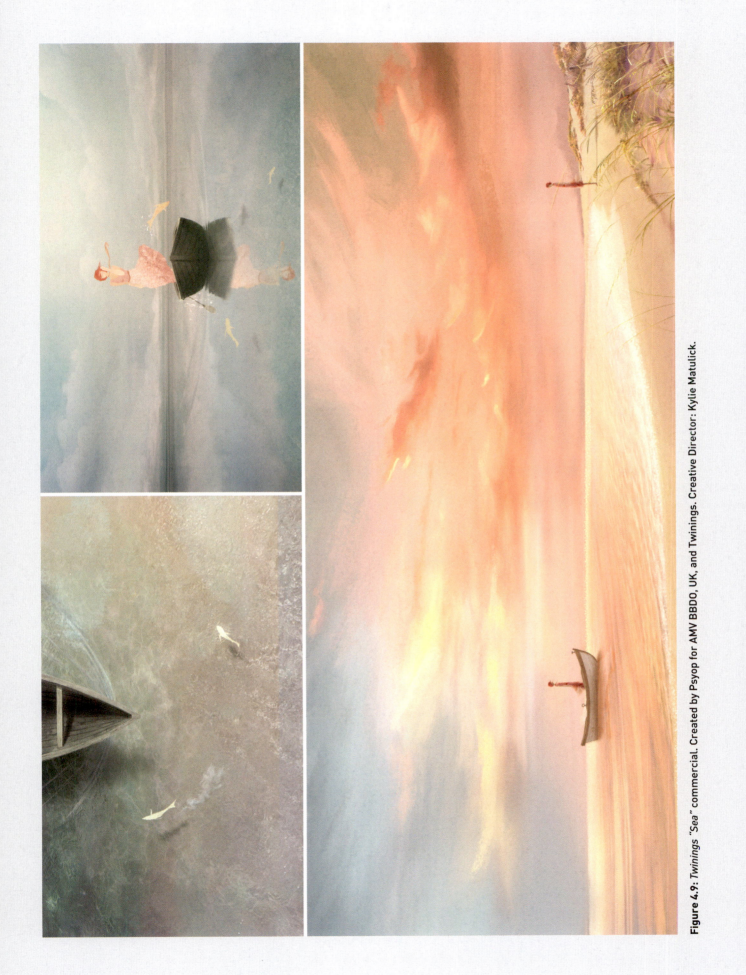

Figure 4.9: *Twinings* "Sea" commercial. Created by Psyop for AMV BBDO, UK, and Twinings. Creative Director: Kylie Matulick.

you so far. You have to go after it! Keep yourself busy, continually perfect your craft. I've seen average designers grow to become truly exceptional through a strong work ethic. Never the other way round.

Lastly, I think it's really important to be curious and to always be asking, "what if?" It is wonderful to meet people who always have a sense of curiosity. If you can always be asking *what if*, you are always open to possibilities. At a certain point, you need to lock in on something, and see it through. But asking yourself questions opens you up to other things in life that will affect your creative perspective. That is an important aspect of growing as a creative person.[6]

Value

The Range of Intensity from Light to Dark

In addition to positive and negative space and symmetry and asymmetry, a designer needs to understand *value*. In the visual arts, value is defined as the range of intensity from light to dark of tones or colors. The ability to render value allows an artist or designer to create the illusion of three dimensions on a two-dimensional surface. In other words, the proper use of value is required to create depth within a composition. Images without an interesting juxtaposition of light

and dark values lack contrast and appear flat. Many students and designers are taught value in life drawing classes or from traditional media, but they have a difficult time translating the principle into digital image-making. When I first began teaching design for motion, I found that students who were not comfortable with value had a difficult time with style frames. Learning to see the range of value in images is the first step to being able to visually render lighting and critical to success in design for motion.

Figure 4.10: *Offf Cincinnati 2014 Titles.* Style frame by Peter Clark. Director: Gmunk.

Why Value Matters

The proper use of value will create depth in a composition. The darkest darks and lightest lights in an image appear to come forward in space. By using this principle, a designer can effectively establish planes of depth by simply creating gradations in the intensity of dark and light. Value can also be exaggerated to direct the eye to a focal point in a composition. The most intense lights and darks will always attract the viewer's eye. A designer can bring visual elements forward or push them back in space by adjusting intensities of value.

Value & Color

All colors have value, meaning a range of intensity between light and dark, but they also have varying degrees of hue and saturation. In order to render an image in color that has depth and a directed focal point, a designer needs to understand how to translate not only value, but also the correct hue and saturation. This skill is especially important in photo-real images where elements are coming from sources with different lighting setups. Composite images can very quickly fall apart if color and value are not handled properly. Alternatively, a designer can create a clear visual flow by selectively manipulating value and color saturation.

Mastering Value

At first, it is a good idea to begin discovering value by working in black and white. Learn to see and recognize the range of intensity from light to dark. Practice rendering everyday objects on a two-dimensional plane or surface. The goal is to give depth, form, and dimension to your images. You will need to identify and apply the correct gradations of gray to achieve this dimensionality. Once you are comfortable with black and white, see if you can translate your understanding of value to color. A good exercise is to identify the range of value in a black and white photograph. Then examine

a color version of the same photo, again identifying the range of value (see Figure 4.11).

Value is key to creating photo-real composites. A designer needs to be able to match values when bringing elements from different sources together to create an image that feels believable. A poor assessment and execution of value are very unforgiving. This skill is indispensable in the disciplines of retouching and compositing, both of which are extremely important to designers of motion. However, once designers are comfortable with value, they can use it to abstract and stylize with skill and confidence.

Value & Line

Value can be translated and expressed through line weight. Illustrative design styles often utilize line as a primary visual element to create images. Variation between thick and thin lines has a similar effect to gradations of light and dark. Thicker, bolder lines come forward, whereas thinner, lighter lines recede. A designer can create a lot of movement and even depth solely with line by creating contrast with value. This effect can be achieved using analog or digital tools. For instance, pencils range from light to dark based on the hardness or softness of their lead. You can exaggerate or diminish the degree of light and dark even further by pushing harder or lighter while you draw. In the digital world, a tablet or interactive pen and display allows you the option of using pressure sensitive settings to create a similar effect. For vector artwork, software like Adobe Illustrator gives you the option to vary the width of the stroke on any path or object. The principle remains the same regardless of which tools you use.

Value in Nature

To explore value is to explore the beauty in life. When you look at the sky, do you just see blue? Or, can you become aware of the

Figure 4.11: Value studies in black and white and color, by Austin Shaw.

gradations of color in the sky? If you look, you will see a range of lighter and darker shades of blue. If you look for a while, you will notice how these gradations change over time. Subtle variations in value are qualities inherent in analog visuals. If you want an image to feel organic or tactile, it needs to have a high gradation in value.

Contrast for Image-Making

Contrast is a principle that is utilized in every aspect of motion design, and it can be a powerful tool for image-making. From concept development and design through production and post-production, contrast creates tension. Oppositions have the potential to produce dynamic relationships when composed effectively. For image-making, tension is important because it creates visual interest. The more dramatic the differences are between elements in an image, the greater the contrast. An artist or designer who understands how to work with contrast can direct the eye towards points of interest.

It is difficult to achieve depth or vibrancy without contrast. The absence of differences will make an image appear flat or washed out. Do not be afraid to explore visual extremes in your designs. A common mistake that beginners often make is not having enough diversity in their images. If you have a large shape or form in your composition, try to counterpoint it with smaller shapes. If your space is too full, try removing elements to create more negative space. If there are areas of extreme light in your composition, build contrast by adding areas of extreme dark. If all of your colors are highly saturated, de-saturate elements that are not the point of interest. Contrast can be applied to every visual principle.

One of the advantages of digital media is the speed and efficiency of art and design tools. We can experiment with contrast very easily and quickly within digital image-making programs. We have the ability to push image adjustments to their extremes and, in many instances, preview what the effect will look like. We can

Figure 4.12: Style frame by Vanessa Brown. Freelance Motion Designer. Style frame created at SCAD, Design for Motion class.

also undo, save versions, or work in a variety of non-destructive manners. This ability gives us a lot of freedom to push the limits of contrast in our design explorations. Analog media is much less forgiving if we push extremes too far and decide we want to undo. However, by digitizing analog assets, we can take advantage of digital efficiency.

Color

Color is a fundamental principle of image-making. Color serves as a unifying element that helps define the visual pattern of an image. This element is commonly known as a color palette. A designer must be able to choose and define color palettes to answer the needs of different kinds of creative briefs. Color palettes also help

to establish the creative borders and boundaries of an image style. A color that is too far outside a chosen color palette will feel out of place.

Color can give an image life and vibrancy. A designer can communicate ideas and feelings with their color choices. Colors have distinct personalities and characteristics. You can endow an image with emotional qualities based on the colors you choose. A helpful metaphor for color in image-making is the phenomena of *synesthesia*. Synesthesia is a neurological condition where a person's sensory experiences are cross-wired, meaning they may hear smells or taste colors.[7] Artists and designers can use the idea of synesthesia as a vehicle to coordinate or sync visual elements with meaning.

A general rule about colors is that warm colors will come forward in space and cool colors will fall backward in space. Warm colors include reds, oranges, and yellows, whereas cool colors include blues and greens. Purple is somewhere in between and can be warm or cool, depending on the amount of red or blue. Warmer colors tend to be more exciting and active while cooler colors tend to be calmer. An image becomes really interesting when colors interact in dynamic ways. Color combinations, such as complementary colors, create contrast. This color contrast evokes tension and establishes a visual flow and hierarchy within an image. Additionally, gradations of value and saturation in color will add depth and dimension to your compositions. The artist and educator Josef Albers presented his theories about color in his book *Interaction of Color*,[8] which book explores how color and value appear to change when juxtaposed in different combinations. This idea is important for artists and designers to be made aware, as each color choice you make will affect and change your image as a whole.

In relation to images for branding, color is also extremely important. Color is used to visually define and distinguish a brand or identity. Color choices made by brands are included in style guides that instruct designers how to maintain brand consistency. Repetition of colors reinforces public perception of a brand's identity and personality. On a smaller scale, this idea of branding, or defining with color, can be used to group and separate visual elements in an image. Color is an excellent tool to delineate and organize elements.

The first step in becoming comfortable with color is to look around you. The natural world is rich with color. Time spent observing nature will reveal beautiful colors and combinations.

You can easily document what you find with a camera. Or, you could sketch what you see with any number of tools like colored markers, watercolors, colored pens, colored pencils, etc. Additionally, creating mood boards for color reference has never been easier. You can gather images from various image-collecting platforms such as Pinterest and organize them by inspirational color palettes.

Depth

A designer needs to have an understanding of *depth* in order to successfully create dimensionality in an image. Depth is the sense of space within a frame or viewport. Value is a key ingredient in creating the illusion of depth. The gradation of lights and darks produce a sense of moving forward or backward in space. However, there are other principles designers need to know in order to establish depth in a composition. Awareness of spatial planes, depth of field, and perspective are principles with which designers should familiarize themselves.

Spatial Planes

A very practical approach to creating depth in a composition is to establish foreground, middle ground, and background planes. Without these basic spatial planes, an image will appear very flat. Visual elements arranged in spatial planes create depth, and a

Figure 4.13: An example of photographic depth of field. Photograph by Austin Shaw.

designer can use that depth to create movement in an image. Also, additional spatial planes include extreme foreground and extreme background. These extremes will create an even greater sense of depth in a composition, with objects appearing very close to the viewer or barely perceptible in the distance.

It is very important to consider value when establishing spatial planes. High contrast of light and dark values will cause visual elements to come forward in space. Neutral values will recede towards the background. By combining value and spatial planes, a designer can effectively establish the focal point of an image.

Depth of Field

Depth of field is defined as "the range of distances of the object in front of an image-forming device (as a camera lens) measured along the axis of the device throughout which the image has

acceptable sharpness."[9] Essentially, depth of field determines what spatial plane is in focus. Planes that are in focus will appear sharp and clear, whereas planes that are out of focus will be blurry. The farther a plane is from the focal point of the lens, the blurrier the objects on that plane will look. This effect can be created either with software that establishes depth of field based on the Z-position of layers in a digital space or by manually blurring layers that you wish to be out of the focal length of the composition's "camera lens." Although depth of field builds on the tradition of cinematic conventions, it is analogous to how we actually see. For instance, when you focus on a single object in a room, it appears very clear in your vision. However, objects that are further away from your point of focus lose definition. A designer directs the viewer's eye in a composition based on the same way we see.

Perspective

The types of perspective that are particularly useful to a motion designer include *linear perspective*, *atmospheric perspective*, and *color perspective*. Linear perspective is a fundamental technique for image-making defined as "the technique or process of representing on a plane or curved surface the spatial relation of objects as they might appear to the eye."[10] This approach provides guides for where to position elements so they appear to exist realistically in space. The frame or viewport represents the viewer's eye or a camera lens looking into a scene. Visual elements that are closer to the lens of the viewport will appear larger in scale, and elements that are further away will be smaller. Working with perspective is mandatory if you wish to create images with some measure of realism.

Atmospheric Perspective

Atmospheric perspective emulates the way we naturally see. This form of perspective, also known as aerial perspective, is defined as a "method of creating the illusion of depth, or recession, in

Figure 4.14: Examples of atmospheric and color perspective. Photos by Austin Shaw.

a painting or drawing by modulating color to simulate changes effected by the atmosphere on the colors of things seen at a distance."[11] The earth's atmosphere is filled with dust, haze, water vapor, and scattered light. These particles make objects in the distance appear to lose contrast of value and definition. The further away an object is from a viewer, the more neutral the values will appear. The closer an object is to the lens of the viewport, the higher the contrast of darks and lights. This technique is useful to create more realistic depth and dimension in an image.

Color Perspective

Color perspective works in a similar way to atmospheric perspective. However, with color perspective, the affected visual principles are color and saturation. Again, due to natural particles in the environment affecting how we see, colors appear to lose saturation the farther away they are in space. Also, elements that are extremely far away will take on the color of the sky. Try and observe this sometime as you drive on a highway surrounded by tree-filled mountains. The mountains that are really far away will appear to be blue in color. However, these mountains are covered with the same kinds of green trees that are right outside of your car window. What is happening is the mountains in the distance appear to take on the color of the sky.

Figure 4.15: Examples of atmospheric and color perspective. Photos by Greg Herman.

Professional Perspectives
Greg Herman

Greg Herman is a multi-disciplinary writer for screen, live-action director, and VFX concept designer for film and television. Greg has worked as a creative director, live-action director, and lead concept artist with some of the best design-driven production and visual-effects companies on the globe.[12]

An Interview with Greg Herman
What is your art and design background?

I started doing design out of necessity. I was playing in different bands, and one of the best ways to make money as a musician was to sell t-shirts. When you play gigs, you have a merchandise table, which is like a cool little store. So, I started to design shirts for my band so we could make money while we were on tour. That's what got me into Photoshop. A big part of design for me is about having an opinion, having some level of taste and being able to make decisions. Back in those days, making band t-shirts till this very day ... those simple things apply.

Back then it was not about a lot of output, but more about input. A lot of looking at magazines, and going to Barnes and Nobles and looking at design books, and immersing myself as deeply as I possibly could in anything that I felt connected with what I liked as a designer. I was forming an opinion. I was starting to form what I liked as a designer, and over time as I developed my craft, I developed my stance. Through the years, my opinion of what I like has changed and evolved.

How has your design opinion changed over the years?

My taste has specialized and gotten more specific. What I have noticed is I took more of a liking to cinema and cinematography. That led me to photography, which led me back to design. For me, becoming more specialized was a matter of seeing all the different styles of design, various ways to tackle obstacles, and that led me more to the cinematic nature of things. Using a camera to tell a story. That influenced my design style a lot. Bringing elements of the lens into my design. Things like depth of field, lens flare, atmosphere, spatial depth, color perspective, atmospheric perspective. All these important elements of art and design found their way back to me through the lens. My design started having more of a unique feel. Through the years, I have been developing my eye to get closer to the things I like. Those little polishes and tweaks of the eye are developed over time.

How has matte painting influenced your design process?

I have a martial arts background. I was inspired to bring some of the philosophy of martial arts into my career as a designer. One of the philosophies is the idea of training and hard work. The idea in martial arts is that you practice, train, and refine your skill. I wanted to bring a certain element of that into design. You can't always just go to competitions and compete because you may never get to the next level. The point is that, if you practice for the competition, the practice becomes what you end up fighting

Figure 4.16: *TNT branding.* Created by Loyalkaspar for TNT. Creative Director: Ben Hansford. Design and photography: Greg Herman.

like. I have tried to take that mentality with my work. That's where matte painting came in. It was the training for me. The job was the competition. Matte painting was like my training. I did my matte painting in the background, as a side project, as a passion project. I worked on it after work, at night, or on my breaks. It's that situation where you are throwing yourself into something new,

something potentially uncomfortable, that you have to learn. The more you train and practice, the better you get. I really had a love for this cinematic film look. I gravitated towards these establishing matte painting shots that tell a story in one shot. It has mood, tone, motion, and color. You learn so much with a single image. I did a boatload of matte paintings. A lot were just for fun—throwaways

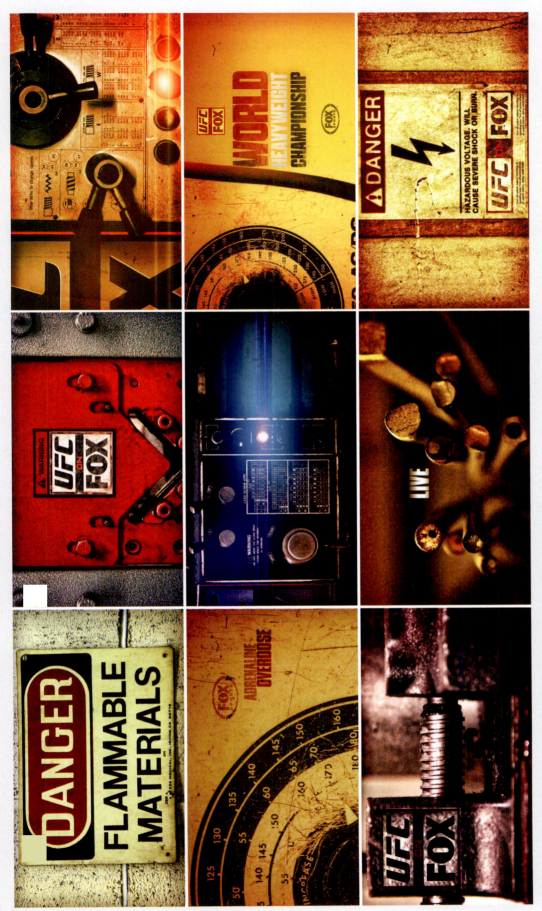

Figure 4.17: *UFC on FOX* design board. Created by Greg Herman for FOX Sports Design.

that were about learning. They were exercises in failing. I looked at it as 100% about exploration and to see where it would go.

How do you approach concept development?

It's better to approach projects with an open heart and an open mind. Don't grip too tightly to any single exploration.

Do you have suggestions for young designers?

Throw yourself in the fire, get the training, and put the time in. The number one thing is to be humble and open to criticism. Be eager to learn and succeed.[13]

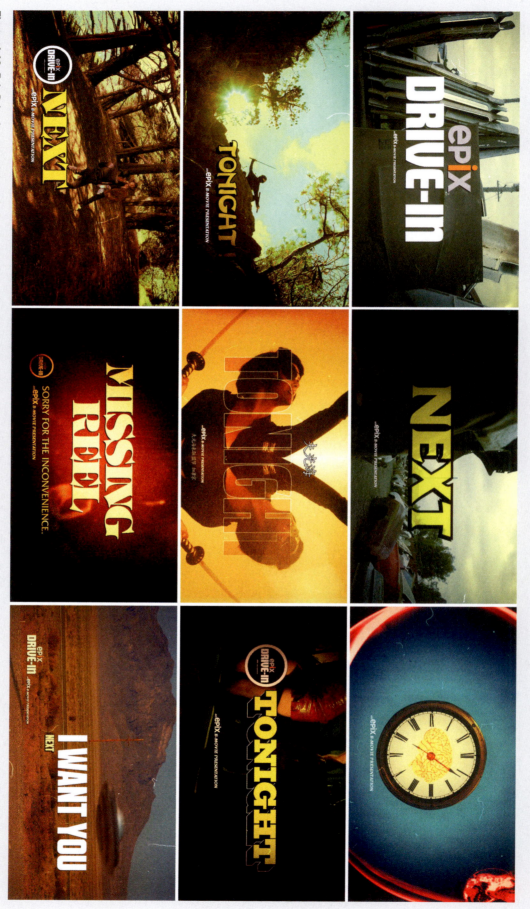

Figure 4.18: Epix Drive-In network launch. Created by Fresh Paint for Epix. Designer/Director: Greg Herman.

Visual Storytelling

Cinematic Conventions

Motion designers need to think like directors. As visual storytellers, we must be familiar with the basic vocabulary of filmmaking and cinematic conventions. A director is responsible for deciding what the viewer will see, thereby influencing how the audience thinks and feels.[14] Different camera angles and distances create varying degrees of visual and emotional intensity. Utilizing a variety of shots can create interesting rhythm for visual storytelling. The camera position can also be used as a transitional device in a motion design piece. Within this section, we will explore the essential vocabulary of cinematic and visual storytelling.

Basic Shots & Camera Angles for Cinematography

Extreme Wide Shot

An *extreme wide shot* will often be used to establish the setting or environment where the story will unfold. They can also be referred to as *establishing shots*. Extreme wide shots can also convey a dramatic sense of scale, perspective, and distance. For motion design, extreme wide shots can be used to dynamically transition and create pleasant surprises that leave an impact on the viewer.

Wide Shot

A *wide shot* reveals the subject matter within the setting. The distance of a wide shot allows the viewer to take in the action of the subject. In motion design, wide shots can describe the visual elements within a scene. Wide shots are also used as transitional elements to advance the plot.

Figure 4.20: Wide shot. Drawing by Evan Goodell.

Medium Shot

A *medium shot* frames the subject at a medium distance. If one is working with actors, a medium shot typically crops the figure

Figure 4.21: Medium shot. Drawing by Evan Goodell.

Figure 4.19: Extreme wide shot. Drawing by Evan Goodell.

from the waist up. With motion design, our subject matter has an extremely wide range of visual possibilities. A medium shot can show medium distance from typography, graphics, or an illustrative element. Medium shots can also serve as a transition from wider to closer distances.

Close-Up Shot

A *close-up shot* is a tight framing of the subject. This distance can create higher emotional intensity. Close-up shots also allow details to be revealed to the viewer. Again, with motion design, our subjects can vary greatly. However, we can treat close-ups for motion design in a similar way that a director would for live-action.

Figure 4.22: Close-up shot. Drawing by Evan Goodell.

Extreme Close-Up

An *extreme close-up shot* brings the viewer even closer to the subject. We can show the audience the most specific or finest details of the subject. This shot is the most intimate and expresses the highest emotional intensity. For motion design, extreme close-ups are often used as transitional devices, showing dramatic changes in scale, setting, or even the subject itself. For instance, an extreme close-up of an eye can transition to become a galaxy.

Low Angle Shot

A *low angle shot* describes a camera position that is below and looking up towards the subject. A low angle shot makes a subject feel larger. In motion design, this camera angle is often used to create a dramatic sense of importance. Low angle shots are often used with logo animations, sports graphics, or any visual element that requires a sense of being monumental.

Figure 4.23: Extreme close-up shot. Drawing by Evan Goodell.

High Angle Shot

A *high angle shot* describes a shot that is framed from above and looking down towards the subject. This type of shot makes

Figure 4.24: Low angle shot. Drawing by Evan Goodell.

are often employed to increase visual interest. From a purely compositional point of view, a Dutch angle creating diagonals in a frame is more dynamic than a straight view showing solely horizontal and vertical planes.

Over the Shoulder

An *over the shoulder* shot places the camera behind a subject, using the head and shoulder to frame a second subject or to reveal a setting. It helps the audience to focus on whatever the first subject is looking at or interacting with. It also draws the viewer into a more intimate circle of action.

Figure 4.27: Over the shoulder shot. Drawing by Evan Goodell.

Two Shot

A *two shot* is a shot that frames two figures or subjects in a composition. In filmmaking, it is used to show how subjects interact with each other. For motion design, a two shot can be employed to show the interaction of visual elements within a frame.

Figure 4.25: High angle shot. Drawing by Evan Goodell.

the subject feel smaller. In traditional filmmaking, this angle makes a character seem powerless or vulnerable. However, for motion design, a high angle shot allows the director to portray perspective and reveal details.

Dutch Angle

A *Dutch angle* is when the camera is rotated to make the horizon appear at an angle, rather than straight. In conventional filmmaking, this angle creates tension and psychological drama. With motion design, Dutch angles also produce tension, but

Figure 4.26: Dutch angle. Drawing by Evan Goodell.

Figure 4.28: Two shot. Drawing by Evan Goodell.

Figure 4.29: Bird's-eye view. Drawing by Evan Goodell.

Bird's-Eye View

A *bird's-eye view* refers to a camera position that views a scene from an aerial perspective or from a very high angle relative to the subject. This view allows the audience to observe a scene from an unexpected angle. It also allows the director to use sweeping camera movements for dramatic effect. In motion design, landscapes can take on a myriad of forms and styles. For instance, a bird's-eye view may be a camera flying over extruded typography or flying over a 3D model of a phone. Scale, proportion, and the definition of landscape are more mutable with motion design than with traditional filmmaking.

Dolly

With physical filmmaking, a *dolly shot* is accomplished by mounting the camera to a track—or stabilizing system—in order to move it smoothly through space. With motion design, we can create similar movement using a virtual camera in 2D or 3D software applications. A dolly camera movement can be used to exaggerate or complement the action of the subject matter. Dollies can move horizontally, vertically, or zoom forwards or backwards through space. A digital workspace offers the potential for camera movements that would be impractical or impossible in a physical space.

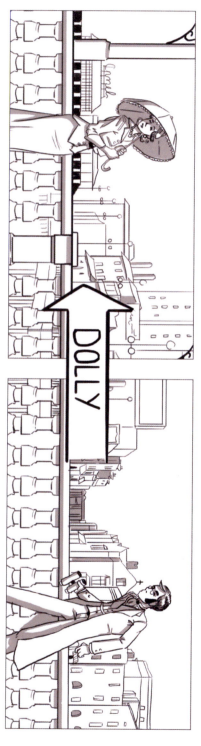

Figure 4.30: Dolly. Drawing by Evan Goodell.

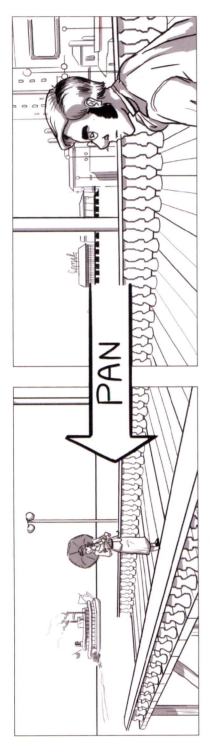

Figure 4.31: Pan. Drawing by Evan Goodell.

Pan

A *pan* is a movement of the camera on its central axis, rotating from side to side. With a pan, the camera position remains stationary, although the orientation of the lens changes. Pans can be used to follow the movement of the subject or to direct the focus of the audience. In motion design, pans reveal depth, volume, and perspective in a scene.

Practicing Cinematic Conventions

Imagine you are viewing your compositions through a cinematic lens. Camera distance can be explored and determined with thumbnail sketches. You can specify if the "shot" of a composition will be either wide, medium, or close. You can also work out the camera angle. For example, an image can be made more dynamic with a low or Dutch angle. Thumbnail sketches allow you to try out different cinematic treatments without having to spend too much time on them. You can then translate your decisions directly into hand-drawn storyboards.

"**When we work on a project where the aesthetic is pretty time consuming, we use the pen and paper approach. We make thumbnails and turn them into** hand-drawn storyboards. We present a style frame or two to assist those. With a time-consuming aesthetic, you sacrifice a good story for all the labor that goes into making all those style frames. With a hand-drawn storyboard, we can focus on storytelling and come up with a better flow and narrative, then do a bang-up job on one or two style frames." —Daniel Oeffinger, *Designer/Director*

Hand-Drawn Storyboards

Hand-drawn storyboards combine image-making with storytelling. Storyboards contain a sequence of frames laid out in an order that visualizes a script or written treatment. From a narrative standpoint, a storyboard illustrates the key moments of a project. Important events in a story, such as how it starts, what happens, and how it ends, should be included. Hand-drawn storyboards are similar to design boards because they establish frame composition, camera placement, and camera movement. However, hand-drawn storyboards do not display the defined visual style of a motion design project. Like thumbnails, storyboards are less polished than a finished style frame or a design board. A term that is often associated with storyboards is

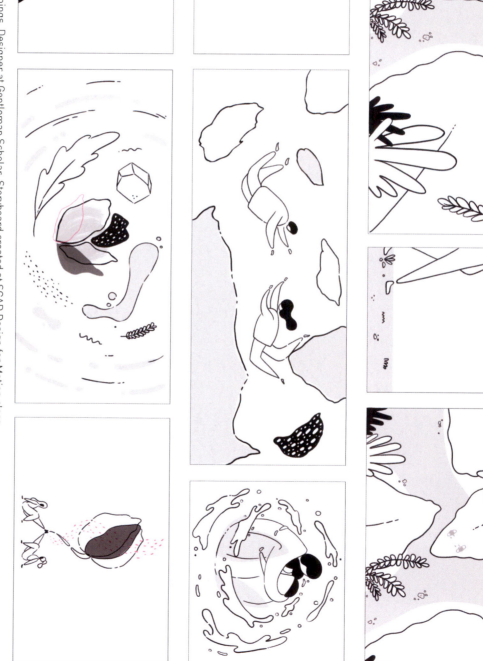

Figure 4.32: Storyboard created by Gretel Cummings, Designer at Gentleman Scholar. Storyboard created at SCAD Design for Motion class.

pre-visualization, as they help to rough out the overall structure, action, and story of a project. They offer an opportunity to explore the cinematic movement and narrative of a project prior to production. Also, for commercial projects, storyboards are often used as part of the pitching process.

Working with Storyboards

Like thumbnails, you can work by hand or digitally to create a storyboard. Either approach is fine as long as you can work comfortably and efficiently. Each frame in a storyboard contains the content for a scene. The content can include frame composition, camera angles, camera movement, transitions,

and direction of talent. Storyboards can be rendered with extreme detail, or they can be comprised of stick figures. The main objective is to clearly communicate the cinematic qualities of each shot. Work with storyboards to your comfort level of drawing. Do not shy away from this tool if you feel your drawing skills are minimal. Legibility of cinematic intention is more important than artistic rendering in a hand-drawn storyboard.

Storytelling & Continuity

The goal is to make the narrative of a project clear with a storyboard. Understanding the language of cinema will help you to envision and plan the direction of visual elements and overall movement in a project. Storyboards can also include notes about camera and scene direction beneath the frames. It is vital that the creative team and the client are on the same page prior to shooting live-action or proceeding into animation. Storyboards,

TITLE: Camera slowly dollys in. Joe sinks under water. His body is limp as if he is asleep, or in a trance.

002: Joe lays unconscious on beach. He has a curious looking rope tied to his wrist. The rope leads off frame.

004: Joe makes his way following the rope up the sand dunes and away from the beach. Increasing tree coverage can be seen ahead.

003: Camera dollys parallel to joe. Joe follows the rope underneath some old pylons holding up a boardwalk.

005: Camera is locked off. As joe walks forward towards the camera he gathers the slack rope in his left hand. The negative space that the rope creates becomes a sort of window. A Tribal like pattern can be seen through the rope.

006: Camera slowly dollys straight back.

Figure 4.33: Storyboard created by Ben Gabelman, Motion Designer at Huge, and Casey Crisenbury. Storyboard created for Student Project at Savannah College of Art and Design.

like design boards, help to guide the creative team and ensure the client is aware of what to expect. For the purpose of learning to design for motion, focus on creating clear compositions and camera movements in your storyboards.

Notes

1 Clair, Patrick, telephone interview with author, July 9, 2018.

2 Elam, Kimberly. *Geometry of Design*. New York: Princeton Architectural Press, 1951.

3 "Golden Section." Merriam-Webster.com. Accessed August 20, 2014. www.merriam-webster.com/dictionary/golden section.

4 "Rule of Thirds." Creativeglossary.com. Accessed August 20, 2014. www.creativeglossary.com/art-mediums/rule-of-thirds.html.

5 "About." Psyop.tv. Accessed August 25, 2014. www.psyop.tv/operations/.

6 Matulick, Kylie, telephone interview with author, July 25, 2014.

7 "Synesthesia." Merriam-Webster.com. Accessed August 21, 2014. www.merriam-webster.com/dictionary/synesthesia.

8 Albers, Josef. *Interaction of Color*. New Haven, CT: Yale University Press, 1975.

9 "Depth of Field." Merriam-Webster.com. Accessed August 21, 2014. www.merriam-webster.com/dictionary/depth of field.

10 "Perspective." Merriam-Webster.com. Accessed August 21, 2014. www.merriam-webster.com/dictionary/perspective.

11 "Aerial Perspective." Encyclopedia Britannica. Accessed August 21, 2014. www.britannica.com/EBchecked/topic/7229/aerial-perspective.

12 "About." Design.morechi.com. Accessed August 25, 2014. http://design.morechi.com/INFO-CONTACT.

13 Herman, Greg, telephone interview with author, July 21, 2014.

14 Van Sijll, Jennifer. *Cinematic Storytelling: The 100 Most Powerful Film Conventions Every Filmmaker Must Know*. Studio City, CA: Michael Wiese Productions, 2005.

Figure 5.1: *Knolling Shoot of designer's tools by Stasia Luo, Austin Shaw, Lexie Redd, Eddy Nieto, Brady Rish, Alonna Morrison, Chase Hochstatter, and Madeline Miller.*

Chapter 5:
Tools, Technology, & Techniques

It is an exciting time to be a designer. The last few decades have transformed the design landscape due to the digital revolution. At every level of experience, designers now have access to high-quality tools and equipment at relatively affordable prices. However, this accessibility has placed even more responsibility on designers to be knowledgeable across a wide range of disciplines. What used to be dedicated professions such as typesetting, retouching, or illustration have become individual skills in the designer's toolkit. The scope of principles and techniques expected in a designer of motion can be daunting. Navigating what to learn, which tools to acquire, and how to adapt to evolving industries can be challenging.

As discussed in the previous chapter, a solid foundation in image-making and storytelling are at the core of design for motion. Furthermore, skills and techniques in the areas of compositing and 3D design serve as gate-keepers to creating a full range of aesthetic styles. Be open, and embrace new tools and methods. But, always remember a designer is a creative problem-solver.

Analog & Digital

A fluency in both analog and digital tools and production methods is ideal. A motion designer should be comfortable moving between the sketchbook and the computer. Analog approaches to ideation and asset creation offer organic and readily accessible options to the creative process.

An important idea to remember is that most of the tools we use on the computer are digital translations of analog practices. The *scissor*, the *brush*, and the *ruler* are but a few of the tools that are directly digitized versions of actual tools. Creative software allows us to utilize these digital means in a rapidly efficient manner. However, we should not abandon analog practices.

Analog methods contain a personal and unique quality that is very difficult to produce digitally. Ultimately, the art of combining analog and digital offers an opportunity to create hybrids of hand-made and computer-generated design. Although many motion design students have some background in fine arts, drawing, painting, etc.—they often forget these practices are available! Students are pleasantly surprised when they are reminded they can utilize skills and materials from their foundation training. Experiment with how far you can mix between analog and digital methods.

Asset Creation

Creating assets and visual elements is at the core of design for motion. The assets we use ultimately define the stylistic constraints and parameters of a project. Graphic design, illustration, 3D design, and photography are different approaches that are employed for the creation of style frames and design

boards. Of course, there are alternative techniques that can be included in your toolkit. Projection mapping, data-moshing, and code-based design are a few examples of processes that can be re-mixed into design possibilities. The more diverse your asset creation, the more options you will have to create compelling style frames.

In professional practice, it is typical to use photographic assets from any source when making style frames for a pitch. With tight deadlines and limited resources to build compositions, we may need to pull photographs from the internet. How else will we composite an aerial shot or a desert landscape if we are working in a studio in New York City? For pitches, this practice is standard. Photos used in style frames for presentations are fair game. However, if a project is awarded, the rights to use those

images in a commercial production must be purchased, or original images must be photographed for usage in the project.

In general, designers should create their own photographic assets whenever possible. We will have much more control of our compositions if we shoot our own images. We can assure that our lighting is consistent if we are compositing different source photos. Shooting our own images may also help to introduce cinematic qualities to our design. Digital cameras are an essential tool to create photographic assets and reference. Scanners are also useful to digitize drawings and illustrations as well as interesting organic textures and found imagery. We can bring images from our sketchbooks directly into the digital workspace to combine them with other assets or use them as references to create digital illustrations.

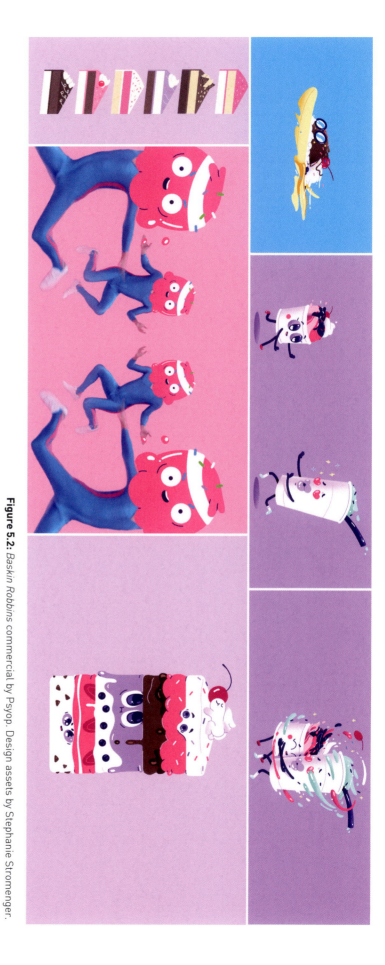

Figure 5.2: *Baskin Robbins commercial by Psyop. Design assets by Stephanie Stromenger.*

Prepping Assets

Often, the assets or layers in a style frame can translate directly into production. Be sure to work non-destructively whenever possible—meaning preserve as much flexibility as possible with your layers and digital assets. Non-destructive workflows are important because they give us the option to undo or revert files and projects. This attribute increases efficiency and can save a studio or designer a lot of time and money. When designing in Photoshop, make it a habit to work with layer masks, adjustment layers, smart objects, and smart filters. In any program we

are designing, naming layers logically will save time when we go into production. Even if we are not animating, we will make the animators happy by labeling layers because it will be easier to find and keep track of assets. If our assets do not translate directly into production, we need to be prepared to remake them.

Digital Library

Building a resource library of digital assets is helpful to your design process. A resource library can contain any combination

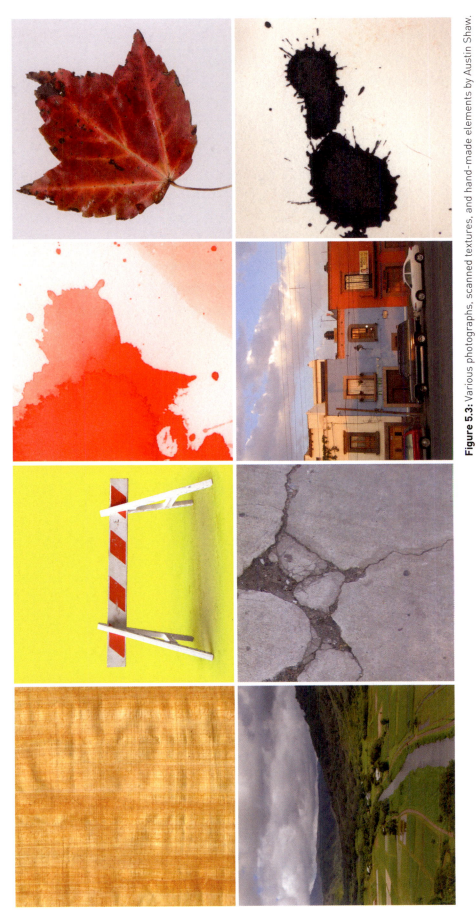

Figure 5.3: Various photographs, scanned textures, and hand-made elements by Austin Shaw.

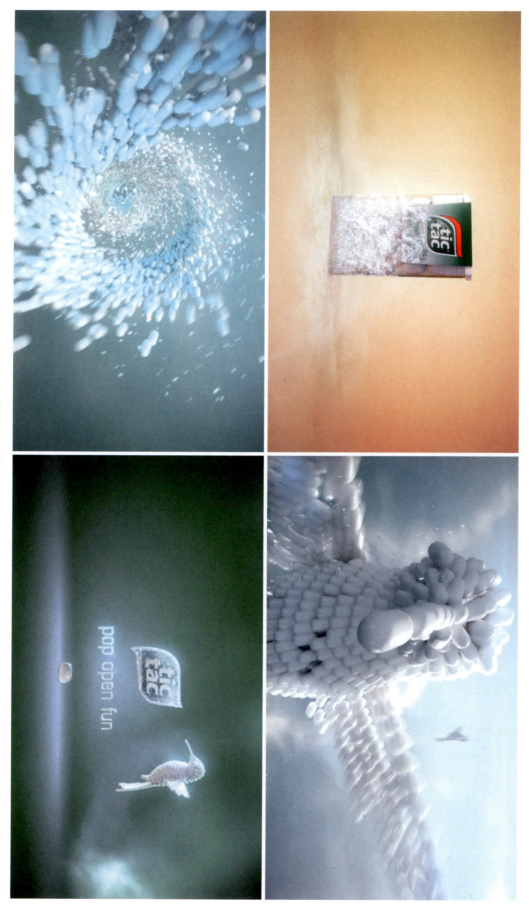

Figure 5.4: *Tic Tac* commercial. Created by Sarofsky for Noise Vancouver. Creative Director: Erin Sarofsky.

of photographs, video elements, digital brushes, textures, vector assets, 3D models, etc. These resources can be re-used and re-mixed in your design. You can organize your assets in any manner you like, but be sure to have some kind of structure. When you travel, capture interesting elements that can be utilized in your design. Nature, people, architecture, and signage are a few examples of the types of subjects that can be added to your resource library. Let your curiosity guide your camera's lens. At every stage of your creative career, whether you are a student, intern, freelancer, or staff, there will be opportunities to expand your library. Share and swap resources with your creative peers. As time passes, your resource library will grow.

Compositing

The Art of Compositing

Compositing is the art of combining two or more distinct elements to create a sense of seamlessness or a feeling of belonging. Compositing is used to select, adjust, blend, or stitch multiple visual elements into a single image. Successful compositing establishes a recognizable visual pattern and is a key skill to create a range of different visual styles. Compositing can be employed in both concrete (photo-real) and abstract manners.

Concrete compositing refers to photo-realistic images, where believability is required. The goal of concrete compositing is to mimic reality in an image. Abstract compositing refers to images that use elements from various sources to create a distinct, but unrealistic style. It is not necessary for an image to look photo-real or believable in an abstract composite; however, abstract composites still need to achieve a sense of harmony. Many of the same techniques are used in both concrete and abstract compositing. However, it takes skill and practice to know how to apply them effectively. Concrete and abstract describe the extreme ranges of composites and many instances will require something in between. Being comfortable producing both concrete and abstract composites allows you to create a diverse range of design styles.

Concrete Compositing

Concrete compositing combines elements from different sources in order to feel real or natural. This side of the compositing spectrum is rooted firmly in the tradition of visual effects and has very strict rules that need to be followed to be effective. Perspective, lighting, value, and color are some of the key principles that are used with concrete compositing. In addition to understanding these visual principles, the designer must know which tools are most effective and how to use them.

Figure 5.5 showcases two different examples of concrete compositing. The designer has used compositing skills and principles to match intensities of value, basic transformations like perspective, and color correction to achieve unity. The image on the left utilizes light direction, cast shadows, and reflective surfaces to create a sense of believability. The image on the right uses perspective, reflections, and depth of field to achieve a sense of compositing within the style frame. Although both images are stylized to some degree, they feel like they adhere to physical laws.

Abstract Compositing

Abstract compositing is bringing elements together in a way that does not appear concrete or photo-realistic. There is a wide range of stylization from slight abstraction to fully abstract. Regardless of how much a design is abstracted, a visual pattern must emerge that holds the image together. An abstract composite must still feel like a representational world in which all elements exist

Figure 5.5: Style frames representing concrete compositing, courtesy of Robert Rugan.

Figure 5.6: *Salt—Everything's Better* commercial. Created by Gentleman Scholar for Grey Advertising. Directors: William Campbell and Will Johnson.

logically, even if the rules of nature are not as strict. In this way, many of the same visual principles that are needed for concrete compositing apply to abstract compositing. Perspective, lighting, value, and color are just as important. Although with abstraction, the designer has liberty to bend the rules.

Figure 5.6 shows two frames from a commercial that can be described as abstract compositing. In this project, all visual elements of the world are constructed from salt. Although the aesthetic style is abstract, compositing skills and principles have created a sense of harmony. Lighting, color, cinematic conventions, like depth of field, and a unified treatment of 3D modeling contribute to the visual pattern of the composite. Additionally, the consistent handling of principles such as positive and negative space, value, and contrast help to define the look and feel of this project.

Core Principles & Skills of Compositing

Compositing is an idea that bridges analog and digital media. In the visual arts, compositing began with photomontage and collage. For motion, compositing has its roots in visual effects and optical printing. Although many analog compositing techniques have been translated into digital toolsets, the underlying principles remain the same. This section introduces essential principles and tools of compositing.

Mattes

Mattes are one of the core concepts and skills of compositing. A matte describes the process of isolating, removing, or extracting specific parts of an image. Historically, this action would be accomplished with a blade or a scissor. Pre-digital designers needed to develop their "hand skills" to aid in their image-making process. Today, these practices still have value but have been replaced mostly by digital methods in commercial art.

In the simplest terms, mattes help us to cut parts of images from their source. For instance, we would employ a matte to remove a figure from a background in order to composite the figure into another image. Mattes are pivotal for compositing, and there are many different tools and methods to make them. Become adept with a range of tools, as varying images will present different challenges. Making a matte for a human figure is far different than making a matte of a sky. A designer must develop the ability to analyze an image and identify which tool or tools will be most effective to make a matte.

Figure 5.7 is an excellent example of compositing that utilizes mattes. The *True Detective* title sequence effectively creates a beautiful and unique aesthetic style reminiscent of double exposure photography. Mattes are used to contain and blend landscapes within figurative elements. Contrast is a key principle in creating these strong visuals. The backgrounds are very sparse and simple, relative to the intensely rich visuals of the double exposure figures. The negative space directs the viewer to the focal point in each frame. Contrast between dark and light values also causes dynamic tension and interest. Variations in opacity and *feathered* edges of mattes add to the visual composite by creating oppositions between simultaneous feelings of depth and flatness.

Feathering

Feathering is a way to control how sharp or blurry the edge of a matte will be. Edges that are either too sharp or too blurry will stand out and look unbelievable. For successful compositing, a designer must learn to analyze and define the degree of softness edges possess in an image. This skill is related to learning to see value and how light affects objects. Feathering also applies to the edges of digital brushes. Adjusting your brush edges to be either hard or soft-edged will give you greater flexibility in your compositing skills.

Figure 5.7: *True Detective* title sequence. Created by Elastic for HBO. Creative Director: Patrick Clair.

Figure 5.8: An example of the power of duplication. This piece of papyrus has been scanned, and duplicate versions have been color treated.

Duplication

One of the most astounding aspects of digital tools is the rapid ease of duplicating files, images, or parts of images. With analog materials and assets, there is only one of a kind. Of course, there may be many different kinds of a material or asset, but each one is unique. For example, you can never have two exact analog copies of papyrus paper. However, once that piece of papyrus is digitized you can duplicate it over and over again. You can adjust the digital image in a multitude of ways.

Duplication is part of a non-destructive workflow and can allow you to take chances you may not be so eager to take with analog materials or methods. Non-destructive describes a process that allows you to undo and preserve layer assets. By making duplicate files and layers, you should feel emboldened to experiment during your compositing and design process.

Basic Transformations

Basic transformations include scale, rotation, position, and adjustments to perspective. Digital tools allow for basic transformations with relative ease, but they can appear heavy-handed when applied without an understanding of compositing. A basic grasp of perspective will help make correct changes to scale and rotation in an image. Distortions can be used to create the effect of an element being foreshortened or to create a dynamic diagonal. Again, like most compositing principles, the key is to have a broad understanding of their varied uses and to know which tool to employ in each situation.

Retouching

There are many powerful digital retouching tools. But, they are easy to overuse. When these tools are not handled well, it is very evident. Too much exact repetition disrupts the pattern of believability in a composite. Images can very quickly begin to look fake or obviously digitally manipulated. However, when used with skill, retouching can enhance composites. The goal is to introduce just enough randomness while retouching in order to create a more organic and believable look and feel. Retouching is very useful for removing unwanted parts of an image, cleaning up blemishes, or blending the edges of different elements in a composite.

Color Correction & Color Grading

Color correction is the art of adjusting the colors of an image to achieve a consistent look and feel. In terms of compositing, color correction can help to unify an image into a cohesive pattern. Color grading creates a stylized tone by enhancing color choices. Again, the goal of compositing is to create a sense of uniformity, and color can be a powerful tool to do so. Motion designers must be able to analyze the existing color space of the assets they are working with as well as define the color pattern of an image. Assets need to be adjusted to match the intended color pattern. These primary art and design principles include hue, saturation, and value.

Hue, Saturation, & Value

Digital tools allow you to make adjustments to hue, saturation, and value very quickly. Changes to these visual elements can help images to feel like they belong in the same space. Often, the needed adjustments may be very subtle. However, precision is required for compositing in order to achieve a degree of believability. This requirement is especially true with concrete photo-realistic images. You may need to boost the saturation of an element very slightly for it to feel like it belongs with the rest of the image. Or, you may need to swing the hue of an element to match the color space in which you are placing it. The ability to adjust and selectively manipulate value is also crucial to successful compositing.

Figure 5.9 demonstrates the principles of color correction and color grading. Color is used as a unifying element in each

Figure 5.9: *Matador* title sequence. Created by Sarofsky for Robert Rodriquez and El Rey Network. Creative Director: Erin Sarofsky.

frame. Although the background and type colors change, the palette is essentially limited to red, yellow, black, and some gradations of gray. The intensity of color saturation is consistent in every frame. Additionally, this style utilizes texture to create a weathered appearance. The combination of highly saturated colors against a distressed and gritty texture contributes to the color style of this project.

Blending

Blending allows you to create unity and integration within your composites. Blending helps to visually merge images to achieve a sense of belonging. Building on the traditions of photography and cinematography, digital blending is essentially a translation of analog methods and techniques. Qualities like luminance, color, and value can be mixed between distinct visual elements to produce unexpected effects and aesthetics.

In Figure 5.10, the titles for *The Pacific* showcase the principles of blending and compositing. Textured paper is blended with filmed imagery to create a unique visual style. The organic qualities of the paper are preserved and mixed with the photographic imagery. Additional compositing choices, like a limited color palette with accents of intense red and a high contrast treatment of imagery, create a visceral response in the viewer.

Figure 5.10: *The Pacific* main title. Created by Imaginary Forces for HBO. Art Directors: Peter Frankfurt, Steve Fuller, and Ahmet Ahmet. Designer: Lauren Hartstone.

Figure 5.11: Various style frames by Lilit Hayrapetyan.

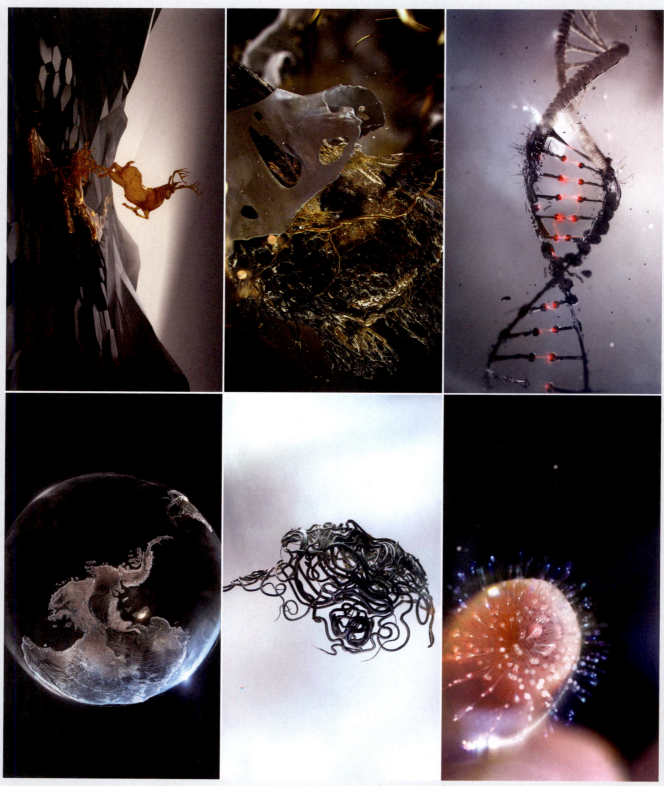

Professional Perspectives
Lilit Hayrapetyan

Lilit Hayrapetyan is an art director, designer, and 3D artist based in the Los Angeles area. Born and raised in Armenia, Lilit was influenced by an array of art media in her youth. From academic drawing to contemporary art and sculpting, her early exposure to visual expression later inspired her to study design at the Yerevan State Academy of Fine Arts in Armenia. Towards the end of her studies, Lilit started her professional career at the leading motion design studio in Armenia, Triada Studio. Here, she gained the opportunity to build extensive knowledge of 3D. After 10 years, she moved to Los Angeles to work at leading Motion Graphics studios. Lilit's understanding of contemporary visual culture empowers her workflow in different Platforms, starting from creative ideas to final production. Her immense passion for design combined with the excellence in technical skills serves to bring her innovative ideas to life. [1]

An Interview with Lilit Hayrapetyan
What is your art and design background?

I was born in Armenia, where people's appreciation for the arts is a core part of the cultural identity. I started attending children's painting and drawing classes when I was 3 years old where we were exposed to various forms of media. My schedule was intense, with three classes a week for few hours a day involving drawing, with heavy emphasis on working with clay. So, I have loved art from a very young age! I was lucky that my mom saw this

in me and really pushed me to take these art classes to turn my childhood passion into a viable career option.

When it was time to choose my career path I didn't have too many school options to choose from as there was only one accredited school of fine arts, the Yerevan State Academy of Fine Art.

Mind you that these were the times when there was no computer design or 3D classes offered. General design was the field closest to my interests, which I ended up taking and graduating from. The program entailed exploration of basically everything from interior design to product design. Here I earned a master's degree in design and painting. Lack of sophisticated computers and programs forced us to create everything manually. Even though it was extremely difficult, it developed my taste and armed me with skills I use today.

When I was in my second year of school, I was recommended by one of my teachers to speak to his son, who started the animation company Triada Studio. Soon after I was offered a position there to assist them with everything I could, where I learned everything about 3D Max 1.1. It was a full-time work with school but also very rewarding. So, after school I would go to this company where they showed me how to use 3D Max. This is where I completely fell in love with 3D. It was just magical, because even when the software was very limited, I totally believed that you could make anything you want in 3D.

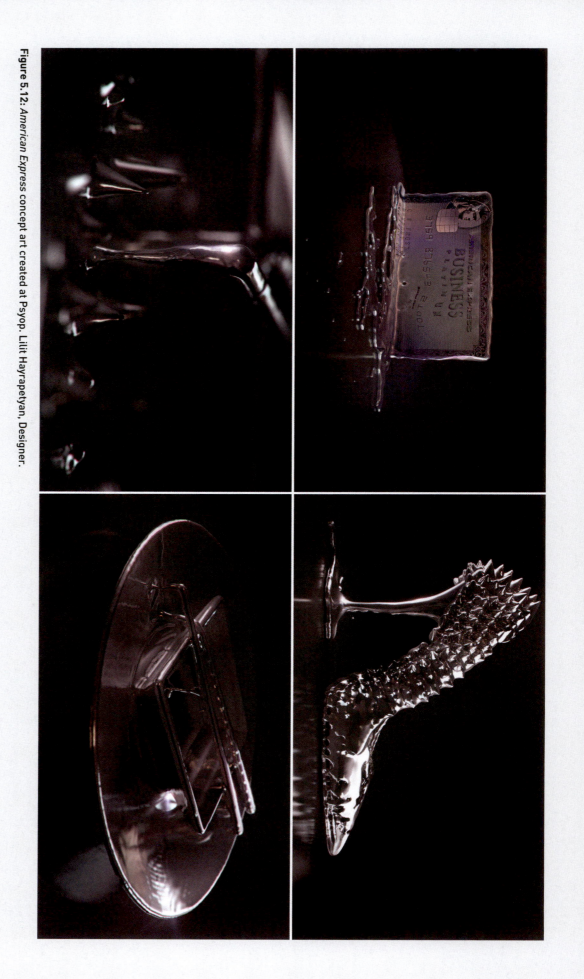

Figure 5.12: *American Express concept art created at Psyop. Lilit Hayrapetyan, Designer.*

It took me about 6 months to go through the basics and learn the ins and outs of it, before I could work on television commercials and promos. This was a really great experience because I had to learn to do everything from the creative side to final animation production. Whenever there was a need to learn a new software and willingness to learn new software gave me the tools to create mostly everything from modeling, lighting, and rendering.

How has your professional career evolved?

After working 10–12 years at Triada Studio, I felt like I needed something more. My search for new creative challenges drove to create exactly what I wanted, I was in. Having a positive outlook

me to send my portfolio to companies where I was interested in working. In 2008, Prologue had a 2-month trial offer, which I gladly accepted and moved to Los Angeles. I loved the projects they were doing and enjoyed working with many talented professionals such as Danny Yount, Kyle Cooper. That 2-month period was extended, and I ended up working there for about a year and a half.

Right at the end of that year and a half period working at Prologue, my coworker moved to Psyop and recommended me for an interview there. Shortly after the move, I was scheduled for one to explore the options available to me. Given the wide range of skills I had, I was asked to express the area of interest I would want to be in. Pointing out that I was interested in creative side of the projects was my first instinct. After talking to me, studying my work and personality, they accepted me as their art director and designer. This is when I made the move to Psyop. I loved the company and all the people there. I worked there 4 years doing design and direction for commercials, promos, and different types of motion graphics and 3D. Here, I further exercised my creative freedom and learned how to lead a team of extremely talented artists.

It was a surprise when I received an email from Riot Games about creating cinematics with my participation. After a short trip to their corporate office in Los Angeles, I was super-impressed by the campus and everything about the company. I never expected to see something like this. Here I learned a bit more about the project and was shown a 6-minute storyboard to make a short film about one of the League of Legends champions. I loved the story of this short film and the idea around it. I was excited to hear about their interest in having me to help build a team to bring this short film to life. This was an opportunity I couldn't pass on and gladly accepted the offer.

The project was named ANNIE:Origins. We wanted to make something completely different, not just a CG piece. It's more

like a painterly animation. There are always a lot of challenges when making something experimental, but I felt at home since I enjoy doing something new. We did a lot of R&D to figure out the projection in 3D and filtering systems in Photoshop. For example, how to make 3D look like 2D or to add final brushstrokes to feel like a realistic painting. It was a really interesting experience to work on this project creatively and logistically.

Why do style frames matter?

When I create designs for a project I have to make something from nothing, this is where I have most fun in process. A huge part of brainstorming is inspiration. I want to be fueled by references I research until I feel like I am entirely immersed in my creative world. Those references are photographs, paintings, and sculpture. In photography, I study lighting, for example, where in sculpture I seek out forms and depth. This step always follows by my desire to create something I have not done before. Pinterest is a great resource especially when they suggest stylistically similar artworks. I think it is helpful to have art background because it helps one understand shapes and see what is beautiful.

In my field, software skills are crucial, but being able to see and appreciate art and have creative drive is an essential. I feel like that is very important.

Do you have suggestions for young designers?

Never limit yourself in learning and trying something new. Even if you think you are going to be an After Effects animator, be curious to explore if you can do cel or 3D animation. It is always great and welcoming to have more skills than are necessary for the position or the project. Be hungry to learn because we are in a field that is always changing.[2]

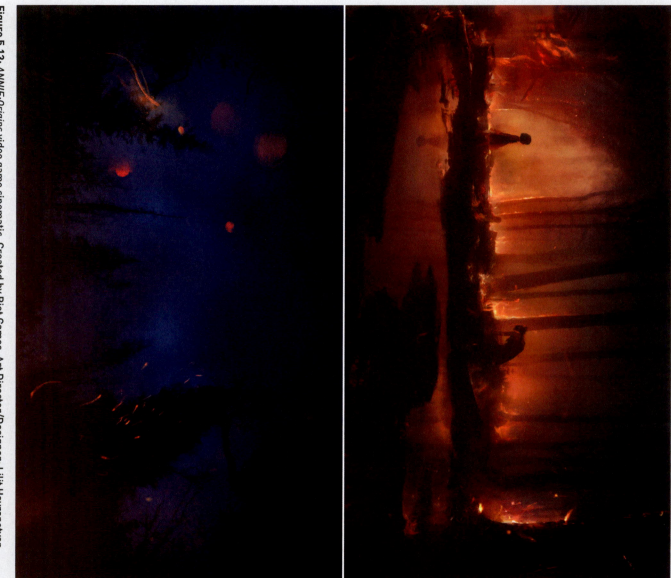

Figure 5.13: *ANNIE:Origins* video game cinematic. Created by Riot Games. Art Director/Designer: Lilit Hayrapetyan.

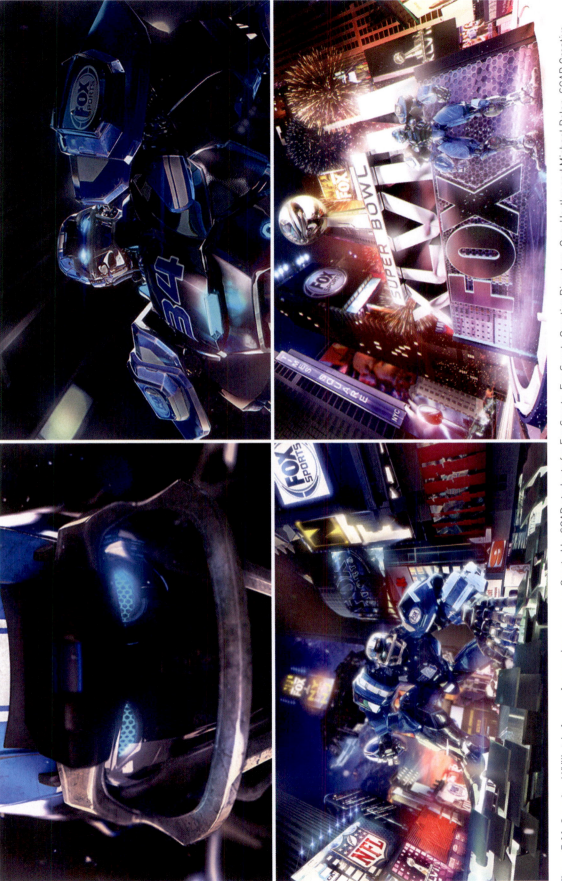

Figure 5.14: *Superbowl XVIII* style frames for opening sequence. Created by SCAD students for Fox Sports. Fox Sports Creative Directors: Gary Hartley and Michael Dolan. SCAD Creative Director: Sekani Solomon. Designers: Keliang Shan, Rick Kuan, Rainy Fu, and Chase Hochstatter.

Using 3D Software for Design

3D software is an extremely powerful tool, which enables designers to create objects and scenes that appear to have three-dimensional form. Mastery of 3D empowers designers to make almost anything they want. Although learning 3D software may be difficult at first, becoming competent with this tool will give you greater freedom and flexibility in your design process. Additionally, 3D software has become more user-friendly as complex programming has been bundled into intuitive user-interface design. What used to require advanced knowledge of scripting to create basic 3D geometry like a sphere can now be accomplished by simply clicking an icon in a menu.

It is important to note that there are entire professions and disciplines dedicated to working with 3D—specialists who use specific tools and software. In animation and visual effects production pipelines, it is typical for 3D artists to specialize as modelers, lighting and texture artists, 3D animators, or riggers. However, from a motion design perspective, it is common to embrace 3D as generalists. Try not to worry about learning every single aspect of software. The capabilities of professional 3D programs are often quite robust. It can be overwhelming trying to understand every menu, sub-menu, panel, field, or option. Focus on learning the basics and expand your knowledge as needed. After you become comfortable navigating the interface of 3D software, the essential skills a designer of motion needs to know are modeling, materials, lighting, cameras, and rendering.

Modeling

3D software allows us to bring sculptural sensibilities into design. We can create the illusion of depth and volume in a digital space. Most 3D software allows you to create simple parametric shapes with the click of a button. Working with simple objects like cubes, spheres, and cylinders is a great way to begin to learn

modeling. These shapes can be easily modified by adjusting parameters accessed through the software's user-interface. Scale, position, rotation, and segments (object complexity) are a few of the attributes that are readily accessible. You can create simple objects by combining shapes and refine your models with *deformers* to *distort*, *bend*, or *twist* objects.

Paths or splines, similar to those used in programs like Adobe Illustrator can be utilized in 3D modeling as well. You can combine Bezier paths with generative objects to create extrusions, sweeps, or lofted models. Importing paths from Illustrator into a 3D software for modeling can be a helpful bridge between working in 2D and 3D. The exact same paths comprised of points and lines you create in Illustrator can be used in 3D. However, in 3D you can create depth and virtually spin around your objects in three dimensions. Also, typographic layouts you create in Illustrator can be imported into 3D, then extruded to give a sense of form and presence. Type treatments or vector logos are often a good entry point into working with modeling as you can quickly see a 2D graphic transform in a 3D object.

More complex modeling requires learning how to work with polygonal objects where you can adjust points, edges, and faces of 3D geometry. Although this process has a steeper learning curve, it allows greater control and flexibility in modeling. Polygonal modeling affords the ability to introduce organic variety to forms. Individual aspects of a model can be selected and adjusted, rather than changes that affect a model globally. For instance, you can make a part of a shape thicker or thinner, independent of the whole form. Box modeling is a technique that starts with a simple cube divided into segments. Specific faces are selected and extruded to form parts of a model. This process can be repeated to refine the shape of a 3D model. Additionally, robust sculpting software such as *Zbrush* offers further capabilities to produce fine details and tactility in 3D models.

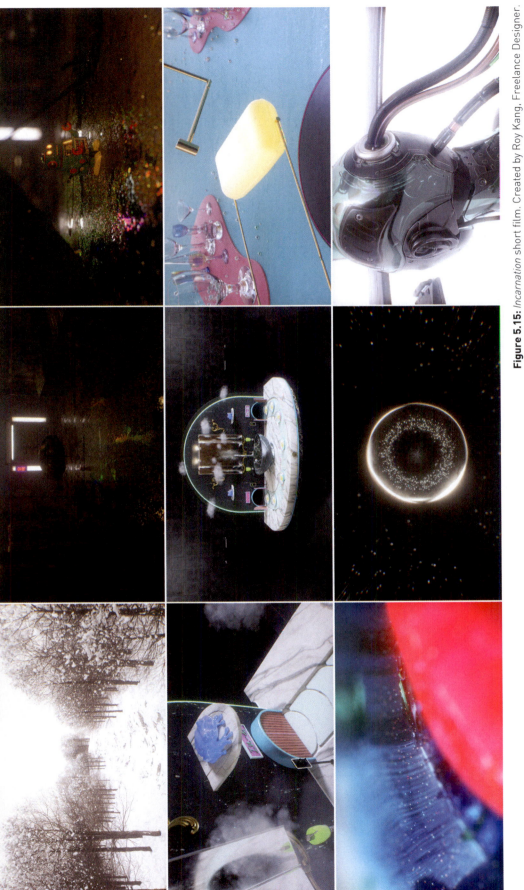

Figure 5.15: *Incarnation* short film. Created by Roy Kang, Freelance Designer.

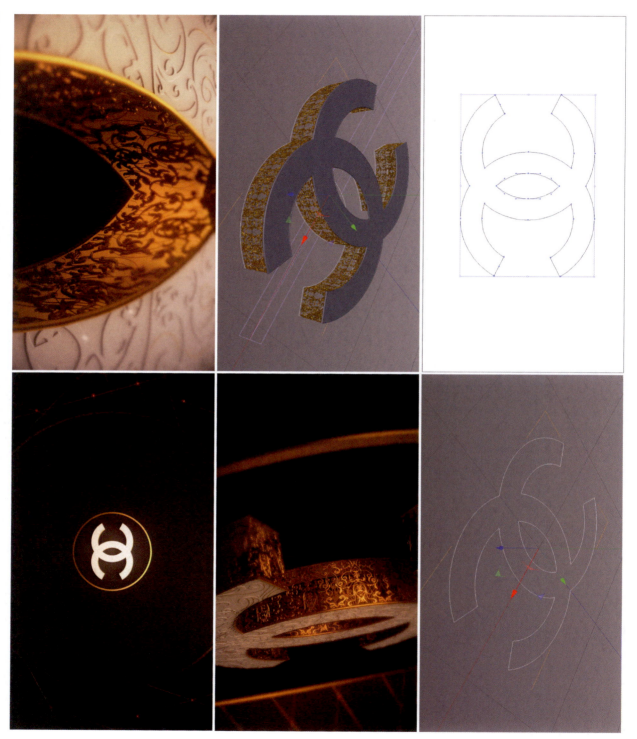

Figure 5.16: This layout shows an example of spline-based modeling. The Chanel logo is imported as Bezier paths from Adobe Illustrator into Cinema 4D. The paths are used repeatedly to create extrusions and other spline-based geometry. Lighting, textures, and cinematic camera work create a dramatic sense of space for this logo animation by Michele Wong, Designer at Create Advertising Group. Logo animation created at SCAD, Motion Branding class.

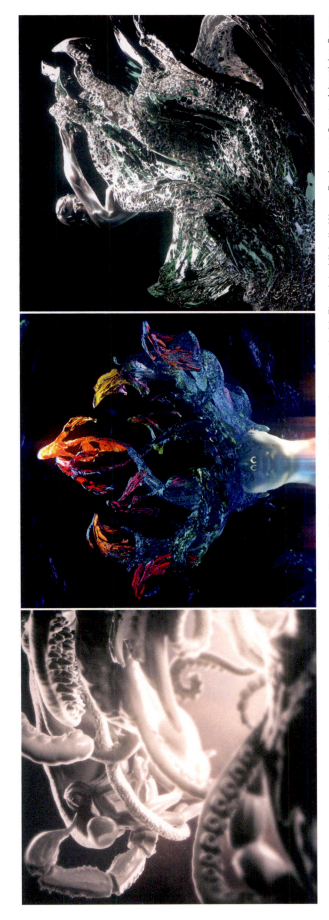

Figure 5.17: Examples of 3D illustrations created with Zbrush by Michelle Wong, Designer at Create Advertising Group.

Materials

Materials wrap around the surface of 3D models. They contribute to the illusion of texture as well as influencing how light interacts within a scene. You can create materials that range from photo-realistic to highly stylized. Materials can be adjusted to control a range of qualities including color, transparency, and reflection. Luminance (black and white) information can be utilized in materials to effect alpha channel, surface texture, and surface displacement. Luminance maps are included within software or you can import your own from high-contrast photographs, etc. Materials are extremely customizable and offer a wide range of different looks and feels.

It is important to learn how materials are projected onto objects in 3D. This determines the way a material appears on the surface of a model. There are various options for material projection and mapping, and different models will require different choices. A common default projection in 3D software is *UVW mapping*. However, if your material does not have seamless edges, you can get undesirable results. Other projections such as cubic, cylindrical, and spherical are great for corresponding object types. Cubic works well for anything rectangular, etc. There are additional mapping types and specialized tools such as UV unwrapping. However, it is a good idea to become comfortable with basic material projections first, then add more advanced methods as you progress in 3D.

Lighting

Lighting is fundamental to success in a 3D workspace. It affects the range of dark and light values in a scene, thus creating the illusion of 3 dimensions in a 2-dimensional space. This principle

Figure 5.18: Frames from *Hidden*: short film by Sekani Solomon. The top image is an example of 3D geometry without any materials applied. The bottom image showcases the application of materials to 3D geometry, giving the models color, texture, and tactility.

applies to any depiction of depth on a 2D surface, such as a drawing or illustration. Effective lighting can help to establish an organic or believable style. Conversely, poorly considered lighting can make an aesthetic feel overly harsh and computer-generated. Knowledge of photography or cinematography is beneficial, as the principles of lighting translate directly into 3D software. However, one of the biggest differences between analog and digital lighting is the absence of *ambient light* in digital environments. In an analog lighting situation, ambient light is naturally created by photons bouncing off of physical objects and surfaces to create a diverse range of light and dark values. Digital lighting requires placing multiple lights of varying degrees of intensity, adding *HDRI* (High-Dynamic-Range Imaging) images to a scene, or using effects to create the illusion of ambient lighting. It takes practice to learn how to efficiently create a desired lighting setup in 3D.

3-Point Light Setup

A good place to start with lighting is a 3-point light setup (see figure 5.19). This lighting technique is derived from practical studio lighting. The 3-point light setup uses three lights to give a model or scene a visually pleasing range of light and dark values. You have a *key light*, a *fill light*, and a *backlight*. The key light serves as the primary light source, emulating direct light from the sun. A spotlight, or soft box with a high intensity, is fitting for a key light. The key light is placed to either side of a subject and slightly above, pointing downwards. A key light that is placed directly in front of a subject will wash out the contrasts between light and dark. When this happens, the subject flattens out and becomes uninteresting. When the key light is placed to the side, a strong contrast between light and dark creates spatial forms. If we were to stop with just the key light, we would have a very harsh lighting situation.

Here is where the *fill light* is employed. A fill light serves to *fill* ambient light into the overly harsh shadows created by the key light. In 3D software, an *area light* works well as a fill light. Area lights project light in a diffused manner. The intensity of a fill light should also be reduced, as it is emulating the behavior of the reflected light in an analog setup. Reflected light bounces off of objects in an environment to fill in the shadows of a subject. Place the fill light on the opposite side of the key light, to reduce the intensity of darkness in the shadows.

The third light in the setup is a *backlight*. Some of the other names for this light are effects light, rim light, or kicker. The purpose of this light is to illuminate the edges of a model or scene. This light is placed behind the subject and can be positioned to either side as needed. A backlight will help to give the model or subject definition and separation from the background. A 3-point light setup is a good starting place for lighting a model or scene. However, you may need to add additional lights depending on the needs of your project.

Cameras in 3D

Cameras are one of the most important tools for designing in 3D because your camera controls how the viewer sees your composition. Once you have modeled, textured, and lit your scene, you can place the camera anywhere within your environment. Camera distance and angle in relation to design elements determines the layout of your image frame. You can adjust your camera and/or objects in a scene to establish depth, hierarchy, and most importantly your focal point. When working with cameras in 3D, you need to think like a film director. Do you want to compose your image with the camera close-up to your design elements? Maybe you want a low-angle? Would a slight Dutch (rotation) angle add interesting diagonals and tension to your image? Successful camera placement can add cinematic sensibilities to your design.

One of the greatest benefits of working with 3D is the ability to record and change camera position. This affordance

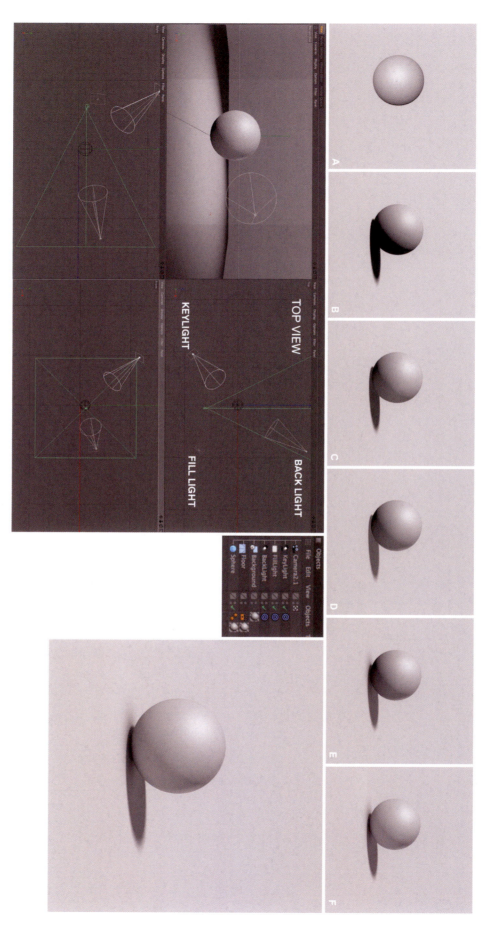

Figure 5.19: An example of a 3-point light setup in Maxon Cinema 4D.

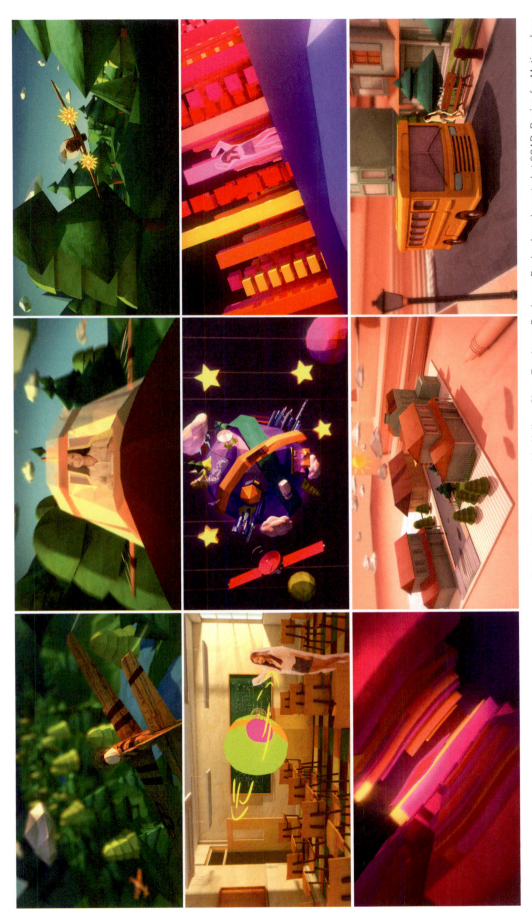

Figure 5.20: Design board by Keliang Shan, Freelance Designer. Design board created at SCAD, Design for Motion class.

can be especially helpful for creating multiple style frames to depict a motion design sequence. Designers can create dramatic changes in camera angle or camera distance within a scene while maintaining consistent lighting and layout. Furthermore, you can also create multiple cameras for different views within the same scene. You can switch cameras to create the effect of making cuts, like you would in a live-action edit. In relation to design for motion, you can easily create design boards that have cinematic continuity.

Adjusting camera settings in 3D is not difficult. They are digital translations of analog cameras with parameters such as focal length and aperture that can be modified. Experiment with camera focal length to create different effects such as wide-angle distortions. Adjustments to aperture can simulate the effect of depth of field, where objects in focus remain sharp while objects further from the camera's focus distance become blurred. Try out various camera angles to create dynamic frame compositions. The beauty of working in digital software is the relative ease of experimentation.

Rendering

Designers need to learn the basics of rendering to utilize 3D for design. 3D Software allows you to configure the output size, file format, and effect settings for a project. Output size is the equivalent of aspect ratio or image size. Width, height, and

Figure 5.21: Various frames using post effects and third-party renderers by Sekani Solomon, Freelance Designer. Additional compositing by Christopher Russo and Timothy Regan.

resolution can be specified for a render. File formats determine how your renders are encoded, and if they are image sequences or movie files. 3D software offers the option to render with an *Alpha Channel*, which allows for a transparent background. For style frames, this option is very important if you want to continue working on your render in a program like Photoshop. Effects such as ambient occlusion and global illumination can enhance a render by adding details to shading and more realistic lighting. You can also stylize your renders with effects like cel or toon shading that give a more graphic or illustrative look and feel.

One of the biggest challenges to using 3D for design is render time. The more complex your 3D scene, the longer your render will take. When you add effects like AO (ambient occlusion), GI (global illumination), or depth of field, you can significantly increase your render time. For individual style frames, long render times may be acceptable. But in production, where hundreds or thousands of frames need to be rendered, efficiency is vital. The traditional means of handling time intensive renders is to use a render farm—a network of computers that work in tandem to complete a render. There are also a host of third-party render engines that can enhance the visual results of your renders as well as optimizing render speeds and previews by utilizing GPUs. If you decide to make 3D a serious part of your design process, you will need to learn extensively about rendering and discover what options are best for you.

Multi-pass Rendering

Image files or movies rendered out of 3D software will flatten or merge visual information by default. We do, however, have the option of rendering the visual information out in separate passes. This is known as *multi-pass rendering*. Multi-pass rendering is the process of separating a 3D render into separate layers or passes. These multiple passes will then be reassembled in compositing software. This process offers the ability to control and enhance the look of an image or movie. When used with skill, multi-pass composites can add polish and finish that greatly enriches the final outcome. Multi-pass compositing is a digital process that integrates 3D rendering and 2D compositing. Consequently, multi-pass requires working between 3D and 2D software.

The advantage of rendering 3D in separate passes is much greater flexibility in how you composite your images or movies. You can individually adjust the separate passes to refine the aesthetic of the composite. Some of the more common passes to render separately include specular, shadow, reflection, ambient occlusion, global illumination, and matte passes. Of course, there are many other types of passes that can be rendered separately. Explore and add to your multi-pass render settings as your knowledge and projects become more advanced.

Compositing 3D

When you render a 3D scene with multi-pass settings, you create separate layers for the designated passes. Multi-pass layers are composited using blending modes in software like Adobe Photoshop or Adobe After Effects. Passes such as ambient occlusion and shadow work well with a blending mode like *Multiply*. This option will deepen and enrich the values and shading of an image or animated scene. However, it is important to maintain a subtle touch when compositing. You may want to reduce the opacity of your passes if needed, as it is very easy to be heavy-handed. Try different blending modes on your multi-pass layers to see what kind of effects they have on your composite.

Another great feature of multi-pass rendering is the ability to render *matte passes*. Matte passes provide luminance information of black and white values that can be used to distinguish between what is visible and invisible. They are extremely helpful to isolate and work on specific parts of an image

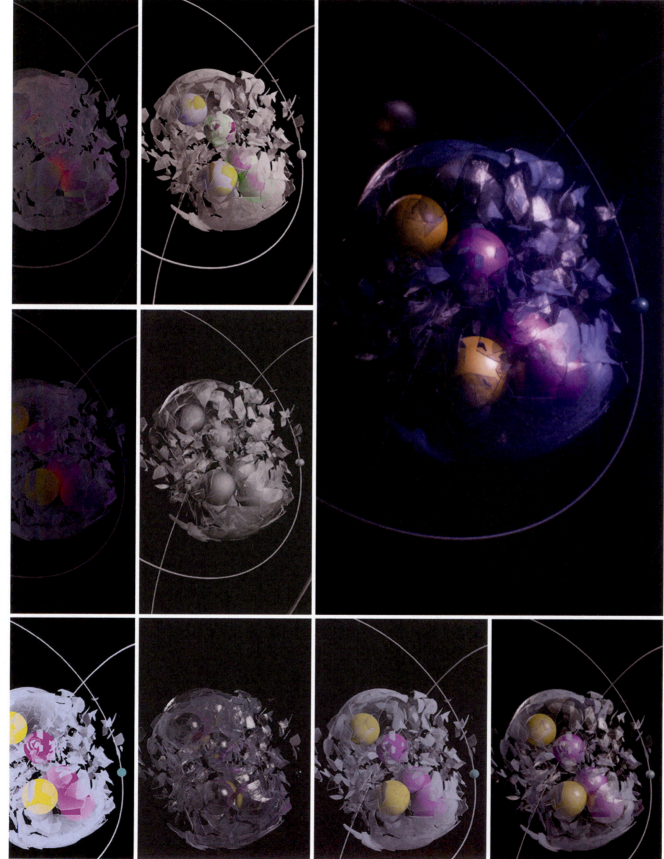

Figure 5.22: Various passes of a multi-pass render by Sekani Solomon, Freelance Designer.

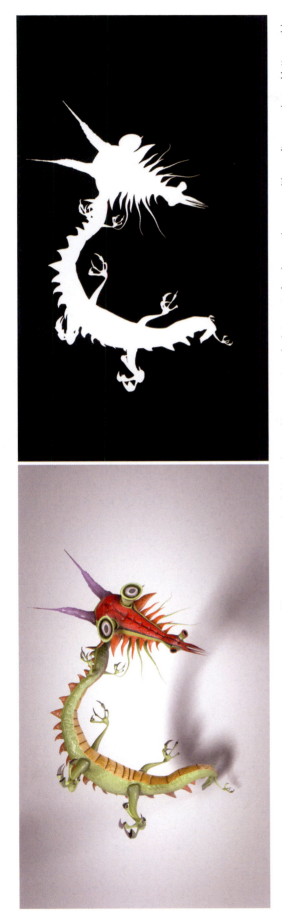

Figure 5.23: An example of a finished render and a matte pass. The matte pass on the right can be used to separate or isolate part of an image. In compositing software, a *Luma Matte* would preserve the white areas of a matte pass and hide the black. Mattes are extremely valuable as they allow a designer greater control of image compositing. Mattes can also be reused and re-mixed repeatedly.

or animation. For instance, with a matte pass you can adjust the color of one object in a scene independently. Also, matte passes can be used to create a transparency to composite layers either in front of, or behind one another.

3D gives you the ability to model, light, and texture objects; position them in space; compose scenes; and choose how they

are viewed through a camera. Compositing your 3D elements will allow you to create any number of unique design styles. With 3D, you can create dramatic compositions for style frames and maintain continuity throughout a design board. It is a valuable skill to add to your arsenal of creativity. Additionally, knowledge or experience with 3D is attractive to potential employers.

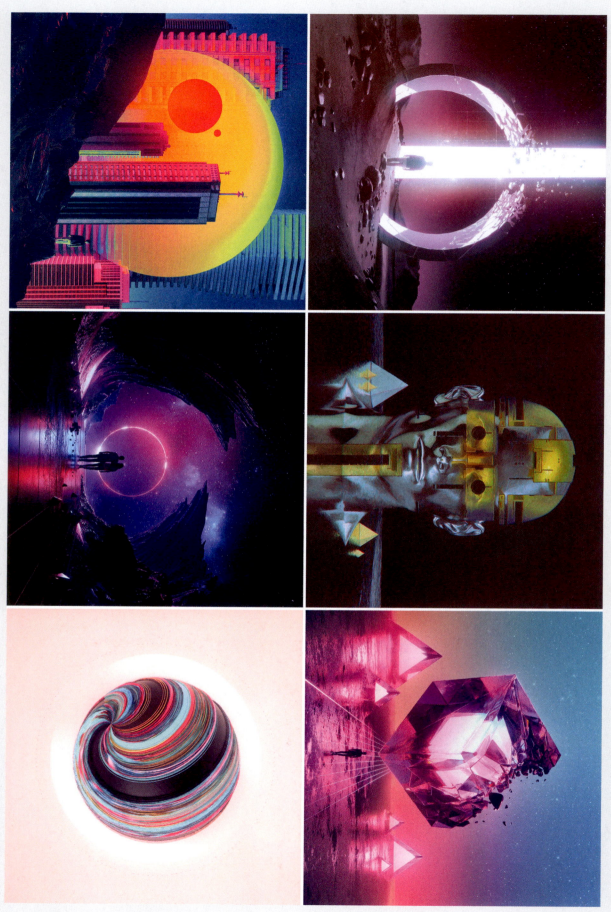

Figure 5.24: Examples of Everydays. Created by Beeple—Mike Winkelmann.

Professional Perspectives
Beeple—Mike Winkelmann

An Interview with Beeple—Mike Winkelmann

What is your art and design background?

I went to school for Computer Science, so I don't really have formal art training. Everything I've learned is from doing Everydays and doing stuff like that. After graduating from college, I did web design for about 10 years and taught myself 3D and motion design on the side. It was just something I was interested in—I hadn't even heard the term motion design until I had a piece on Motionographer. Then I was like, "Oh, I guess this stuff is called motion design." I had already been doing it for a couple of years but had never heard the term because I didn't go to school for it.

What do you like about 3D?

As soon as I started doing graphic stuff I was like, "3D man ... that's the *real thing*," because then you could do anything, you could make anything if you could do 3D. After I did a year of Everydays, doing drawings, I thought that if I could do a render a day, I could learn 3D. I picked Cinema 4D because I heard it was one of the more user-friendly programs.

3D encompasses everything. It is the most powerful tool to learn because it opens up so many options for you, in terms of what you can do. I think it is only going to get more relevant as things move into AR and VR spaces. A lot of things that are fine today as 2D assets will need to be 3D assets. Twenty years ago, not every business needed a website or an online presence. Now,

every business needs that. I think in the future every business will need 3D assets.

What are the Everydays?

I saw an animator, Tom Judd who runs Animade in the UK, that he was doing a sketch a day, and I thought that was such a cool project, to get better. I wanted to get better at drawing, so the first year was doing a drawing every day. I saw a huge improvement in my skills—I was still really bad at drawing, but I saw a big improvement over the year before that, just because I was drawing way more. I transitioned that into learning Cinema 4D, then I did a year of Illustrator. I did some digital photography, and the last few years have been back to doing Cinema 4D. It was never my intention to keep going for 11 years. The reason I started doing it was to get better, and the reason I continue to do it is to get better. There are still tons of things that I would like to be able to make that I just can't make right now. So, that is what keeps it going. I can see a clear trajectory upward of my skill-set since starting the Everydays. It forces you to work a lot more.

What else do you do besides your Everydays?

I do freelance work, mostly concert visuals, some AR/VR work, and album art. I've never really worked on a "commercial," which I think is very odd. I feel like there are a lot of things that normal motion designers know and have experience with, that I just don't.

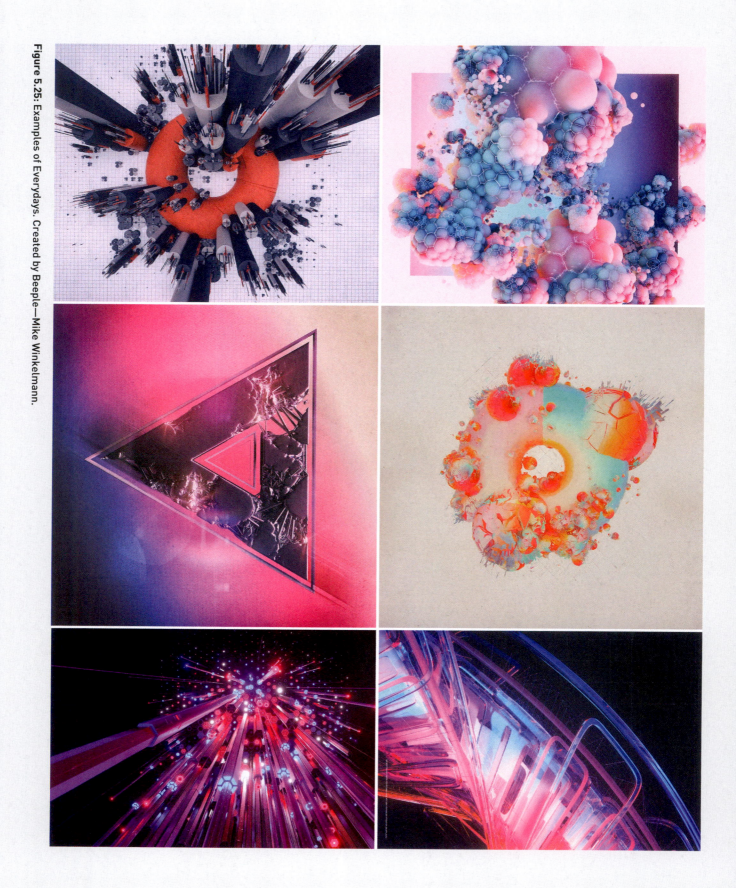

Figure 5.25: Examples of Everydays. Created by Beeple—Mike Winkelmann.

I can fudge my way through it, but I have never worked with a studio. I worked with a small web design place in Wisconsin where I was the only designer. Then I went straight into freelance from there; so, I never had the chance to work under people doing motion design. I wish it would have happened at some point, but where I lived in Wisconsin, it was never really an option. I definitely recommend to students to not try to go freelance right away. Take a job at a studio for at least 3 years; 5 years would probably be better, to get that really strong foundation. From there, they can crush it doing freelance. There were a lot of things I did learn working at that web design company, in terms of client relations, which would be really hard if you went straight into freelance.

How do you balance doing your Everydays with your freelance work?

I feel like I do not balance it well. I work a shocking amount. They both need to get done in a day. The freelance stuff, concert visuals have quick turnarounds. You really can't put it off for 3 weeks; it needs to get done pretty quick. There isn't that much of a chance to fall behind with anything. I get enough sleep, but I don't do anything else. I work from home; I spend time with my wife and kids. Other than that, I do almost nothing else. I am on the computer all fucking day. I enjoy making stuff.

Maybe something good about not having worked in a studio is that I definitely do not know the correct way to things. I do a lot of things the incorrect way, which is sometimes much faster. I think that is an advantage with the type of work that I do. The Everydays have a very quick turnaround—everything start-to-finish, usually in about 2 hours. You don't have time to do the "best practices" way of doing everything. And concert visuals are kind of the same way. Usually, the teams I am working with are pretty small pipelines, and the work is disposable in a way because the performance happens, and then it's done. It's not something that needs to stand up to an insane amount of scrutiny.

I am always trying to find the quickest way to get to the endpoint. Clients don't care about how you get to the endpoint; they just care about the endpoint. And people don't care either aside from a few Cinema 4D nerds here and there. Most people do not give a fuck. Does it look cool? Awesome, great. But they don't care how you made it.

How do you come up with ideas for your Everydays?

I've got a Pinterest board with a bunch of pictures that I find interesting. I will take one of those ideas and develop it into a picture. For the most part, it was whatever I am feeling and can get semi-excited about that day. Usually, it is a struggle to find some sort of direction or concept down. A lot of times I will have a vague idea, or this sort of shape, this sort of composition, or this sort of color scheme. By the end, it is totally different. Having some direction helps a lot versus sitting down with a blank canvas noodling around in Cinema 4D. Usually, it will take much longer and turn out crappier.

Are there themes that re-occur in your Everydays?

Yeah, there have been. After I hit 10 years, I started to use more assets that I had made previous Everydays or I had downloaded. In the beginning, I wanted to learn how to model being new to Cinema 4D. If I wanted a tree, I would force myself to model the tree. By the end of the 10 years, if I wanted a tree, I would just put in a model of a tree. After 10 years, I took all the restrictions off of myself. I will use any models, from anything, anywhere—any materials, anything. Since then, the work has become more narrative. If I had to model every figure from scratch, and model the ground, and every plant, and every machine part, that's just not remotely possible in one day, much less a few hours.

Themes have evolved, and I usually have a few going at once. Right now, the bug theme is one where these weird bugs

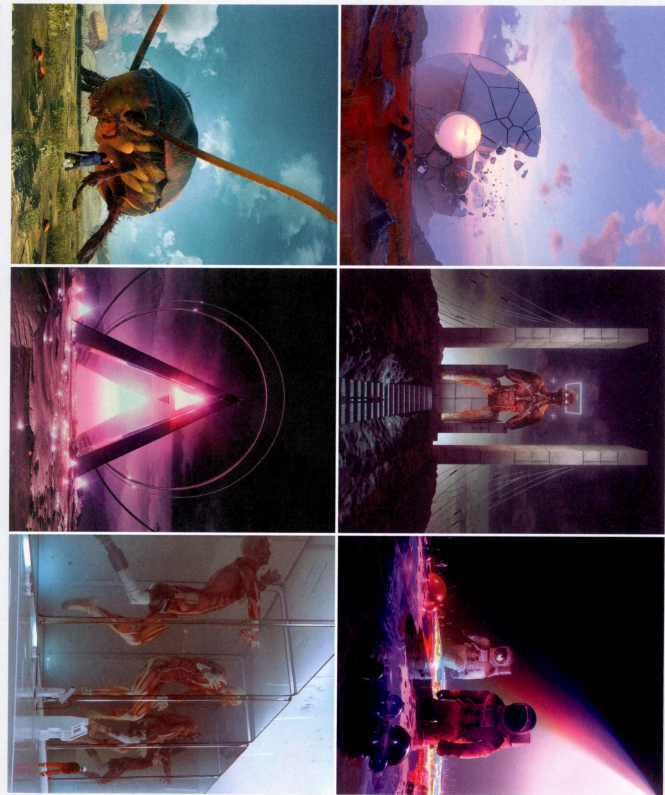

Figure 5.26: Examples of Everydays. Created by Beeple—Mike Winkelmann.

have been used for industrialized and weaponized purposes. There are also pictures imagining what Facebook and Google will be in the future with more advanced robotics. In the past, I did some imagining these cargo container structures of what Facebook, Google, and Apple might turn into if they fizzle out. They are usually very vague and are not trying to sway people in any particular direction. They are more like the ideas I am exploring.

How did you get into doing visuals for music?

I had released a bunch of Creative Commons VJ clips that people can download and use for whatever. Those got downloaded, quite a bit. So, people started contacting me for custom visuals. Mostly musicians or people who made visuals for musicians to create concert and tour packages. The work has very tight turnarounds. One of the biggest challenges now is that the screens have insanely high resolution. That is something you need to be cognizant of as you are designing for something that has to be rendered out at 12,000 pixels wide—you have to take that into account. The deliverables are fairly different every time. I don't do most of the rendering myself. I usually work for a company where I am doing the higher-level design in terms of what the song will look like, and from there, I will hand it over to somebody who will animate and edit out the rest of it. I don't have to have an insanely huge GPU farm. If it's not a crazy-high resolution, sometimes I will do the full piece end-to-end.

Sometimes, they will have a very good mood board, and sometimes, they will have very little direction. So, I will listen to the song and try to come up with something. I will look at their album art, look to see if they have a music video for the song on YouTube, and put together a concept. I will usually animate out small sections—5-second motion tests to show what I am thinking for each section of the song. Then I will package up the Cinema 4D assets, and it gets put into the pipeline from there in terms of producing the final piece.

Do you have suggestions for young designers?

Save your money. Immediately start saving money once you start making money, at least 10% in a 401k or stuff like that. That is going to open up a lot more possibilities—you are going to have options in terms of leaving a job you don't like or taking some time off to learn a program. Those are things that, if you don't have any savings, you are not going to be able to do.

What's up with Beeple?

If you google "Beeple toy," it's a fuzzy looking Ewok thing from the 1980s. If you cover their eyes or change the light, then they beep. So, I guess it's like "this interplay between sound and light." Yeah, I guess that was it.[3]

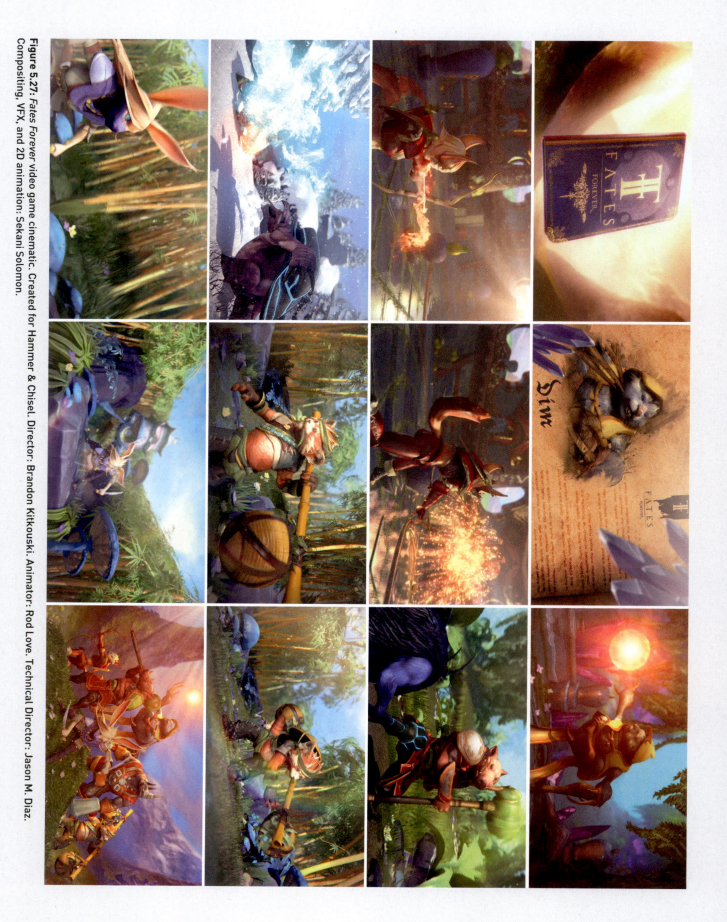

Figure 5.27: *Fates Forever* video game cinematic. Created for Hammer & Chisel. Director: Brandon Kitkouski. Animator: Rod Love. Technical Director: Jason M. Diaz. Compositing, VFX, and 2D animation: Sekani Solomon.

Professional Perspectives
Sekani Solomon

An Interview with Sekani Solomon

What is your art and design background?

I fell into motion design by accident. It all started when I used to watch Saturday morning cartoons. I used to love to draw little characters with colored pencils and markers. It didn't look like what I saw on TV, and I wanted that really cool refined look. So, I realized I had to jump on the machine to do it, and that is when I opened up Photoshop for the first time around 2004. I picked it up and was like—wow, this is kind of crazy and complicated, so I put it back down. Then in 2008, I rediscovered it because I was helping out my high school teacher to design his website. By that time, the internet had really changed, and there were so many resources to learn the software and that was super cool. I jumped back into Photoshop in a very intense way, learning stuff and just trying to get better. Then I discovered a little piece of software called After Effects, and that is when my mind really blew. I didn't know anyone doing anything like that, and I was like, "Wow, this is amazing." Then I discovered Cinema 4D shortly after that. Not necessarily with any sense of design or anything like that. I was just making stuff that I thought looked aesthetically pleasing. Then it was time to go to college. At first, I wanted to study software engineering, but I ended up changing to design. At that point, I still didn't know what motion design was. But I knew I liked making stuff—I was doing motion graphics before I knew what it was.

I went to SCAD, and they had some super-duper talented students who helped to push me and to push my craft. I have always had this work ethic of wanting to improve. During my freshman year, when everyone went on spring break, I was at school in the computer labs working on a promo video because that was what I would rather be doing. I had the opportunity to work for a lot of really cool companies through internships, and I ended up landing a job right before graduation with Imaginary Forces. That is where things started to take off.

What is your experience with internships?

The first internship was the summer after sophomore year with Loyalkaspar. During winter break of junior year, I interned with Gentleman Scholar. The following summer after junior year, I did a double internship with The Mill and Imaginary Forces. It is really good to get work experience in that somewhat safe space that interns have because if you mess up, it is sort of expected. You can learn in a somewhat less stressful environment. When you get hired coming out of school, there is more pressure on you to perform. Being an intern and gaining real-world experience helped me know a little more of what I was doing when I got my first job.

Where do you find inspiration?

Inspiration comes from trying to push the boundaries. With whatever platform I get on, I want to take it a step further. How

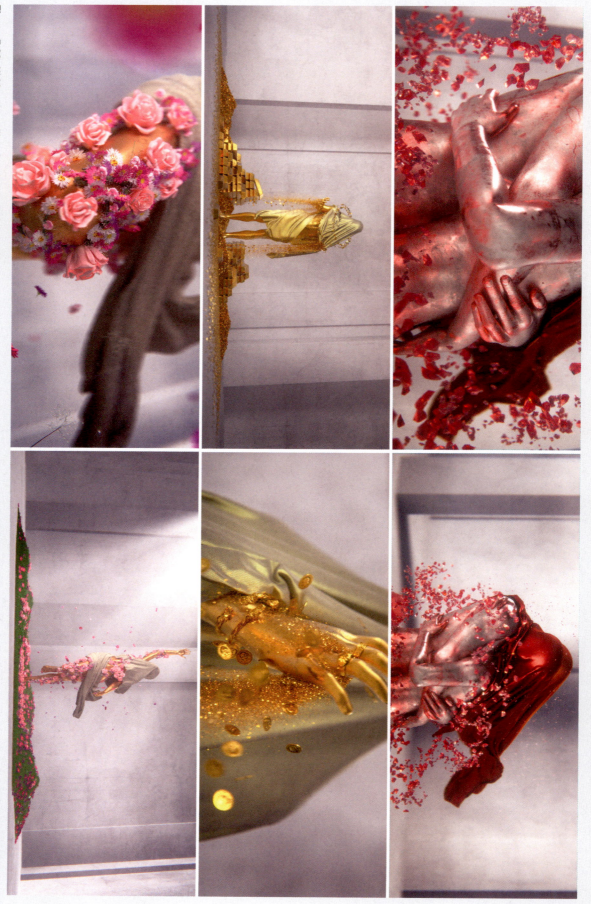

Figure 5.28: *Hidden* short film. Created by Sekani Solomon.

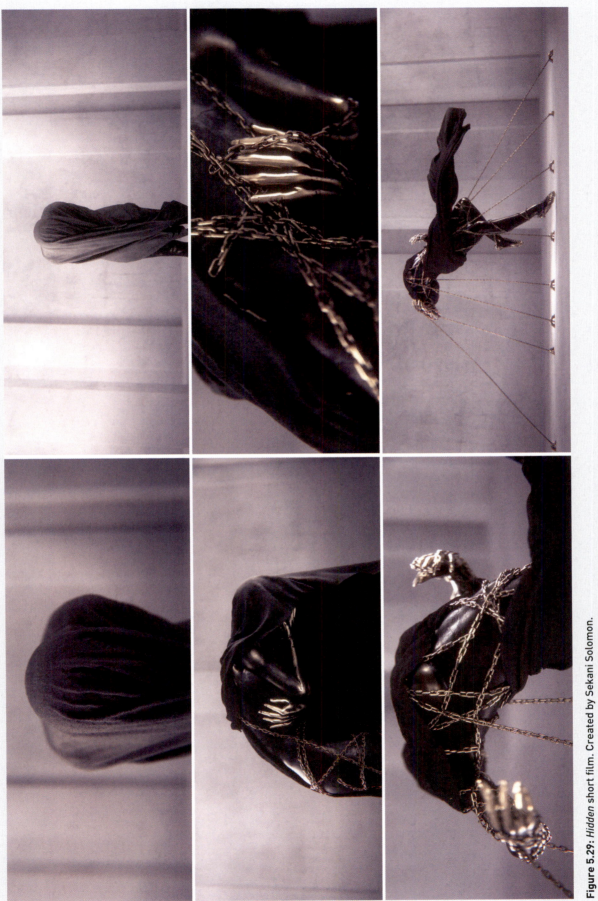

Figure 5.29: *Hidden* short film. Created by Sekani Solomon.

much further can I push my craft? It's a combination of being self-driven and being excited to see what else I can make. At the same time, I like looking around at all the cool stuff and seeing what other artists are making. Because 3D is becoming more common, what can I do to still keep my edge and be ahead of the pack?

Why are passion projects important?

The reason I work on passion projects is because that is how I keep growing. If I am not working on a passion project, then I am learning new skills to work on a passion project. If you are waiting on client work to bolster your portfolio, your portfolio is never going to be as good as it could be. Make the type of stuff you want to work on, and people will come to you for that kind of work. A project like *Hidden* shows my voice and the type of work that I want to do.

Hidden is my greatest accomplishment as a motion designer. To execute that level of production by myself, and to stick with it over the course of a year, was a test of discipline and tenacity. The idea that I conceptualized and saw the production through to the end, that meant a lot to me. All the visuals were planned, based on the concept that I had, which essentially was about self-appreciation and bringing to light the things about ourselves that we may not want to see, or to share. Then I had to figure out how to portray four different emotions—what type of colors, what type of elements, and what type of postures. So, I did a lot of visual research beforehand, looking at pictures of dancers and statues. Roman statues have these majestic postures. I also looked at materials like crystal formations, gold, and chains to represent the emotions I had planned. Then I took some time off of work and created style frames. From the style frames, I jumped into production.

How do you approach concept development?

I think it is super-important to have an idea and be able to execute it; that is like the ultimate power. I was never about creating nice 3D, just for the sake of nice 3D. I look at a cool piece and look for the artist write-up to get some context, but I don't find any. Then it feels flat, there is no dimension. So, I always feel it is important to have a conceptual aspect. Personally, I like to explore themes about how we are in society as emotional individuals. It is always important to have a purpose behind anything that you are doing.

I love making things and coming up with the idea as well. It gives you an edge in the industry. When you are working with a creative director, you can think in a design-based way versus having to be art directed all the time when you are in production. It is a great advantage to have, because a lot of production artists are like, "Tell me what to do, and I will make it," versus let me start you with an idea and see how you manifest it.

What are the qualities of a design-driven 3D artist?

When I was in school, I would look at the work that was being made in the industry and try to re-create it. But now that I have settled into the industry, I think, "How can I make something that people haven't seen before? How can I make something that is fresh?" I think that evolution is interesting. I think you need to be design-conscious when looking at work and to get into the habit of coming up with ideas and making them.

One of the benefits of SCAD was having the opportunity to come up with ideas, create style frames, and then execute the project. Creative directors and companies take notice of that type of skill-set. There are not a lot of people that can do that—design, execute, and comp at a high level. It's the type of thing you have to want to do, you can't force it. You have to learn so many things and practice often to keep stuff fresh. You have to really like the process.

Do you have any experience on mobile/social first as related to motion design?

When you deliver a project now, you are doing a social deliverable and a broadcast deliverable. It is a format that is here to stay, which makes sense because it is the screen we look at the most. The social deliverable is always a short clip. Eventually, we are going to have to be able to tell cooler stories in shorter amounts of time. But there is still a place for storytelling, regardless if it is broadcast or mobile.

How do you approach learning new software and interfaces?

There is always going to be that initial intimidation. You have to keep thinking that you are not supposed to know anything and you are supposed to feel that way. You work to alleviate that feeling. When you learn new software, you have to keep the goal in mind. It is like a marathon, you have to be patient and work at it over a

period of time. It is not going to be something that you pick up in a day. That is something you need to understand initially. You are going to be lost for a while, but then it will come together and be amazing. That is the carrot on the stick that keeps me going. You learn bits and pieces, and it clicks eventually. If you approach it like that, then it becomes less daunting.

What do you like about 3D?

I like having an idea in my head and being able to make it. I can't do that with just 2D. I can't get the dynamic, cinematic quality that I want. I like the ability to add dimension to my work. Say you wanted to do a 3D move, but have it look 2D. 3D can do that! You can do multiple visual aesthetics in 3D—it doesn't just have to look like 3D. 3D allows me to do multiple aesthetics—it can be photo-real, it can be abstract; it can be cosmic lines. I can do a whole bunch of different things with it. 3D really opens up your creative borders. [4]

Notes

1 "Info/Contact." Lilit Hayrapetyan, www.lilithayrapetyan.com/Info-contact.
2 Hayrapetyan, Lilit, telephone interview with author, July 23, 2018.
3 Winkelmann, Mike, telephone interview with author, June 16, 2018.
4 Solomon, Sekani, telephone interview with author, May 9, 2018.

Chapter 6:
Social/Mobile First

Motion Design on Social & Mobile Platforms

A profound has shift occurred in the way people consume and interact with media. People now spend significant portions of their time on social media, sharing photos and videos, searching for inspiration, promoting their work, and creating content for digital platforms. A great deal of this interaction takes place on phones. As people's attentions are spread across a variety of platforms, advertisers now need to meet people where they are, and new types of motion design projects have emerged. Multi-platform is an old term that has been reborn as deliverables are needed in a variety of aspect ratios and durations. Each platform has its own specific constraints and requirements, which are constantly evolving. For example, Instagram began as a photo-only sharing platform, then shifted to also host 10-second videos, which then changed to 60-second videos, and then another addition of live videos and 24-hour stories. Platforms will continue to adapt to user trends and preferences.

Brands are realizing they need new fresh content all the time. Motion design projects created for social and mobile platforms have become a regular part of the commercial world. Traditional design-driven production companies have adapted their pipelines to meet the needs of this changed media landscape. Additionally, a new breed of digital agencies has arisen to deliver projects specifically for social and mobile. The rapid production and consumption of media has propelled

in-house creative teams at advertising agencies, networks, and corporations to produce a continuous stream of content for digital platforms. Traditionally, commercials on broadcast television were the most effective means of capturing an audience. As consumers have shifted to spending more of their time on social media, advertisers are challenged to captivate audiences in this new digital space.

"There is this push for things to be able to live everywhere now, and with good reason. Every different platform has slightly different formats, concerns about duration, whether it has audio or not, whether it is skinny or wide, it is just part of what we are doing now. It's definitely a consideration that is not going away. I don't know if there is any such thing as a broadcast designer anymore, but learning Motion design is not tied to something as fundamental as a 4:3 box. The line between interactive and non-interactive is always blurring, but I think the fundamentals are the same. It's about communication, design, and consideration for the way you engage an audience."[1] —Patrick Clair, *Director*

Glance Media

Social media gives viewers choices about what kind of content they want to watch, where they want to watch it, and they can do

so whenever they want. This freedom from the old model of linear television is not without consequence. With so many options, the attention span of viewers has become shorter and shorter. Users hop across platforms and slide through feeds at breakneck speeds. These new realities have forced advertisers to rethink how to engage audiences. If a viewer is not instantly drawn in, they will continue to scroll through a feed, and that becomes a missed opportunity. Motion design can be an effective solution to cutting through the bombardment of visual and sensory clutter. When things move, they feel alive. Animation and motion design produce the illusion of life or soul,[2] thus capturing a viewer's attention.

Capture Attention Quickly

The most important goal for content in social media is to capture the viewer's attention quickly. This idea has been expressed in the *3-second rule*—if you don't capture them in the first 3 seconds, you are not going to get them at all. Some professionals argue that you have even less than 3 seconds to capture the viewer's attention. Regardless, this idea has shifted the importance of the initial hook of content on social media. Strong design and motion have the ability to catch the viewer's eye as they are scrolling through their feed. Bright colors, contrast, strong compositions, compelling imagery, and quick dramatic changes are some of the design choices that can help to capture the viewer's attention quickly. Physiologically, our eyes pick up movement to avoid being ambushed by predators in the wild. Today, we can use this biological defense mechanism to snare viewers as they scroll their social feeds.

Thumb-Stoppers

A term to describe an effective social media post is a *thumb-stopper*. A thumb-stopper causes a user to stop flicking their thumb, thus pausing their scrolling. A post must be engaging enough to not only capture the viewer's attention, but also deliver the message. The average social media user spends hours a day scanning feeds, gliding past significant amounts of content. What is going to pierce the visual clutter and get them to stop and pay attention to a post? Again, strong design and motion can grab the interest of the user and engage them for a short time.

Figure 6.1: Various Instagram posts by Pablo Rochat.

Professional Perspectives
Robert Lester

An Interview with Robert Lester, Creative Director and Technologist

Robert Lester is a hands-on creative and art director with a love for collaboration and innovation. He is inspired by emerging technologies such as Augmented and Virtual Reality, 360 Video, AI, and voice assistants, and he seeks every opportunity to explore them and incorporate them into his projects. Robert's experience producing many different types of creative content and leading teams has given him a wide perspective on the creative process and taught him how to integrate many disciplines into compelling results.

What is your art and design background?

My creative journey began from a musical place. I come from a musical family and was surrounded by professional musicians. Creativity was welcome in the context of my household and my parents were really open and encouraging of me getting into music and art. It all started converging when I went to college at the University of Michigan. I went as a Music Education major, but I found out about a Performing Arts Technology degree, which was essentially a multi-media arts degree with a music focus. It really encouraged students to branch out into other forms of digital media, mixed media, and all these types of things. I was taking video installation, as well as After Effects 101. The curriculum was really about exposing you to the tools and opening up your mind as to what could be made with them. It got me skills and experience with all the tools that we think about now, whether we are creating motion design or distributing your work through things like video projection.

I moved to New York and was doing a range of freelance design, music composition, and songwriting for a few years. I was freelancing across a bunch of different media types. I would be scoring a commercial one day, then helping a band with a website the next, then doing illustrations for t-shirts or posters. A lot of my work was somehow music related. Other creative friends of mine were elevating their work with motion, and I was introduced to this whole other framework of motion and design. That was a big moment where it clicked for me. I had always approached movement as thinking about it in terms of animation, rather than as a function of design. When I married the design thinking with creative ability to make content move, that was a really helpful moment which set me up for what I am doing now.

How has music influenced your work as a motion designer?

I think because music is a time-based creative medium, there is something that makes sense as you get into movement, animation, and motion in general because that sense of timing drives so much of it. I think a lot of musicians get into design

because it's opportunistic. All musicians need things made, and some of them are going to take their downtime and figure out how to make it themselves. Then, you learn about how timing can be added to that graphic design principle. It starts to take you back to what you like about music. I use a lot of musical analogies when I am directing a motion designer or team member about a time-based thing. I will mouth [rhythmic sounds] these weird soundscapes of the timing. It can be really quick to use a sound phrase to help express how something needs to move.

Figure 6.2: Various Instagram posts by Robert Lester.

How would you describe your experience working at GLOW?

GLOW's area of expertise is social and digital media, from both a strategic standpoint as well as execution. Inside the vast world of digital experiences, we are constantly giving thought to the social media user experience and its constant evolution. We are always thinking about not only how our output can technically work in those environments, but also how we can take advantage of the full range of opportunity so we can get good engagement. Because the client base is really strong in entertainment, that often involves a translation of storytelling.

Figure 6.3: *The Night Of*, social strategy and creative execution created by GLOW for HBO.

If we are working on an HBO show, there is going to be a tremendous amount of media created to express that IP [Intellectual Property]; the whole season's worth of edited video, other things the network has produced and provided from BTS [behind the scenes] to other marketing materials. What we are doing is thinking about how we can take that and make the important touchpoints of that story understandable, interesting, and a conversation-starter in that social space. Our content is specifically tailored for the ways that people like to talk, engage, and consume content online.

The presentation and storytelling opportunities on social media is huge. Even within a single platform like Instagram, you have tons of options—posts versus stories, static and video, lenses, and lots of different ways to think about sequencing those things. Take a carousel (multi-image, swipeable) post for example: how can you use that in a clever way for storytelling that is aware of how people engage? It's a carousel; you know people are going to swipe right. How can you turn that act of swiping into a part of the creative process and help tell the story? You can tell a story that is propelled forward by the user's behavior of swiping. You might be posting static images built off the concept of an animation. You can think about how you connect the action that happens in these scenes in really interesting ways that conveys a sense of space that's larger than your phone screen.

Given that most social content is experienced on people's phones, motion design, and design in general, has the opportunity to become more tactile. These types of pieces are not seen from afar, like animation that is happening on a screen in a theatre; it's now happening in the palm of your hand. User behavior can introduce an element of chance or collaboration that can be part of the story-making, with screenshotting and reposting and things like that.

How do you design for user agency?

Part of it is thinking about the constraints, about how the platform works, and constantly paying attention to how people are using

the platforms. Take advantage of the fact that people are going to swipe or double tap to like an Instagram post. Can we feature the presence of the heart that appears when you do that in an interesting way compositionally? Then we have to layer on the consideration for a given brand. With a brand, you want to be conscious of the narrative you are presenting and the opportunity that creates.

What is different about social motion than traditional motion design?

Attention span is a consideration. Users are always going to be scrolling quickly through their feeds. What is going to capture their attention? You really need to frontload your creative "hook." You don't necessarily want to tell the whole story in the first second so that it is on someone's screen, but you at least need something that will get them to stop and watch a little bit longer. You think about the sequencing of the creative content a little differently when you think about making it competitive in a really visually rich environment. You can think of Instagram scrolling like channel surfing at lightning speed.

Social media is also a communication platform. Unlike a TV, which communicates in one direction, the audience both consumes and creates content for platforms, typically, even if only photos, GIFs, or text. People who are really native with it— who grew up with cellphones and social media existing—they use social media in a different way than the last generation. That has given rise to some really interesting, curated motion design Instagram accounts that don't fit any kind of typical presentation of motion design work. People are doing really weird experiments with Houdini and other 3D software, where they are making really short art animations that work so incredibly well in an Instagram feed, and they are getting tons of engagement. What if the only way to have experienced this unusual motion design work was in a gallery context? Would 50,000 people have seen this thing and responded as positively, or, is the juxtaposition of all the

things you see on Instagram, and then some weird mind-bending Houdini experiment that makes it really interesting? A lot of this work doesn't make it to the TV, or advertising, *until it starts getting 100k+ likes*. Now brands start paying attention and commissioning things, and the experimental animated stuff gets amplified, and I think that is a great thing. Really exciting outcomes happen when you become cognizant of how people are going to be engaging with what you do. It is not passive, it is interactive.

At GLOW, we are thinking along these lines. Thinking about the interactivity of the work, thinking about animations that you can touch, that you can swipe, that has user experience elements surrounding it. We are thinking at a campaign level, releasing content episodically, the sequencing of the story, how motion design can help convey quickly the spirit or benefit of the show. You are going to animate a comedic asset differently than you are going to animate a dramatic one. We are thinking about a really short window of time to capture somebody's attention in a feed. If we are trying to capture people who love suspense and mystery stuff, we are going to think about the pacing of the first second differently than for someone who loves slapstick humor.

Are there other best practices you use for social?
Because we know that the vast number of people who are viewing the stuff we create, are viewing it on mobile phones, we are thinking a lot about legibility. That is a design principle that is top-of-mind for us. When designers are working with their files at 100% scale on their desktop machines, doing really intricate details, we have to remind them that people are going to see their work at a size that is much closer to 20% of their screen space. Thinking about how your visuals scale down is really important. Also, how it crops, because depending on the workflow, you might not have the budget or opportunity to export things at different aspect ratios. Nowadays, vertical aspect ratios are more important because they want to maximize the real estate of how people hold their phone, without having to force people to turn their screen. It

turns out people usually just don't turn their phones. They will just view it much smaller holding their phone vertical. We think about how people hold phones and how far they hold them from their face on average. That is a part of what we talk about when we are critiquing work.

Do you have suggestions for young designers?
Start learning to think spatially with motion. I am always extremely impressed by people who have some 3D knowledge and experience. I think it shows a different way of working, and even if you are working in After Effects for example, if you bring a sense of depth and space to it, your work is going to be reflective of that. I think what we will see is more and more interactivity surrounding the way that we are encountering motion design. UI and UX is really helpful, even at a cursory level because in the case of the phone, people are going to touch the device where your animation is playing. Game engines, like Unity and Unreal, are already increasing their importance in the way we create work. I think we are going to see the way we think about designing movement, not as designing something that is fixed in time, but thinking about design as a set of movements and behaviors that are triggered by actions. Video games are already doing this, obviously. That is part of what makes certain games really enjoyable to play or not—the way the mechanics feel, which is expressed through things like movement and sound, easing and bounce, all that stuff in relation to user action.

Also think about *shareability*, or how your content might be used by others, because if it becomes popular, this will happen. GIF stickers are a really good example of these little building blocks of animation that anybody can access to help tell a story that they want to tell. You now have a platform like Instagram where content was posted, that people can use to create content that is more than just something that is captured with the lens of your phone. You are capturing something and then appending it with all this additional stuff.

Captain's Log [4.3.18]:

TBS, GLOW, Adobe, and Olan Rogers have teamed up to produce the first-ever, live-streamed, interactive game with an animated character that is voice-acted in real-time on Facebook.

To kick it all off, we had just one question for the fans...

Final Space's Cards with Gary was the most engaging Facebook Live broadcast ever on a TBS brand page, with a more than 100% engagement rate during the live stream.

Figure 6.4: *Final Space: Cards With Gary* social strategy and creative execution created by GLOW for TBS. This stunt created awareness of *Final Space* through innovation and expanded audience engagement through multi-platform storytelling. *Cards With Gary* is the most engaging Facebook Live event ever produced by TBS, with an engagement rate of 100%.

Think about loops. Because we make such short videos, it is likely, and hopeful, that people will watch them multiple times. The default behavior for short videos on most social platforms is looping. We try to think about the *loopability* of something. At a certain point, if you can't discern a beginning or an end, that is kind of a positive thing because it usually means somebody will spend more time with your content. If that is the case, then you are delivering a higher value to your client.

What do you like most about design for social platforms?

I like how many different ways there are to tell stories and capture people's attention. Motion design is a bigger part of that every day.[3]

Short-Form Projects

Perhaps the greatest shift in motion design projects for social/mobile is duration. The 30-second commercial spot for broadcast television used to be the pillar of the motion design industry. As advertising has moved to hand-held devices, budgets have bifurcated to meet viewers where they are—on digital platforms. The mainstay 30-second broadcast spot has splintered into a variety of short-form projects. Looping GIFs, paid social ads, and even graphic show packages for scripted shows on vertical platforms all operate on much shorter timelines.

"If we are marketing a show, we are trying to get people to watch the actual show. Our content needs to function like a taste, and a snack is a good way to describe something that you are only going to have a taste of. In the same way that when you have a snack, you have something that tides you over, but doesn't make you full. We want to make our content *snackable* in that it should whet your appetite, but not be the full meal." —Robert Lester, *Creative Director*

"With paid media, you are creating shorter content. You are creating things that are 15, 10, or 5 seconds. You look at it in a different perspective than you would for a music video or an opening title for something. You need to figure how you grab someone's attention in this timeframe. You are also adding *call-to-actions*—what you want the viewer to do after seeing the project." —Melanie Abramov, *Director*

These shorter timelines have altered the traditional narrative of motion design projects. Designers need to think about social projects as compressed storytelling relative to a 30-second commercial or a title sequence. The purpose is to engage a viewer very quickly and deliver a message or call-to-action. Rather than allowing a narrative to unfold slowly or tease out an idea, social media tends to hit the viewer fast and hard. Adjusting to the needs of social timelines requires adjusting your mindset for design and storytelling. When designing for social media, you are often delivering motion in a very specific platform, for a specific audience, and with a specific intention; that is to "pique" the viewer's interest and then allow them to move-on. An industry slang term for short-form social media content is *snackable*. A snackable is bite-sized content that meets the needs of advertisers on social platforms.

Another consideration for storytelling on social media is delivering essential information immediately. For longer motion design projects where losing the viewer's attention is not a concern, narratives can follow a more traditional structure. Representational worlds can be established, climaxes can build, and logo animations or *end tags* can resolve, at the end of the spot. With social media, instead of ending with a logo, many advertisers are starting with a logo. Front loading content can help advertisers insure that a branding opportunity is not missed.

Design for Sound-Off

Social media needs motion design content to work with or without sound. Many users are watching videos on social media without audio. Although platforms offer the option to toggle sound on or off, audio is not a requirement. In fact, a high percentage of users react negatively when caught off guard by video ads with sound.[4] This dynamic can be challenging for motion design, as audio can serve a critical role in effectively arresting the senses of a viewer. However, the need to adapt to designing for sound-off environments has inspired a resurgence of typography. In response to user feedback, Facebook offers automated captions for video ads. As designers of motion, we can push further than simple captions.

Creative Captioning

Well designed and kinetic typography can be extremely effective for capturing attention and delivering messages on social media. Type combined or composited with imagery, graphic treatments of type over footage, lower 3rds, or purely type-driven videos serve to communicate information. Especially when content is being viewed without sound. Hierarchy established by font size, weight, and contrast in addition to legibility and timing operate in the same way as traditional motion design projects. Type can serve to convey specific moods and personalities to social content.

"Most people are viewing content without headphones so content is viewed on mute. We try to design captions to help convey tone or character. The type design and movement of the type that is being delivered through creative captions can speak to the feeling or identity of the show." —**Robert Lester,** *Creative Director*

Typography plus interactivity has also become a regular part of social media. Facebook *text delights* allow users to trigger playful animations by clicking on highlighted keywords such as *congratulations.* When a keyword is clicked, a short animation appears overlaying the feed. For some of these keywords, successive clicks will produce iterations of the animation with variations in color and arrangement. This combination of interactive text and animation built into the interface of Facebook demonstrates the capacity for motion design to surprise and delight users.

Figure 6.5: *Maniac* title sequence created by Madison Kelly and Marcelo Meneses. This project was created at SCAD Motion Branding class.

Professional Perspectives
Melanie Abramov

An Interview with Melanie Abramov

Melanie Abramov is a film director and creative from Brooklyn, NY. She lends a necessary and provocative voice through her uninhibited approach and surrealist style. *Dame Factory*, her 2012 directorial debut was an award-winning experimental short film, exploring themes of sexuality in advertising. Melanie is currently the Experimental Programmer for the *Brooklyn Film Festival*, curating a diverse selection of visually expressive art. Commercially, Melanie has worked with clients such as Toyota, Y&R, UVPH, and Digitas on commercial, on-air and social campaigns. Presently she is Senior Director of Video for Ralph Lauren in NYC, working across all platforms in digital media.

What is your art and design background?

I started as an artist first, expressing myself through mixed media. I was exploring how different elements; ink on paper, oil on canvas, photography, etc., allowed me to visually convey all of my emotions and things I needed to say out loud. While I was in high school, I worked for a company that taught Adobe programs, and they allowed me to sit in the classes for free. So, by the time I went to college, I was pretty versed in the software. After high school, I attended Parsons School of Design, focusing on graphic and broadcast design. While focusing on my studies, I was also working for a company as a graphic designer creating flyers and site graphics. I always had a pull towards video, motion graphics, and experimental film. I regularly made films on my own and began to

understand the ways you can bring stories to life using After Effects and Final Cut. Motion became more interesting to me than just design. How you take footage, layer it with visuals, copy, and make it come to life was so cool. From that point forward, I continued at Parsons fully focusing on motion and experimental film.

How did you begin your career as a creative professional?

I freelanced for about 7 years in NYC for post-production houses in motion graphics: special effects, on-air packaging, music videos and title design. I really needed to push myself further in order to be to combine live-action film with motion graphics. Through all the different freelance opportunities and creatives I encountered, they gave me a perspective and understanding of what was happening in the industry and what was needed.

I then landed a perma-lance position at Digitas, an advertising agency which brought me into creating content for brands in a more structured corporate space. I gained experience working with paid media, editing videos for various clients like Amex, Chase, and Converse. At an agency, you are following a different type of flow. It's creative, but at the same time there are more boundaries.

How did you transition to working as a Creative Director and Live-Action Director?

I had been directing and creating experimental films on the side to express myself for quite some time and didn't know if that

Figure 6.6: Various projects by Melanie Abramov, Director/Creative Director.

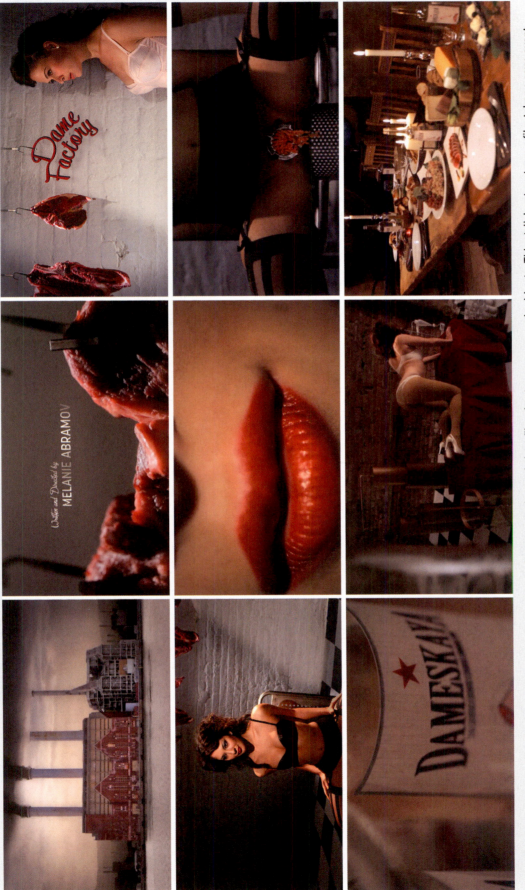

Figure 6.7: *Dame Factory* short film. Dame Factory Inc. is an award-winning experimental short film about power, sex and cold cuts. This stylish yet grotesque film takes a sexy, avant-garde look at the roles women play in our culture—a tasty treat for the hungry eyes. Director: Melanie Abramov.

could merge with my day job. I was working for Ralph Lauren as an editor and motion graphics artist. I invited my boss at the time to a screening of my short film *Dame Factory*, and to my surprise he came! It was a film that I directed, edited and was the lead on visual effects. The film did really well; it won awards in film festivals globally and had tons of press along with very opinionated reviews due to its provocative and grotesque nature. My boss said, "Wow, I didn't realize you had this capability of directing. We need to get you on some projects." Through that, I started coming on sets and directing shoots at work. It gave me confidence that a very personal point-of-view and unique style translated to the commercial space. The lesson was that everyone should continue to pursue what speaks to them, allowing people to see the layers of talent we all have. I started directing more, handling productions, and really thinking about motion in a 360 perspective. Understanding where it's going to go and being part of the pre- and post-production helps to achieve the vision beforehand. The goal is that you and everyone involved has a clear idea of what you are going to deliver at the end and how it will impact the audience.

Can you speak to the idea of 360?

The 360 approach is thinking about how the content is going to be everywhere and what the customer journey is; on social, short-form, long-form, paid, organic, in-store, and on the website. You are then starting to see the world that is created around one project. What the goal is, who is the audience, and what you need to do in order to grab their attention. For each platform, what is the business strategy? You may have 7 platforms you are thinking about.

In the beginning of my career, I thought of projects as just being great videos. I was thinking visually about what I wanted. I started realizing I was missing how it was connecting to the bigger picture—what is the impact versus just what I think is cool.

There's an accountability to all of the shareholders, including; the brand, marketing and creative teams. You're all part of this ecosystem where deliverables are more than visual art and impact is seen as tangible growth of impressions, dollars, and social engagement.

What are your thoughts on motion design for social media?

Motion design will never go away because it is such an impactful way to speak to an audience. For social media specifically, you have 3 seconds to get somebody's attention. Motion design works so well because it catches your eye immediately and can feel like a loopable piece that doesn't have a beginning or end. It keeps you hypnotized as you look at it. Kinetic typography allows you to tell a story very quickly on social where audio maybe isn't being played. You can deliver someone a message in less time than copy or an image can on its own. There was a quote by Dr. James McQuivey that a video is worth 1.8 million words per minute. This sentiment captures the power of video.

How have budgets been impacted?

It has been such an evolution. The majority of traditional advertising budgets and paid media for video content now goes to social. The push is on Facebook, Instagram, YouTube and Snapchat. And those are just the current platforms. Every year the budgets go down and the amount of content and deliverables goes up. Just because it is on social doesn't mean it shouldn't have a standard of production value. That is the challenge—focusing on how to tell several native stories within one campaign shoot. With budgets being smaller, how do you get around that? Somebody is shooting with a mobile phone, somebody else is shooting on a camera and also thinking about the story in small, 10-second micro stories versus one long narrative. It is being diligent about the money we are spending, and also experimenting with new techniques. Shooting solely on a mobile phone doesn't create the

FALL 2019

THE TRENDS

#1: BLACK TIE OPTIONAL

BRINGS THEM
ALIVE
IN NEW WAYS

Figure 6.8: Fashion campaigns. Director: Melanie Abramov.

production value for all platforms yet it works for others that are intentionally less polished like IG/FB/Snap Stories. We have been learning that users see right through commercially produced videos versus content that is made for that social space.

How do you plan for multi-platform?

When you create the master grid of deliverables for a shoot, it looks like a matrix. You have vertical, horizontal, portrait and within those, various lengths all customized for specific platforms. Plus, you are capturing additional native content like backstage moments, interviews, and bloopers for micro edits. Your feed or other permanent placements are more curated with higher production value. When we map out a shoot, you have to think of all of those elements and your deliverables list may end up being 20 edits in various dimensions. It's important that you budget enough time to execute and edit the wide range of content. Prioritizing is key.

What are some skills you think belong in a social media toolkit?

People who have not worked in video have been creating GIFs in programs like Photoshop by taking frames that connect together and making a mini-movie. That is a skill I have seen utilized in a lot of ways. I think what is interesting about social is the idea of hypnotizing the viewer without a clear beginning or end. You can do that with GIFs, cinemagraphs, or boomerangs. There is an array of iPhone apps you can use to edit with directly from your phone and then post without ever touching your desktop or laptop. And of course, there are After Effects, Premiere, and

Cinema4d for those with more experience. Social is changing so fast that we have no clue where it will go next or look like in 6 months or even 5 years from now. It's also based on how communication evolves between all of us on this planet. We have to be ready, with no resistance to continuing to learn, experiment and evolve with it.

Do you have suggestions for young designers and female designers?

When I started in motion design there were not that many women in the field which I honestly didn't notice until later in my career. I never thought of myself as a "female" designer, I just did what I wanted to do, networked, and killed it. I really am sensitive to the culture of women in the creative industry, especially as it applies to the current environment of women in the workplace in general. It's amazing to see young female artists pushing boundaries and challenging norms with provocative, thoughtful visual commentary. For ALL humans and artists, it is important to own your voice. If you have done your work, explored, experimented, and are open to growing, you will have confidence to lead. It's important to have your unique vision, push boundaries yet also see other perspectives. Communication and collaboration are the keys to everything. You don't have to know everything, (if you think you do, let's pop that bubble) but continue to learn, fail forward, and challenge yourself. With every project, problem-solve and embrace constructive criticism. Besides that, be authentic and be a rebel.[5]

Multi-Platform

Social and mobile media have transformed motion design deliverables. There is no longer a single standard aspect ratio such as 16:9. Rather, content needs to be formatted for multiple platforms at horizontal, vertical, and square sizes. In some instances, horizontal is not even the main deliverable or needed at all. Content needs to work across all platforms, adapting to size, duration, and audio constraints. *Social/mobile first* speaks to the idea that these platforms should be considered first in the concept and design development of projects. Indeed, if user/viewers are spending the majority of their screen time on social media, then there is a lot of merit to this idea.

"It used to be that we would create one project. Now, we are pitching on projects thinking about the different mediums, the different aspect ratios, and all the different platforms. How do we stay relevant using the technology as it evolves, stay ahead of the curve, and really craft something, but be really responsive to it too? It has changed our timelines, our schedules, and the type of work that we do. It still exists, but that really polished, overly sophisticated, cinematic storytelling piece has really gotten boiled down to what captures the viewer's attention in 6 seconds."[6] —Will Johnson, *Director, Gentleman Scholar*

Designing for motion that needs to live on a variety of platforms and sizes is challenging. It requires efficient pre-production and planning. During the early stages of concept and design development, knowing for which platform content is being created is essential. Designing for a horizontal composition is different than a designing for square or vertical compositions. Cropping becomes more involved than just dropping a horizontal project into a vertical comp. You have a lot more space to play with on the top and bottom of the frame, and not so much on the sides for

vertical aspect ratios. Problems arise when assets are not created to accommodate the various sizes, leaving designers to creative problem solve by rebuilding or retouching imagery. For projects that incorporate live-action, footage may need to be shot at both horizontal and vertical orientations.

"Every job we do has some kind of toolkit component to it, multiple screens and formats. A lot of stuff we do has quick cuts and different styles. So, we talk about how a quick cut in a specific style can get lifted and become an Instagram post. We can do 1 broadcast spot that can have 60 Instagram posts in it. When shooting, we keep in mind that a shot is getting cropped 1:1 for square or 9:16 for vertical. Do we shoot with a camera that is normal landscape and shoot with one that is vertical side by side to get both deliverables at once? It's not as reactive as it used to be. We have to be preemptive, which allows us to be more collaborative."[7] —William Campbell, *Director, Gentleman Scholar*

For multi-platform projects that need horizontal, square, and vertical deliverables, perhaps working with square-safe guidelines is a smart design choice. At least for essential information such as copy, logos, and key artwork. Working in this way can speed up production, especially if many versions are required for delivery. Typography also functions very differently in a vertical versus a horizontal frame. Stacking type on multiple lines may be the most elegant and effective solution for vertical, where a single line may work best for horizontal. Designers also need to consider actual screen size, especially with mobile devices. Typography and logos may need to be larger than normally designed for a broadcast spot.

Designing for Interactivity

Traditional motion design is consumable, meaning a viewer passively watches the piece. Social media allows motion design

projects to provide user agency, or the ability to actively engage with content. Users can touch, swipe, and tap content to contribute to the experience of a piece. These affordances bring motion design projects into the realm of interactivity and even game design. Designers of motion need to consider these capabilities when creating projects for social media.

"For me, it is important to understand how people behave when looking at Instagram or any platform I am working on. They are not just passive viewing when they are sitting on a couch. They are actually holding something, so more of their body is involved. I think about that when I come up with ideas around how to play with that in a fun way. It's more than just people's eyeballs now. It's their thumb that can be interactive just by the nature of the platform where you can tap, scroll, or swipe to the next video. Someone can be on the subway, they could be anywhere, but you know they are going to be holding their phone, looking at it, and using their fingers to touch. These are just more materials to play with."[8] —Pablo Rochat, *Art Director*

One huge difference between design for motion and design for interaction is the need for *prototyping*. Design for interactivity and user experience requires testing. Prototypes allow designers to test the usability of their ideas. Methods may include paper prototypes, apps, and private test accounts. Regardless of the how you test your projects, the goal is to simulate the user experience and work out any bugs prior to posting the completed work. Fortunately, the need for digital content and advances in user interface design have introduced a host of designer-friendly prototyping tools. Designers can spend less time worrying about coding and more time on solid concept and design development.

The rise of social media has elevated the understanding of design for everyday users. Creative affordances such as adding typography, animated stickers, AR filters, or boomerangs to a post empowers users to design. Although the palette may be limited relative to a professional designer's toolkit, the opportunity to curate and make design choices is there for everyone.

"Because platforms like Facebook, Instagram, Twitter exist, all of us, whether we consider ourselves creative or not, we are making things for them. With YouTube, we are making videos and films. It creates a broader understanding of the tools and techniques that go into telling a story, or go into making something that gets people's attention, or that people find interesting. Before, there was only a certain group that was making media, that was making commercials, that was making advertising. They were the only ones that were responsible for that, but now everyone is making things. Everyone is responsible for the collective understanding of meme culture and videos. Vine was really huge. Those 6-second videos that people made and told stories with. Before then, how was it even possible to tell a story in 6 seconds? Vine disproved that and created this whole new genre of making media and communication. I think Instagram and those platforms continue to do that. It's interesting because the level of the general public's vernacular and understanding of creative work is so much higher. Everyone is now part of the "making" process. As creatives or makers of things, we are able to do a little more and be more creative when we get the opportunities because everyone's perceptions are a little more heightened around what they are used to seeing."[9] —Andrew Herzog, *Creative Director*

Professional Perspectives
Pablo Rochat

What is your art and design background?

I was always kind of an art kid in high school. I went to college to study art and ended up studying Graphic Design. With that, I started in the tech world doing UI and graphics stuff for screens, mobile, or desktop because I am interested in technology and that's where I thought people were spending their time. It was good to learn the basics of type and screen design. All the while, I have always been interested in humor and entertaining people anyway I can, whether it is putting a video on YouTube or a meme on Reddit.

This past year I have focused on making motion, memes, or pieces of entertainment in the form of videos every day, and putting them on Instagram and getting familiar with how to design for a phone which is either vertical or in a square. Basically, taking an idea and figuring out the best way to communicate that in a short period of time because people have a short attention span. I Google and YouTube how to use tools like After Effects and Photoshop. If my goal is to entertain or communicate an idea, it is important to have that. Most of the time it is an idea first and then learning how to make that happen. For my audience, I am interested in a piece of entertainment, so oftentimes the simplest idea that may not take more than 30 minutes to make performs better in terms of people liking it and sharing it, than a video that I spent 5 hours making.

How do you approach concept development?

I have a sketchbook that I am always trying to put stuff into. I also have a folder of unfinished ideas that I will go to in the morning, so that if I don't have a new fresh idea, I will look back into a collection of unfinished stuff and see where I can take it. I also have material that I thought would be cool, whether it be old videos or characters, something to mess with. Material, half-finished ideas, pen drawings and sketches that I do in my notebook that I use for references and starting points to create a finished piece. I work better in the morning, so I wake up early and make sure I block out a chunk of time where I can just think and get inspired. If I exercise later in the day, that is generally a place where I have some good ideas too. It's hard to control when you are going to have ideas, it's easier to control the environment where ideas can happen. For me, I've learned that is in the morning or after I have gone for a run.

How do you balance your everyday Instagram posts with professional work?

I have my own little studio where I work with brands who reach out to me because of my Instagram or other projects. I work directly with brands to make videos, social content, just a range of things, but most of it comes from people looking at my Instagram. Because I post regularly to my Instagram, clients may look at that and see something they may want to do or inspire them to want

Figure 6.9: Various Instagram posts by Pablo Rochat.

Figure 6.10: Various Instagram stories by Pablo Rochat.

to work with me. So, my personal work actually feeds into what

clients end up asking me for, which is nice.

Was it valuable to work for an agency first, before going out on your own?

I got to meet other creative people, especially when I first moved to a city. People who have similar ambitions of creative work, people with different styles, and people with more experience. Because agency life can be kind of grueling, you spend a lot of time there, so you get to know people pretty well. The community of people you get to meet is really important. Now that I am independent, I am making a lot of business decisions and handling client management myself. I have learned at the agency how that was done, at a higher level. In the end, the agency's job is to provide quality strategic thinking and creative work for clients. That's what I am doing too, maybe on a smaller scale, but I am providing generally the same service—so, being around people who are really good at that, and to understand the basic value of an agency, why clients come to them, or why clients choose other ones. I am interested in not only the creative part, but also in the business part. That was fun for me to get insight into that. Also, because I was an art director, I met great copywriters. You get to see how a great script is written and brush up against that experience. I learned about strategy and how to make a presentation for a client. There are a lot of things I wouldn't have learned in school or learned independently.

How would you describe your aesthetic?

I like to take things that are familiar to people and twist them in unexpected ways. I like bright colors, things that are happy, the things that I would like to see in the world are the things I like to make. What is going to get me excited to work all day? I am still just like a kid playing with blocks. Low-fi and high-fun; I like things that are fun and things that are funny. I am most happy

when I am having fun and when I am laughing. Coming from an agency where there is so much money spent on high-production stuff, as a creator I really like the idea of accomplishing as much entertainment with little means. I like the idea that I can create the funniest meme in the world with just my phone and a good idea. That really frees and inspires me.

Often times, the funniest moments of life are just things that we experience. So, it's not always something that someone spent millions of dollars on and years filming. That world is now reflected onto the internet because everyone can be documenting that world that we are experiencing. That allows for small moments that may have gone undocumented to be shown to everyone. Everyone gets the chance to be entertained by these things that happen to us every day.

I work well with limitations and get a little bit paralyzed when there is too much freedom given to me. Creative problem-solving is enhanced for me when I am given a set amount of tools, limitations, or boundaries. Instagram does that for me in having to think, "What can I do with this square, or what can I do with these 2 squares put together, or a 5-second vertical flip?" It gives me a starting point. A reveal, a setup, or a misdirection as a form of storytelling in the context of creating something on Instagram can be helpful for entertaining content. I have a test account where I put sketches on before I post, to see if they will work. I do prototypes and storyboard it out on Photoshop, or do a quick test in After Effects.

Do you have suggestion for young designers?

Coming out of school, I think it's really important to find a place where you can really learn from experienced people. Help people who are doing work that you love. Get in the mix. The work that you make will determine who might want to work with you. Get better at the things you like to make because that will help to find the type of people that will hire you to do more of that.

Because so many people spend time on Instagram, it has been a worthwhile place for me to put my ideas out there. When I look for motion designers to work with, I often look at their Instagram page because it is a portfolio site in that sense.

The best motion designers I have worked with and continue to work with, are really nice people. Because you spend so much time working together and that last-minute details and tweaks can be really stressful, the people I remember, and want to work with again in the future, are people I enjoy working with. That is a huge part of the job—pleasant people to be around.

I have learned over the years that people show up again, and randomly, so it is important to leave a good impression. Even if you are a student. When I was in school I didn't realize that all these people around me, my classmates were going to be at these companies and part of the community I am involved in. Being a good person is a smart strategy for your career. People may ask you for more work in the future, they may refer you to someone else, or they may move to a new, cooler company and have work for you there.[10]

Figure 6.11: Various Instagram posts by Pablo Rochat.

Social media offers tremendous opportunities for motion designers. In turn, motion design is an effective vehicle to deliver advertising content to users. In relation to job opportunities, it is a requirement for designers of motion to be familiar with the parameters of social media. Another aspect of digital is the growth of data-driven marketing. The widespread use of social media gives advertisers information about user preferences and behaviors. This knowledge is used to target and to place very specific ads in a user's feed. These factors contribute to the need for more advertising on multiple platforms that is updated constantly. As technology evolves, designers must adapt to meet the challenges of audiences that are increasingly more savvy with digital media.

"There are more screens with more moving pixels. Motion design has become more important with every step forward. From a student's perspective, I think it is an incredibly rich area to be moving into that is full of potential and growth. But, part of that is understanding that it is not going to be what the generation before did. Just like what our generation has done is very different to what the generation before us did. It's just going to keep changing."[11] —Patrick Clair, *Director, Antibody*

Notes

1 Clair, Patrick, telephone interviews with author, July 9, 2018.
2 Thomas, Frank, and Ollie Johnston. *The Illusion of Life: Disney Animation.* New York: Hyperion, 1995.
3 Lester, Robert, telephone interview with author, October 8, 2018.
4 "Capture Attention with Updated Features for Video Ads." Facebook. https://www.facebook.com/business/news/updated-features-for-video-ads.
5 Abramov, Melanie, telephone interview with author, December 20, 2018.
6 Johnson, Will, telephone interview with author, July 23, 2018.
7 Campbell, William, telephone interview with author, July 23, 2018.
8 Rochat, Pablo, telephone interview with author, November 15, 2018.
9 Herzog, Andrew, telephone interview with author, August 16, 2018.
10 Rochat, Pablo, telephone interview with author, November 15, 2018.
11 Clair, Patrick, telephone interview with author, July 9, 2018.

Chapter 7:
Presentations & Pitches

"There may be any mix of things you might present. You have to listen to the idea. One idea may just need to be told as a story, perhaps with one photographic frame so that people know what the feeling is. Another design board may need fifteen graphic frames that are showing exactly what the typography is and exactly what we are doing with transitions. Some ideas are 100% written with hand-drawn frames. Sometimes you pick a track of music because it's really about the editorial style. Other times, you do an animation sample because it's the best way to describe it. You have to listen to what you want to express. There is not a one size fits all approach to how you communicate ideas."[1] —Karin Fong, *Designer/ Director*

Process Books & Design Decks

Process books and design decks are used to present and pitch various aspects of projects, but for different reasons. Students use process books to document and showcase the development of their creative process, whereas professionals use design decks to present work to clients. Process books are very effective for attracting the interest of potential employers, whereas design decks are effective for winning new business or moving a commercial production forward.

Despite the differences between process books and design decks, they both serve as containers for creative work. They should always be created with professionalism and as a supportive element for the content within. Many of the design principles that apply to creating beautiful style frames and design boards are applicable to both process books and design decks. As an outcome for design for motion, a designer must edit and curate process books and design decks to best showcase their work and communicate their ideas.

Process Books

The primary purpose of a process book is to document your creative process. You can showcase all the crucial steps, process strategies, methods, and thinking that went into your concept development. Additionally, you can also showcase the polished outcomes of a project, such as style frames and design boards. Process books tell the story about the development of your concept and design direction. For students, process books are extremely valuable for their portfolios. Process books can demonstrate how you handle problem-solving and arrive at solutions to creative challenges. In a face-to-face interview, you can show either a printed process book or a digital version such as a PDF. On your portfolio website, you can feature examples from your process books along with your projects.

The value and importance of process books in relation to career and employment cannot be overstated. Finished outcomes are always important. It is a given that your portfolio should contain the very best of your work. However, showing a potential employer *how* you think and develop concepts, in addition to your finished design outcomes, will make you a stronger candidate. Employers enjoy delving into students' process books. Your sketches, ideas, and references are interesting and informative. A strong process book shows your ability to consider the needs of a creative brief and craft a purposeful solution. Most importantly, a process book can present your talent for creative problem-solving. This skill often determines the difference between a creative lead and a creative technician in a commercial setting.

Design Decks

Design decks serve an extremely important purpose—a means of presenting work to a client. They contain the solution to a creative brief, or challenge, in a commercial setting. A design studio will present a design deck to a client either to win a project or to gain approval to proceed on a production. Studios need to win jobs to stay in business and design decks are the key to delivering style frames, design boards, and written treatments to clients. In general, a design deck is more carefully curated than a process book. Process books give a peek under the hood of your creative process and may include rough ideas and iterations that show snapshots of your problem-solving. A design deck is far more outcome driven, focusing primarily on the solution to a creative brief.

Pitches typically involve a creative lead, such as a creative director or an art director, presenting the design deck to the client. This pitch can be done in person, over the phone, or through "video chat." If the pitch is conducted in person, the design studio will prepare and print design decks for the client. Printed design decks will be distributed to the clients, and the creative lead from the design studio will talk everyone through the solution. There may be a monitor or projector where a PDF version of the design deck can be displayed. If the pitch is done over the phone, each party can review the design deck as a digital file while the creative lead presents. The details and logistics of pitches have infinite variations, but the essential pattern of pitching remains the same. The creative lead uses the design deck to help sell the concept to the client.

"If you want to be a creative director, learn how to pitch. You get in the first couple of pitches, and you're a nervous wreck and probably not very good at what you are doing. But, just continue to get into those pitches and try to figure out the best possible way to communicate your ideas. Be concise, and take those big ideas and cull them down into simple things people can swallow." [2] —Rob Rugan, *Designer/Director*

Professional Perspectives
Patrick Clair

Patrick Clair is a director, creative director, and motion designer based in Los Angeles, California. He is creative head of production studio Antibody. He has an undergraduate degree from Queensland University of Technology, where he focused on live-action directing, including 16mm short films, and a graduate degree in Visual Effects and Title Design from the Australian Film, Television and Radio School. After finishing his studies, he worked at MTV and with Australia's national broadcaster the ABC. He freelanced for several years until starting Antibody in Sydney, Australia.[3]

An Interview with Patrick Clair
What is your art and design background?

I started out with a focus in live-action, and I trained as a live-action director when I was still kind of absurdly young. I found myself leaving college, living in a small city in Australia with a piece of paper saying I was a director. It was a bit ridiculous, considering there were probably a handful of working directors in the city I lived. I was looking for another way to enter into the industry in a practical and realistic level. At the time, there was some genuinely thrilling things happening in motion design. There was work coming out of houses like Psyop and MK12 that were really fusing images together in a way that I had never seen before. It was taking motion design out of the realm of being credit rolls and end tags, and turning it into something

that is truly innovative. I got really excited about motion design and went in that direction because I thought it was something new and an interesting approach. I went and did some post-graduate studies at the National Film School in Australia, specializing in title design and visual effects, and getting some proper technical grounding. I was lucky enough to get a job with MTV, which was wonderful. It was really creative, and I had lots of freedom. I got to jump around between doing motion design, cutting my own stuff, producing promos, and directing musical artists. It was great, but very driven by aesthetics and what was trendy. Eventually, I wanted to do something with content and storytelling. I started to find my own voice, my own perspective on how I wanted to do things. I started making animated documentaries for the Australian Broadcasting Corporation, which is very similar to a body like the BBC or somewhat similar to PBS in the states. It's from there that I started to build a style of motion graphics design that could focus on slightly longer format storytelling.

Why does communication matter for motion designers?

If I would describe my career progression, I trained as a live-action filmmaker. I wasn't necessarily a good one, but that was my training, very traditional filmmaking. I didn't have any design training whatsoever. Then, I started learning how to use After Effects, and I learned every nook and cranny of it. I never had

the technical depth in 3D the way a lot of the Cinema 4D kids do these days, but I knew After Effects like the back of my hand. Then I learned to be a motion designer, which was predominantly learning what to use After Effects for. Don't use all the crazy plugins, don't make things technically complicated, just get to the heart of the simplicity and the design and communication. Then I was a motion designer for a living. From there, it got to a point where I was really making PDFs for a living. I would argue

that even sort of graduated to the point where now, I am making these phone calls for a living. What I mean by that is, that being able to do good design is not just opening whatever software you use and creating a frame. It's really thinking about "how do I communicate with an audience? How do I solve a problem in much the same way that a chair designer might have to solve a problem to do with materials?" Then you have a communication problem, or challenge, or task.

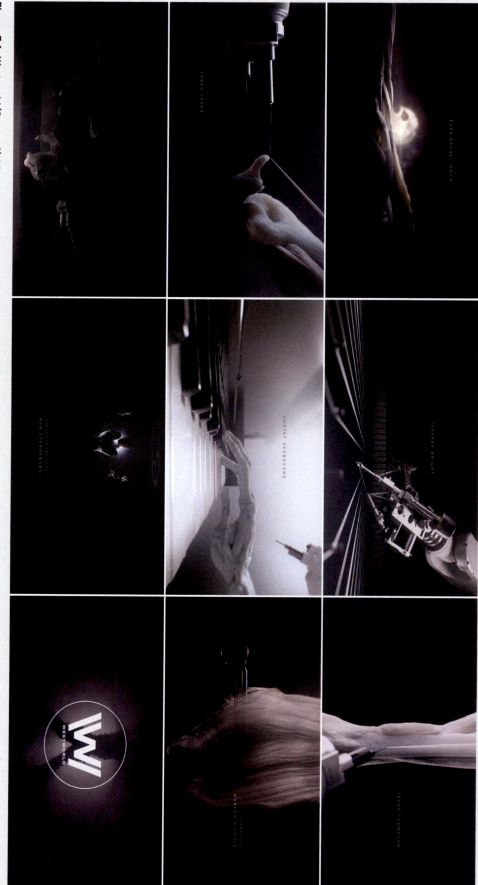

Figure 7.1: *Westworld* (Season 2) title sequence. Created by Elastic for HBO. Director: Patrick Clair.

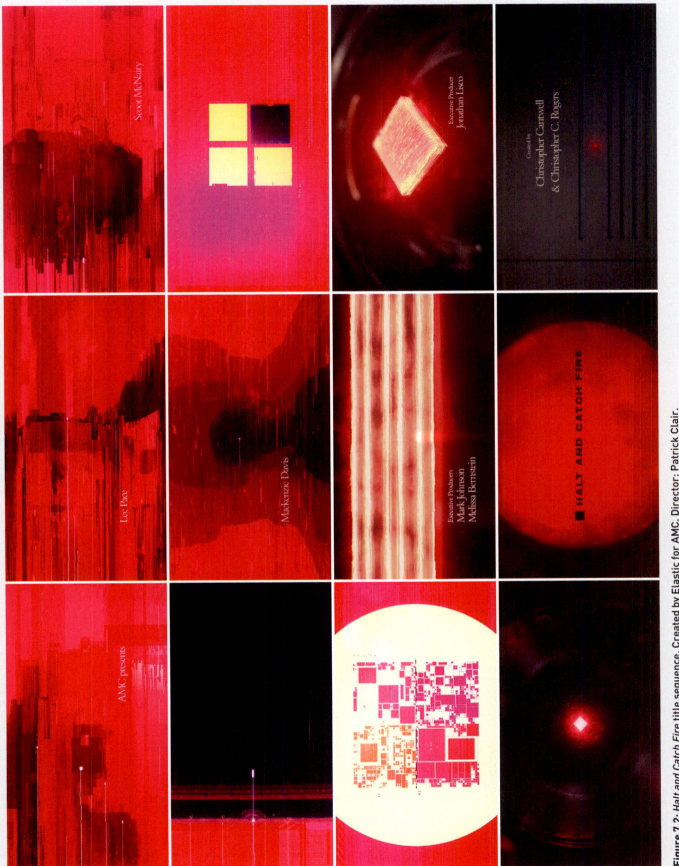

Figure 7.2: *Halt and Catch Fire* title sequence. Created by Elastic for AMC. Director: Patrick Clair.

In title design, it is to bring the viewers into the world of the show, in broad strokes. On a deeper level, it is about creating images that evoke the deepest, most fundamental, most interesting aspects of a character or a story in such a way that, your first time you experience it, it might be intriguing, but as you come to understand those characters as you watch more episodes, you need to make sure your title sequence is also able to take on deeper meanings and nuances for audiences. It doesn't mean hiding Easter eggs in it or anything, it just means getting to the fundamental truth of what is happening with that character in a way that gives the audience pause for reflection.

So, to do that, you really need to go through a process of *not just conceiving an idea, but articulating the idea*. It is always going to be a conversation back and forth between you and your client, whether that client is a creative director from an agency or a showrunner from a drama series. For them to buy your idea, to sign-off on it, and to give you the resources and opportunity to make it, it really is about articulating the idea to them, listening to their feedback and the information they can give you, reconceiving the idea, and really knowing what your idea is and rigorously challenging the idea, and the biggest part of that, is articulating that. Everyone does it in different ways. I do it with a lot of talking, but I also do it with a lot of written words, a lot of reference, sometimes sketches, sometimes design frames. I tend to start with combining reference; hopefully surprising reference with ideas and often from there go to sketches. I can't draw a stick figure to save my life, but I work with a storyboard artist who gets my abstract sort-of nonsense that I spurt, and they are able to translate that into pictures, and we are able to use those to get clients to come along on the journey with us and to believe in what we are doing.

Is writing important to your process?

I really do think that the articulating your ideas is fundamental to the craft. When you first come to writing, the temptation can be to use as many descriptive words as possible, and that's dangerous. It is something I fall prey to everyday of my life, but really, you want to make as simple and as clear as possible. I had a fantastic executive producer when I was working on a journalism project many years ago, and she said something to me that has been in my brain ever since, and it has become one of the truisms that I do my work by. She said, "If you can't describe your idea in a sentence, you don't know what it is." That is a really good one to keep coming back to because it challenges you to get to the core of your idea; not to let style get in the way of substance, not to let details skewer your purpose or what you're trying to communicate. Being able to talk about your ideas and articulate them on paper using visuals and words is key to being successful in this field.

Writing was part of my training at film school, and I wrote some pretty terrible short film scripts. Then I went to the other end of the spectrum, the opposite of academic writing, which was writing voice-overs for MTV. In that sense, the relationship of the words and the visuals have always been part of what I do. The stuff that first got me work beyond Australian shores was documentary stuff—some of which I had written and some of which I hadn't, all of which definitely involved a really symbiotic relationship between voice-over, text on screen, and graphic design. So, I think I was lucky in that sense that words were always part of the mix for me.

I think if people aren't naturally wordsmiths, that is not a problem. The challenge is not so much writing; the challenge is articulating your idea. You may do that with a few pages of reference and six words. It's really more about understanding conceptually what you are trying to do and what you are trying to say.

What is your concept development process like?

My process starts with ideas and from there it goes to reference. I try to have researchers who are really thorough. I tend to find that younger, hungrier researchers are better because, as you

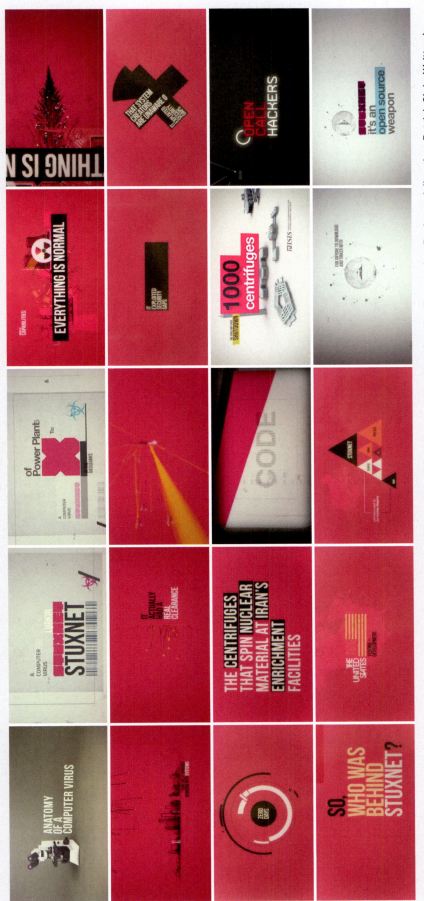

Figure 7.3: *Stuxnet: Anatomy of a Computer Virus* infographic. Created by Zapruder's Other Films for Australian Broadcasting Corporation. Design and direction: Patrick Clair. Written by: Scott Mitchell.

get on with your career, you lose patience to dig through endless websites. The energy that comes with being early in your career is really beneficial to research. The process tends to follow that. I will write down a number of things I want to have image pulls of. You want to not be derivative, but to pull inspiration from really different and unusual places. Once we have all that reference, I start to pull that together and draw associations between it, by putting it all into a presentation with things that interest me next to each other. There are often odd connections between things. That's when you start to see how it is going to come together. I

work with a storyboard artist for a day or two to pump out a bunch of sketches, to figure out the layout and visually communicate the story. Traditional style frames come in after that.

It's a combination of things. Obviously, it's a visual medium, so I try to drink in as much visual culture as I can through books, the internet, and all the rest. I think designers can get distracted doing that to some degree; I know that I certainly used to. I think the most important things to keep in mind are story, communication, and meaning, in a really simple, basic, and straightforward level. When I am approaching a concept these

days, it is really about "What is this trying to achieve? Who is it trying to reach, and how should I be speaking to them? What is the simplest way to bring my message to life visually? What is going to engage an audience and keep them engaged in a way that is not overcomplicated, indulgent, or style over substance?" It's really about the basics of the communication and storytelling.

What do you like about storytelling?

Storytelling is at the core of our roles in the film and television industry. I think it also applies to the work many of us do in advertising. All screen content is really storytelling, and it's easy when you are in the thick of making it to get distracted by aesthetics. But, ultimately our job is to have an impact on people and convey to them some information or some kind of emotional effect; to take them on a journey, engage them with characters, and engage them with story points. If you use that to guide your decisions, then you will end up with a stronger piece of work.

How did you come up with the visual language for *American Gods?*

I like to be overly literal. Sometimes just being as simple as possible with my thinking. What is the most American thing I can think of? An astronaut. What is God? God can mean a million different things, but I grew up in a Catholic household, so there were lots of crucifixes hanging around. So, I am like, "American Gods. Why don't we crucify an astronaut?" I am thinking there is no way they are going to let us crucify an astronaut on national television. But they wanted to do something thought provoking, without being offensive. When we did the presentation, I expected them to show us the door. But they were like, "This is great. What else have you got?" So, then we got to go on this conceptual journey of trying to come up with interesting mash-ups of Gods and modernity, or modern symbols. That was one of the most fun things I ever got to do. There was this idea in the 1990s that TV

was kind of safe. It's not safe. They are looking for bold ideas. You can play here with incredible freedom. Showrunners are hungry for ideas that push things further.

Do you have a favorite project?

True Detective. The director and the show runner were fantastic. I think it's really proof that good work comes from good clients. Most designers can do amazing work. You just need to find the right brief and the right client, directing you in the right way. They had a gift where they were able to make succinct, direct requests throughout the process. I think they got a sequence that they pretty much wanted. At the same time, it is a sequence that we can all feel ownership and authorship over. It was a great collaboration. I hope everyone gets to work on a brief like that, where you get the right idea, at the right time, for the right job, with the right people. I feel very lucky.

We chose the double exposure for a very particular reason. The way the drama of the show used landscape to tell the audience things about the characters. We thought we could mirror that idea of using landscape to build character. To do that visually, we literally used pieces of the landscapes to build visual portraits of the characters.

Do you have suggestions for young designers?

I spent the first 5 years of my career learning how to use all the different things in After Effects. Then, *I spent the next five years learning not to use them.* What I do now is use a couple of the most-simple elements, but I don't think I could have gotten to this point of being so confident using the simple stuff if I hadn't spent all that time making things unnecessarily complicated. The latest effect or latest trend won't make something good or better. It's good to know how all that stuff works, but eventually, you will find a couple of things you can trust. Often a simple bit of well-set type will do a job better than any plugin can generate.[4]

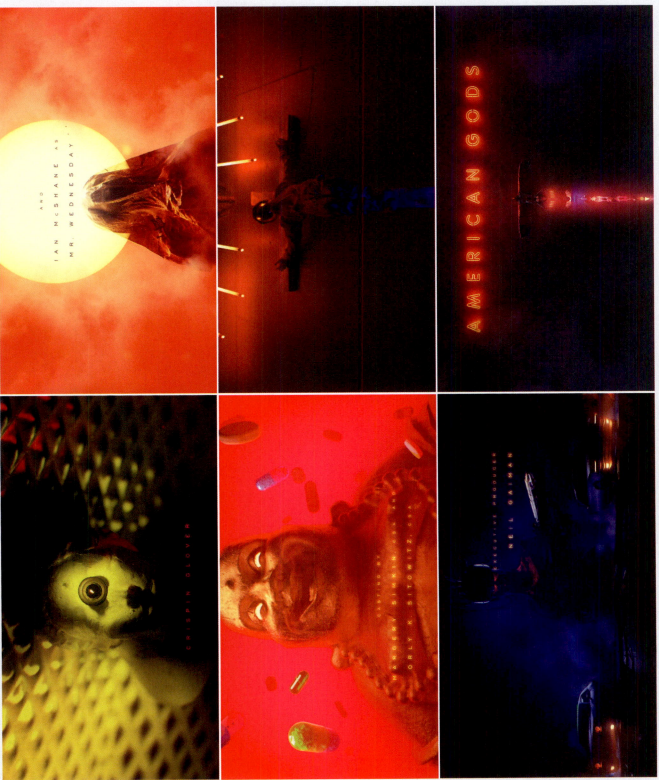

Figure 7.4: *American Gods* title sequence. Created by Elastic for Starz. Director: Patrick Clair.

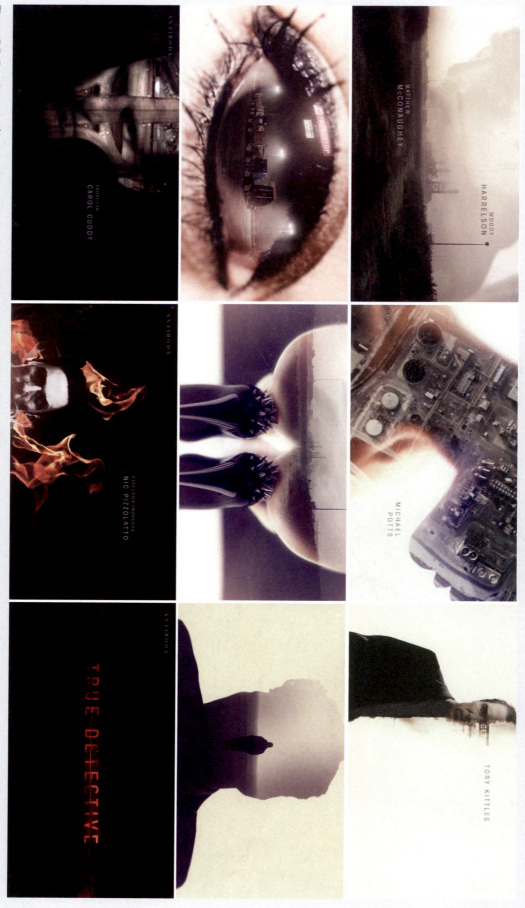

Figure 7.5: *True Detective (Season 1)* title sequence. Created by Elastic for HBO. Director: Patrick Clair.

Relationships & Trust

Part of winning a creative pitch is convincing a client that you, or the studio you represent, can be trusted with their project. First, a client must believe that you can deliver the project, meet deadlines, and stay on budget. A professional design deck, demo reel, and solid reputation can go a long way in building this kind of trust. However, there is more to client-driven creative projects than coming up with awesome concepts and design directions. In relation to presentations and pitches, how you present your work, and carry yourself in client relations, may be just as important as the quality of the work itself.

The quality of your presence during a pitch influences how your work is received. Of course, your creative solutions and designs must be appropriate and solve the needs of a creative brief, but a client is also evaluating if they actually want to work with you. In addition to whatever costs they are investing in a project, a client is also spending their time. There is an unspoken, yet vital threshold that must be crossed to be successful as a creative lead. Are you someone a client feels comfortable working with? When working with a client, you are working *together* to solve a creative brief. This process is a *collaboration* that requires mutual trust and respect. In addition to being able to meet the concrete needs and specifications of a project, trust is earned through *how* you collaborate.

All of your interactions with a client affect the creative relationship—from the very first pitch to long-standing creative partnerships. Are you reliable? Do you show up on time for meetings and conference calls? Do you pay attention to details and double check your work? Are you a courteous participant in creative discussions? Do you listen to what a client has to say, and ask questions that help the creative process? Or, are you just trying to do what you think is cool? Again, creative productions are a collaborative effort. It is extremely important to treat the client relationship as cooperative. You will get much further by inviting a client to participate in the creative process, then trying to force solutions.

"One of the mistakes I see in either young designers, or designers who are very talented but have not had the opportunity to advance up the ladder as far as they would like, is that when you are in the meeting and you see them presenting the idea and see it not being accepted either because it is not strong enough, or because it is style over substance, it's just something the designer wants to do, or because they haven't articulated it well—that can manifest itself as resentment. Even if they think they are hiding it, they are not hiding it very well. It is really important that young designers focus on managing and getting past, because if people feel that you are not listening to them or resenting their feedback, it is a sure-fire way for the relationship to go off track."[5] —Patrick Clair, *Designer/Director*

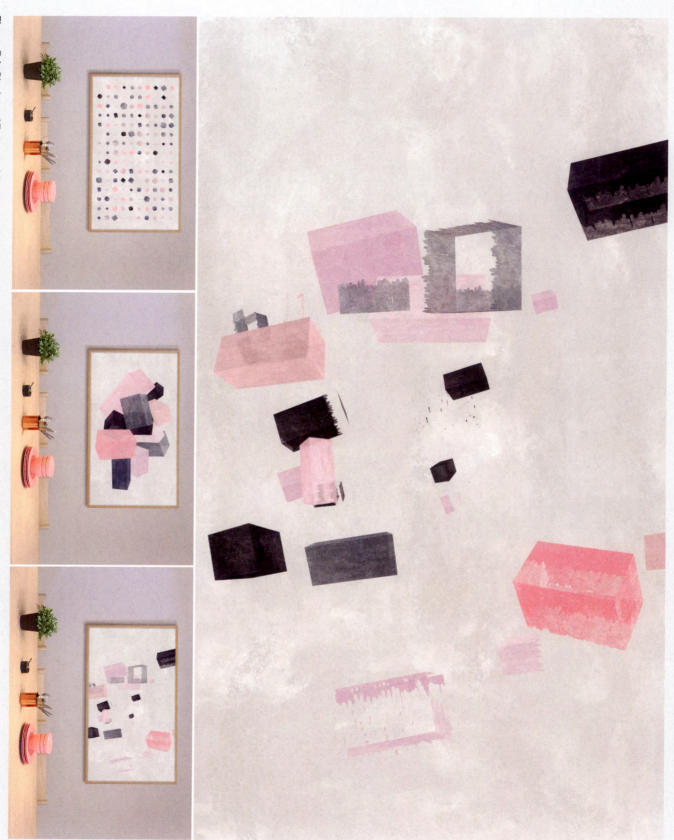

Figure 7.6: *Blocks and Textures* video art, by Carlo Vega. Commissioned by Microsoft—Alanna MacGowan and Stephen Bader.

Professional Perspectives
Carlo Vega

"I often try to create art with strong rules, constraints and slow movement. It helps me reflect and make a visual comment on the fast-paced Motion Graphics work that's used in commercial projects. This video art piece, *Blocks and Textures*, repeat the same cube element. The cubes slowly rotate, draw on, and draw off, endlessly transforming into one another. It has no start and no end; it's an endless hypnotic loop of a single shape morphing." [6] —Carlo Vega

Carlo Vega is an independent creative director, designer, and animator. He works fluidly between art and design, constantly creating work that inspires the creative community. Carlo has built a strong reputation in the motion design industry. But even more impressive is his passion and dedication to creating his own professional path.

An Interview with Carlo Vega
How did you become a motion designer?

I became a designer strictly by luck. I never intended to be one. My plan was to paint. I wanted to be a painter, and I wanted to be an artist. I was in it to create things. I opted to go to a university instead of an art school because I wanted to take a variety of classes. I took classes like Advanced Calculus and Latin American Literature where we would just read books in Spanish. It was fun because I like to do different things. Late

in my schooling, I took a class in graphic design. I found it interesting, and it came naturally to me. They were teaching me tools to do print design, but that didn't do it for me. During my senior year of college, we went on a field trip to a web company. I started asking questions about the tools they were using, and after the tour, the creative director offered me an internship. I negotiated it into being a job. I worked full-time until I graduated.

After I graduated, I moved to New York. I ended up working at a variety of inspiring digital agencies and motion graphics studios. At first, I was doing motion for websites using Flash. But, I remember after about a year of doing that, opening After Effects for a project. That changed everything for me. I was like, "What's the point of doing Flash?" From that point on, I wanted to focus more on motion. I moved to production companies that gave me that opportunity. Everywhere I went, I found small, talented, young, and naive teams. We were overworked and underpaid. It's very different than now. Now you have so many companies doing motion. Back then there was only a handful of decent places that one wanted to be associated with.

After bouncing around in a few places, I started to feel like I did not want to work at a company. So, I left, and started working on my own. I really felt that if I was going to design, animate, and creative direct to make money, I would like to do it on my own terms. I feel like that was the moment that

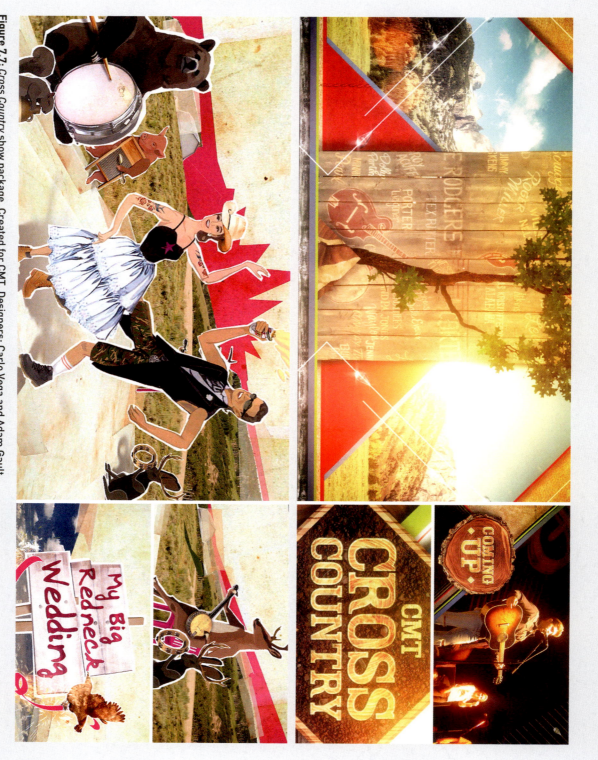

Figure 7.7: *Cross Country show package. Created for CMT. Designers: Carlo Vega and Adam Gault. My Big Redneck Wedding show package.* **Created for CMT. Designers:** *Carlo Vega and Adam Gault. Illustrator: Stefanie Augustine.*

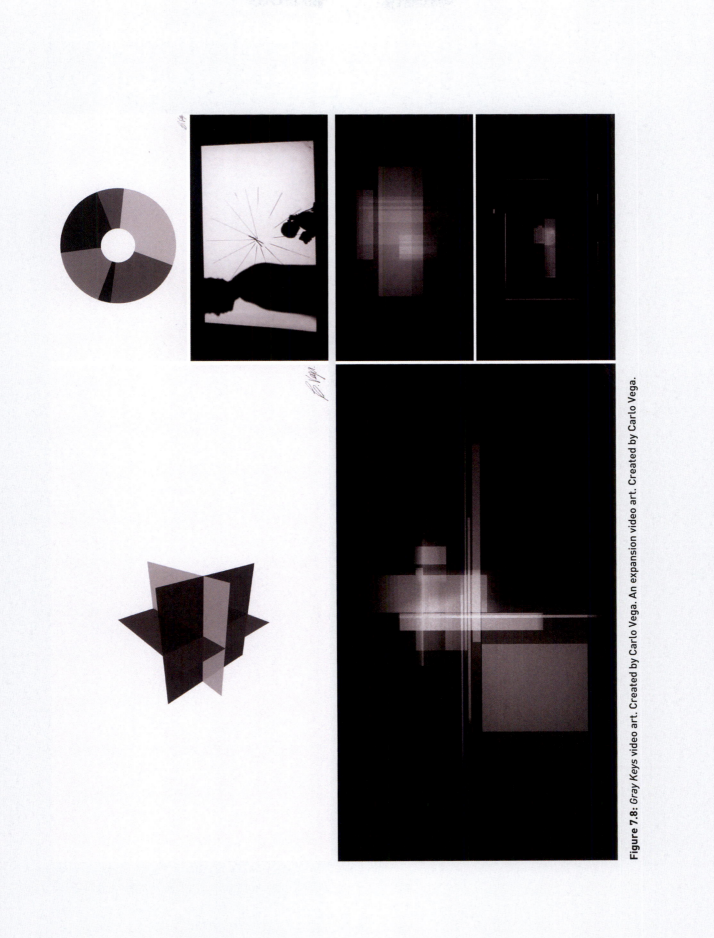

Figure 7.8: *Gray Keys* video art. Created by Carlo Vega. An expansion video art. Created by Carlo Vega. Created by Carlo Vega.

my career as a creative professional really started. I made a conscious decision to work things my own way. Before that, it was all about making money and doing my own experiments and painting. The experiences at different companies and the people I met were very important for me, but I wanted to do things my own way.

My approach is to make things enjoyable and realistic while creating relationships with clients that are collaborative and long-lasting. That's how I started my career as a designer, designing everything from websites to postcards, video work, commercials, rebrands, network rebrands, and shooting live-action campaigns for companies.

What do you enjoy most about motion design?

Ongoing, direct-to-client relationships are very rewarding. My process is to develop a partnership with my clients. I am helping them accomplish something they want to do. If we are going to do it, we are going to do it together. If we succeed, we succeed

together. If we fail, then we fail together. I enjoy all aspects of this interaction very much.

Do you have any suggestions for young designers looking to develop client relationships?

Help the client to organize ideas, and make these ideas come out in a clear way. It's important to start conversations about what the project will be doing. Then references can be suggested. I had to learn how to read client briefs and to talk to clients. Making sure we were on the same page, showing them references, hearing them out. I try to have conversations to create constant communication. You have to have conversations about a project if you are going to solve their problem in a creative way. You have to collaborate if you want the client to be happy in the end. It is a partnership, and it's teamwork. That's what I love about doing projects with clients. I don't just look for cool projects, but ongoing creative relationships.[7]

How To Make Process Books & Design Decks

Figure 7.9 shows selected pages from a PDF design deck for the titles of *Matador*. The design of the design deck is clean, clear, and consistent. Relevant project and contact information is included as well as the style frames. Although this design deck was delivered in a digital format, the inclusion of wooden textures, tactile elements, and a hand-written signature creates a unique and personal touch.

Process books and design decks need to look professional. Their design should feel clean, simple, and organized. As containers for creative content, the design of process books and design decks should never compete with the content. Be very careful not to be heavy-handed with textures or bright background colors. The design style should be supportive of whatever content is placed into the book and consistent throughout the entire document, including choices about typography, layout, and color.

Typography

Typography should be limited to no more than a few typefaces. You can work with a single typeface and vary the weight and/or point size to create a hierarchy of visual importance. Bold or heavy font weights can be used for headers, whereas regular or lighter font weights can serve for body copy. You may also consider using a *display* font for your headers—a typeface that has a little more personality. For body copy or lengthy written descriptions where legibility is important, a utilitarian or functional font is most appropriate. A common mistake for beginners is to make typography too large in their process books. When type is too large in a process book, it appears unprofessional as the copy appears to be competing with the content for the viewer's attention. Look at strong graphic design layouts for reference about how to size your type.

Layout

Negative space is extremely important in both process books and design decks. Always leave a healthy amount of visual space on all of the edges. Be careful not to squeeze the layout by having visual information too close to the sides, top, or bottom of a page. The eye needs room to breathe, and too much clutter will make it hard for a viewer to know where to focus. Classic graphic design principles apply to the design of process books and design decks. For example, working with a *grid system* will help to keep design elements aligned and proportionately spaced from each other. Most digital art software has the option to toggle visibility of a grid.

Color Palette

For color, a neutral palette is a good starting place. Use bright or highly saturated colors sparingly. They should be reserved for highlights or visual accents. Again, the design of process books or design decks should be supportive of its content. Color can easily distract from or alter the appearance of the work being presented. Black, white, and shades of gray work very well for process and design decks. For typography, contrast is an effective way to be sure your copy is legible. As a general rule, use darker type over a light background or lighter type over a dark background.

Clear Communication

Process books and design decks need to communicate certainty, and the design style should support this idea. The cover page should be simple and clear. For a process book, include information such as the title of the project, the date, and your personal branding on the cover. A design deck will usually include the client's logo on the cover as well. Depending on the length, process books and design decks can also include a table of contents. Subsequent pages are usually numbered and have consistent headers, footers, and text styles. A simple "Thank You" page at the end of a process book or design deck is always a

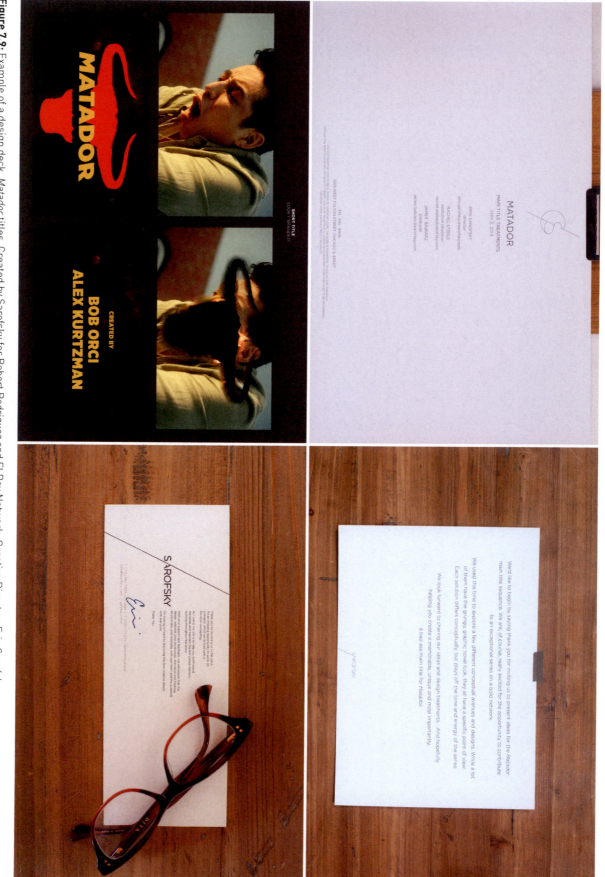

Figure 7.9: Example of a design deck. *Matador* titles. Created by Sarofsky for Robert Rodriquez and El Rey Network. Creative Director: Erin Sarofsky.

are multiple creative leads. A blank template for the design deck will usually be saved on a shared network for easy access. Adobe InDesign is great for creating such a template. The master page option allows you to create a variety of style pages that can be easily duplicated and versioned.

Always Be Professional

Creating a process book can elevate the professional appearance of your work. It is also great practice for developing presentation skills. The focus should be to create a clean and organized layout that can best showcase your creative work. Do not be overly concerned with your personal branding; it will develop over time. You can always update the layout and design of your process book in the future.

nice message to send to clients or viewers. Also, do not forget to proofread or spell check your copy! This advice may seem self-evident; however, students constantly present work with spelling and grammar errors. In a professional setting, these mistakes can appear amateurish or convey a lack of interest in a project to a client.

Creating Templates

Creating a template for your process books or design decks is a really good idea. A template will make your workflow for creating presentations more efficient. Design studios also use templates to maintain consistency. In a studio setting, creative directors or art directors usually create the design decks. Using a template ensures the design of design decks is uniform, especially if there

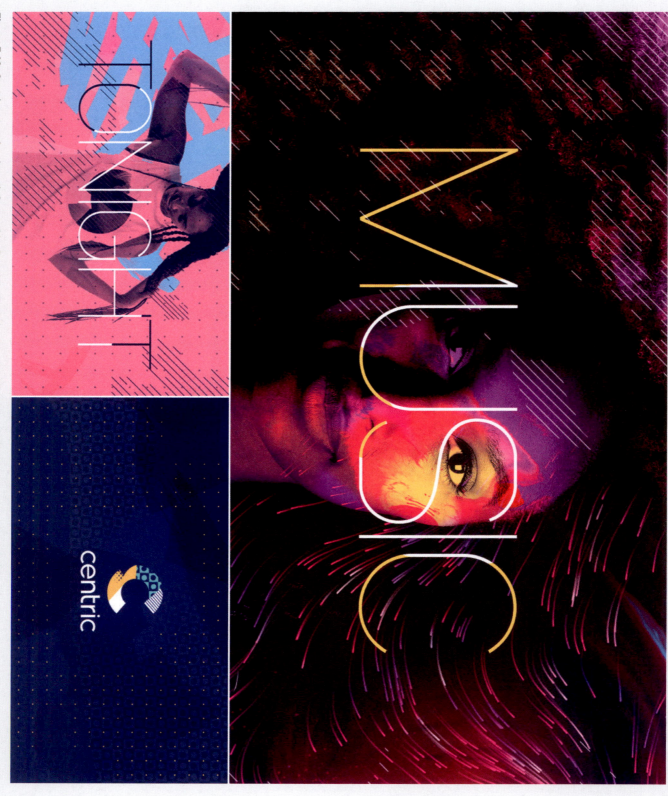

Figure 7.10: *Centric network rebrand. Created by Gretel for Centric. Creative Director and Designer: Lauren Hartstone.*

Professional Perspectives
Lauren Hartstone

Lauren Hartstone is an Emmy-nominated creative director, designer, and live-action director in New York. She specializes in thoughtful storytelling and compelling visual identities for a wide range of brands. Lauren's aesthetic balances minimal and graphic with playful and emotive. Clients include Google, Ford, HBO, BVLGARI, CBS, TNT, Coach, Paramount Network, and Pepsi. Lauren's work has been recognized by Creative Review, Brand New, IdN, Fast Company, and PromaxBDA.[8]

An Interview with Lauren Hartstone

What is your art and design background?

I went to Washington University in St. Louis where I majored in Visual Communication. The program provided me with a foundation in graphic design, with a strong focus on print and typography. I loved my experience there, and even though I didn't have the opportunity to study motion, I think in some ways having a more traditional or formal design training has helped shape my approach and aesthetic. My junior year, I had an internship with VH1's off-air print department, and over the course of the summer, I got to know some of the people in VH1's on-air department. They were so nice and helpful, walking me through their work and the programs they used. They showed me how with the addition of time and sound I could bring my work to life, and in that moment, everything changed. When I went back to college for my senior year, I knew that I wanted to work in motion.

How do you develop concepts?

I write down my first ideas, even the terrible ones. Then I research, pull references, and start to hone-in on what the best ideas are. I try to narrow it down to two or three really good ones. I will work with other designers to pull things together. We will print things out and put them up on a bulletin board—circle things, tear things down, and write additional thoughts. Once we have the main concepts developed, then we will start designing.

What do you like about motion design?

I love the creative challenge. Whether it's telling a story, setting a tone, or communicating a brand, I love that every job is different. I could be designing something very graphic one day and filmic the next, and I love that I still learn something new on every single project.

How do you approach presentations?

Presenting is really interesting, because it doesn't matter how good the idea is, if you don't sell it right, you probably won't win the pitch. Literally, half of the work is how you build the presentation—the sequence and layout of the frames, the writing, the tone, how you lead someone through the idea. You can put six frames on a page and just show that, or, you can build a presentation that really reflects the tone of the idea on every single page and walk them through your process. These days, everyone has access to the best reference—it's all so easy to

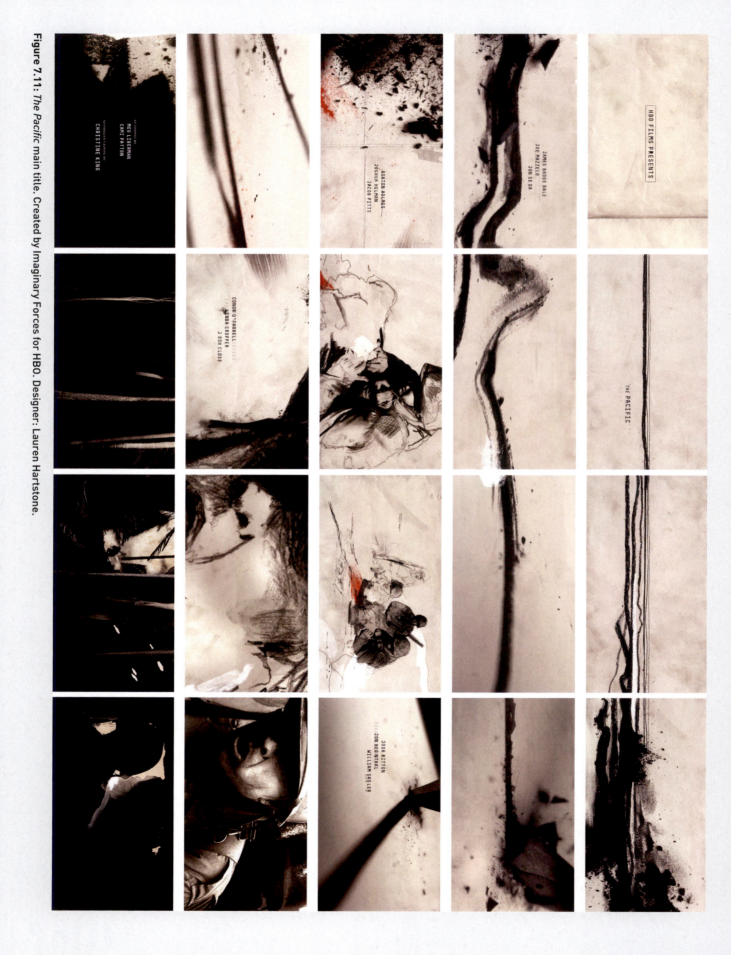

Figure 7.11: *The Pacific* main title. Created by Imaginary Forces for HBO. Designer: Lauren Hartstone.

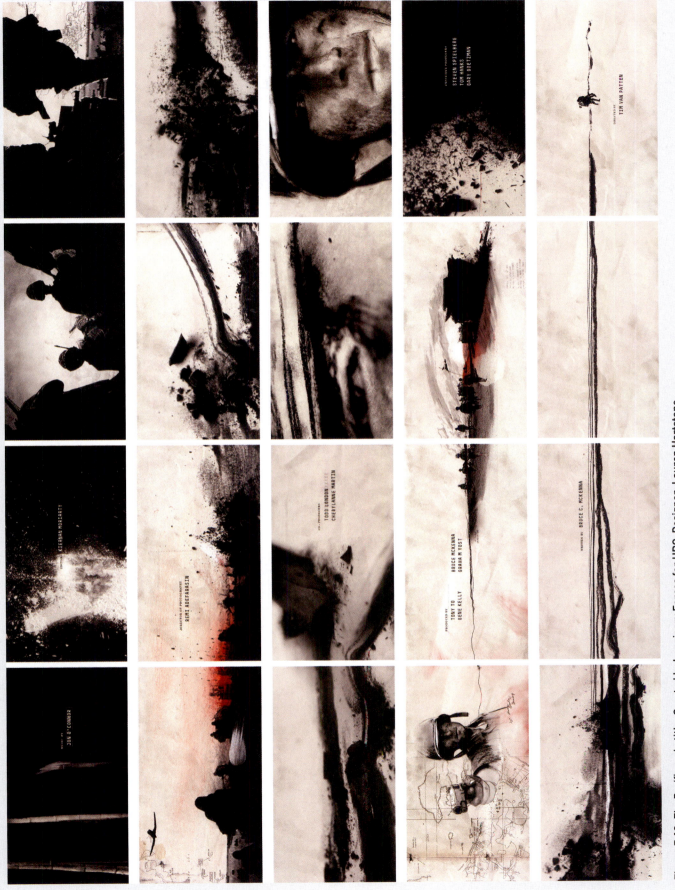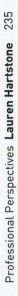

Figure 7.12: *The Pacific* main title. Created by Imaginary Forces for HBO. Designer: Lauren Hartstone.

access online. So, your idea *and* the way you present it have to play a much bigger role.

Do you have any suggestions for young designers?
Keep designing, illustrating, experimenting, and diversifying your portfolio. Don't get caught up with one specific niche. I think that will make you more desirable, particularly if you don't animate as well. I never try to retrofit a style into job. It's not about what style you want to do, it's about what works best to solve the problem. I do the style that is the best solution to the job. So having the ability to do a little of everything really helps. I would also urge young designers to learn from every single person around you—animators, 3D modelers and lighters, illustrators, DPs [directors of photography], production designers. Ask them questions and soak in what you can whenever you can. And lastly, when you are designing a storyboard, try to think about the whole picture. Usually, you are creating a narrative or sequence, not a poster. Make a ton of frames, and look at them collectively. Change them as you go. If you get too caught up in noodling with one frame, you will lose sight of the bigger picture.

How did you get into directing live-action?
I really stumbled into it at Imaginary Forces. I was designing a brand for the Canadian network Dusk, and live-action was the

only way to really get my idea across. I co-directed it with Mark Gardner, and I remember that day so well because it was another one of those moments where I knew immediately that this is what I wanted to be doing. I loved everything about it—working with the props and miniatures designer, figuring out the lighting with the DP, the whole experience of being on set and making my frames come to life. It was incredible. Since that shoot, I've had the opportunity to work on several others—big and small—and each one has taught me something new.

Do you have a favorite project?
That is a very difficult question. *The Pacific* is still one of my all-time favorites. It had so many aspects to it—design, illustration, live-action, typography, and most importantly a really compelling narrative. And, I worked with an amazing team of people at Imaginary Forces. Another favorite would be the Google Chromebook project I worked on at Gretel. We partnered with Google's Creative Lab for an experiential take-over of Times Square for 3 full days. There were 9 buildings, all with several screens, and we were tasked with creating 15 minutes of unique content for each building. All of course during Hurricane Sandy—so that in itself was an experience. It was a really fun and very different kind of project for me.⁹

Figure 7.13: Google Times Square. Created by Gretel for Google Creative Lab. Associate Creative Director and Designer: Lauren Hartstone.

Notes

1 Fong, Karin, telephone interview with author, August 5, 2014.
2 Rugan, Robert, telephone interview with author, May 8, 2014.
3 "Patrick Clair." Artofthetitle.com. August 25, 2014. www.artofthetitle.com/designer/patrick-clair/.
4 Clair, Patrick, telephone interviews with author, August 13, 2014, and July 9, 2018.
5 Clair, Patrick, telephone interview with author, July 9, 2018.
6 Vega, Carlo. "Copy for Book." Message to the author. September 30, 2018. E-mail.
7 Vega, Carlo, telephone interview with author, May 12, 2014.
8 "About." lhartstone.com. December 28, 2018. http://lhartstone.com/about/.
9 Hartstone, Lauren, telephone interview with author, May 10, 2014.

Chapter 8:
Creative Briefs for Portfolio Development

"Every illustration, image, object, design, or building that has a visual style involves a rejection of all but a select few options. Be it the rejection of all the colors in the rainbow except for cool blues and warm yellows or the simplification of form, stylistic invention begins with reduction. If it were not for that, all images and designs would simply look like photo-collages, mish-mashes of everything, including the kitchen sink. This, in fact, is one of the common mistakes of beginning designers; constantly adding more and more elements in the hope that something works. It is reduction that not just amplifies a design, but also makes it quickly identifiable in the world. Amplification is the selective prioritizing of one or more elements over all the others, be it through scale, exaggeration, repetition, or other devices. The paintings of Vincent van Gogh are marked by the amplification of brush strokes. The Volkswagen is marked by its amplification of near-circular curves. The opening title for the feature film *Se7en* is marked by its exaggeration of hand-drawn writing."[1] —James Gladman, *Professor of Motion Media Design, Savannah College of Art and Design*

Style

A visual style is comprised of creative borders, boundaries, and parameters. A style comes alive when a recognizable visual pattern is created. This pattern serves as the overall framework for the look and feel of a piece. Fundamental qualities such as color, material, medium, line quality, and scale as well as choices about cinematic qualities all contribute to a style. The goal is to create unique visual styles that stand out and connect with audiences. However, a visual style should emerge from a concept and should also serve to express that concept. In other words, the style is the form, and the concept is the function.

Clearly Defined

Definitive choices are required to create a visual pattern. Once a visual pattern has emerged, each subsequent frame or visual element in a project needs to feel like it belongs within the overall style. Of course, each frame in a project will be different. Compositions change, cameras move, and narratives unfold. However, a recognizable visual pattern is needed to carry the viewer seamlessly through the piece. If the change in visual patterns is too abrupt, it will cause the viewer to disconnect.

Stylistic Range

To be a successful designer for motion, you need to be able to create a range of visual styles. This flexibility is where a designer for motion differs from a traditional illustrator. Rather than specializing in one distinct style, designers for motion can adapt to many different creative briefs. A strong foundation in compositing is essential to achieve this range; hence, the previous exercises in compositing are suggested. Mood boarding can help to inform the direction for a visual style, but, ultimately, you need to be able to create a defined look and feel for a project. You need to have both a solid understanding of image-making principles, as well as proficient technical abilities. With these skills, you can design across a dynamic spectrum of styles.

> **"The people we tend to look for have a nice range of styles. They don't all have to be good, but what that proves is their willingness to go outside of their comfort zone and try something new."** [2] —*Will Johnson, Gentleman Scholar*

Using the Exercises

In addition to showcasing and exploring the variety of visual styles utilized in motion design, the following chapters can be used as creative briefs, each with specific aesthetic constraints. These exercises are designed to help you to expand your comfort zone and to practice your craft by taking you through Design for Motion projects from *kick-off* to *delivery*. These briefs can be modified according to your needs or goals. However, the general purpose of each exercise is to kick-off a creative brief with a prompt.

Prompts to Kick-Off Creative Briefs

The prompt is a jumping-off place for a concept and can be interpreted in any number of ways. A prompt can be as simple as a single word, chosen indiscriminately, or through something like a random word generator. The prompt serves to construct

a framework for creative problem-solving. Below is a list of sample prompts that I use to kick-off creative briefs/exercises. I often shuffle the pairing of prompts with the various stylistic constraints every time I teach a Design for Motion class. The goal of these exercises is to develop strong concepts and visual styles regardless of the prompt or stylistic specifications. Feel free to apply prompts to different assignments as you practice creating style frames and design boards. Additionally, you can come up with your own prompts that inspire interesting concepts. Look for words that are potent with meaning and have a wide range of interpretation.

- Revolution
- Hipster
- Serenity
- Alchemy
- Mythology
- Love
- Primal
- Surreal
- Nature
- Invasion
- Wayfarer
- Dreams
- Fable
- Nostalgia
- Re-mix

Schedule & Deadlines

To best model industry practice, work with specific deadlines. A deadline will force you to make decisions and eliminate procrastination. Time management is a vital skill for a motion designer, and learning to budget your time wisely will help produce the best results. Do not wait until the last minute to start

your project. Otherwise, you will feel rushed and your work will suffer. Do not worry too much about finding a solution as soon as you begin. This kind of pressure will cause you stress and remove the fun.

The default timeline for each exercise is 1 week. This deadline may seem like a fast turnaround, but it is actually rare to have this much time to work on a design board in the industry. Working at this pace will help to prepare students for the fast-paced demands of professional commercial art. If working in a classroom setting, it is suggested to have a couple of *midpoints*, or reviews, during each project.

The first day or two should be spent on concept development and brainstorming. By mid-week, an initial style frame should emerge. The rest of the style frames and the design board should be fleshed out and compiled into a process book for delivery by week's end. I often require students to post work-in-progress to a group web space halfway through a project. This deadline helps them to manage their time and ensures that they are not waiting until the last minute to start working. It also gives them the benefit of giving and receiving feedback. This practice keeps the connection of the class persistent outside of the classroom. Constructive critique and direction can be offered during this time.

If your class meets often enough, it is helpful to have a studio session to give specific feedback or demonstrate helpful techniques. Of course, the amount of time dedicated to each exercise could vary depending on your class and skill level. You can complete creative briefs in shorter or longer time frames. Speed alone should not be the goal. I always stress quality over quantity. However, it is a good idea to get familiar and comfortable with realistic industry timelines.

I often use the metaphor of gesture drawing while describing the *kick-off to delivery* concept to my students. When you create a gesture drawing, you begin by loosely analyzing the essential shape and form of the subject. If you are doing a gesture drawing of a human figure, you work quickly to rough out the primary directions of the x-axis and y-axis. You find the central line and movement of the spine. You see and draw the direction of the shoulders and hips. Gesture drawings capture the energy of a scene or subject in a fast and efficient way. You do not worry about details during the gesture phase of a drawing. Rather, you work on roughing out the entire composition in a connected manner.

Once the overall shape has been defined, you pause and begin to work on the values of light and dark in a broad-stroke manner. You continue in this way until you reach the point where the composition is strong. You gradually slow down and finally begin drawing the precise details. Design for motion projects should be approached in a similar way. Begin loose and free until your concept has a solid shape and form. Then gradually slow down until you put the finishing touches on your project.

Aspect Ratio & Size

An *aspect ratio* is "the ratio of the width of a television or motion-picture image to its height."[3] Style frames have traditionally been designed in either 4:3 or 16:9 aspect ratios, which correlate to Standard-Definition television, High-Definition television, and film. As the need for motion design has grown into other venues like the web, mobile devices, social platforms, digital signage, and projection mapping, the variety of aspect ratios has increased. In addition to horizontal screens, motion design is being displayed in vertical, square, and multi-screen layouts. The expansion of screen space is great news for designers, as opportunities to work professionally across a range of creative industries continues to grow. Good default sizes to work with for these exercises are horizontal 1920 × 1080 pixels, vertical 1080 × 1920 pixels, and square 1080 × 1080 pixels. Feel free to vary from these sizes if a concept or style lends itself to an alternative aspect ratio.

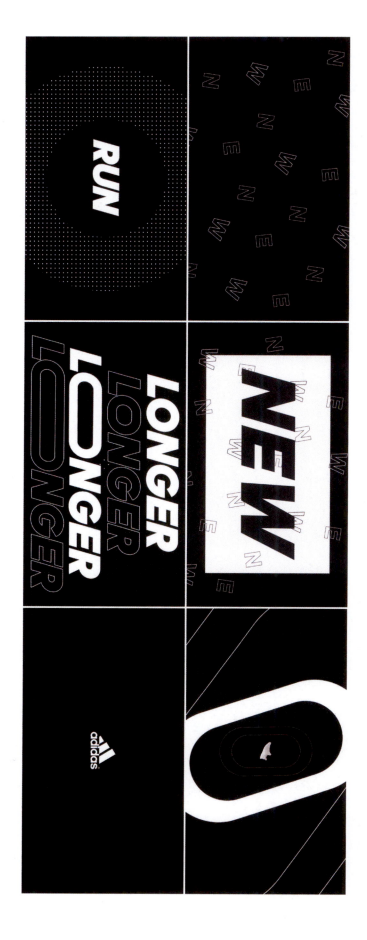

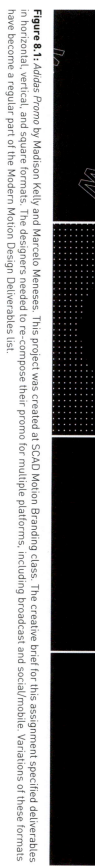

Figure 8.1: *Adidas Promo* by Madison Kelly and Marcelo Meneses. This project was created at SCAD Motion Branding class. The creative brief for this assignment specified deliverables in horizontal, vertical, and square formats. The designers needed to re-compose their promo for multiple platforms, including broadcast and social/mobile. Variations of these formats have become a regular part of the Modern Motion Design Deliverables list.

Figure 8.2: *Adidas Promo* by Madison Kelly and Marcelo Meneses. This project was created at SCAD Motion Branding class. The creative brief for this assignment specified deliverables in horizontal, vertical, and square formats. The designers needed to re-compose their promo for multiple platforms, including broadcast and social/mobile. Variations of these formats have become a regular part of the Modern Motion Design Deliverables list.

Figure 8.3: This style frame is an example of an extra-wide aspect ratio. Created by Stephanie Stromenger, Freelance Designer. Style frame created at SCAD Design for Motion class.

Alternative Aspect Ratios

Once we become well-acquainted with the practice of making style frames, we can try experimenting with alternative aspect ratios. Panoramic or extra-wide style frames can be very fun to design and have the potential to make a strong impact on the viewer. Extremely wide frames can allow us to create depth, dynamic compositions, and suggestions of camera movement. From a business perspective, an epic style frame that is extra-wide can make a favorable impression on a client and thus, win a pitch. However, if we are working on a commercial project, we need to make sure that everyone is on the same page. We may have to explain that the alternative aspect ratio is meant to exaggerate a specific mood or indicate camera movement.

The aspect ratio and size of style frames should be created at least as large as the specification of a motion project. If you are designing for an HD 1920 × 1080 piece, then your style frames should be at least that size. This makes it easy to prep and save design assets from your style frames to be used directly

in production. If you make your style frames larger, you will give yourself, or your animator, the option of scaling up or pushing into elements. However, larger image sizes can have some drawbacks. Your file size and source elements will need to be larger, as well.

Practice and experience will train you to gauge the sizing needs of projects. As long as you work at the required size for delivery, you should be fine. Always double check the creative brief of any project for the needed aspect ratio and size. If the needed size is not clear, ask your client to clarify. You can lose a lot of time and energy if you begin working on a project at the wrong size.

Number of Style Frames for Design Boards

For the exercises outlined in this textbook, you have options for the number of style frames per design board. In the industry, unless specified, there is no set number of style frames. Some pitches can be won with a single style frame, whereas others may need dozens to win the job. To reap the most benefit from these exercises, put the same amount of effort into a project

regardless of the number of style frames you create. On average, a 30-second commercial requires 9 to 12 style frames in a design board. This is a good number to begin working with for each of the assignments.

However, you may vary this number to accommodate a concept or stylistic direction. An alternative is the pen and paper approach.[4] This method involves creating one or two extremely detailed and time-consuming style frames that are accompanied by a set of hand-drawn storyboards to describe the narrative. If you choose to create a single frame for an assignment, you should invest as much time and energy into that single frame as you would for a design board with twelve style frames. This sort of epic style frame should be like a matte painting in terms of depth and detail. Alternatively, you can create something in between. You may create three to five panoramic style frames that are extra wide to indicate camera movement or to make compositions more dramatic. Again, as long as the effort is equal for each project, feel free to experiment with alternative aspect ratios and the number of style frames per design board.

Practice Kick-Off to Delivery

Begin each project by dedicating time to concept development. Even with a really short deadline, you can spend time coming up with ideas. For instance, if you only have 1 day to create a style frame, you might spend the first couple of hours on ideation and mood boarding, then transition to designing the frame once you have a solid concept. You may feel compelled to run with the first idea that pops into your head. However, do your best to devote some quality time to concept development as this greatly increases your chance of producing strong outcomes.

With each creative brief, as your concept begins to take form, write a treatment or script for your project. Think about the kind of story you want to tell. Remember to use contrast to create dramatic tension in your narratives. With the shape of your concept in mind, seek external inspiration and create a mood board. Once again, try not to worry about the outcome of your project. Rather, seek to be inspired. As your concept develops, begin working with thumbnail sketches to explore the compositions of your hero frames. Do not be too precious with your thumbnail sketches and do not be afraid to make a lot of them. The more time you spend working out strong compositions during this stage, the better your style frames will become.

The next step is to begin sequencing your thumbnail sketches into a hand-drawn storyboard. The hand-drawn storyboard helps you to visualize your narrative as you block out events and action. Although you are still exploring the look and feel, you eventually need to arrive at a defined style. When this happens, repeat the visual style across a series of style frames that will become your design board. Check to see that every style frame feels like it belongs in the design board. Transition frames will help to maintain continuity. After you have applied finishing touches to all of your style frames, arrange them into a design board. The layout of your design board should be clean and professional. Use guides, grids, or templates to ensure your style frames are aligned proportionately.

Once you have finished your design board, construct a process book to document your project. As you approach the delivery of the project, slow down and double-check your work. Proofread your writing and use spell check to catch any errors. This is the time to really focus on details and make sure everything appears professional. Include the highlights from your concept development, design development, and final outcomes in your process book. Creating process books will give you practice in the construction of professional design decks as well as providing you with content for your portfolio.

Design Book

In relation to portfolio development and practical usage, a *design book* is an excellent tool for a designer for motion. Traditionally, a design book is a literal book of a designer's best work, packaged in a carrying case, also known as a portfolio. Of course, analog portfolios are still in use today and can certainly make a strong impression in an in-person interview or meeting. Indeed, the tactile nature of a physical portfolio has the potential to capture attention and engage a reviewer. However, it is highly suggested to also have a digital version of your portfolio in the form of a website. Your portfolio website can be viewed by anyone, anywhere, as long as they have an internet connection. As a designer for motion, you can take your professional outreach even further with a digital design book.

A digital design book can be as simple as a curated PDF file of your best work. You want to show a range of the type of work you like to do. However, be sure to only include the very best of your work. In the case of a design book, less is more. The goal is to make a strong first impression that inspires the viewer to want to see more, either driving them to your website or prompting an in-person meeting. A PDF design book is an excellent marketing tool because you can easily showcase your work. You can send your PDF design book to a potential employer or talent coordinator as an attachment in an email. You can also store a photo album of your design book on your smartphone for quick viewing at industry events, such as conferences or meet-ups.

Professional Perspectives
Gentleman Scholar—William Campbell & Will Johnson

Gentleman Scholar is a production company. We are a band of like-minded storytellers and solution-driven artists held together with advanced technical understanding. Together we have extensive experience in strategy, live-action production, animation, digital, and print. Above all, we believe in hard work, honesty, and that nothing is more important than loving what you do. We have shared the same vision since forming Gentleman Scholar in 2010: to create a collective of artists who share their love for creation and an eagerness to push the envelope. Today, our family is an ever-growing representation of just that. From the technically savvy to the narratively inclined, our team represents the best of the design universe. And frankly, we like them a lot.[5]

An Interview with Gentleman Scholars William Campbell and Will Johnson

What is your art and design background?

William Campbell: I have a background in photography and cinematography. I got into animation for the independence of it. With film, it took so many people to see a vision come to life. With After Effects, I was able to see my vision come to life with my own hands. It felt closer to photography or painting in a traditional art

kind of way. I think that attracted me to bring more traditional art and techniques into this field.

Will Johnson: When I was younger, I was really into architecture, and I was following that path. I didn't realize how many avenues could follow the structure of architecture and incorporate fine art, style, and personality as well. So I ended up following a techno-graphic, graphic design, flatter, type-infused, design-driven format. I fell in love with the idea of bringing a message to life in animation. I became obsessed with keyframes.

Where did you guys meet?

Will Johnson: We met at SCAD and immediately became mortal enemies. It was the competitiveness that we both had. Campbell's work was really awesome, and we went at each other during presentations and critiques. We ended up somehow working together, again, once we left SCAD. At Superfad, we were forced to work on a project together that we both got to art direct. It was for Target: a 2D–3D artistic representation of slam poetry called *Art Connects*. Once we realized we could use each other to benefit and strengthen our own core values, we immediately took off. We ended up graduating from Superfad and moving on and wanting to experience something on our own.

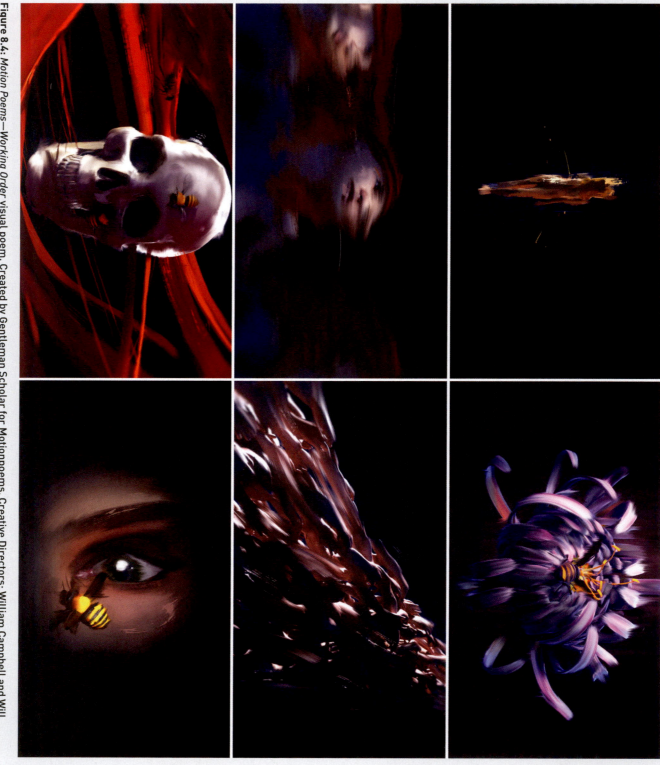

Figure 8.4: *Motion Poems—Working Order* visual poem. Created by Gentleman Scholar for Motionpoems. Creative Directors: William Campbell and Will Johnson.

William Campbell: We both envied each other's work in a way that we were definitely competitors. The competition made us stay separated, but once we came together, it pushed us to get better. It's a difficult balance, but it's something we try to reinforce at GS. That competition can be healthy. How we can help everyone to push each other forward, but still promote teamwork. At Superfad, we both pitched on the Target piece, and the client wanted to blend both of our design boards together to make one spot. So, the client forced us to work together for the first time.

How would you describe the culture of your studio?
Will Johnson: We wanted to create a place where you could work with fun, smart, invigorating people. If you're having fun, you're going to put energy into the work you're doing. That work is going to get better. More cool, fun people are going to come and want to work there. The work has evolved, but the core idea of filling the rooms with cool inspirational people has not changed. Plus, we are in the pit working on projects; we grind just as hard as everybody.

William Campbell: We stay in touch with what's happening. We never want to be the kind of bosses who are distant. We stay really connected and a part of the culture. We have also been students of other companies. Every company we have gone to, we have taken a little piece of. We have astutely combined them into the kind of place we want to work.

Can you describe your approach to mixed media?
We do a lot of different kinds of projects, so our styles range dramatically. As timelines have crunched, we have to use more people, but that means we get to experiment and try more things. That is cool because the stuff that hits the cutting room floor is sometimes some of the cooler stuff. Then we get to use that and evolve that for the next round.

When we started Gentleman Scholar, we met a lot of people who said, "You guys need to pick a style and stick with it." We were way too ADHD to be stuck in one style. We wanted to mess around with 2D, 3D, mixed media, whatever. We surrounded ourselves with talent that could build a foundation of doing all those things. With a project like *Bleacher Report*, we wanted to make something that makes us all happy, which is all these variations of styles. That bred from all these crazy talented people who do different things and have different interests. That mixed media stuff really filtered into our business model, but on top of what we like to make, and on top of what this whole new social world wants to digest—which is a lot of different types of things all the time.

Do these mixed media projects get your creative team excited?
For sure it does because everyone gets to spin their personality on it. Art directors, designers, and animators all get to experiment. It's really important for us because that is how we figured out what we liked. For everybody here, it's an opportunity to try something strange. People get really pumped on it.

Do you have any suggestions for young designers?
Will Johnson: Don't be afraid to fail. If you're so fearful of failing or doing the wrong thing, you will never learn how to do the right thing. Be a little bit looser with what you are trying to accomplish. If you don't know how to do something, try it. Don't stop at an obstacle.

William Campbell: Sometimes we tell designers to make a bad set of frames, just make a quick set of frames in a day. That relieves the pressure you have on yourself to make something. Then you can actually free your brain, and let your creativity flow.[6]

Figure 8.5: *Bleacher Report #sportsalphabet* commercial. Created by Gentleman Scholar for Bleacher Report. Directors: William Campbell and Will Johnson.

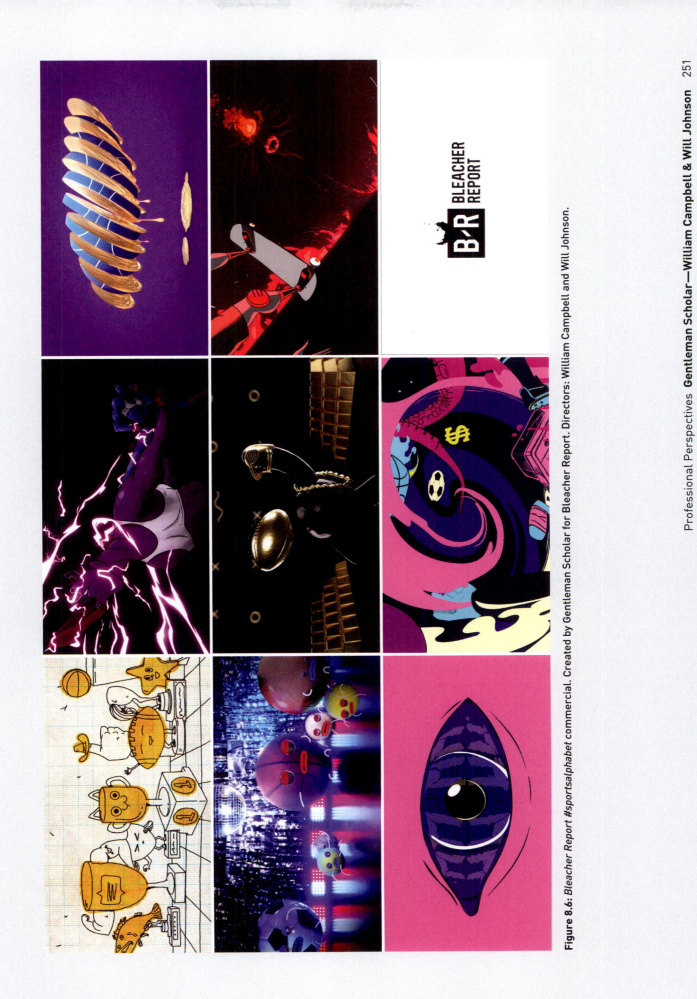

Figure 8.6: *Bleacher Report #sportsalphabet* commercial. Created by Gentleman Scholar for Bleacher Report. Directors: William Campbell and Will Johnson.

Notes

1 Gladman, James, interview with author, July 14, 2014.
2 Johnson, Will, telephone interview with author, July 23, 2018.
3 "Aspect Ratio." Merriam-Webster.com. Accessed August 28, 2014. www.merriam-webster.com/dictionary/aspect ratio.

4 Oeffinger, Daniel, telephone interview with author, July 17, 2014.
5 "About." Gentlemanscholar.com. Accessed August 25, 2014. http://gentlemanscholar.com/about/.
6 Campbell, William, and Johnson, Will, telephone interviews with author, May 11, 2014, and July 23, 2018.

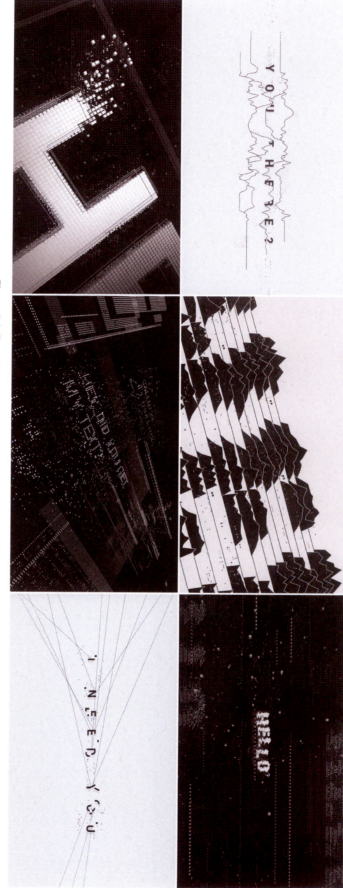

Figure 9.1: Type-driven design board by Audrey Yeo, Art Director at Buck. Design board created at SCAD Design for Motion class.

Chapter 9:
Type-Driven Design Boards

Typography is the art of designing and setting words for visual communication. *Kinetic typography* is type in motion, adding the dimensions of time and movement. A motion designer needs to understand how to treat type effectively and appropriately for a creative brief as well as envision how type changes over time. For design-driven productions, a motion designer's ability to handle typography is valuable because type is used so often. Nearly every motion design commercial production utilizes typography in some capacity. Projects can range from entire spots that are composed of kinetic typography, to type treatments or logo resolves for end tags.

History & Culture

Although typography is a fundamental skill-set for graphic designers, motion designers need to at least know the basics. After all, graphic design is one of the many traditions motion design is built upon. In addition to becoming familiar with the history of typography, it is vital to understand the cultural

significance of type. Each culture has psychological associations with various typefaces due to popular usage. Even the laymen with little to no historical knowledge of type will recognize emotional and intellectual significance when encountering various typefaces. Slab serif wood type conjures images of the American West. Stencil type instantly produces associations of the military motifs. The collegiate type family reminds us of varsity letter jackets and sports, whereas script or calligraphy feels more elegant and timeless.

Awareness of how specific cultures influence typography enables motion designers to make educated decisions regarding which typefaces to use. Additionally, typography can also reference specific periods in history. Knowledge of the preferred type treatments of different eras will allow a designer to craft and elicit intended responses from an audience. This knowledge can help to endow a design style with specific tones such as classical, modern, retro, or futuristic.

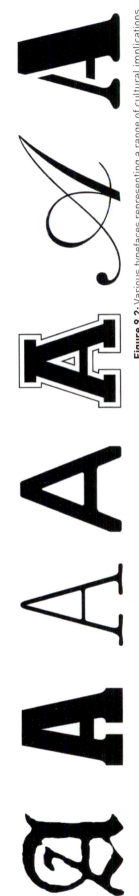

Figure 9.2: Various typefaces representing a range of cultural implications.

SERIF SANS SERIF

Figure 9.3: Examples of Serif and Sans Serif typography.

Motion designers need to know a few basic typographic terms and principles. There are two main type families: *serif* and *sans serif*. Serif describes letterforms that have an accent or flourish stemming off of each end of a character in the font family. Serif is considered to be more traditional or classical, and it is useful for body text or large amounts of readable text. The body text of books or magazines is often written with a serif font. It is easier to read because the horizontal strokes of serif letters help to reinforce and maintain a sense of separate lines.

Sans serif describes letterforms that do not have any flourish or visual accent. Sans serif, which literally means without a serif, is commonly used for headlines and utilitarian signage such as traffic signs. Sans serif is considered relatively more contemporary and modern. It is cleaner and offers clear legibility. However, it can be difficult to read large amounts of sans serif as body type.

Anatomy of Type

Another term motion designers need to be familiar with in relation to typography is the *baseline*. The baseline is the invisible line upon which the bottoms of letters sit. Legibility and aesthetic qualities diminish very quickly when type is not aligned with the baseline. You can use the baseline to keep your type aligned while you make modifications to individual letterforms. Keeping words and lines of type aligned will help to maintain visual balance and maximize communication.

In order to effectively layout or set typography, motion designers need to understand and be able to adjust *kerning*, *tracking*, and *leading*. Kerning is the space between two individual letterforms. Kerning is important, as the distance between letters affects the legibility and visual balance of words. When kerning is either too tight or too wide, a word may become difficult to read. Additionally, poor kerning can disrupt the aesthetic harmony of type layout. The average person might not be able to identify exactly what is wrong with a poorly kerned word, but they will feel that something is not right.

Typefaces that are installed digitally have default settings for kerning. Often, these default settings need to be modified by a designer to achieve the most aesthetically pleasing space between two letters. Kerning needs to be considered like any other visual principle. Positive and negative space, contrast, and harmony all affect the visual relationship between letterforms.

Tracking is the space between all of the letters in a word. Like kerning, tracking affects legibility and the visual aesthetic of typography. A motion designer needs to be able to analyze and adjust the appropriate spacing for type in relation to the needs of a creative brief. In some instances, the spacing may need to be decreased or visually tightened. In other cases, it may need to be increased or visually widened. Each modification will have a different effect on the viewer.

Leading (pronounced "ledding") is another principle motion designers need to understand and be able to modify. Leading describes the space between lines of typography. This space applies to the type setting of headlines as well as the layout of body type. Again, leading affects legibility and how pleasing typography is to the eye. If leading is too tight or too wide, it will affect how the type is experienced and interpreted.

Visual consistency is another factor to consider with leading. Sudden changes to type leading communicates a break or disconnection. Typically, paragraphs are separated by an additional line space. This spacing lets the reader know that an idea has come to an end. Similar considerations must be

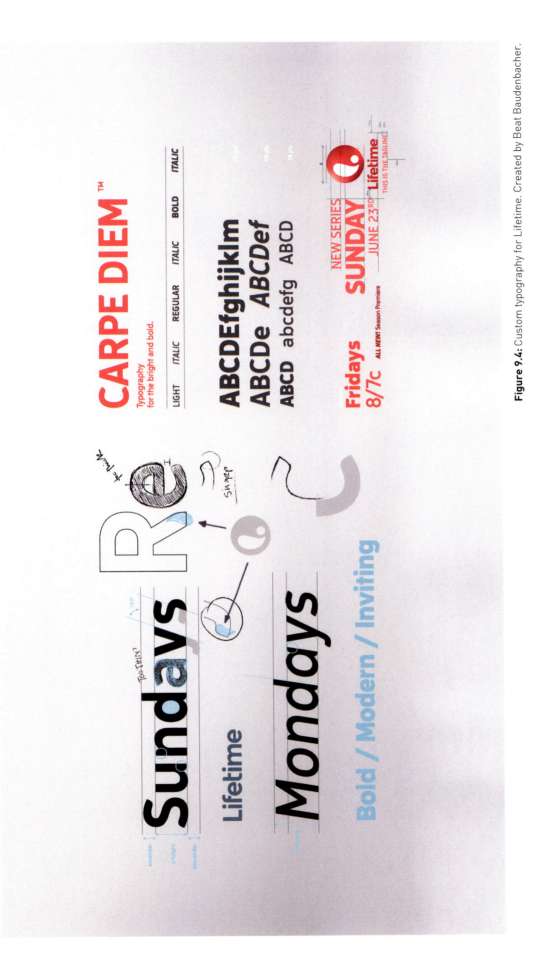

Figure 9.4: Custom typography for Lifetime. Created by Beat Baudenbacher.

taken into account for motion designers as they layout type.

These skills take time and practice to master. The reward of proper kerning, tracking, and leading is legible and aesthetically pleasing type. As a design tool, typography maximizes certainty. Beautifully handled type often performs its function with little fanfare. The average person does not stop and marvel at the elegant treatment of typography. However, poorly set type is quickly recognized and distracts from communicating the intended message, or fails all together. Competency with typography is vital for motion designers and those who develop a passion for type possess a valuable skill for potential employers.

Casting Type

Motion designers need to be able to choose the appropriate typeface in relation to the needs of a creative brief. Because typefaces communicate information and emotion to viewers, a naïve or careless choice of font may express unintended or even contrary meanings. With so many typefaces to choose from, selecting a typeface can feel like an overwhelming task. A helpful way to approach this task is borrowed from the worlds of film and theatre. When choosing a typeface, try to think of yourself as a *casting director*.

A casting director needs to find an actor that will best fit the role in a script. In order to complete this task, the casting

Figure 9.5: Type-driven design board by Patrick Pohl, Freelance Motion Designer. Design board created at SCAD, Design for Motion workshop.

Type Treatments

There are a number of different stylistic treatments that can be applied to typography. Motion designers should become acquainted with a range of styles to be able to meet a variety of creative needs. Type can be created graphically, hand lettered, constructed tactilely, extruded in 3D, or composited into an environment. Graphic treatments of type are the most common and include choices about color, texture, and customized letterforms. *Hand lettering* is type created by hand, and it often has a personal sensibility. There are many different options for treating typography. However, stylistic considerations should always reflect the needs of the creative brief.

director needs to properly identify the defining qualities of the role. Is the character comedic, tough, or mysterious? Is the mood of the script contemporary or classical? These considerations will narrow the scope of potential candidates. They will also provide keywords and descriptive characteristics for the role. Determining the boundaries of a role will aid in the process of casting the part. A similar approach can be used when selecting a typeface.

Start by identifying the keywords and qualities that best describe the message, emotion, or idea you want to express. Use adjectives to help shape the identity of your choice. Typefaces have distinct personalities, so the more descriptive you can be, the easier your search. Is the message you need to express playful or serious? Is the overall style of your project modern or traditional? These kinds of questions will help guide your exploration. The longer you work with typography, the more familiar you will become with a range of different typefaces. The skill of choosing typefaces is a combination of research, concept development, and experience.

Integrating Typography

Another skill motion designers need to develop is the ability to integrate typography into a composition. Beginners often treat type like an afterthought, pasting it onto a canvas after all the other visual elements are in place. This action gives the impression that the type is a secondary consideration. Seeing typography as an integral component in a composition can be difficult. It may require a great deal of practice and failed attempts. However, typography that is not integrated in an image will flatten out the overall composition. Type should be treated just like any other visual element. The stylistic applications to space, value, contrast, transparency, color, or depth of field that are used in an image should also be applied to typography. This consistency will help to achieve a level of compositing where the type feels like it belongs.

Figure 9.6: Type-driven design board by Camila Gomez, Motion Designer at Rosewood Creative. Design board created at SCAD Design for Motion class.

Creative Brief: Type-Driven Design Board

This exercise requires typography to be the heroic element of a design board. Typography is extremely relevant to motion design for a number of reasons. Most importantly, type serves as a means for communication. Beyond what we perceive with our physical senses, words are a ubiquitous aspect of our lives. Our thoughts and conversations are composed of words. Signage and labels contain typography that inform us about the objects and places we interact with. Entertainment—including books, songs, plays, and movies—revolves around the use of words.

For this exercise, you will create a type-driven design board. Typography should be the hero and focus of your concept. Type as a hero for motion design projects can range from commercials, title sequences, or information graphics. Any of these genres can work for this assignment, as long as typography is the primary visual element and treated in an interesting manner.

- Concept: Select a random word as your conceptual prompt. Alternatively, you can use a script, quote, poem, or song lyrics.
- Deliverables: Design a project with typography as the dominant visual element. Document your concept and design

development as well as completed style frames and design board in a professional process book. Include any interesting and relevant sketches, research, writing, storyboards, etc. in your process book.

Essential typography skills to consider for this project:

- The ability to set type elegantly
- The ability to choose appropriate typefaces to express emotions or ideas
- The ability to build dynamic compositions with typography
- The ability to composite type into environments

Specific techniques to consider for this project:[1]

- Hand lettering—Typography made by hand
- Graphic construction—Typography that is treated graphically
- Tangible/tactile—Typography that has the feeling of touch or a 3-dimensional quality
- Ephemeral—Typography that feels temporary or impermanent

Figure 9.7: Type-driven design board by Francisco Betancourt, Freelance Designer. Design board created at SCAD Design for Motion class.

Figure 9.8: *Sherlock Holmes: A Game of Shadows* main on end title sequence. Created by Prologue for Warner Bros. Pictures. Creative Director: Danny Yount.

Professional Perspectives
Danny Yount

Danny Yount is an American graphic designer and commercial director who has a diverse visual style and a unique range of depth and craftsmanship in motion arts and film. He has been recognized internationally for his work in feature film and television main titles and show opens. As a leading title designer, he has collaborated with top film directors and producers—designing some of the most recognized sequences of the last decade, like *Oblivion*, *Iron Man 1-3*, *Six Feet Under*, *Kiss Kiss Bang Bang*, *RocknRolla*, *Sherlock Holmes*, *Tron Legacy*, *Tyrant*, and many others.[2]

An Interview with Danny Yount
What is your art and design background?

I started out wanting to be a graphic designer. I didn't go to school, but I was really hungry to do something that I was passionate about. I knew I wanted to make art, and I thought graphic design was really cool. This was around 1989–1990. I was moving to Seattle from the Bay Area, where I grew up. My wife reminds me of a story where I looked down at the Pioneer Square Area in Seattle, and I said, "I want to work down there and be a famous designer someday." I started making steps, reading *HOW* magazine and *PRINT* magazine. I was able to get a Macintosh on credit and started learning that. It was such an amazing time for a young designer to break into the field because all of it was brand new. No one knew that it would take over the print industry. No one knew how far it would go. When you consider a world where

you're laboring over these hand materials, and all of the sudden desktop computing comes in, you can see how it went completely nuts. I got to be there, working with all these brand new tools, and it was wonderful for me.

I finally got a break after working at a series of sign shops. I started toying around a little bit with interactive media. I made a portfolio in Macromedia Director that was color, that went through my work, and that I sent out on floppy disks. By today's standards, it was pretty poor. But, it was enough to get their attention. I got hired on in Seattle, in Pioneer Square, by an amazing designer named John Van Dyke. He had a really acute sense of elegance, powerful imagery, and loved technology. I discovered Premiere by accident. I edited digitally for the first time. Then I was able to put in some animation and some design. I was completely sold. I was like, "This is what I want to do!" It got me really fired up. I did everything I could to wiggle my way into projects like that. After five years, I went into news broadcast of all things. At the time, the post-industry was the place you would do motion work. You would take film, put it on digi-beta, then transfer that digi-beta into Avid. That was the establishment at the time. I started at the bottom again.

I worked very hard to make a reel and sent that reel to Imaginary Forces in LA. They brought me in, and I worked on some projects. It was great, but I could not move my family there. So I sent my resume back home, to Digital Kitchen. At the time, they were part of the establishment and would have ignored a

Figure 9.9: *Six Feet Under* title sequence. Created by Digital Kitchen for HBO. Director/Designer: Danny Yount.

guy like me. Now, all of the sudden I was a freelance designer coming from LA in their view. They hired me on, and we did the *Six Feet Under* titles. I didn't know it at the time, but when the *Six Feet Under* titles came out, everyone loved it. It got an Emmy, and all of a sudden, *my whole world as a professional changed. That's how I got in. I wish I would've had formal training, so I wouldn't* have to learn everything the hard way. But, then again, that's kind of my personality. I don't really learn something unless I screw something up. I learn more from failure. I don't really learn from the book. I like to break something first. Then I learn something.

Do you have suggestions for young designers?

For motion, you really have to learn how to tell a story. Even if you are doing it with the simplest of means. *The way to master title design is to learn how to use graphic metaphors to tell a story. To*

me, that is the holy grail of motion design. Because if you don't do that, what you really are is a graphic sampler. You may be a great technician, but you don't know how to make something that gets into someone's emotion. That's where storytelling comes in. *That is the cream of the industry—people who know how to tell stories with design and motion.*

Be diverse so you don't get pigeonholed into doing one or two things. You have to be a go-to person to establish yourself. But, once you establish yourself, pursue what your real gifts are. Don't do anything that you are not passionate about. *You have to steer your career.*

Are titles your favorite kinds of projects?

They are. As a younger designer, I used to get-off on the fact that my work was on the big screen. But, that kind of wears off, and you

Figure 9.10: *Kiss Kiss Bang Bang* title sequence. Created by Prologue for Warner Bros. Pictures. Title Designer: Danny Yount.

ask yourself "Why am I really doing this?" I really love it because the challenge is to engage an audience at a high-art level of storytelling. With Hollywood production, everything you do has to be completely distilled and concentrated. It really has to do its job. There are a lot of really talented people you are working with, and if it is not doing its job, they will let you know really quick.

In Hollywood, it's all about viscera. You tell a story, but you're almost invading someone's senses. Kyle Cooper is great with that. It goes even further than story. It gets into your senses. I learned as a designer and storyteller to make things that really set the tone for the film, but also get into the senses of the audience. To prepare them for what they were going to see,

or leave them with something that was powerful ... for them to remember the film.

How do you approach concept development?

One thing I learned from my mentors, meaning John Van Dyke and Paul Matthaeus, is that you have to get as many ideas out as quickly as you can. You have to have the ability to step back from them and look at them as a whole. That could be putting 27 frames up in Photoshop on your screen or literally printing them out and posting them on a wall. With computers, everything is very inward. We have to master the art of being able to lay everything out. Continuously review and refine that canvas. When I was younger, I would beautify singular frames. I would hyper-focus on one frame, and another part of the production sucks because you didn't focus

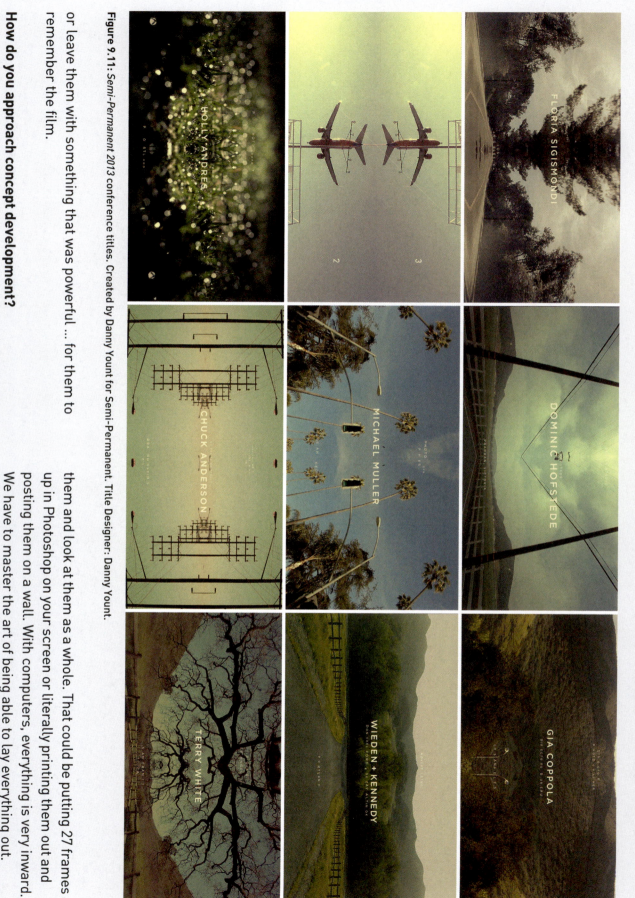

Figure 9.11: Semi-Permanent 2013 conference titles. Created by Danny Yount for Semi-Permanent. Title Designer: Danny Yount.

on that. Then it's time to put a presentation together, and you lost an opportunity. As Paul Matthaeus would say, "It's a very funnel-shaped process." You capture it very wide, and then you make refinements to the entire project as a whole as you work. Once everything is working, then you have the ability to really focus on weaker or stronger areas to make statements and bring it all together.

The other thing I learned that was really important, and my whole life changed when I realized this, is to *let go*. It's a cliché, but you have to learn to let your babies go. If you hang on to something because you're so proud of it, you can't let it go. If it confuses your audience, then you've lost. I used to be just adamant, and dig my heels in, and say, "I am going to make this work." That was very destructive. I finally learned to say, "This is a great idea, but it is no longer valid. I will set this aside, and maybe use it in something else someday." It's important for young artists to know you have to learn to let go. Step back and put on your storyteller hat, and say, "Well, this isn't telling the story. So it doesn't matter how cool this is right now. But, I can use this

somewhere else." That will give you a lot of freedom and space to develop as a real artist. As opposed to someone who has just learned how to sample something. You have to be mature enough to know that we have to service the story more than our own conceits. It's a professional honesty that we have to develop.

Where do you find inspiration?

Aside from working with some of the best people in the world, there is nothing better than Pinterest right now. Pinterest is like every magazine store that I could possibly visit in a year. That is for my workspace, where I get inspired when I have to sit down and come up with something. But what inspires me in a much richer way is travel. Being able to see different cultures and experience different things in life. All of that pours back into your work. You gain knowledge that you didn't have before. You are able to put something into your work that means something for the right occasion. Travel and having a really broad world-view is critical for designers.[3]

Figure 9.12: *RocknRolla* main title. Created by Prologue for Warner Bros. Pictures. Title Designer: Danny Yount.

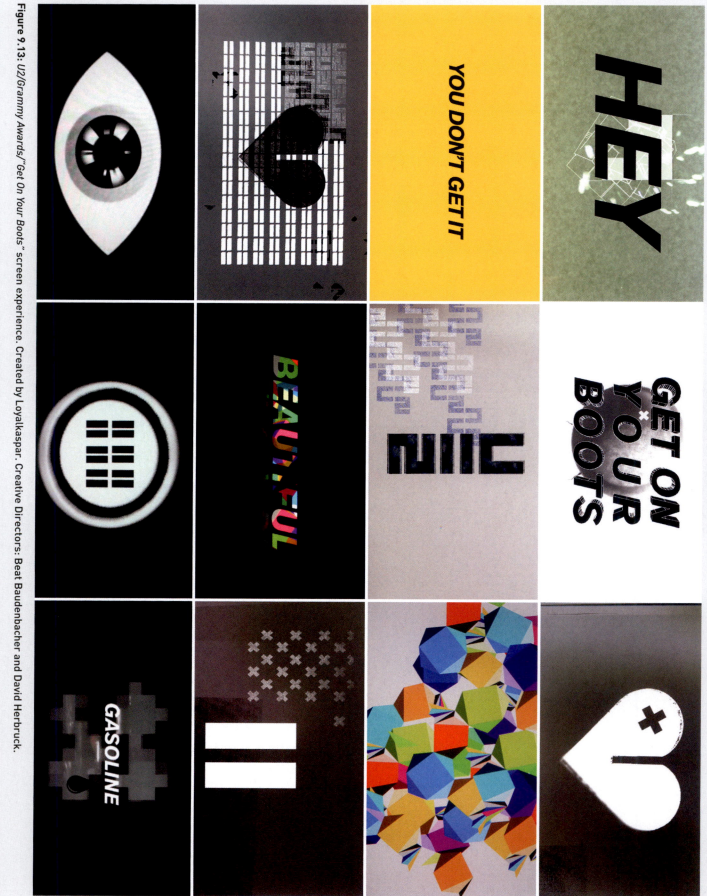

Figure 9.13: *U2/Grammy Awards/"Get On Your Boots"* screen experience. Created by Loyalkaspar. Creative Directors: Beat Baudenbacher and David Herbruck.

Professional Perspectives
Beat Baudenbacher

Beat Baudenbacher is a Principal and Chief Creative Officer of Loyalkaspar. He co-founded Loyalkaspar, an Entertainment Branding Agency, with his business partner David Herbruck in 2003. Beat believes design is storytelling that transcends borders and languages. He is obsessed with brands, particularly how they look, behave, and communicate with individuals and society at large.[4]

An Interview with Beat Baudenbacher

What is your art and design background?

My mom is an artist, so I grew up drawing, painting, and making stuff with her all the time. I didn't think there was a career in art, so I was going to study Economics for some strange reason. One day my dad, who is a surgeon, came back from a conference with a catalogue from Art Center. I looked at it, and it was awesome. At the time, Art Center had a Swiss campus. I spent a summer putting together a portfolio of stuff, and I got accepted. It was sort of by chance, but I feel like everything led up to that. I finished at Art Center in Pasadena, CA. I came to New York in 1998, and I had studied graphics and communication design but hadn't done any motion at all. Design studios were gobbling up people out of school and throwing them at motion design. It was a sink or swim kind of thing, and that is how I fell into this industry. I thought it was really exciting, that you get to tell stories. You get to figure out how to get from point A to point B, as opposed to working on one static image.

How did your graphic design training prepare you for motion design?

Composition, layout, how you construct a frame, your focal point, how to use your diagonals, and the anatomy of a frame; I think that is where Swiss graphic design is really helpful. Whether it is complex or not, super graphic shapes or a complex CG environment, the main principles still apply. Even in a very complex world, you still need one focal point. I feel like a lot of pure motion designers fall a little short, because they don't have the traditional design foundation. Things can get pretty messy if you don't know those rules and guidelines.

How did you learn about storytelling?

I had taken filmmaking classes, and I had written screenplays. The basic structure of how to construct a story, I took from that. So if you have 5 or 10 seconds, in many ways it is still a three-act structure. You have an introduction, development, and then a conclusion. I took those from filmmaking and applied them to design and visual storytelling. The visual aspect was instinctual, but the intellectual approach to storytelling came from filmmaking. At some point, you need to learn how to put that stuff into words, as well. I think writing is very useful in this business.

How do you approach concept development?

I think a lot of people jump to the internet a little too fast these days. It's a great tool, but I don't think it entirely replaces sitting

down and trying to figure out what you want to say, or what your concept is. Research, inspiration, thinking about it, writing stuff down, and the act of doing it. Sitting down and making frames is where I tend to find the narrative.

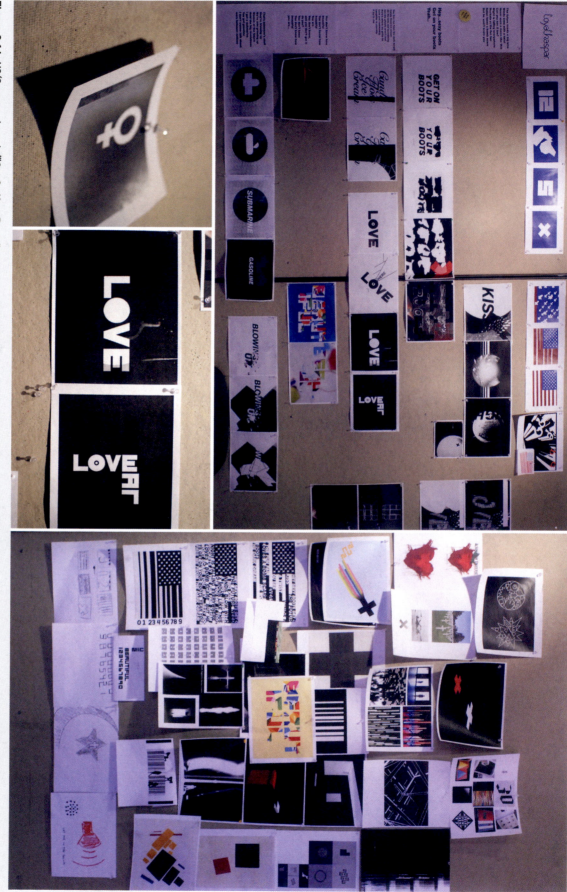

Figure 9.14: *U2/Grammy Awards/"Get On Your Boots"* process and development. Created by Loyalkaspar. Creative Directors: Beat Baudenbacher and David Herbruck.

Do you have suggestions for young designers?

Don't let technology overpower or overshadow the simplicity of a good idea. It's easy to get caught up in software. You can think you need to learn everything and do everything. But, at the end of

the day, a great idea can be more powerful than knowing all the software in the world.

I think it's really important that people who come into this business still do their own creative work. Find ways to do your own work. I see so many frustrated designers and animators in this industry who have been doing this for a long time. They make too much money not to do this anymore, but they are frustrated. At the end of the day, we are creative people who go into this

business thinking we have something to say and something to share. I think small pockets of time to experiment, to do your own thing, be your own client, is super important. The creative services industry is an on-demand business. You are being forced to create on-demand constantly. If you don't have the time to play, to experiment, and to fail, you never have time to recharge your batteries to be creative on-demand!

Figure 9.15: *House at the End of the Street* film titles. Created by Loyalkaspar for Relativity Media. Creative Director: Beat Baudenbacher.

Do you have suggestions for creating a successful company?

You need a vision of what you are trying to do and stick with that. My vision was always to be a place that does many different things, to never get pigeonholed into one thing. Looking at all the stuff we are doing now, that has come true in many ways. A lot of it is strategy, directing live-action, branding, and storytelling on a much larger scale. *Have a vision and go for it, and realize that it is a marathon, not a sprint.*

Do you have any design heroes?

When I was in college, David Carson was huge. Looking at *Raygun*, it was something totally new and different. *Tomato* was really big, too. They were a huge influence on me.[5]

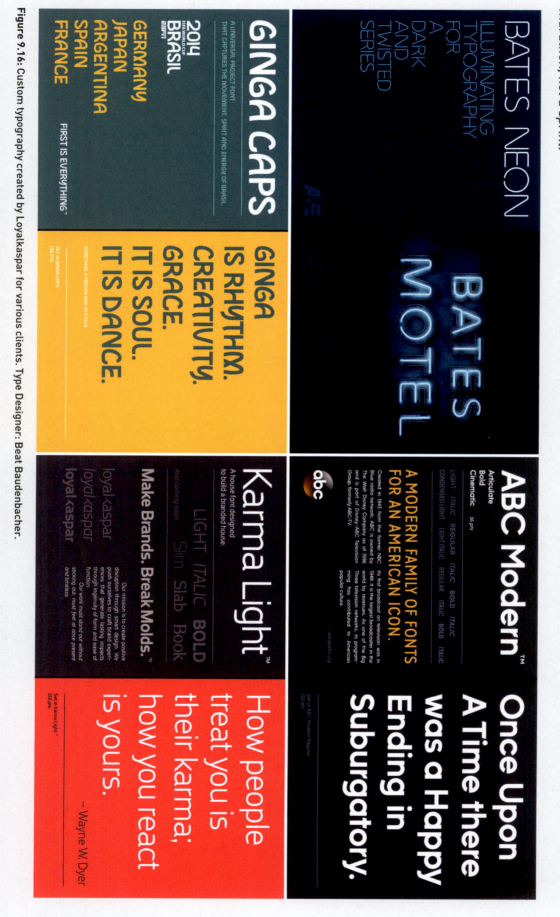

Figure 9.16: Custom typography created by Loyalkaspar for various clients. Type Designer: Beat Baudenbacher.

Notes

1 Klanten, Robert. *Playful Type: Ephemeral Lettering and Illustrative Fonts*. Berlin: Die Gestalten Verlag, 2009.

2 "About." Danny Yount. Accessed August 25, 2014. www.dannyyount.com/info. html.

3 Yount, Danny, telephone interview with author, August 16, 2014.

4 "About." Weforum.org. Accessed August 14, 2014. www.weforum.org/ contributors/beat-baudenbacher.

5 Baudenbacher, Beat, telephone interview with author, August 12, 2014.

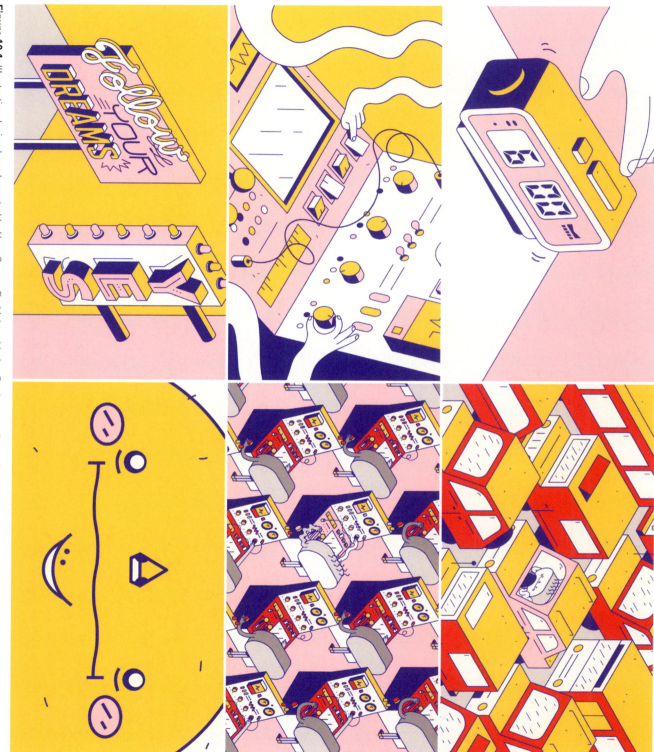

Figure 10.1: Illustrative design board created by Vero Gomez Frobisher, Motion Designer at Buck. Design board created at SCAD Design for Motion class.

Chapter 10:
Illustrative Design Boards

Some of the most notable motion design projects and studios utilize illustrative styles. Concepts and stories expressed through illustration can both capture audiences and communicate messages. Visual storytelling can also evoke emotions and motivate action. Illustration is used extensively in commercials, promos, and explainer videos. However, motion illustration has expanded into the realm of social and digital media as well. GIFs, animated stickers, and emojis permeate messaging apps and social feeds. In whatever screen or platform, illustrative styles for motion design projects continue to give form to ideas.

Illustration Styles

Many designers find their way into motion design through illustration. For designers of motion, having drawing and illustration skills is very helpful. Many professionals who work exclusively on the design side of motion design come from strong image-making backgrounds. These artists tend to be quite flexible in their ability to produce a wide range of visual styles. For *designimators*, those who both design and animate, illustration skills can only help to articulate your vision and contribute to the creative process.

There are countless varieties of illustration styles that range from highly detailed to extremely minimal. Illustration styles are defined by establishing visual parameters or patterns. The visual principles of line, color, value, shape, and texture are the illustrator's tools to accomplish this task. Additionally, compositing skills contribute to being able to create distinct illustration styles. From photo-illustration to the integration of hand-made elements with digital materials, there is really no end to the possibilities for creating unique visual styles.

Analog & Digital

Traditionally, illustrations were created with analog mark-making tools such as pencils, pen and ink, markers, charcoal, and brushes as well as techniques such as watercolor, photography, collage, etching, woodcuts, and lithography. Digital illustration offers translations of many of these tools and techniques, but with the affordances of being able to save, undo, and work non-destructively.

Digital brushes in programs like Photoshop and Illustrator can be pushed pretty far in terms of an organic look and feel. You can achieve a painterly or stylized aesthetic with a wide range of value and depth using these tools.

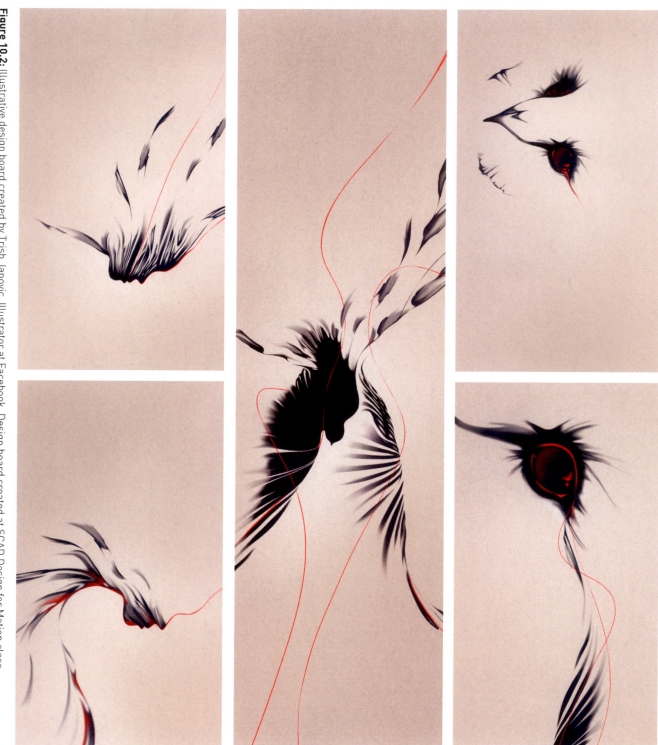

Figure 10.2: Illustrative design board created by Trish Janovic, Illustrator at Facebook. Design board created at SCAD Design for Motion class.

Figure 10.3: Illustrative design board created by Aishwarya Sadisivan, Designer at Black Math.

Hybrid styles of analog and digital illustration tools and techniques combine the strengths of both. Organic and tactile sensibilities of analog can meet the ease and efficiency of digital workflows. Designers can work fluidly between both types of media utilizing tools to digitize hand-made drawings and textures. Scanners and cameras can preserve organic qualities whereas tablets and interactive pen displays can render physical strokes directly as digital media.

Sequential Thinking

Motion design brings illustrative styles to life through animation and cinematic storytelling. Because illustration is traditionally a static medium, a composition is defined by a fixed "camera" or viewport in relation to the viewer. Even with motion illustration such as animated GIFs, the experience of viewing is akin to looking at an animated drawing in a picture frame. When designing for motion, you need to think more like a film director. How does the camera distance change over time? Do we start close up and pull the camera back to a wide shot? Do we cut from a medium shot to an overhead? How do we get from one style frame to the next? Variety in camera distance creates a dynamic sense of presence within a representational space.

Figure 10.4: Illustrative design board created by Jackie Doan, Designer at We Are Royale. Design board created at SCAD Design for Motion class.

Creative Brief: Illustrative Design Board

For this exercise, you will create an illustrative design board. Illustration has a wide range of visual possibilities and mediums.

Any project that utilizes motion design can potentially use illustration. Specific types of projects that can use illustration in motion design include animated movies, title sequences, commercials, motion branding, video game cinematics, and interactive motion. Be sure to develop a unique visual aesthetic for your illustration style and to be consistent with it throughout your design board. The stylistic direction you choose should enhance and express the concept you develop for your design board. In other words, form should express function effectively.

- Concept: Select a random word as your conceptual prompt.
- Deliverables: Design a project with illustration as the dominant visual aesthetic. Document your concept and design development as well as completed style frames and design board in a professional process book. Include any interesting

and relevant sketches, research, writing, storyboards, etc. in your process book.

Essential illustration skills to consider for this project:

- The ability to define a visual style to enhance a concept
- The ability to express emotions and ideas through illustration
- The ability to think sequentially with illustrative elements
- The ability to work between analog and digital mediums

Specific techniques to consider for this project:

- Analog illustration—Illustration made with analog tools and methods
- Digital illustration—Illustration made with digital tools and methods
- Hybrid illustration—Illustration that combines analog and digital tools and methods

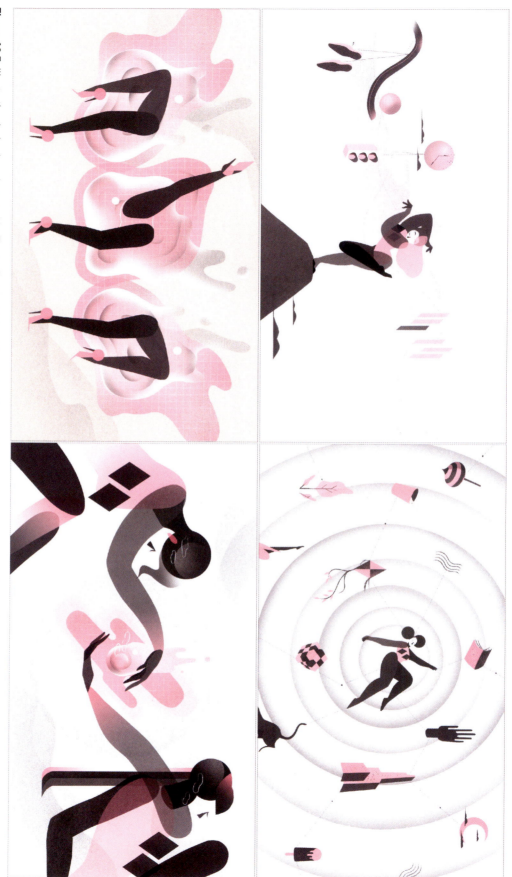

Figure 10.5: Illustrative design board created by Eleena Bakrie, Motion Designer at We Are Royale. Design board created at SCAD Design for Motion class.

Professional Perspectives
Matt Smithson

Matt Smithson is a director, animator, designer, and maker of odd drawings of ghosts and things. From humorous, craftily cut animations to uplifting films, Matt creates with a unique style that attracts clients from all over the world. He was recognized in 2009 with a Young Gun award from Art Director's Club, and his work was displayed at the Smithsonian Cooper–Hewitt National Design Museum in New York as part of the "Why Design Now?" Triennial Exhibition.[1]

An Interview with Matt Smithson
What is your art and design background?

I graduated from the College of Charleston with a degree in Studio Art, where I focused on painting and printmaking. After graduating, I completed a master's at the Savannah College of Art and Design. I wanted to combine drawings, paintings, and these things that I make, with storytelling. And, it seemed like motion graphics was the best place for that. It was a perfect way to combine all my weird ideas and drawings with motion and animation to make experimental and fun shorts.

How do you use dreams and stream of consciousness in your process?

I have a lot of oddball dreams. Like automatic writing, I shut my brain off and allow the words and images to flow naturally. This process creates stories, phrases, or sometimes only a single word that I transform into drawings and animation. The art becomes an interpretation of a dream or a sentence. It's a great starting point.

When I was in school, I used every project and opportunity to further explore using my dreams as a source of inspiration. It worked in my favor because it allowed me to figure out my own voice. I wasn't trying to follow trends but focused on creating a style of my own. When I graduated, my work really stood out, and it helped me get a job. I was signed as a director at Curious Pictures and Not to Scale right out of school. It took a while to start getting work as a director under my belt, but I really liked having the opportunity to have creative control over the projects I worked on. I liked that freedom because it allowed me to keep using this process and to draw from the same source of inspiration.

How was your transition from graduate school into being a director?

There were some things that were really new to me when I first started. I hadn't been exposed to and wasn't really prepared for, some of the real-world business stuff. Some things caught me off guard, like managing budgets and dealing with clients. I watched how other directors were dealing with these things, and I got some experience by directing small jobs. Producers were there to help with scheduling and keeping jobs on track, but I had to learn

Figure 10.6: Various style frames. Created by Matt Smithson.

quick how to explain and sell my concepts to clients. When I was in school, we didn't learn these skills so I needed to learn them in the field as I gained more experience. All in all, it wasn't a difficult transition. There were just a lot of things I needed to learn right from the beginning.

What is the story with you drawing on the pages of old books?

I like working on their paper because it feels less intimidating than starting on a fresh canvas. I was always looking for the right books. There are certain books that have the perfect paper, and they can be really cheap. I was always the creepiest guy in Strand Bookstore—which says a lot, because Strand has some creepy dudes. I would be the guy in the back of the store shuffling through old art books, collecting paper, trying to find the perfect ones.

How do you approach concept development?

I always start with writing down ideas. Every script is a puzzle, and I comb through it to see where the pieces come together to make it interesting. If we are developing a script, it's about first identifying the audience and then figuring out a way to keep them interested and entertained. The goal is always to create a final product that fulfills, or exceeds the client's expectations, while still challenging us creatively. We like to have fun!

Where do you find inspiration?

It comes from all over the place. I love to explore what other artists are doing, but it's easy to get lost or overwhelmed by the sheer amount of work you can be exposed to on a daily basis. Back in the day, before the internet even existed, artists like Picasso or Miró were surrounded by the work of others, but not nearly on the same scale. It seems like today, we are bombarded by creative work from every direction, and at times, it can be distracting. I feel like it is important to find a balance between outward inspiration and your inner eye. I am drawn to art and to things that haven't been made for a particular client or job, things that have been made by a person who was simply inspired to make something. For example, I love Zines, which tend to have an analog and homemade look and feel, where people just make things to share.

Are there certain types of projects you like to work on?

I like the idea of working on projects that promote a good cause. They are a lot of work and a lot more stressful, because I feel like there is more weight on my shoulders, but they are nice to work on because they are trying to make the world better. If I had my choice of any project, I would love to work on surf videos, documentaries, or projects for clients like Adult Swim, where they support artists and their creative vision.[2]

Figure 10.7: Drawings and mixed media by Matt Smithson.

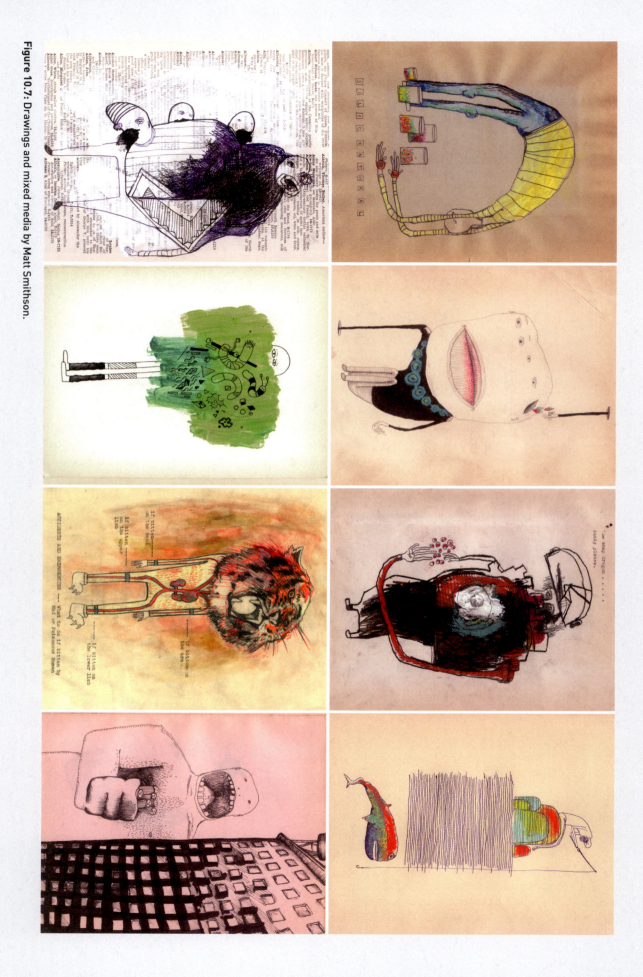

Figure 10.8: Drawings and mixed media by Matt Smithson.

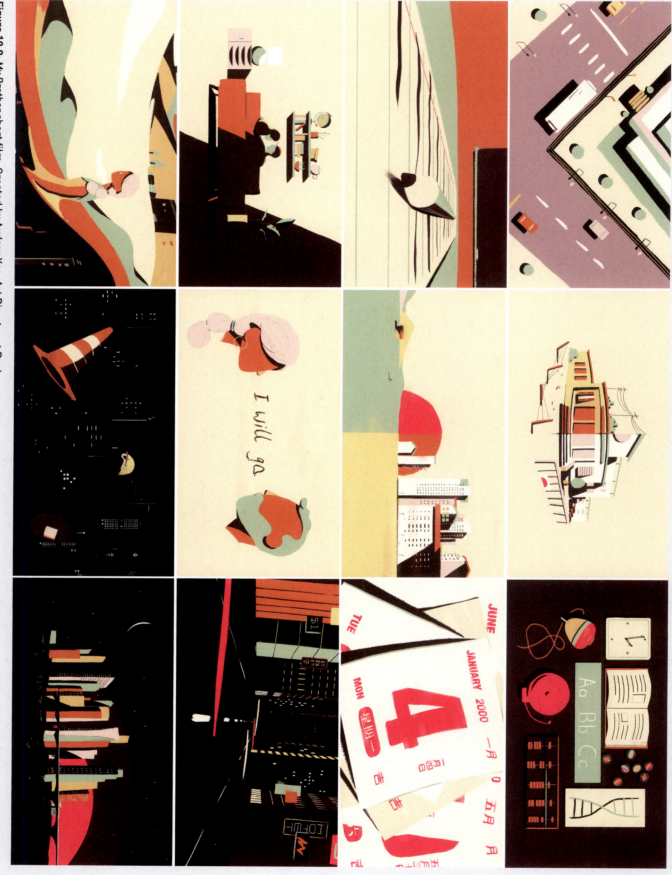

Figure 10.9: *My Brother* short film. Created by Audrey Yeo, Art Director at Buck.

Professional Perspectives
Audrey Yeo

What is your art and design background?

What got me into art in the first place was graffiti. I loved using spray paint and making stickers. I have a background in animation. I studied it for 3 years after high school. I was doing a lot of character design, and I wanted to see my characters move. I was doing both 2D cel animation and 3D animation. After graduation, I worked at a motion graphics company in Singapore for 2 years. Then I decided to further my education, and I went to study at the Savannah College of Art and Design.

What was it like coming to study at SCAD after your previous education and work experience?

It was one of the best decisions I ever made because I came with a very different perspective. I felt a lot more mature. When I was working professionally at an animation studio in Singapore, it felt like a "do or die" situation. I knew very little about After Effects, yet I had to deliver client work. So, I had to learn very quickly. I also had to follow creative briefs very strictly, so it was limiting in that sense. When I was able to take what I had learned from the professional work environment, both technical skills and work ethic—school was like a playground. I felt like I could make anything without limitations. It was very liberating for me. I could try different techniques without knowing what outcome to expect. I felt like I could experiment and not be afraid of failing.

How do you approach concept development?

I like to start with words. I pick keywords that pertain to the overall feel or a crucial phrase in a script that needs to be developed visually. I like to write a lot before I even begin to dive into finding visual reference. I like to write down a list of nouns and a list of verbs and then try to match them—to find a visual that best represents the concept. Then I start looking for style references.

Where do you find inspiration?

I have a very open-minded approach to art. I collect stuff on Pinterest—not just motion graphics, but architecture and photography. It is through this process of gathering that I have refined my aesthetic. I am always inspired by words. I have a whole Pinterest board of words! With words, you can imagine anything.

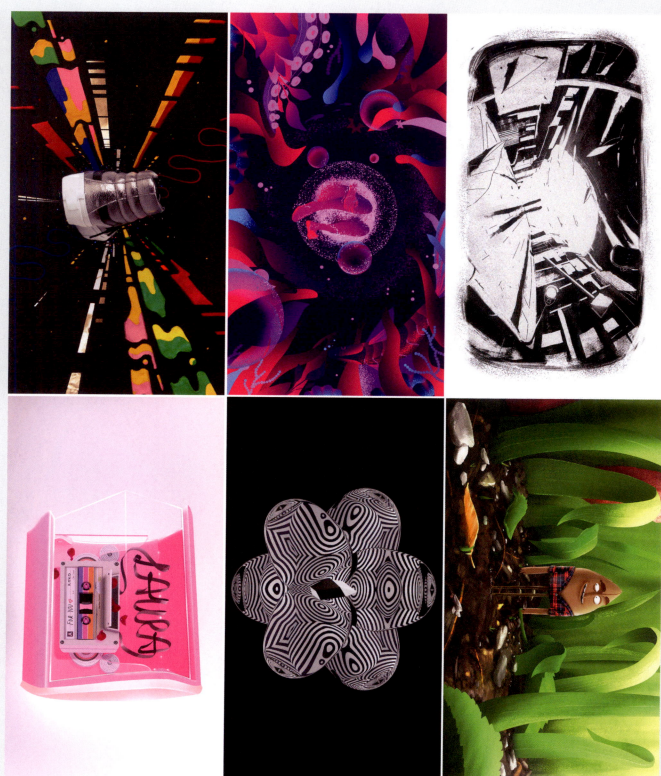

Figure 10.10: Various style frames. Created by Audrey Yeo, Art Director at Buck.

As an alumna of the Design for Motion class, did you find the class helpful?

Design for Motion helped me to become versatile. In the class, I was able to try out different styles and techniques—how to design with code, how to design with paper, how to design with clay, etc. It has helped me a lot in this industry because you have different clients wanting different things. I learned how to set aside my style and set aside my ego aside to go with whatever best matches the project. Design for motion is a platform for you to be daring and try different things.

What are your thoughts on social/mobile first?

We are using our phones so much now, that design has to change for that. Whether it is as simple as considering the font size, now that you are viewing design on a smaller screen; or considering how users interact, which is usually through scrolling—so, how can you capture their attention in the first 1–3 seconds, before they scroll past it? For non-social or non-mobile work, you can start with something fairly minimal in the intro and build up momentum. But, with social and how quickly people scroll, I find myself considering intros much more. Even if it is something as simple as starting your ad with your end tag or logo, for example. It can be tough because you have to make sure your design can work on multiple screens—having to design for 16:9 and then also making sure it looks fine for portrait mode, which is totally different.

What is your experience with emerging technologies?

For both AR and VR, there is an additional spatial element that you now have to consider. You also need to consider our agency—our capacity to interact with stuff. Different user actions will lead to different results. These are things I find myself needing

to consider a lot more when doing AR and VR. I like to design for AR; it is enjoyable because you are adding to the world. You can become more engaged with the current world. Like *Pokémon Go*, it was one of the first AR games that was widely used. It is fun because you are going around in your own world and discovering new things. With AR, you are free—you don't have to have a headset or wear a data glove.

Do you have suggestions for young designers?

Be patient with yourself and persist. When you persist, your future-self will thank you for going through those tough times and coming out better. I have had so many negatives in my life and moments that really would have made it easy for me to quit. I almost failed my art class in high school. I was so bad in art and was really good in science. I could have chosen something that easily made me more successful. But, even though I was so bad at art I knew it was something I wanted to do. After 3 years of studying animation in Singapore, I applied to art school at my local university, but didn't get in. I wasn't good enough. So, I worked professionally in animation for 2 years. I decided to apply to my local art school again, and I still got rejected! All of these things and more could have made me feel like art is not my thing. If I had stopped there, it would have been such a waste. But I was patient enough, and passionate enough, and love what I do so much that I am thankful that I pushed on and allowed myself to grow. When I put aside my expectations, all I have is passion and room for failure. And, if I have room for failure, it means I also have room for growth.

What do you enjoy about motion design?

I love that motion design can be almost anything. It can be illustrative-based or animation-based. It can be so flexible and is so inclusive. I feel like motion design is for everyone.[3]

Figure 10.11: *Slapstick AR app.* Created by Buck. Executive Creative Director: Ryan Honey. Designer: Audrey Yeo.

Notes

1 Igor and Valentine. "About." Igor and Valentine. http://igorandvalentine.com/about-2/.
2 Smithson, Matt, telephone interview with author, August 7, 2014.
3 Yeo, Audrey, telephone interview with author, May 19, 2018.

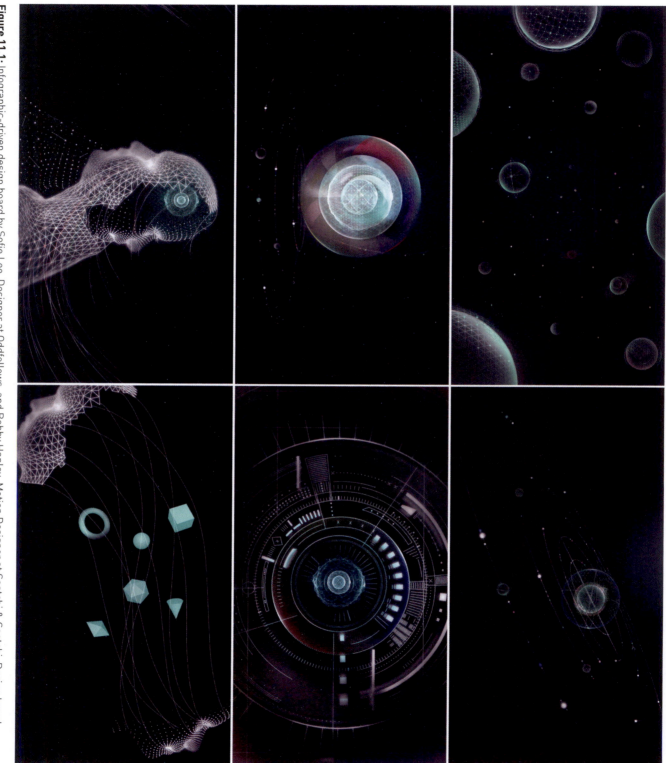

Figure 11.1: Infographic-driven design board by Sofie Lee, Designer at Oddfellows, and Bobby Hanley, Motion Designer at Saatchi & Saatchi. Design board created at SCAD Design for Motion class.

Chapter 11:
Info-Driven Design Boards

Communication design relies on smart solutions to simplify and deliver messages. The ability to transform information into functional and aesthetically pleasing visuals is vital for designers. "Information graphics" and "data visualizations" are terms that describe the process of translating information, ideas, and data into easily recognizable visual forms. With the *Internet of Things*, the network of devices and technology that communicate with each other continues to expand, and effective design is needed more than ever to give form to an increasingly data-driven world. In addition to graphics, typography often serves as a key element in communication design. Type is often paired with images to deliver messages as well as contribute to a project's overall design style.

Info-driven projects can range from entire pieces based on information graphics and kinetic typography to user experience and interface design. In addition to traditional, linear-based motion design, the demand for motion in interactive design is expanding. You may be creating infographics for explainer videos, title sequences, special effects shots, user interfaces, or interactive apps. Regardless of the medium, solid design is the foundation for beautiful motion.

An *information graphic*, or infographic, represents complex ideas, instructions, or knowledge in a simplified manner. A stop sign, map, or thumbs up emoji are all examples of information graphics. Infographics often use abstracted forms, iconography, or symbols to represent information quickly. Ideally, an infographic communicates as broadly as possible, using shared visual symbols to bridge languages and cultures. Data visualizations similarly give form to information, but typically with much larger amounts of data. Designers develop aesthetic styles and parameters to represent systems of information, often working in tandem with software or algorithms that collect data.

Graphic Hierarchy

The purpose of information graphics is to communicate information to viewers in a short amount of time. To do this, your design style must be clear, concise, and consistent. Additionally, information graphics and data visualization depend upon hierarchies of visual importance. Color, value, scale, and depth can be used to direct the viewer's eye. For example, bright colors stand out against a neutral background. A mixture of thin and thick lines can create depth and direct movement in an image. For type, variations in size and font weight helps to establish visual importance. When creating info-driven design, use contrast of visual principles to distinguish between your primary and secondary information or elements.

Grids, Shapes, & Symbols

Traditional graphic design grid systems can be very helpful when designing infographics, especially when precise alignment and

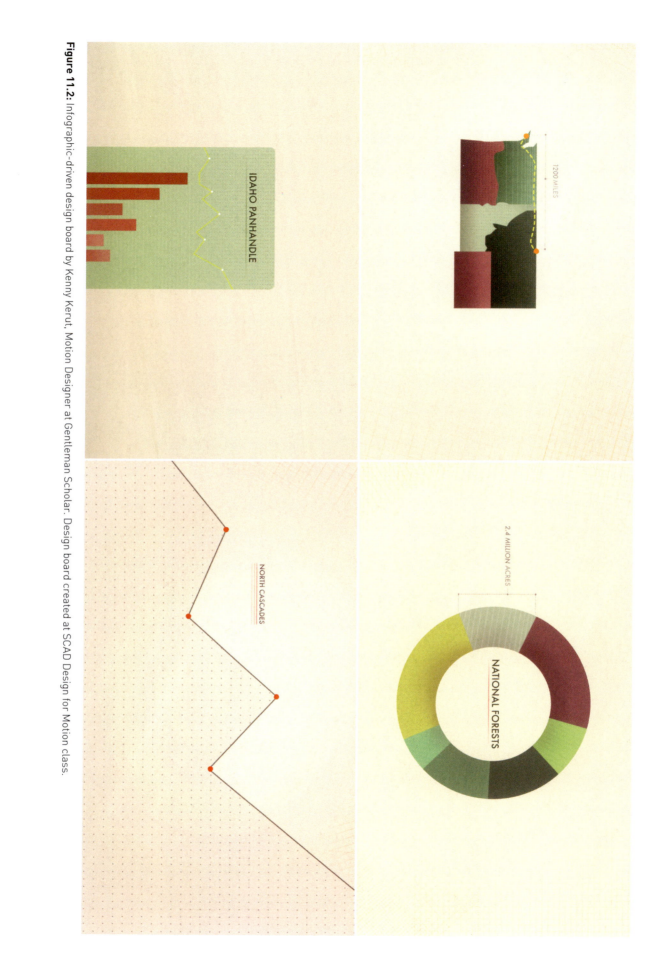

Figure 11.2: Infographic-driven design board by Kenny Kerut, Motion Designer at Gentleman Scholar. Design board created at SCAD Design for Motion class.

proportionate distances are required. Grids comprised of lines or dots serve as frameworks to design user interfaces, prototypes for futuristic visual effects, or simply to imply the aesthetic tone of information or data. Again, variations in line scale or line thickness create depths in your design grids as well as detail and intricacy.

Simple geometric shapes are often used for info-driven design. Circles communicate wholeness, unity, or completion. Triangles feel energetic and direct movement, while squares appear stable and strong. Duplication, variation, and the offsetting of forms imply change and motion. Basic shapes can also supplement information graphics and technical illustrations. For instance, a line with a dot on the end can signify a specific point of information in an instructional graphic.

The combination of simple shapes creates symbols and icons that are very useful for information graphics. Iconography and abstracted forms are quickly recognized as well as add charm or appeal to a design style. However, when working with symbols, be aware of the inherent emotions and messages that basic shapes communicate. There are collective historical, psychological, religious, or spiritual meanings associated with shapes like circles, squares, and triangles. The study of semiotics speaks to the use and interpretation of signs and symbols and can be very useful for designers.

Visual Metaphors

In many cases, information is rendered and displayed graphically. However, another option is to approach information graphics and data visualization through the lens of visual metaphor. Information can also be expressed through more tactile or unconventional representations by repurposing everyday objects to signify information. These more tangible elements represent visual analogies for data. Be sure to design a logical system that communicates your information effectively. Unexpected visual metaphors can be pleasantly surprising, thus communicating a message by capturing the viewer's attention.

Cinema-Graphic

The term *cinema-graphic* describes the process of applying cinematic techniques and effects to graphic elements. This includes qualities like depth of field, lighting effects, atmospheric particles, and/or cinematic camera movements. You can give depth and dimension to graphics that ordinarily feel flat. Cinema-graphics are by no means exclusive to information graphics or data visualization. Typography can be enhanced and integrated into various design styles using cinematic principles. However, the graphic style of this assignment provides opportunities for these techniques. 3D user interfaces, or *HUDs* (heads-up displays), designed for visual effect shots, often employ cinema-graphic styles. They help to composite information graphics with live-action.

Aesthetic

Too often, information graphics fail because they are visually too busy. The human eye can only process so much data at a time. One of the benefits of time-based media is that information can be delivered through sequential moments. Time-based media allows viewers to process information in manageable pieces as they are guided through a motion design piece. Keep this fact in mind as you design your style frames. You do not need to communicate all of your information at once. Your design style will benefit from a healthy amount of negative space. This principle is especially important, as a pleasing aesthetic will help to connect viewers with the information you are presenting.

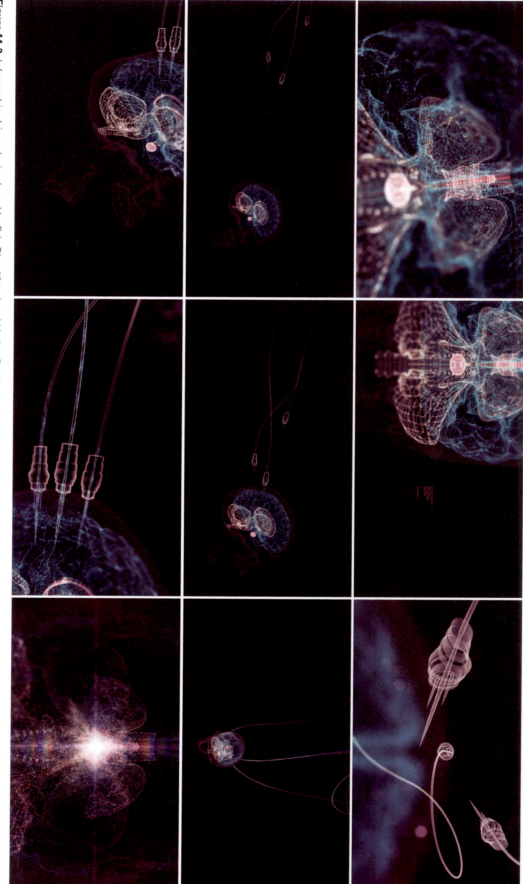

Figure 11.3: Infographic-driven design board by Eric Dies, Visual and Motion Design Lead at Microsoft. Board created at SCAD. Design for Motion class. This design board is an example of cinematic effects such as depth of field being applied to graphic imagery.

Creative Brief: Info-Driven Design Board

For this exercise, you will create a design board in the style of information graphics or data visualization. The challenge of this assignment is to reduce and simplify information or data into recognizable graphic elements. Can you express complex ideas through symbols, icons, illustrations, and typography?[1] The goal is to graphically represent information in an accessible and appealing manner. Although this project focuses on the communication of information or data, be sure to develop a narrative. Your design board should still tell a cinematic story.

- Concept: Select a random word as your conceptual prompt, a random topic to communicate information about, or a dataset that you are interested in exploring.
- Deliverables: Design a project in the style of information graphics or data visualization. Document your concept and design development as well as completed style frames and design board in a professional process book. Include

any interesting and relevant sketches, research, writing, storyboards, etc. in your process book.

Essential information-graphic skills to consider for this project:

- The ability to express ideas through symbols, icons, illustrations, and typography
- The ability to establish hierarchies of visual importance
- The ability to create effective visual metaphors
- The ability to translate information into aesthetically pleasing visual forms

Specific techniques to consider for this project:

- Analog—Information graphics created using analog or organic materials and methods
- Digital—Information graphics created using purely digital materials and methods
- Hybrid—Information graphics that combine analog and digital materials and methods

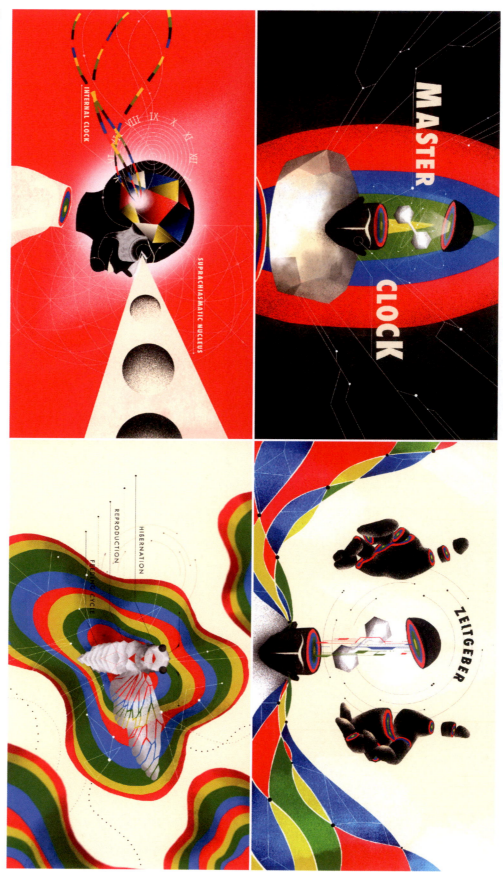

Figure 11.4: Infographic-driven design board by Eleena Bakrie, Motion Designer at We Are Royale. Board created at SCAD, Design for Motion class.

Professional Perspectives
Bradley (GMUNK) Munkowitz

Bradley G. Munkowitz (GMUNK) is a Graphic Designer by foundation who has over a decade of experience functioning as a Design Director for the motion graphics industry. He's also remained passionately involved in the global design community, giving lectures around the world about his process and experiences. His work is characterized as a hybrid of science fiction themes informed by a psychedelic visual palette.[2]

An Interview with Bradley G. Munkowitz (GMUNK)

What is your art and design background?

I graduated from Humboldt State in Arcata, California. I worked really hard in school. I was really inspired, and I was always hustling. I had a burning desire, and I always tell students to hustle while you can. Push it as hard as you can; this is your one opportunity to do it for yourself. I learned Flash and After Effects and started making interactive Flash pieces. When I graduated college, I entered one into the New Media and Vision Awards in San Francisco, and it won Best in Show. I was really lucky in that two of the creative directors of the interactive company that I looked up to the most wanted to hire me as a designer. I teamed up with all of the guys that I was idolizing in college. All the people that I loved, I ended up working with. I had to up my game to their level. I moved to London, and it was the most inspired time in my career. Those 2 years out of school were where I really learned everything.

From there, at a conference, I met Kyle Cooper who gave me a job at Imaginary Forces. That was my real motion graphics training. From there, I freelanced for years and years and years. I got another big break at another conference where I met Joseph Kosinski. He bought me in to work at Digital Domain, which led to me working on *Tron Legacy* and *Oblivion* with him.

I moved to San Francisco to work at Bot & Dolly, and BOX happened, which unexpectedly blew up the internet. I go from one place to the next with an open mind and an open heart.

How do you approach concept development?

I am 100% a visual person. I am really voracious on Pinterest collecting reference. Looking at reference sparks my ideas. In filmmaking, I will collect images that I love and then take those keyframes and weave them together into a narrative. I will eventually write the story, but I start with the keyframes first. I will stare at those keyframes and think about ways to explore an awesome visual. With design, it's the same thing. I collect reference like crazy. I love to share my reference. When I collect a project, I share the mood boards and everything that I was looking at. I think it's part of the cycle and part of the process of design. What you were looking at and what inspired you. Sometimes it's completely different than what you intended to do. When we were referencing and researching for *Tron*, we were looking at drawings of organic, natural organisms for high-tech, digital holograms.

Figure 11.5: *OFFF Cincinnati 2014 main titles. Created by Autofuss for OFFF Festival. Creative Director and Lead Designer: Bradley (GMUNK) Munkowitz.*

That's the beauty of it in a lot of ways. You can really flip things upside down with reference to inspire a thought. That's really how I often work. I will find an image that I love and that will inspire a lot of different things.

Where do you find inspiration?

Obviously, nature. I love *Burning Man*. I am obsessed with infinite fractals, sacred geometry, and Islamic symmetry. I also like to consume films on the iPad or go to the theatre. I study the

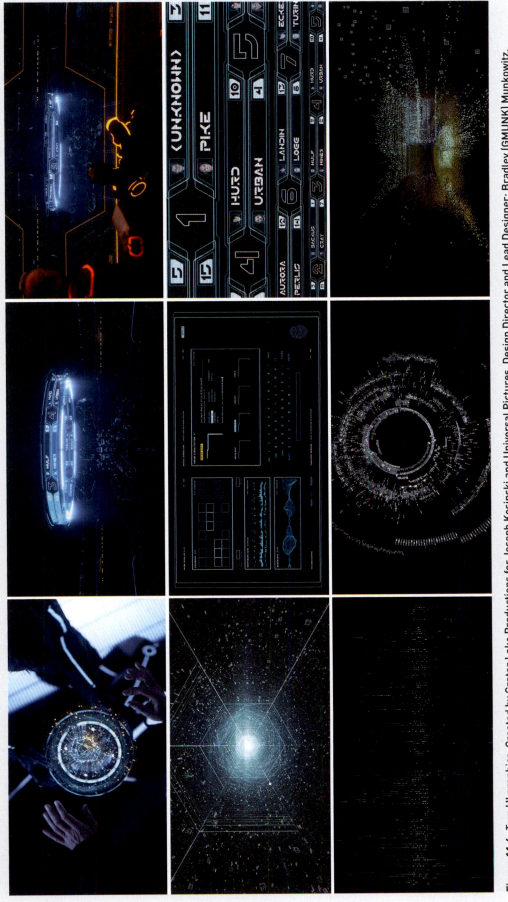

Figure 11.6: *Tron* UI graphics. Created by Crater Lake Productions for Joseph Kosinski and Universal Pictures. Design Director and Lead Designer: Bradley (GMUNK) Munkowitz.

masters, Chris Cunningham, Spike Jonze, Wes Anderson, and Kubrick's work as nobody does it better than the masters.

who become pioneers in the field. It takes a certain commitment and effort to get there.[3]

Do you have suggestions for young designers?

Find what you love and run with it. This is your time, when you will have the most energy. *The people who really want it are the ones*

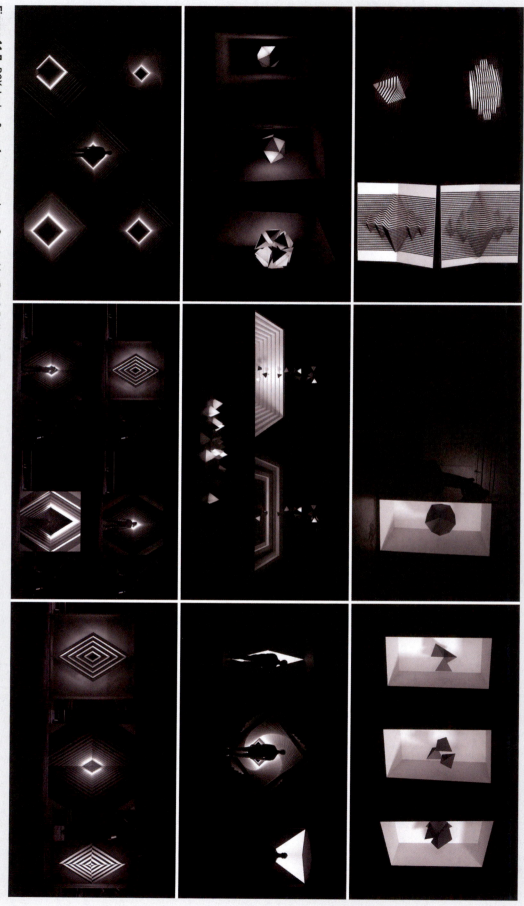

Figure 11.7: *BOX* design & performance piece. Created by Bot & Dolly for The Future. Design Director and Lead Designer: Bradley (GMUNK) Munkowitz.

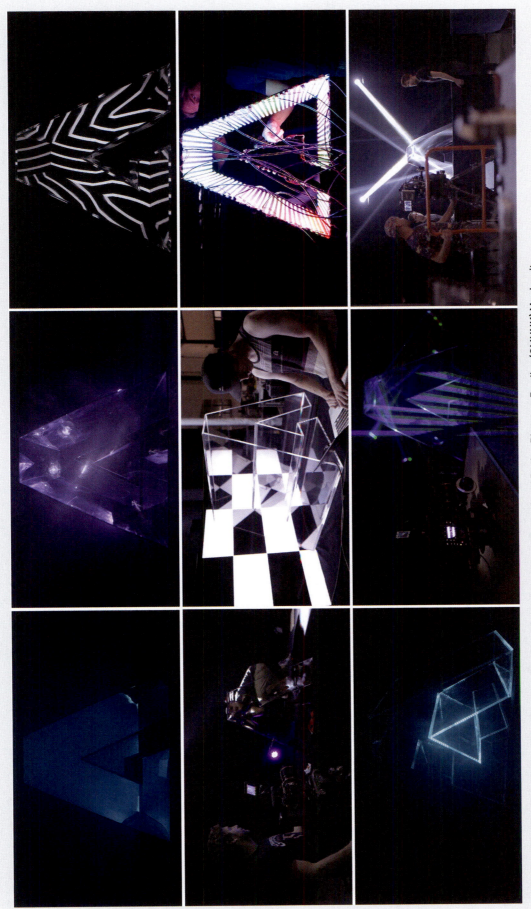

Figure 11.8: *Logo Remix Project Adobe.* Created by VT Pro Design for Adobe. Director and Design Director: Bradley (GMUNK) Munkowitz.

Figure 11.9: *OFFF BY NIGHT* 2016 title sequence. Created by The Mill. Creative Director: Mario Stipinovich. Designer/Director: William Arnold.

Professional Perspectives
William Arnold

An Interview with William Arnold

William Arnold is a designer and director based in New York City. A keen observer of the natural world, William's work is inspired by various preoccupations: the complexity of organic patterns, order vs. chaos, and the value of surprise. Visually, his work is often a combination of meticulous planning and unpredictability. He has shared his work and observations at a variety of institutions and festivals, including OFFF Tel Aviv, OFFF Antwerp, Motionographer, and The School of Visual Arts. William is currently an Associate Creative Director at Apple, focusing on interactive projects.

What is your art and design background?

I was always an artistic kid, but I didn't take an art class until my senior year of high school. At that point, I had never considered studying art in college. I ended up going to NYU as a Political Science major. But during my freshman year, I started hanging out with kids who were in the Tisch School of Arts, and I got a broader view of what it meant to be an artist. Before that, I had a very narrow view of art and design. I ended up transferring to the Photography and Imaging department at Tisch. After I graduated, I didn't really know what to do with my degree. While I was studying art, I never seriously considered its commercial applications. A few years after that, I found myself working at the front desk of a production studio called Brand New School.

I was really lucky, because at the time, I just needed a steady job.

Did you know what kind of work Brand New School did?

When the job was proposed to me, I thought that the studio made video games. But that still sounded great, because I was just working a minimum wage job at a bakery. So, I was working the front desk, taking lunch orders, answering the phone, and emptying the dishwasher. Within the first few months, I met some guys who seemed really cool, and as fate would have it, they were in the design department. Once I got a better sense of what they were doing on a daily basis, I started connecting the dots. I saw similarities between their work and what I had done in college. When I first started working at Brand New School, I had this notion that everyone there was a technical specialist, and to enter into any of those positions, I would have to go to school all over again. But once I got a better sense of what the designers did, it became a little bit more approachable. When I would see someone do a style frame or a photo comp, it felt like an elegant version of the photo collages I did in high school and college. That was my initial entry-point into the world of professional design.

Once I set my mind to it, I was diligent about learning as much as I could. I reached out to all the bands I knew and told them that I would design their gig posters for free. For 6 months,

I worked on posters every night after work, and my plan was to do enough of them, and make them look good enough, that I wouldn't feel like a fool showing them to the creative director of the studio. Eventually, I worked up the courage to show him, and he was nice enough to let me transition to the role of junior designer. I was at Brand New School for another 2 years. I treated those years like grad school for design. I was hungry to learn new things, and I was really lucky to work with Ricardo Villavicencio, an amazing designer, and Chris Palazzo, who showed me the technical ropes of typography and laying things out on a grid.

After that, I got let go. It was one of the first times in life when I felt like I tried my absolute hardest and the end result was still a devastating blow. I think that lit a fire under me, and as a freelancer, I really wanted to prove myself.

Why do style frames matter?

I think there are two ways to answer this question. The first deals with the production realities of the advertising industry. Often, before a client or agency agrees to give you money, they need to know what they're paying for. Being able to see style frames that

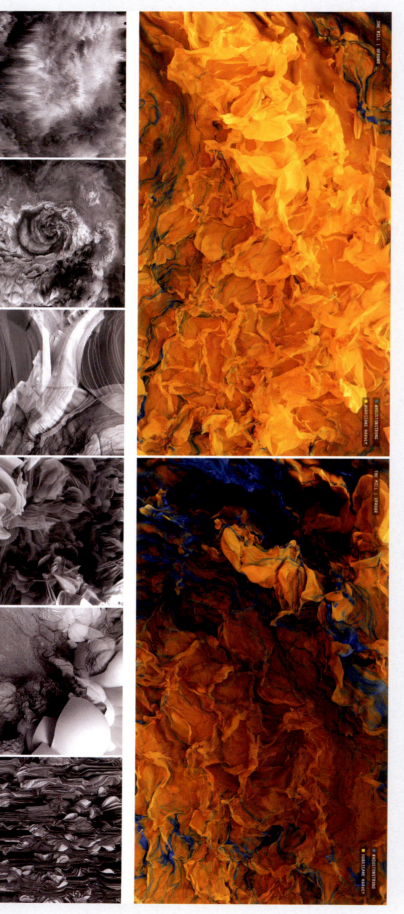

Figure 11.10: *Day for Night* UPROAR installation. Created by The Mill. Designer/Director: William Arnold. Co-Director: Kinda Akash. UPROAR is a tribute to the resilience of the people of Houston in the face of Hurricane Harvey. The fluid, painterly projection depicts large swaths of color that ebb, flow, and mingle over time. Within this abstract gestalt exists a data visualization—one that pins wind and rain data against the rise of #HOUSTONSTRONG on Twitter over the course of the 4-day storm.[4]

give a sense of how the spot is going to look, what the action is going to be, and how their product is going to be featured serves a practical purpose of getting a job in the first place.

Secondly, from a creative standpoint, it provides a backbone for everyone to be on the same page. Whether it's a 2D After Effects animation or a more robust 3D spot, you need a playbook for everyone to speak the same language and have something tangible to point to when there's a question.

What is your approach to working with creative briefs?

A lot of briefs have gone beyond the typical 15- or 30-second commercial. Briefs now include things like interactive installations, augmented reality effects, and virtual reality projects. Because of this, the functional purpose of style frames has evolved. Before, I thought it was necessary to represent each beat of a piece. Now, if it's just to get the client on the same page, it's more about showing possibilities and less about communicating each specific moment.

How do you approach storytelling?

I gravitate towards moments of surprise. Whether its unexpectedly changing a camera position, or taking a familiar icon or shape and then subverting it, I really like those moments in both 2D and 3D. I usually aim for something familiar, but then flip it on its head for a moment of surprise. One thing I've realized is that if you're going 100 miles per hour for an entire piece, nothing stands out. You need to have slow moments in order to create something unexpected.

How do you develop ideas?

I'm always searching for my own voice and trying to bring in things that I'm genuinely interested in. From there, it's easier to come up with ideas. When I first started designing, I was copying a lot of other people. It took me a while to figure out how to bring my own personality into the work. Anytime that I'm able to do that, or I'm

able to apply a technique that I've been exploring outside of work, the project seems to go so much faster, and I'm happier working on it.

How would you describe emerging technology in relation to motion design?

I think it's a natural evolution. Most projects that fall under emerging technology are about taking images or ideas that used to be on flat screens and, for the most part, putting them in space. There is a translation in terms of how you approach something when you are walking around it versus looking at it on a flat screen. But, a lot of the same motion principles apply. You don't want anything to move too quickly, and you still want those moments of contrast. It's a slightly different mindset, but I don't see a whole lot of difference in terms of the fundamental principles of motion design. It might be a different path to get to the end result, but the end result is still something familiar.

Anytime you are dealing with code or developing for a real-time platform, there is a certain amount of unpredictability inherent in the content. Often, you are building a tool for someone else to use, and you don't know exactly how they're going to use it. All you can do is make certain assumptions and predictions. I'm trying to craft loose parameters for someone else to explore within.

Can you describe the AICP project?

What makes good design? That was the fundamental question behind this project. In my opinion, good design is a combination of following rules, but at the same time, allowing for a certain amount of unpredictability. Those two things seem contradictory. On the one hand, you have design principles, but on the other hand, when you break those rules it actually feels good. It's hard to reconcile that contradiction. This piece was really an exploration of that contradiction. Using real-time software and code, we laid out very strict design principles. But, within those

guidelines, we let the computer make random decisions. This led to results that broke a lot of traditional design rules. For instance, I would never put two identical shapes next to each other. But when it actually happened, it worked and it really felt really gratifying. It's a really nice combination of structure, but also surprise.

Do you have suggestions for young designers?

The best advice I could give to a young designer would be to think about the things they're naturally drawn to, and really try to bring those concepts into their own work. Some of the most important ideas that go into my projects are inspired by the things I loved

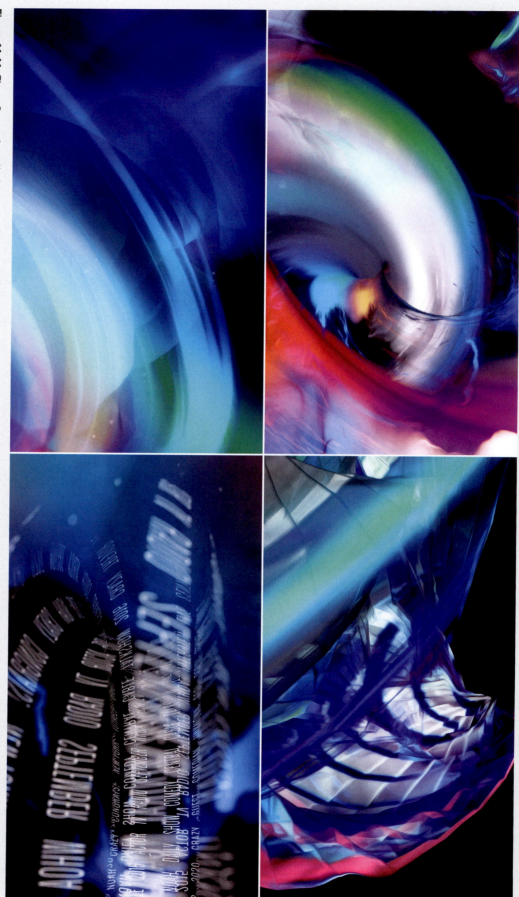

Figure 11.11: *Times Square* installation, created by The Mill for Viacom. Creative Directors: Rama Allen and Roxana Zegan. Designer: William Arnold. "For their flagship location in Times Square, Viacom wanted an installation capable of visualizing their diverse range of content. In order to do this, we referenced a series of natural systems—starting with a massive delta and ending with microscopic drops."[5]

Figure 11.12: *AICP 2018 Real-time system at the MOMA. Created by The Mill for AICP. Designer and Director: William Arnold.*

when I was younger, well before I had any formal understanding of art or design.[6]

Notes

1 Klanten, Robert. *Dataflow*. Berlin: Die Gestalten Verlag, 2008.
2 "About." Gmunk.com. Accessed August 19, 2014. http://gmunk.com/.
3 Munkowitz, Bradley (GMUNK), telephone interview with author, August 13, 2014.
4 "Day for Night: Uproar Installation." William Arnold. Accessed February 16, 2019. www.williamarnold.tv/#/day-for-night-uproar/.
5 "Viacom Times Square Installation." William Arnold. Accessed February 16, 2019. www.williamarnold.tv/#/viacom/.
6 Arnold, William, telephone interview with author, August 20, 2018.

Figure 12.1: Tactile designs by Guatam Dutta, Freelance Designer and Illustrator.

Chapter 12:
Tactile Design Boards

Tactile

tac·tile [tak-til, -tahyl]
adjective
1. perceptible by touch: Tangible
2. of, relating to, or being the sense of touch[1]

Tactile design describes creative work that incorporates a sense of touch. The sensory experience of touch can either be literal or inferred. Touch is almost always imagined and implied with screen-based media. In this way, tactile design triggers the viewer's perceptions to experience tangible and organic qualities. The perception of material, texture, and physicality is enough to inspire an emotional response in the viewer. The beauty and power of tactile design lies in the ease with which it can be approached. The organic qualities of tactile design invite a sense of touch. Paper craft, fibers, sculpture, tactile illustration, 3D modeling, and 3D printing are some of the methods and materials used in tactile design.[2]

Analog & Digital

The organic nature of tactile design is expressed through texture and material. The feeling of tactility can be achieved through analog or digital techniques. Analog materials inherently possess organic qualities. Digitizing analog objects and textures with a camera or scanner can preserve physical sensibilities.

Alternatively, design crafted in a purely digital production environment can still come across as being tactile. However, this approach requires an understanding and practical ability to create digital assets in an organic fashion. In other words, digital tools need to be used with enough variation and diversity to convey a sense of tactility and uniqueness. A hybrid combination of analog and digital materials and techniques can be very effective.

Texture

Textures influence the stylistic look and feel of tactile design, as well as exaggerate and exemplify a particular idea or message. Stone feels hard and heavy, whereas fur feels soft and warm. Smooth, polished wood communicates a different sense than rough, porous concrete. The sense of touch conveyed by texture adds depth and dimension to an image, while also sparking our imagination. When digitized, textures can be composited into Photoshop files using blending modes. Mixing textures with blending modes produces unexpected results. However, it is easy to be too heavy-handed with your textures. Experiment by trying various blending modes and adjusting the texture layer's opacity.

3D artists seek to embody their models with realistic textures so they will feel more alive. The eye is drawn to natural materials because they are unique and organic. Custom materials for 3D models and effective lighting can express the feeling of tactility. Materials in 3D are used to simulate surface texture

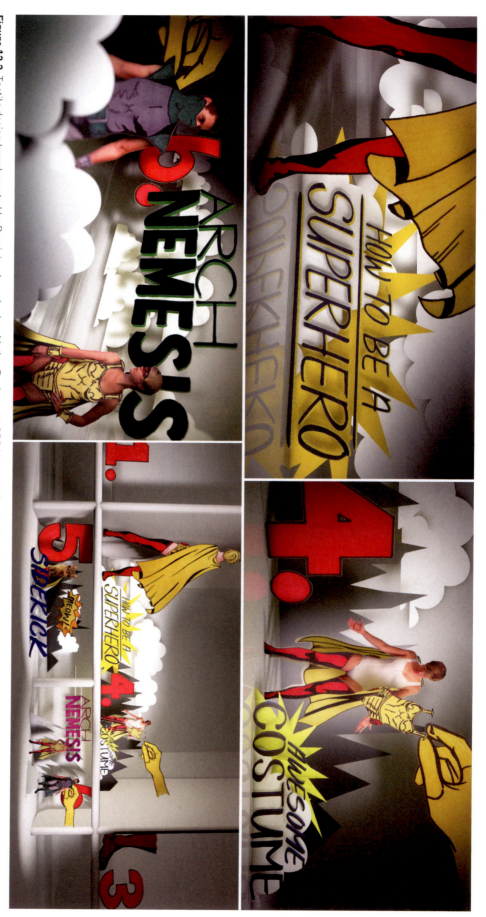

Figure 12.2: Tactile design board created by Dominica Jane Jordan, Motion Designer at CBS Network. Design board created at SCAD Design for Motion class.

through bump, displacement, and normal mapping channels. If you are seeking to expand your texture library, a fun activity or exercise is to go on a "texture hunt." Arm yourself with a digital camera and see how many interesting and unique textures you can discover in your neighborhood. You will probably be surprised how many beautiful and useful textures you pass by every day. Compositions come to life when texture is used to inspire our natural senses.

Organic Materials

Your choice of material will also influence tactile design. There are a number of ways to bring your tactile elements into a digital production environment. Flat elements can be scanned and composited digitally. If your design is more dimensional or sculptural, they can be photographed. Once photographed, you can use selections to isolate elements for compositing. If your design is more elaborate, you could compose entire scenes and

Figure 12.3: Tactile design by Jackie Khanh Doan, Designer at We Are Royale. Design board created at SCAD Design for Motion class.

photograph different shots. A descriptive term for this kind of setup is a *tabletop production*. Once your assets are digitized, you can enhance, modify, or manipulate them. Any of these methods can be used to create style frames and a design board.

Paper is a popular choice, as it is used in many different applications and can be crafted into any number of forms. Paper is relatively inexpensive and easy to work with. You can find

paper in a variety of thicknesses and densities to best match your concept. Semi-transparent paper can be affected by light to create interesting effects. Thicker papers can be cut or folded to construct shapes and objects. *Papier-mâché* is a process that combines paper with wet paste to create sculptural forms. Glue, tape, scissors, or a blade can be used to build a tabletop production out of paper. Paper can also be fashioned into props

or even costumes and wardrobes for live-action and mixed media installations.[3]

If you have a background working with fibers, this project is an excellent opportunity to blend your skill-sets. Textiles, fabric, and cloth can be embellished or woven to create objects, characters, and other visual elements. If you are not familiar with fibers, this could be an opportunity to collaborate with an artist from a different discipline. Fibers are extremely tactile and can be utilized to create unique design styles.

Modeling clay is another material that can be utilized for tactile design. The malleable nature of clay allows you to organically shape different forms, objects, and characters that

Figure 12.4: Tactile design board created by Camila Gomez, Motion Designer at Rosewood Creative. Design board created at SCAD Design for Motion class.

can be photographed for compositing in your design. Clay can be combined with simple wire armatures to create figurative models. You can also press unexpected physical textures into clay to create interesting impressions. Modeling clay is available in many different colors and consistencies. Alternatively, you can apply color digitally after you have photographed your assets.

Found objects can be really fun to work with. A found object is any object that you find and repurpose for your design style.

Everyday objects can be utilized in tactile design, but it is up to the designer to envision how to advance or elevate a concept using everyday objects. Spend time observing ordinary objects, and imagine how they can be transformed into something interesting for a motion design piece.

Tangible materials offer an opportunity to step away from the computer. Take a trip down to your local art supply store and explore analog tools and materials. Have a look through

Figure 12.5: Examples of fiber-driven design by Paige Striebig.

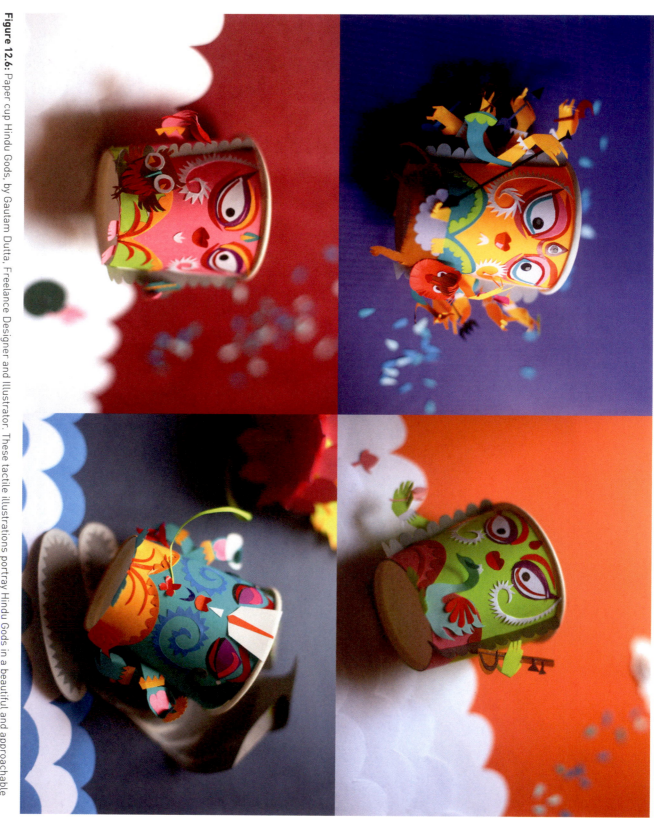

Figure 12.6: Paper cup Hindu Gods, by Gautam Dutta. Freelance Designer and Illustrator. These tactile illustrations portray Hindu Gods in a beautiful and approachable manner. The choice of material contrasts the gravity of meaning behind "divine beings." The relationship between material and subject matter creates dynamic tension and interest.

assortments of hand-made paper and various hand-held tools. Hand-made work can be refreshing for designers and viewers alike. There is an important idea to remember about working with analog material. It can be very laborious and time-consuming. Be sure to plan your project carefully, as these materials and methods can be very unforgiving. If your design process goes awry, see what kinds of beautiful distortions you can come up with.[4]

Materials should be used with integrity, meaning they are used in context with their essential characteristics. For example, metallic materials could be used for mechanical or robotic elements. Conversely, materials can be used in counterpoint to an idea. For instance, here is a relatively inexpensive or common material that is used to personify a divine concept.

These tactile illustrations portray Hindu Gods in a beautiful and approachable manner. The choice of material contrasts the gravity of meaning behind "divine beings." The relationship between material and subject matter creates dynamic tension and interest.

3D Printing & Laser Cutting

Another option for tactile design is to create models in 3D software and print them. This process offers an interesting opportunity to generate analog objects from a digital origin.

Once printed, you can position and compose your elements for photography. Character rigs can be 3D printed in parts and then assembled to serve as posable puppets. This method is especially useful for creating tactile assets for motion productions.

Laser cutters are another tool that can efficiently combine analog and digital production methods. Vector or raster files can be cut or etched into many kinds of materials including paper, acrylic, wood, fabric and metal. Once elements are laser cut they can be utilized for any number of design purposes. Laser cut designs can be photographed or used for projection mapping. Transparencies in materials can be affected by various light sources. Laser cut designs can also be stacked to create depth and dimension.

Tactile Design in Motion

There are a number of production methods that are well-suited for tactile design. Stop-motion animation, 2D animation, 3D animation, frame-by-frame animation, and live-action can all employ tactile design. Many of these techniques seamlessly mix analog and digital elements in post-production. Some artists and studios specialize in creating miniature sets and tabletop productions. Once elements and scenes are shot, they are invariably modified and composited further in post-production.

Creative Brief: Tactile Design Board

For this exercise, you will create a tactile-driven design board. Tactile design expresses qualities related to our sense of touch. Tactile projects for motion design include stop-motion, live-action animation, compositing analog and digital elements, and purely digital productions that possess tactile and organic qualities.

- Concept: Select a random word to serve as your conceptual prompt.

- Deliverables: Create a project in the style of tactile design. Document your concept and design development as well as completed style frames and design board in a professional process book. Include any interesting and relevant sketches, research, writing, storyboards, etc. in your process book.

Essential tactile design skills to consider for this project:

- The ability to concept for a tactile design style
- The ability to create tactile design elements
- The ability to use tactile design to communicate ideas and emotions
- The ability to integrate tactile design in storytelling

Specific techniques to consider for this project:

- Analog—Creating assets entirely by hand
- Digital—Designing purely in a digital workspace while establishing a tactile aesthetic
- Hybrid—Compositing analog assets within a digital workspace

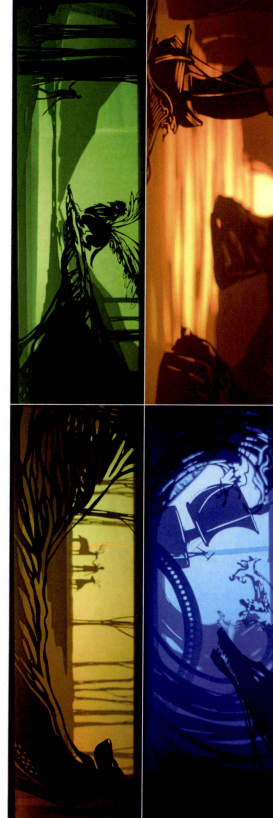

Figure 12.7: Tactile design board created by Michelle Wong, Motion Designer at Create Advertising Group, and Taylor Thorne, Motion Designer at Turner Networks. Design board created at SCAD Design for Motion class. This design board was created using both digital and analog production processes. Layers of paper were laser cut from vector illustrations, photographed, then digitally retouched.

Professional Perspectives
Lucas Zanotto

Lucas Zanotto was born in the Alps of Northern Italy. He has lived and worked in Milan, Barcelona, Berlin, and Helsinki. Lucas combines analog and digital media to create motion design that is deceptively simple and captivating. He has also translated his unique design and animation style into the interactive realm with art-driven apps.

An Interview with Lucas Zanotto
What is your art and design background?

I studied architecture for 2 years because I liked to draw. But that was not exactly what I was looking for, so I changed to product design. I got really into that, and I saw design was my thing. I went to school in Milan, got a product design diploma, and worked in that area for a couple of years. I worked on designing products from toasters, to tennis rackets, to skis, to medical objects. I really enjoyed it, and I am still a fan of that area because it involves modeling, forms, shapes, colors, and textures. But, it was very marketing-driven. It seemed like the marketing process was designing more than the designer itself.

So, I started making some short films, putting together friends and people interested in making short movies. I was also playing around with Flash and animation. I saw that animation was exactly what I wanted to do. It involved software and a certain amount of "nerdism," as well as graphic design and stop motion. I liked including photography and lights and filming, putting it

all together. I like to mix these different medias. I started doing different freelance jobs and then got signed by Film Technarna. I started doing pitches and directing. At that point, I was proud enough to start thinking of myself as a director. I think animation and motion are good jobs because there are so many screens that need content.

How has your experience with product design influenced your motion design?

I think the path to come to the final product is the same in every design area. You start with research, coming up with a concept, shaping the concept, planning, production, and fine-tuning. I learned a lot about the steps of production. Of course, I learned about model making, improvising things, materials, textures, and mechanisms. I think this hands-on, analog, and crafty process is reflected in the work I do now. I also bring the minimalistic feel from product design into my work now.

How do you develop concepts?

Most of the time I receive a script and initial ideas from an agency. They will refer to work I have done before that they like. I try to put a new twist or add an idea or perspective change that gives the idea something new. Repeating work does not drive me a lot. I like combining techniques to bring something new out. I try to sketch the idea down in some way with style frames or explanatory texts.

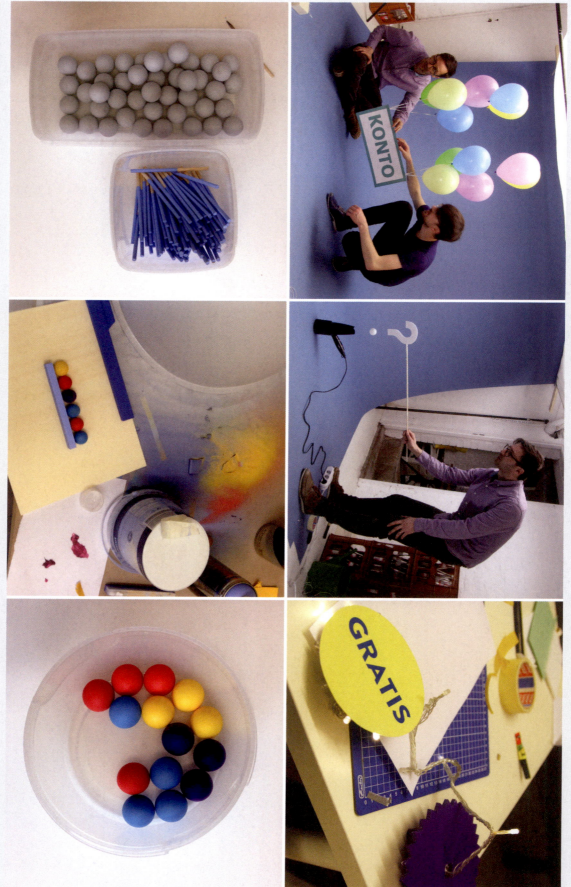

Figure 12.8: Process photos. Courtesy of Lucas Zanotto.

Where do you find inspiration?

It's everywhere. Often, it is playing with my kids, building stuff. We may be building a cardboard boat, and then I think about a background, then a big set with confetti flying from the top, and then you put a character in the boat. You filter out of your daily life the stuff you are interested in already.

Can you describe your tabletop productions?

It's a punk approach I would say. It's always budget-based. So in my earlier stages, I did a lot of improvisation. It's about improvising with the stuff you have and making the best of it. Improvising a soft box with sheets. That's one thing I really like, that if you see it from outside, it looks really punk. But if you just see the frame, it looks super clean, graphic, and illustrative. Suddenly you jump out of the set, and it's all these messy lights, messy things hanging, maybe not so fancy. That's always a cool effect.

Of course, it's always nice to shoot on a RED camera, have fancy lights, and a cinematographer who really knows about lights and cameras. If you have the budget, it's great. But if there is not budget or a low budget, you need to improvise. It depends a lot about the level of a project. A big brand, with an agency and production company needs to be storyboarded properly. You have to make an animatic beforehand, so that everybody approves and agrees. Then you go on set and shoot it live. On set, you need a bit of freedom. With live-action, a ball never bounces the same. You plan a storyline and a certain length. You match it together somehow to work the best.

What is the story with your interactive motion design projects?

I am making high quality, simple apps for kids. It started with the *Drawnimal* app. I was playing with my daughter, and she was learning letters. I thought it would be great to combine a tactile and interactive experience. In 1 or 2 days, I sketched the concept and how it would work. That was the exciting part. Then I had to find a developer. It took a while to find the right developer. Then I found a good sound designer. We kicked it off and tried some first tests. Now it's amazing, we got featured on the homepage of Apple. I think it got a lot of PR because it brings your kid back to crayons, thinking outside of the screen. It kicked-off very well. It's a great project that gave me a lot of PR, and I got new animation jobs from it.

What do enjoy most about motion design?

I enjoy the thinking part, putting new ideas together. I also like the doing part, being on set. I am not the biggest fan of post-production. If I can outsource that part, I am happy. But, I do like character animation. I enjoy playing with timing.[5]

Figure 12.9: Process photos. Courtesy of Lucas Zanotto.

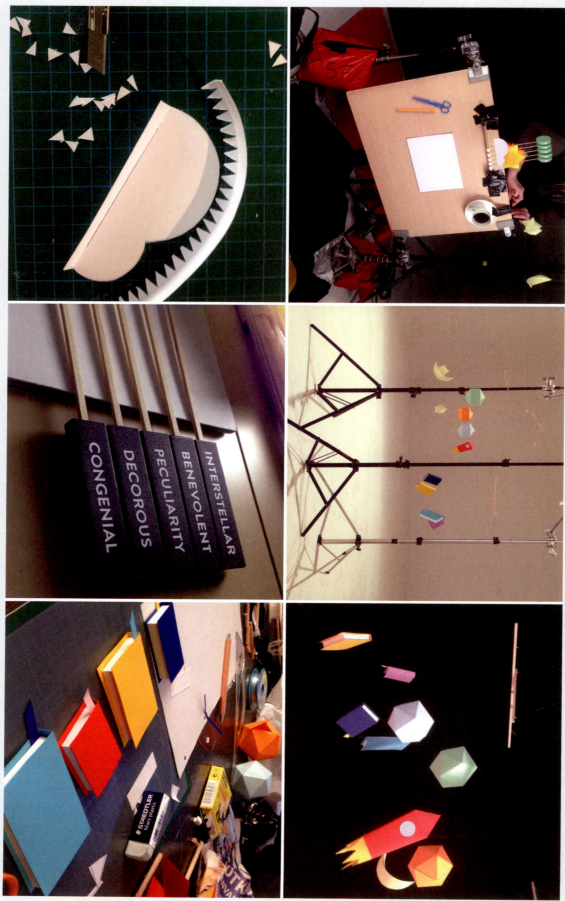

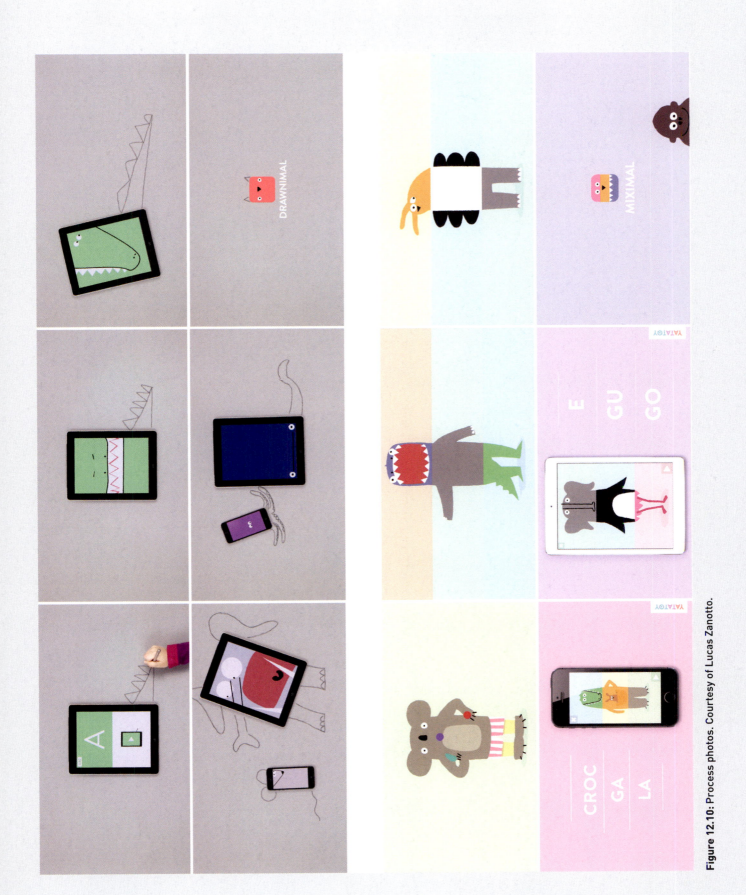

Figure 12.10: Process photos. Courtesy of Lucas Zanotto.

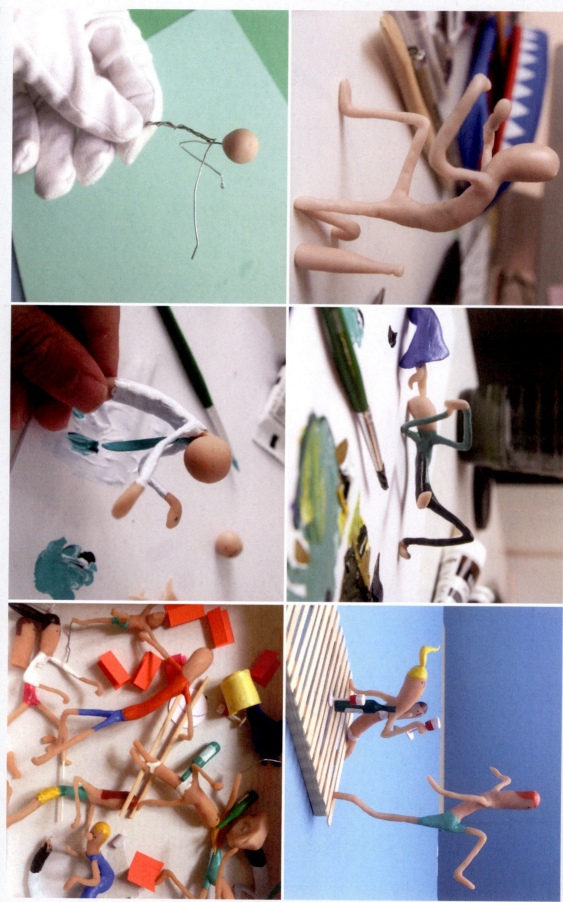

Figure 12.11: Process photos. Courtesy of Lucas Zanotto.

Professional Perspectives
Peter Clark

An Interview with Peter Clark

What is your art and design background?

The first digital arts I got into was in high school because they made the mistake of getting us laptops instead of having us use notebooks. They put Photoshop on my laptop, and I would do photo-bashing stuff during classes instead of taking notes. It wasn't great for math, but I learned a lot of Photoshop tricks. That got me into doing photo-comping when I was pretty young, which made it seamless when I transitioned into SCAD. I started in Graphic Design. I thought I wanted to do album covers and graphics for music. But then, I discovered the Motion Media Design program, and it was everything I wanted and more. I could make my music, combine it with visuals, and tell stories.

From there, I went to work at Autofuss and got to work with one of my dream designers—GMUNK. It was a crazy experience being surrounded by these people who do all these different creative mediums. So, I kept trying different things. Once that studio closed down, I kept working with GMUNK and that same crew at a bunch of different studios. I have slowly gotten into directing my own pieces that are direct-to-client. That has been the evolution so far.

What do you enjoy most about motion design?

The thing I enjoy most is that there aren't any rules about how it needs to be done. If you really love different processes, you

can embrace them and bring them into your piece. You don't always have to do a thing with After Effects, or always have to do a thing with Cinema 4D. I like that you can mix media, you don't have to always do it the same way. That opens up a lot of different collaboration opportunities. In other disciplines, it can be hard to justify bringing on other people. But in motion design, it is really helpful to bring people from different disciplines to help bring it all together. I like that it promotes collaboration.

Have you always been comfortable with alternative processes?

I grew up building a lot of skate ramps and constructing a lot of things—not necessarily well, but I liked the process of building. I have always liked the idea of constructing and combining things, but I didn't start doing multi-media stuff until I was at SCAD. In Graphic Design, they would have us do tactile things, and that went into the Design for Motion class where we would do tactile boards and multi-media prompts to make our style frames. College is really where I started to embrace the idea of multi-media, and that was hammered home when I did my first gig, working out of school, which was the OFFF titles with GMUNK. It was an entirely practical effects piece, and that really allowed me to embrace combining practical effects with digital effects.

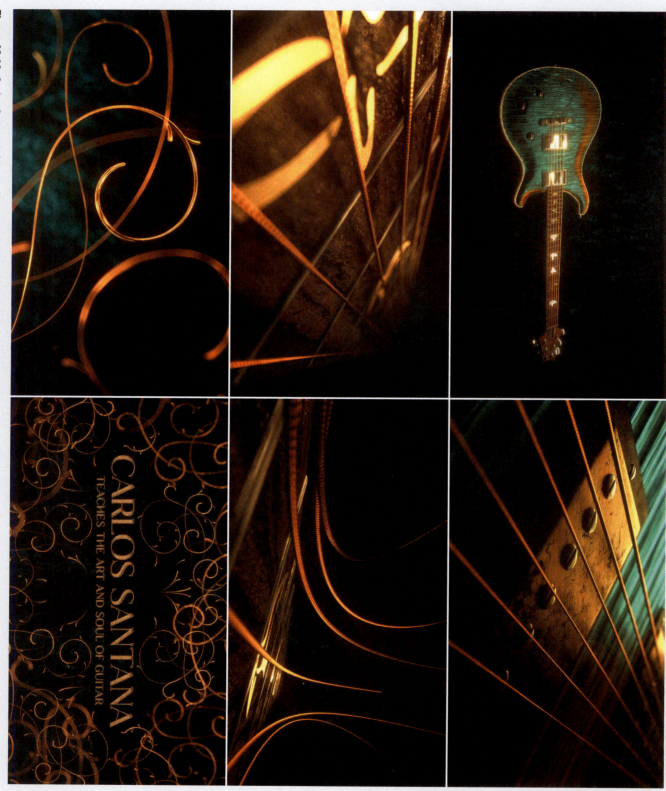

Figure 12.12: *Carlos Santana's Master Class. Created by Peter Clark for Master Class.*

Do you have a favorite project?

I don't think projects are ever special to me for what we've made in the end. It's all the process—the act of making it is what makes me passionate about them, and it's the part that I actually remember. I push my projects to be as memorable as possible and less about sitting in front of the computer. It's about doing things with people, building things and experimenting with materials, and being on set, listening to weird music, and all that good stuff.

How do you approach concept development?

It usually starts with my sketchbook. I tend to do a lot of *mind-mapping* and write out my *keywords*. I really like using the Dictionary app during concept development. I will type in the first half of a word that I am thinking about and see all the related words that come up and look at their definitions, look for keywords within those that I can start building on. I really like finding words with double meanings, so, when someone reads the title and watches the piece they don't get one resolute idea from it; they get a multitude of things it could be.

I will do thumbnail sketches, trying to fill pages so they are half drawings and half words, and develop from there. Usually, after that I will start looking for visual reference, going on YouTube looking for weird science experiments or trying to find inspiring artists who are doing things outside of Motion Graphics. I like looking at people who are doing a lot of sculpture, installation art, lighting designers, and lots of microscopic textures. I also go on walks pretty often, and maybe it's kind of weird, but I will explain my concept to myself as though I am telling someone about them. Something about that lets me iron out my concepts. When you have it in your head it seems like it makes sense. But, when you say it, you realize the holes in it. Final stages are talking to my collaborators about it, running ideas by other people.

What has helped you become a better designer?

Definitely iteration—never letting the first attempt at something be the last attempt at it. Doing projects with people like GMUNK where he gets me to do like 30 iterations of style frames or a set of boards before he says we are ready to show it to a client. Iteration inherently helps you get ideas out and explore. It helps me realize, if I am going for my first idea, which is usually the most surface level, it can always go deeper and get crazier.

Having other people give feedback is probably the thing that has pushed me the most. There is a channel that I share with other designers on Discord, where we will post our renders that we're working on and share what we're making. We'll post feedback to each other. Being surrounded by other designers who are really passionate about what they're doing, and they're always making crazy work—that pushes me to make my work crazier and to always be making things. The guys I know are always posting things at 4 in the morning because they're always rendering, always working on a personal project, or something that they just had to make. Being around that kind of community is the biggest driving force to create work and to get better.

How important are practical effects to your projects?

I tend to blend digital aspects with the practical effects. I shoot a lot of my practical effects in that film noir style where things are heavily lit with one light source or just a tiny bit of a secondary light source, so they get more of a graphic feel. I like when you can't quite tell if something was made in real-life or if it was computer generated. It becomes a graphic style with a lot of real-life textures applied. I am also influenced by a lot of 1980s retro, which tends to have that kind of glow to things, and lights flare out and go crazy. I like working with lasers and really saturated colors. Practical effects are all about abstracting reality just enough to where people can't tell if it's in camera or not.

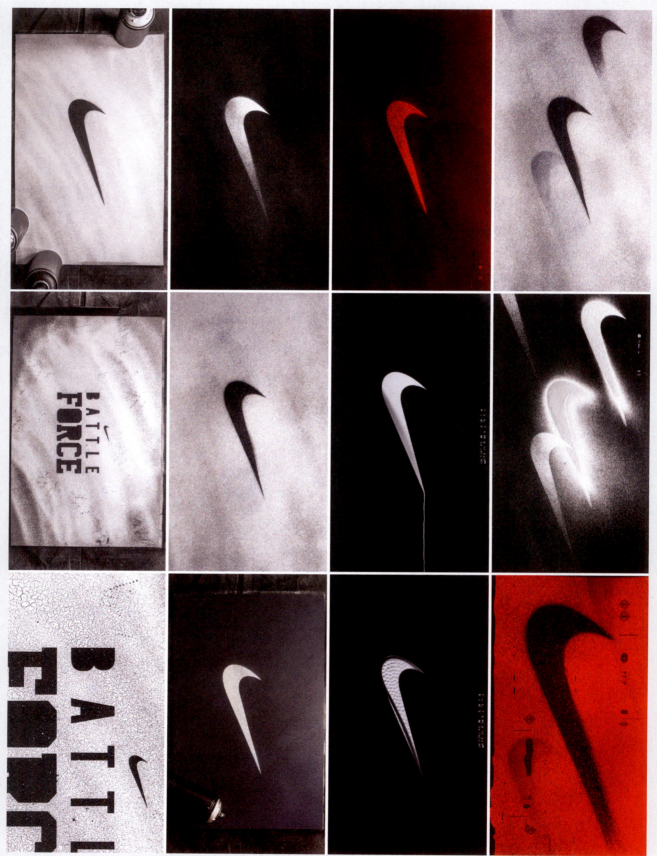

Figure 12.13: *Battle Force* commercial. Created by Oddfellows for Nike. Design: Peter Clark. "Most of the passes I created for the Nike swoosh reveal involved stop-motion sequences of spray paint. After laser-cutting a few stencils, I used several different types of spray paint to find an interesting way to reveal the logo form." —Peter Clark.

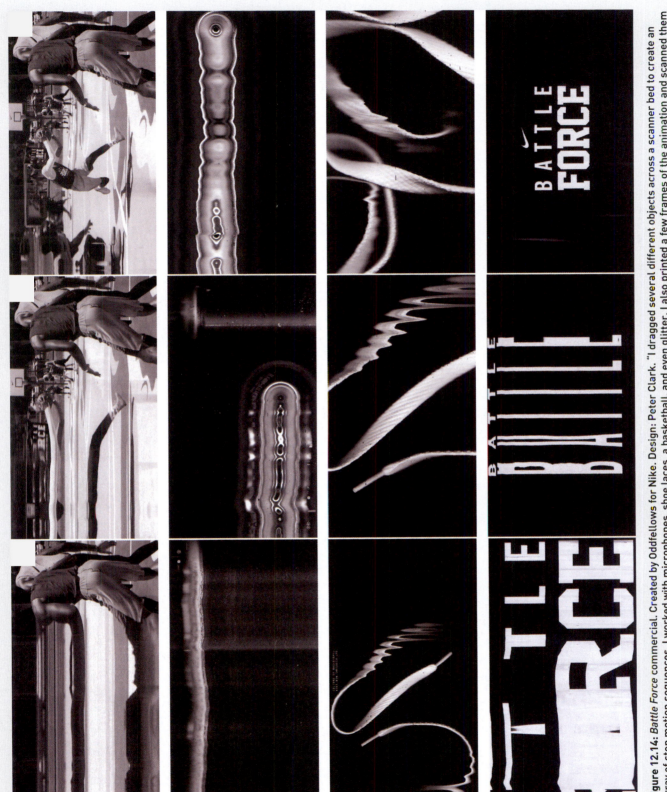

Figure 12.14: *Battle Force* commercial. Created by Oddfellows for Nike. Design: Peter Clark. "I dragged several different objects across a scanner bed to create an array of stop motion sequences. I worked with microphones, shoe laces, a basketball, and even glitter. I also printed a few frames of the animation and scanned them to create liquefied transition effects." —Peter Clark.

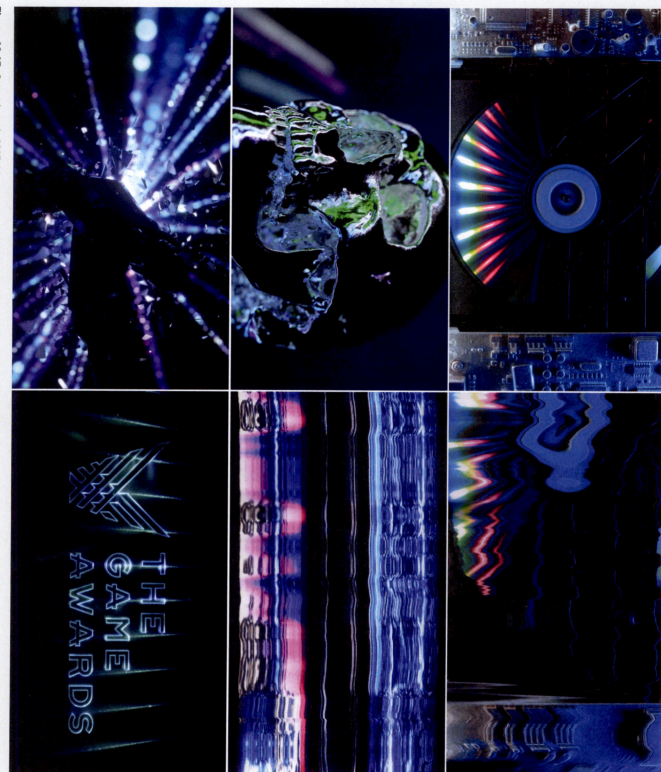

Figure 12.15: *Game Awards 2017 title sequence. Created by Peter Clark for the Game Awards.*

Projects get a little stale for me if I spend too much time on the computer. If it is part being on the computer and part being on set experimenting with a camera, that's enough for me to build a memory around a project.

How do you approach making optical effects?

I definitely have a bag of tricks. Laser cutting acrylics shows up in almost every project I do. I use a lot of reflective objects, especially for bouncing lights or lasers. I do a lot of microscopic work. I have a few microscopes and an attachment where I can attach a microscope lens to my camera, and take it wherever. I like to re-shoot things on screens and shoot through acrylic objects to distort things. I use a haze machine all the time. Having

natural haze in a space adds a lot of weird depth to things, and you get secondary motion from the smoke.[6]

Notes

1 "Tactile." Merriam-Webster.com. Accessed August 23, 2014. www.merriam-webster.com/dictionary/tactile.
2 Klanten, Robert. *Tactile: High Touch Visuals.* Berlin: Die Gestalten Verlag, 2009.
3 Klanten, Robert. *Papercraft: Design and Art with Paper.* Berlin: Die Gestalten Verlag, 2009.
4 Klanten, Robert. *Tangible: High Touch Visuals.* Berlin: Die Gestalten Verlag, 2009.
5 Zanotto, Lucas, telephone interview with author, July 10, 2014.
6 Clark, Peter, telephone interview with author, April 4, 2018.

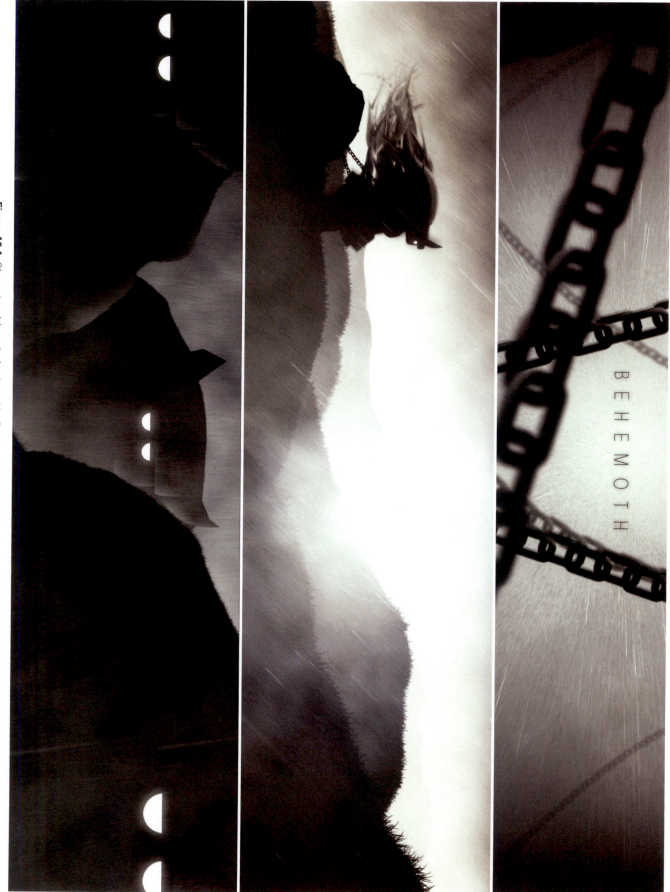

Figure 13.1: Character-driven design board by Graham Reid, Motion Designer at Snapchat. Design board created at SCAD Design for Motion class.

Chapter 13:
Character-Driven Design Boards

Character design is used in many motion design projects. Characters have the potential to emotionally connect with viewers as well as contain metaphors for big ideas or feelings. Viewers can relate and empathize with beings, even abstract or illustrative ones. An effectively designed character can break through walls of apathy to snare a viewer's attention. Once a character connects with a viewer, it becomes a device to help deliver a concept through its story.

Exaggeration of Essential Qualities

Because motion design is a relatively short form of storytelling, a character's personality is often exaggerated. Characters can be reduced to simple elements or traits that exemplify their nature or message. In your concept development, identify the core ideas and emotions you want to communicate. Let your keywords define and shape the expressive qualities of your characters. The visual traits of your characters, such as line, form, and color, should be guided by your concept. You can also explore and exaggerate opposing meanings of your keywords to help develop contrast.

The Process of Character Design

Character design is a specialized discipline. Professionals dedicate their time to developing characters for animated films, television, video games, or other types of character-driven media. For the purpose of this assignment, we will introduce the process

Figure 13.2: *Dreamcatchers—Alf.* Character for an animated series pitch. Progress sketches from left to right. Drawn by Nath Milburn. Animated series developed by Nath Milburn and Andrew Melzer. Production studio: Fort Goblin.

of character design. Understand that the suggested steps and process can be expanded upon in great detail for larger character-design projects.

Character design may be out of your comfort zone. You may not consider yourself to have strong drawing skills. However, with some courage and grit will pay dividends. Consider this project as an opportunity to expand the range of your aesthetic and produce a quality portfolio piece.

Written Character Profile

A good place to start with character design is to create a written character profile. Because there is such a condensed timeline for motion design, the essential qualities to include are emotional characteristics, behaviors, and mannerisms. Writing a back-story can also help to flesh out the needs and personality of your character. For longer format media, a character profile would be much more detailed.

Initial Sketches and Character Thumbnails

Spend time working in your sketchbook. The initial sketches should be free and loose. Use this time to explore possibilities and do not forget to have fun. A written character profile can give you starting points for your sketches, but allow your character to unfold in the process of drawing. Do not be afraid to create a lot of quick sketches. Once your design begins to take shape, create a few refined character thumbnails. Character thumbnails are still sketches, but they are closer to the realized look and feel of your design.

2D Layout Sheet

A 2D layout sheet is a tool that helps to visualize different views and proportions of a character. The standard views are front, profile, back, and three-quarter. You may not need to create a 2D layout sheet for this design board. However, this step is an indispensable facet of character design for longer-format, character-driven media.

Action Poses

Like the 2D layout sheet, you may not need to create separate action poses from your design board. However, action poses are a standard part of the character design process. They help to visualize the gestures and movement of a character. Action poses created from sketches can be translated directly into style frames for your design board.

Translating Character Design into Motion

Once you have designed characters, they must be prepped for motion. This process can be executed in a number of ways depending on your visual style. 2D characters can be colored, layered, and rigged for 2D animation. 3D characters need to be modeled, textured, and rigged for 3D animation. Tactile characters can be rigged for stop-motion or live-action animation. For style frames, the degree of character preparation varies, depending on the scope of your design board.

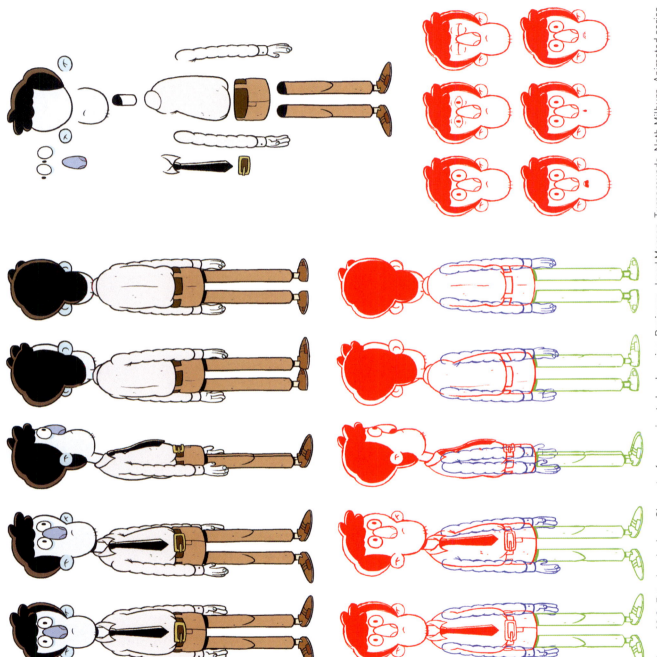

Figure 13.3: *Entry Level—Jonzy.* Character for an animated web series. Designer: Jared Morgan. Turnarounds: Nath Milburn. Animated series developed by Nath Milburn and Andrew Melzer. Production studio: Fort Goblin.

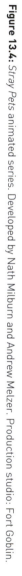
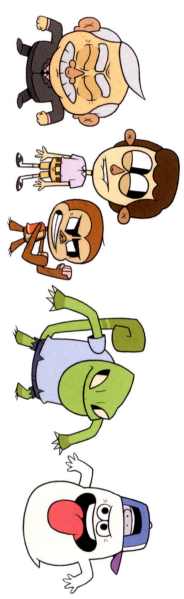

Figure 13.4: *Stray Pets* animated series. Developed by Nath Milburn and Andrew Melzer. Production studio: Fort Goblin.

CHINOINK

MORTAR MAN

FLYING WORKER

PENGUIN

LOVE PUPPY

WORKER

Figure 13.5: Character designs for *Coke "Happiness Factory"* commercial. Created by Psyop for The Coca Cola Company. Designer: Kylie Matulick.

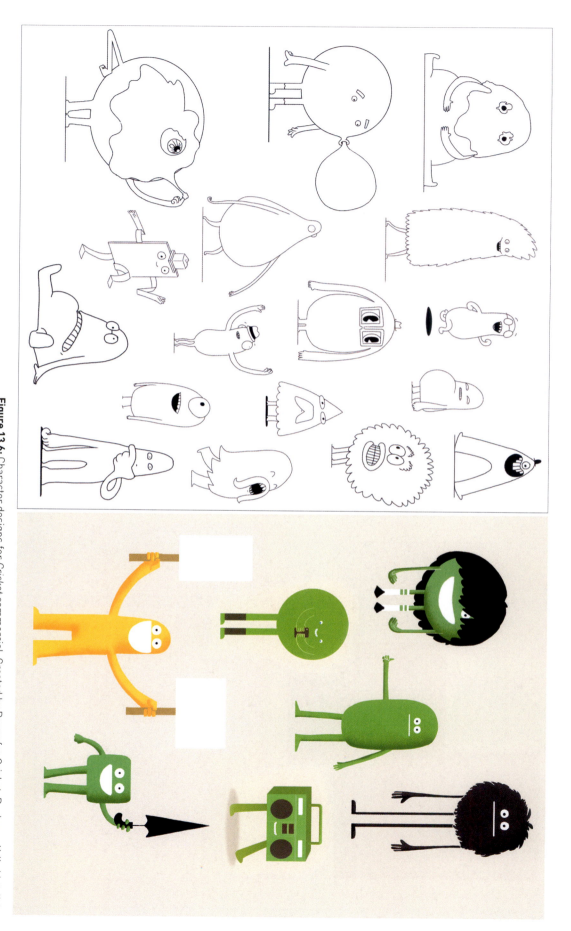

Figure 13.6: Character designs for *Cricket* commercial. Created by Psyop for Cricket. Designer: Kylie Matulick.

Figure 13.7: *Cricket "Anthem"* commercial. Created by Psyop for Cricket. Creative Director: Kylie Matulick.

Creative Brief: Character-Driven Design Board

Figure 13.8: Character-driven design board by Yeojin Shin, Designer at Buck. Design board created at SCAD Design for Motion class.

For this exercise, you will create a character-driven design board. Character design is a specialized skill that allows ideas and emotions to be expressed through stylized beings. Characters can be used in any form of a motion design project. They typically create a connection with the viewer and lead them through the story. Try to use a variety of camera distances and angles for this design board, as it will add a cinematic quality to your project.

- Concept: Select a random word to serve as your conceptual prompt.
- Deliverables: Create a design board that utilizes character design. Document your concept and design development as well as completed style frames and design board in a professional process book. Include any interesting and relevant sketches, research, writing, storyboards, etc. in your process book.

Essential character design skills to consider for this project:

- The ability to concept and design characters in relation to a creative brief
- The ability to express emotions through character design
- The ability to think sequentially with characters
- The ability to create compelling characters that connect with viewers

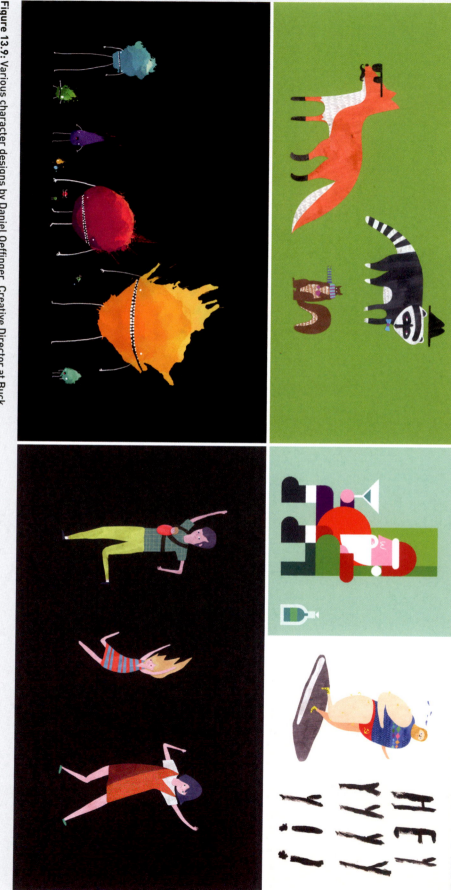

Figure 13.9: Various character designs by Daniel Oeffinger, Creative Director at Buck.

Professional Perspectives
Daniel Oeffinger

Daniel Oeffinger is a multi-disciplinary designer and animator. He likes to get his hands dirty in every aspect of production, from art direction and illustration to animation and compositing. Bold colors, graphic illustration, and a passion for storytelling are his favorite things to bring to the table. Daniel graduated from the Savannah College of Art and Design in 2006. After a few years of freelancing in New York City, he took a staff job at Buck NY, where he is currently employed as a Creative Director. Daniel also teaches at the School of Visual Arts in New York City.[1]

An Interview with Daniel Oeffinger
What is your design background?

I went to the Rising Star Summer program at SCAD before I graduated high school. It was awesome. I didn't apply to any other colleges, went straight to SCAD. I started studying web design and graphic design. I quickly morphed into motion. Web was more technical, and motion graphics combined everything I loved into one awesome thing. The broadcast design revolution was ongoing while I was in school. Brand New School started getting really big and popular. MK12 and the big industry giants were really inspirational. The other students I was in school with were awesome, and that drove me more than anything. I graduated in 2006 and came up to New York to freelance. I worked as a freelance designer and animator for 4 years. I took a staff position at Buck in 2009.

What do you enjoy about working at Buck?

Everything is driven from illustration, as well as design. It isn't all about Helvetica and proper layout. It is more about illustration and street art, which is exciting. It is an awesome crew to work with. Everybody is excited to be there. It is refreshing to go into an atmosphere where it is so positive and creative. It is like being back in school again, where everybody is doing what they love.

What are your thoughts on freelance vs. staff?

Freelance is awesome for some things, but you never get to grow too much. When I was freelancing, I was always playing it safe. You are brought in to put out fires, or do a quick turnaround on a lot of jobs. You have more creative flexibility, or at least you're not afraid to throw out crazy ideas when you are staff.

How do you approach concept development?

My basic process is to spend the first day, if we have that much time, purely ideating. We like to build mood boards a lot. We reference illustrators, photographers, and painters as a way to let ideas percolate. When you look at stuff, some of it clicks in your head when you're thinking about the creative brief. Mood boards are like a scratch pad of ideas. Once we have that, we come back to it the next morning and see what is appropriate to the brief ...

Figure 13.10: *How to Make Music for Advertising—AMP Awards 17 title sequence.* Created by Buck for the AMP Awards. Executive Creative Director: Orion Tait. Creative Director: Daniel Oeffinger.

Figure 13.11: *How to Make Music for Advertising—AMP Awards 17* title sequence. Created by Buck for the AMP Awards. Executive Creative Director: Orion Tait. Creative Director: Daniel Oeffinger.

what's fitting. After a day of looking at images and piecing things together, that usually lends itself to some animation ideas right there. If it is a heavy storyboarding job, then it's more about what kinds of actions and metaphors are being bought up. In that case, we go straight to pen and paper and make thumbnails. In that case, we go straight to pen and paper and make thumbnails. My thumbnails are rough, but I bring them to life in Photoshop and Illustrator. We'll bring all of our work together and see what's working and what's not. Sometimes we'll team up on concepts that are close together. If two artists have concepts that are very similar, we'll assign them together so they can build style frames together. It's a very loose process.

Where do you find inspiration?

I pull a lot from modern illustration. That stuff changes so much. I like to look at naïve illustration. Where characters aren't rendered fully anatomically correct. There is something whimsical and bulky about it. I like the stuff that is a little bit off, not super polished.

Do you have suggestions for young designers?

Having a stand out design portfolio does help. But, take the time, and put in the effort to make something that is unique and your own. Don't purely emulate. When you're in school, use the time to be experimental. Stay away from motion graphic trends.

Do you have any design heroes?

When I was in college, it was probably the same as a lot of people—GMUNK. He is always making short films and staying relevant. He is still a design hero.[2]

Professional Perspectives
Sarah Beth Morgan

An Interview with Sarah Beth Morgan

Sarah Beth Morgan is a freelance art director, motion designer, and illustrator based in Portland, OR. She grew up in the magical, far-away Kingdom of Saudi Arabia where she was deprived of bacon and cable television but granted a unique and broad perspective. After attending SCAD, she worked at Gentleman Scholar and Oddfellows.

What is your art and design background?

I've always loved art and design. As a kid, I was constantly drawing, writing, and painting. But, when I was in high school, I never really considered art as an actual career. My parents were encouraging me to go to a liberal arts school; they weren't 100% into the "art college" idea. But, I eventually convinced them and ended up going to SCAD (Savannah College of Art and Design). I enrolled as a graphic design major. I took a required digital media class and really loved it. That was the first time I ever used After Effects, and I was really intrigued by it. I liked the idea of stop-motion, moving illustrations, and combining mediums. Compared to graphic design, which felt restrictive, motion design was super fluid. Later that year, I watched the inspiring Motion Media Design department reel and decided to switch my major on the spot.

After I graduated, I landed my dream job with Gentleman Scholar and moved to LA. I worked there for two and a half years. I gained so much insight about the industry, being around staff

artists and freelancers on the daily. They often taught me new techniques. Design-wise, I was even on three pitches a week at times, and because of that, I essentially learned how to illustrate while I was there.

My fiancé (now-husband), Tyler and I grew weary of Los Angeles over our time there and decided to move onto Portland, OR. We were both incredibly grateful to get hired by Oddfellows, a studio that we'd looked up to for years. It was a wonderful experience, but after two years there, I was ready to try my own independent path. That's when I went freelance.

During that time at Gentleman Scholar, were there any pivotal moments where things clicked for you?

During my first annual review, my bosses essentially told me: "If we're ever going to move you into an art director role, you need to have more confidence." That kind of kicked me in the butt and motivated me to build my confidence. I really looked up to my bosses; they were awesome mentors. Throughout the process, I could ask them how they thought I was doing with my leadership skills, and they were always very honest. Without that, I probably wouldn't be as bold as I am now. I'm a better artist for it.

What is your approach to concept development?

At Gentleman Scholar, where we were constantly pitching, you had to pick your battles with concept. Concept was super important

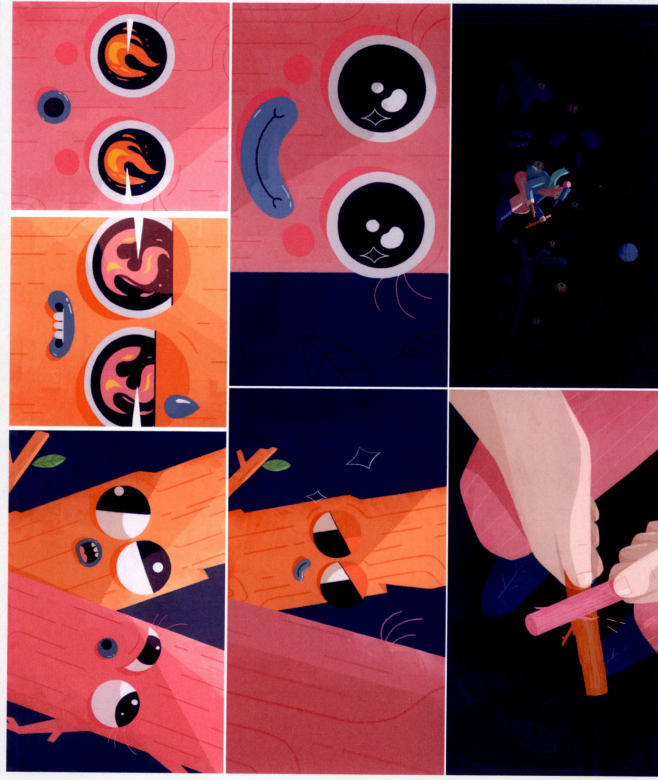

Figure 13.12: *Knotty Logs.* Created by Oddfellows for Yule Log. Design: Sarah Beth Morgan.

there overall, but it wasn't always top priority when you had to finish a design frame in one day.

At Oddfellows, there was so much time for concept development—weeks, at times. I think that's because there were a lot of direct-to-client jobs, so the timelines were much more drawn out. We had a lot of headroom to develop concepts, pull reference, and write ideas. We would gather in a conference room with the whole team and brainstorm. Before diving into a frame, we would sketch and get ideas approved by our bosses, but getting to this point could take a while. Working like that took some adjustment, but, Oddfellows helped me to slow down.

Now, as a freelancer, I often have the luxury of either developing concepts quickly or slowly, since I have experience with both. I typically start with research on the topic, looking at articles and reference outside of the design world. Maybe even visiting a location (if possible) to spark ideas. Then I gather inspirational material on the internet. Then, sketches. I like to present a couple different conceptual ideas for clients so they have options.

Why do style frames matter?

I love illustrating! Creating a style frame in Photoshop or Illustrator is like a breath of fresh air.

But besides just being fun for motion designers to create, they're important for animators. If you're a designer who's well versed in motion design, you should understand how things should move. *Good* style frames inform not only the stylistic direction, but also the movement and action that should occur once animated. It's important to storyboard everything out to know how it'll all fill together, generally outlining the motion through style frames is helpful for the animation phase. There's much more behind the style frame than meets the eye.

Where do you find inspiration?

I definitely hone most of my creative inspiration focus on social media. I love discovering new and unique artists over Instagram, Dribbble, Vimeo, Pinterest ... basically anywhere on the web. I also delve into podcasts that focus on artist features quite a bit. (Animalators is a favorite.) I sometimes love getting off the computer and working with my hands. It's refreshing, I love making things by hand. I think there's something true and warm about things that are tactile. Design feels more inviting that way. A lot of my daily motivation comes from other artists in the industry, especially the female artists I look up to. It's wonderful seeing other women achieve big things. I've had issues with confidence, so seeing other people who are confident push themselves is very inspiring.

Do you have suggestions for young designers?

Don't hold back in your designs! When I was in school, I thought I had to animate everything myself, so I restricted my design work based on my limited ability to animate. If I had known I didn't have to animate my own work in the industry, I could have made my work in school much more interesting.

And, making mistakes is okay. It's good, actually. It's fine to fail. I used to scrap work that looked bad in my first round of sketches—I was such a perfectionist in school. Now I know I can draw something that looks horrible at first, but if I keep working at it, I can mold it to look better—beautiful, even. Failing and making mistakes is part of the process, and if you don't fail, you're not going to get anywhere new.[3]

Notes

1 "Info." Daniel Oeffinger. www.oeffinger.com/info.
2 Oeffinger, Dan, telephone interview with author, July 17, 2014.
3 Morgan, Sarah Beth, telephone interview with author, July 8, 2018.

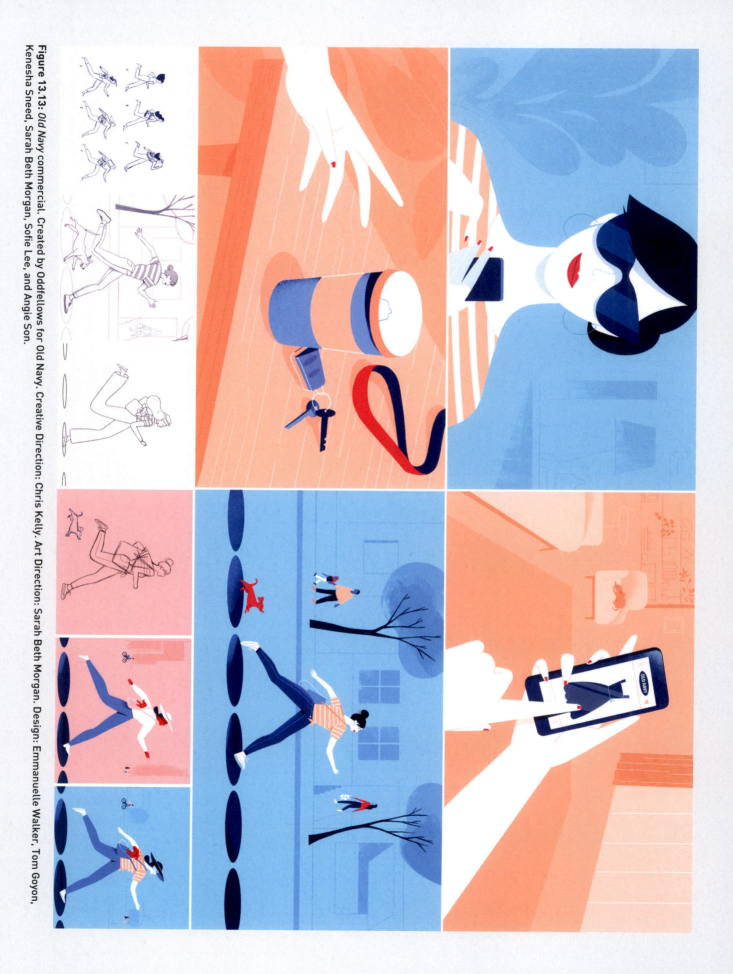

Figure 13.13: *Old Navy* commercial. Created by Oddfellows for Old Navy. Creative Direction: Chris Kelly. Art Direction: Sarah Beth Morgan. Design: Emmanuelle Walker, Tom Goyon, Kenesha Sneed, Sarah Beth Morgan, Sofie Lee, and Angie Son.

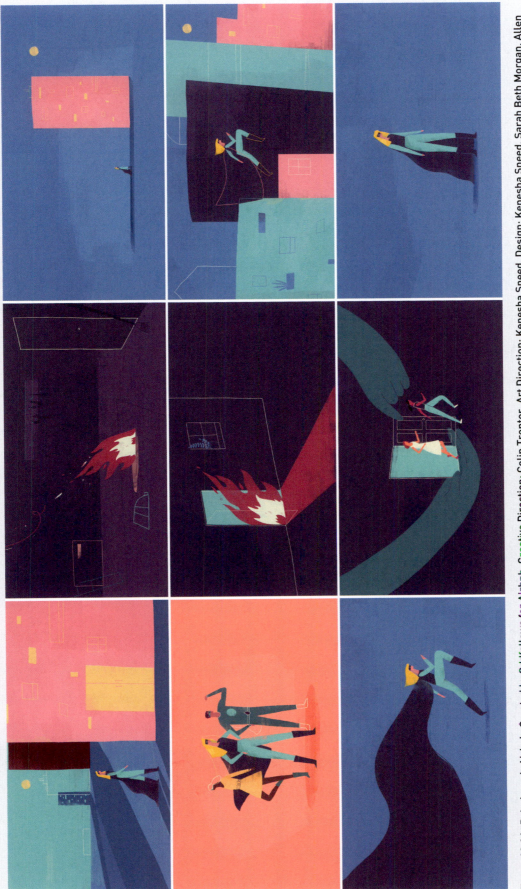

Figure 13.14: *Belo Awards* Airbnb. Created by Oddfellows for Airbnb. Creative Direction: Colin Trenter. Art Direction: Kenesha Sneed. Design: Kenesha Sneed, Sarah Beth Morgan, Allen Laseter, and Colin Trenter.

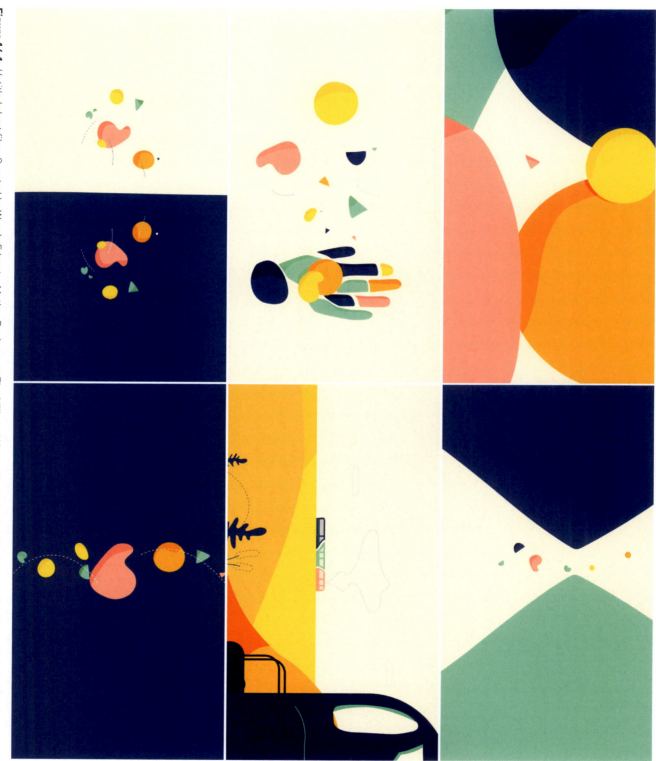

Figure 14.1: *Untitled* short film. Created by Wendy Eduarte, Motion Designer at The Mill, and Kenny Kerut, Motion Designer at Gentleman Scholar. Project created at SCAD as an independent study.

Chapter 14:
Modern Design Boards

Less is more. This phrase is used quite often in art and design discussions. The modernist movement sought freedom from the constraints of realism. In the realm of fine art, it began with the Impressionists. They rejected and departed from contrived and formulaic styles. Post-Impressionism continued the tradition of abstraction. What followed was a series of "isms," including *cubism, Fauvism,* and *surrealism. Modernism* culminated with the *abstract expressionists* and ended around 1945. Out of these movements, a philosophy and practice of simplification and reduction emerged. In the world of commercial art and design, modernism was expressed by the Bauhaus. Designers like Saul Bass, Paul Rand, and Milton Glaser expanded upon the tradition of modern design.

Simplicity & Reduction

Clean, bold, simple, and functional are some of the keywords associated with modern design. The goal of this aesthetic is to figuratively say the most with the fewest words. You can think of the stylistic challenge as a visual haiku. Try to create the strongest impact with the minimal amount of lines, shapes, or forms. Creating minimal yet effective design is no small task. You need to really think about your concept and how to express essential qualities visually. With this design style, there are no flourishes or embellishments to hide behind. The design needs to stand on its own and communicate a concept with clarity and power. One of the objectives of this exercise is to practice reducing visual elements. Find the essence of what you want to express, and strip away anything that is extraneous.[1]

Naïve Sensibilities

The publishing company Gestalten released a book titled *Naïve.* It is a collection of design and illustration that blends the modern style with content that speaks to a sense of innocence and youth. This kind of style has the potential to connect with a viewer's "inner child." For commercial art, this style is very sellable. For motion design in particular, the playful nature of the Naïve works very well. When the Naïve look and feel is applied to serious subject matter, it can create compelling contrast and tension.[2]

Vector Artwork

It is by no means a requirement to work with vector artwork for this aesthetic. However, vector graphics can be very effective for creating modern design styles. Geometric shapes like circles, squares, rectangles, and triangles can be created very quickly. You can also create illustrative and typographic elements within software like Adobe Illustrator. Your style frames can be created purely within Adobe Illustrator, or you can copy and paste elements into Photoshop. One advantage of working between Illustrator and Photoshop is the ability to add textures by using blending modes. You can also take advantage of more refined selections and gradients in Photoshop.

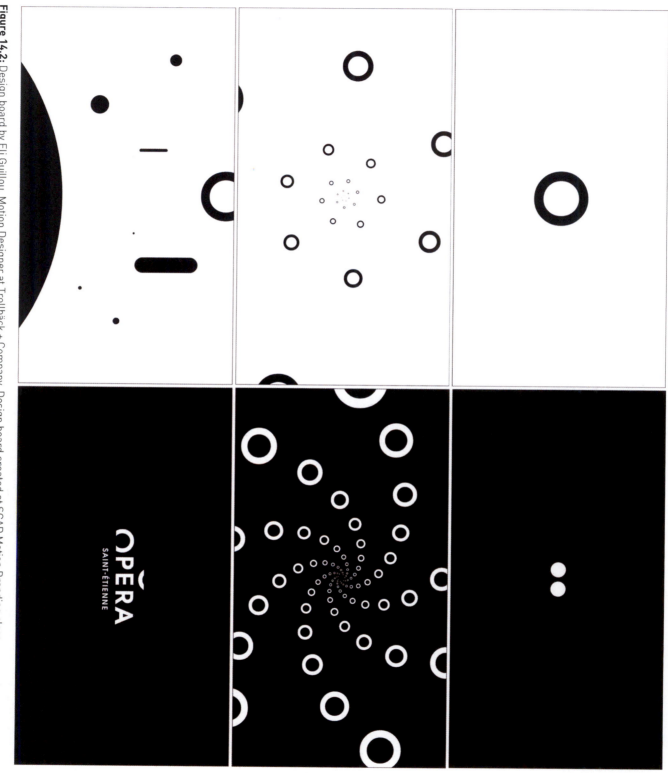

Figure 14.2: Design board by Eli Guillou, Motion Designer at Trollbäck + Company. Design board created at SCAD Motion Branding class.

Figure 14.3: Naïve design board created by Stephanie Stromenger, Freelance Designer. Design board created at SCAD Design for Motion class.

Creative Brief: Modern Design Board

For this exercise, you will create a modern design board. Modern design relies on reduction and simplicity to express a message or story. The Naïve sensibility inserts a sense of innocence in unexpected contexts. Both of these aesthetics are effective for motion design. Challenge yourself to limit your design choices in order to visualize the most essential qualities of your concept.

- Concept: Select a random word to serve as your conceptual prompt.

- Deliverables: Create a design board in the style of Modernism. Document your concept and design development as well as completed style frames and design board in a professional process book. Include any interesting and relevant sketches, research, writing, storyboards, etc. in your process book.

Essential modern design skills to consider for this project:

- The ability to reduce a concept to its most essential elements
- The ability to visually say more with less
- The ability to tell a story with limited assets
- The ability to create contrast between a concept and its visual form

Figure 14.4: Design board created by John Hughes, Motion Designer at Gunner. Design board created at SCAD Design for Motion class.

Professional Perspectives
Stephen Kelleher

An Interview with Stephen Kelleher

Stephen Kelleher is an independent graphic designer working with local and international clients for over 15 years. His design ethos is to produce maximum clarity with minimal means. His process always begins with a phase of thorough research before exploring ideation and appropriate implementation. He believes this union of thoughtful strategy and purposeful form maximizes effective communication and can deliver real value to a client. [3]

What is your art and design background?

I went to the National College of Art and Design in Dublin, and I studied Visual Communications. I have always been interested in design, illustration, typography, and I thought I was going to be a graphic designer. When I graduated, the first position I was offered was from a post-production studio in Dublin called Piranha Bar. I was thrown in at the deep end, learning After Effects and applying what I had learned about graphic design to that world. It was 2003, which looking back was kind of like the *golden age*. The owner of the studio sent me an email with a link to Psyop's Bombay Sapphire job with a one-line email simply asking, "Do you want to do this kind of work?" Haha! I just responded like, "Wow yes!" So yeah, the next 2 years working at Piranha Bar was like a baptism of fire. Back then some of the studios that were really popping off were Brand New School, Psyop, and Shilo. Almost every new

spot that came out was like a new technique or style or way of flipping things that you had never seen before. On every job, you would learn something new and try something new. At the time, it was far more exciting to me than other traditional graphic design jobs where I might be laying out an annual report or a brochure. Motion design could also incorporate all this stuff I loved about graphic design, but it had other critical elements like music and movement, which I was super-excited about. It felt like a whole new world. That's where I came from and how it started for me.

Do you have any design heroes?

There are so many legends. Ikko Tanaka is a big one for me. When I think about design heroes, I think about mid-century masters. Stefan Kanchev, who was a logo designer is also big for me. Obviously, Paul Rand and Saul Bass. Mid-century modernist graphic designers are my jam. The older I get, and the more I look at it, the more I realize it's timeless. These days I want to try and create work that is timeless which may mean being less 'trendy', whereas before, in my early 20s, I just wanted to make work that was cool. I have changed a lot. Guys like Tom Geismar; he's 87 years old, and he still goes into the studio every day. He sharpens his pencil, and he makes work. That guy is a hero. He comes from a time where you are a working graphic designer until the day you die. That kind of ethos, where you are sharpening pencils and doing the work yourself is something I hope to emulate.

Figure 14.5: *Google Material Design:* explainer animation created by Buck for Google. Executive Creative Director: Orion Tait. Designer: Stephen Kelleher.

Why do style frames matter?

In architecture, the end result is the physical building. The building that you are marveling at, is actually the execution of an idea and a plan—without that plan, the building wouldn't stand up! Can you start an animation in animation? First, you need elements to move, and certainly when it comes to commercial jobs you have a task to accomplish. The only way to execute that task is with a plan. So, you have to figure out what are the visual elements that will help tell the story in the correct way. There's such an interesting balance with motion design. It's never just the design, it's always thinking about the elements moving as you're designing the elements. What you create in a style frame also needs to live outside of that static image. That metacognitive splitting of your awareness when you are designing for motion is definitely a skill you need to learn and develop. In this case, the egg comes first, not the chicken. The chicken is the sequence in motion. It's common that most of the work you do as a designer working in motion is misperceived; it's categorized as "animation" because that's the final format, as opposed to design which has been animated. The inherent nature of animation or movement is so seductive so that when you look at it, all you see is "animation." Because it's perceived temporally, it's quite hard for the audience to differentiate the movement from the design. But it's also that harmony that makes it so beautiful and symbiotic.

It's like the relationship between a songwriter and a singer. Someone who writes a song is creating the structure of the music, but then a singer takes that and brings it to life in real time—they can't fully exist without each other. Similarly, to be a designer of motion is like being a music composer writing down notation, but the ultimate form of your work is the performance of that music—for us, that performance is the animation.

Can you speak to the Mythos project?

I wanted to try telling a complex story with simple shapes that people could understand. It was important to me that every element had significance and that the animation was trying to communicate a narrative. It was also a riposte to all of the beautiful but meaningless C4D Octane work that is currently being made.

The design and format criteria I set was that it had to loop, it could only use 4 or 5 colors and materials, and we could only use basic shapes and primitives. The content itself was the awesome ancient Greek myths we all know and love. The actualization of the project came from knowing somebody who was down to dedicate real time to making something we could both be proud of. Chris Guyot is a 3D animator and modeler, so I thought of something we could work on together. I think it's a good example of how motion can tell stories in a way that still images simply cannot.

Mythos is a good example of why my personal projects have always been super important for me; they're a vehicle for my conceptual and aesthetic ideals. That desire has always been somewhat at odds with my image of myself as a working designer for hire. To create personal projects is more like something an "artist" would do—realizing your own idea and the form it will take. But, I don't think of myself as an artist; I'm a very proud designer! So, when I want to make a personal project, I still have to create a brief with rules and restrictions which become a conduit to make the work.

I guess personal projects are also a way for me to feel a little more free to execute my concepts and vision without that annoying client feedback. But despite a lack of a client, they are always realized in the language of graphic design because I am ultimately trying to communicate things to people. That's been very enlightening for me too—I've found I naturally like making

Figure 14.6: *Mythos:* short films. Created by Stephen Kelleher. Art direction: Stephen Kelleher. Modeling & animation: Chris Guyot. Sound design: John Poon.

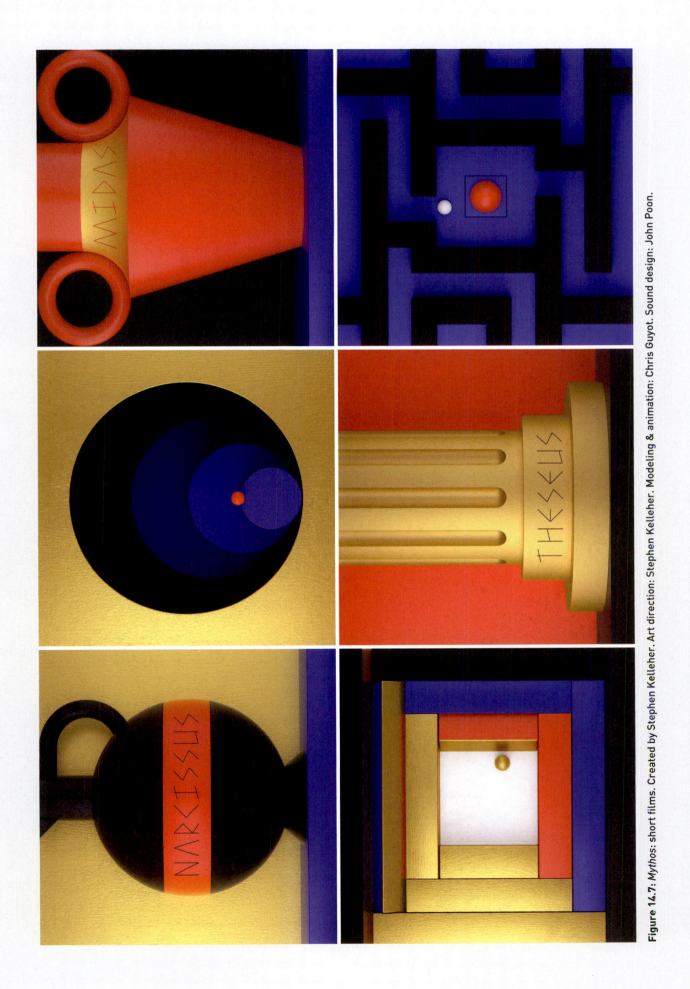

Figure 14.7: *Mythos:* short films. Created by Stephen Kelleher. Art direction: Stephen Kelleher. Modeling & animation: Chris Guyot. Sound design: John Poon.

a series and iterations, which speaks to my interest in system design. "Here are the rules, and here are different variations of it." I think it is important to show you can create a system that can be expanded upon, can live with different kinds of content, is versatile, yet unified. That's a very "designer" approach to personal work, which for me, feels natural.

What is most challenging about motion design?

To do good work, you have to really push yourself and put everything you have into it. You never switch off. I'm not just talking about sitting at the computer. You're on the train home or having a shower, and your mind is always on the problem you are trying to solve. You're pouring your whole mental effort into this thing, and when you don't win the pitch, it doesn't end up getting animated. So, it's almost like the work you did doesn't fully exist in the world. It's a bummer, man!

I regularly work with some of the most highly regarded individuals in the industry. For the most part, they are really outwardly professional in the sense that, when the job doesn't go how they want or the client is always changing stuff, they suck it up with a smile like, "Well, I guess the client has changed everything, but let's make it the best we can!" That is the right attitude. I personally have never been able to detach myself from the work or achieve that level of "professionalism." I care, and it will affect my mood. I know it's the more helpful, sustainable,

and reasonable thing to do; to see your work as a job. But I don't think I can make work that I am really proud of if I go into it with that frame of mind. I need to go into it with a "this is going to be the best thing I've ever made" frame of mind. That is an emotional investment. And when that doesn't pan out, it is really hard for me to just shrug it off. That said, real life is great for some perspective on work issues.

Do you have suggestions for young designers?

I would like to think that things like motion design, graphic design, or whatever discipline you are learning can be seen as metaphors for how you solve problems in your life. I try to think about things in a lateral way, "Why am I doing this? What is the purpose of doing things this way?" So many people just focus on "How do I do this?"

I think it's really important for students and people who are coming up to be keenly aware that their worth is in the solving of problems that computers can't comprehend. We are guaranteed to have machines that can create arbitrary, complex beautiful visuals. Your value as a human designer is to answer human problems with human solutions and present them in a human way. That is problem-solving. That is something a computer cannot do. Creatives need to put their weight into that kind of thinking, rather than just making eye-candy.

Professional Perspectives
Chace Hartman

Chace Hartman is a New York-based Director, Creative Director, and Designer. He is the Director/Creative Director for Gentleman Scholar NYC. He has helped to conceive, design, and direct spots on a range of exceptionally well-crafted campaigns for digital, commercials, live-action, identities, and broadcast needs for notable brands such as Target, Timberland, Oreo, ESPN, Draft Kings, Spotify, IBM, MSNBC, Chevron, Verizon, American Express, Kraft, Toyota, Pepsi, BBC, Tiffany's, Wells Fargo, NBC, and others. Chace's experience, adaptability, and synergetic nature has helped him become a trusted partner to creatives at top agencies such as 72 and Sunny, BBDO, Deutsch, Havas, Ogilvy, McCann, Pereira & O'Dell and many more. Prior to joining Gentleman Scholar, Chace has worked at multiple bi-coastal offices as a creative director and director working with many major internationally recognized brands.

How did you get started as a motion designer?

I had a good thing going doing technical illustrations, but I could see exactly where I would be at 40—looking back and doing the same thing I did when I was 25. I had always liked animation. I didn't know how to do any of it, but I was attracted to it. Motion design was just coming of age. I could have stayed at my first job doing packaging and illustration and done well, but I would have been bored out of my mind. I got an opportunity to do some freelance animation for Digital Kitchen. I was in way over my head,

but I figured it out on the fly. It was new and challenging, and I was hungry. I was just glad it wasn't huge amounts of technical illustration. I started doing design boards for Digital Kitchen, which solidified in my mind that I could do this. I also realized at that point, that I could rely on my illustration, and get better at design and typography.

There were only a couple of places doing motion design in Seattle at the time. I was ready for a change. I realized if I was going to move to New York, I needed to save some money. So, I moved into a friend's place. I paid him $200 a month and just slept in the closet. I had a sleeping bag, my bike, and a duffel bag of clothes. I stayed there for a year and a half, built up my reel and saved money. I emailed studios in New York and told them I was moving there in 6 months, even though I didn't have a plan yet about how I was going to do it. I found a sublet in New York and started freelancing with Eyeball. Then I got booked at Brand New School. I freelanced between Seattle and New York for around 12 or 13 years.

Then I got married and started having kids. So, I got a full-time job at Superfad in New York. I had avoided taking a staff position for a long time. But, I found I was able to nurture and grow with one place. This allowed me to hone my art directing ability, work more with clients, and manage people better, which you don't get to do as a freelancer. Most of the time you are running-and-gunning or doing damage control with freelance.

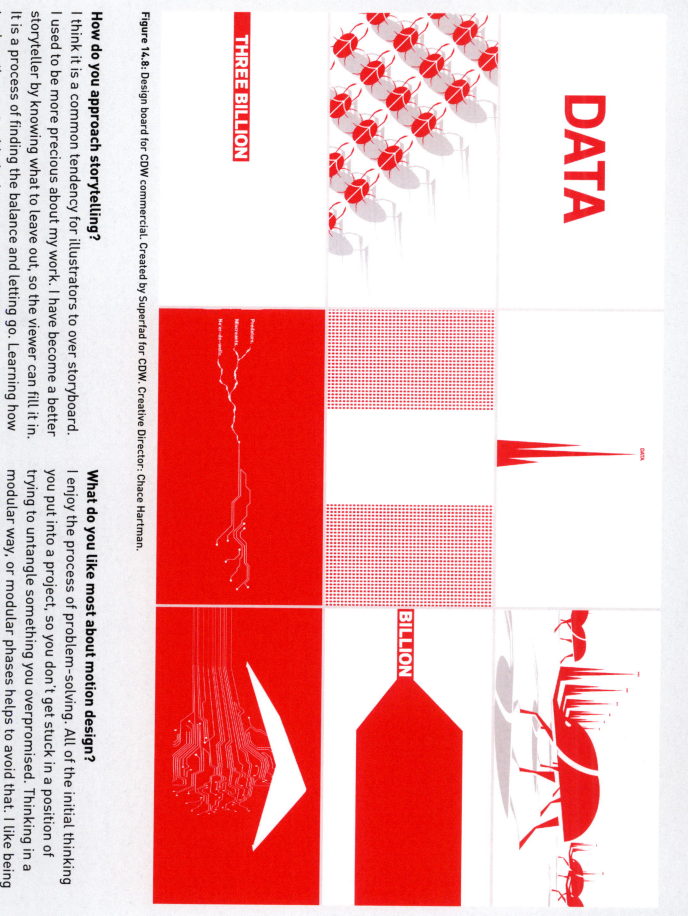

Figure 14.8: Design board for CDW commercial. Created by Superfad for CDW. Creative Director: Chace Hartman.

How do you approach storytelling?
I think it is a common tendency for illustrators to over storyboard. I used to be more precious about my work. I have become a better storyteller by knowing what to leave out, so the viewer can fill it in. It is a process of finding the balance and letting go. Learning how to show the most, with the least amount of detail.

What do you like most about motion design?
I enjoy the process of problem-solving. All of the initial thinking you put into a project, so you don't get stuck in a position of trying to untangle something you overpromised. Thinking in a modular way, or modular phases helps to avoid that. I like being inspired by other people's work, and learning from their skill

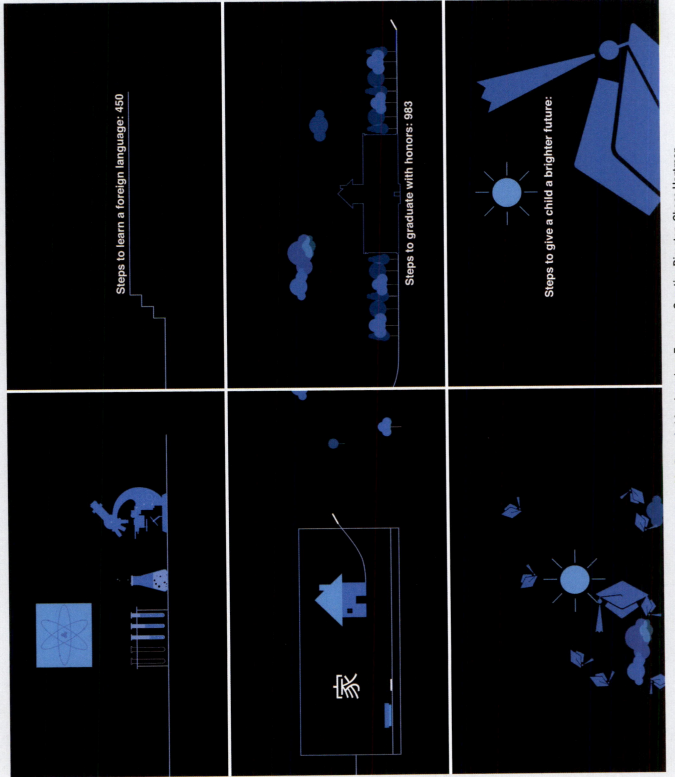

Figure 14.9: *American Express "Beaker"* commercial. Created by Superfad for American Express. Creative Director: Chace Hartman.

Within the image:
- Steps to learn a foreign language: 450
- Steps to graduate with honors: 983
- Steps to give a child a brighter future:

sets. As soon as you stop learning, you won't be passionate about your work.

Do you have suggestions for young designers?
Get to know what you are good at, but don't let it be your only strength. Have a couple of things you really like to do. Not

every job is going to need your strength, so you need to be diverse within reason. Having a diverse skill set is a good attribute and attractive to people who want to hire you. It will allow you to think in different ways and solve design problems. It will also keep you from getting bored. *You can't let not knowing stop you from trying.*[4]

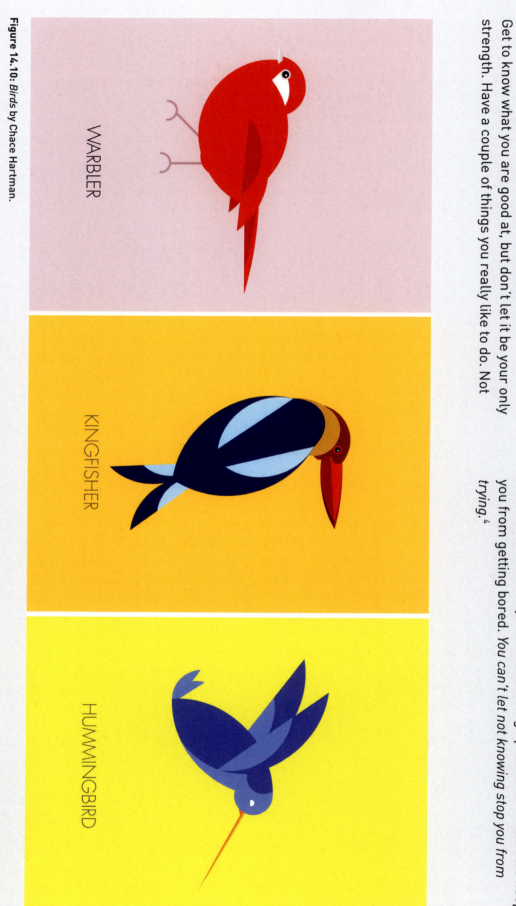

WARBLER

KINGFISHER

HUMMINGBIRD

Figure 14.10: *Birds* by Chace Hartman.

Notes

1 Klanten, Robert. The Modernist. Berlin: Die Gestalten Verlag, 2011.
2 Klanten, Robert. Naïve: Modernism and Folklore in Contemporary Graphic Design. Berlin: Die Gestalten Verlag, 2008.
3 "Info." Stephen Kelleher. Accessed February 22, 2019. https://stephenkelleher.com/Info.
4 Hartman, Chace, telephone interview with author, July 10, 2014.

Figure 15.1: *Notes from the Design for Motion Class. Created by Chrissy Eckman, CEO of Kineticards. Notes created at SCAD Design for Motion course.*

Chapter 15:
Looking Forward

Motion design has come of age. The business model of design-driven production has firmly taken root across a range of creative industries. Motion designers are needed in many capacities and for many different platforms. From traditional post-production artists to original content creators, opportunities for motion designers continue to expand.

As creative problem-solvers and digital media generalists, motion designers are poised to be the next generation of creative leaders. We are armed with a strong foundation in art and design principles and embrace both analog and digital technology. As screens become even more ubiquitous in our daily lives, the demand for content increases. The overlap of motion design and interactivity offers entirely new avenues and directions for creative professionals.

Motion designers are like the mythological Hermes, able to travel across many realms and boundaries. We need the introspection and drive of traditional artists and designers to craft our individual visions. We also must be able to collaborate and work seamlessly within a team, like members of a film production. We wear many hats, and this multi-talented quality makes us attractive to employers.

Amidst the shifting tides of media needs and platforms, the challenge will be to stay relevant over the course of a career. Adherence to beautiful art and design is a time-tested path that will continue to pay dividends. Flexibility and the willingness to adapt to changing technology is necessary. Above all, stay curious and keep learning. Cultivate a passion for the exploration of culture and experience. Your journey will feed your creativity and add to the tradition we are building together.

Index